The Artist's Guide to GIMP, 2nd Edition

THE ARTIST'S GUIDE TO GIMP

SECOND EDITION

creative techniques for photographers, artists, and designers | *michael j. hammel*

The Artist's Guide to GIMP, 2nd Edition

Copyright © 2012 by Michael J. Hammel

Printed in Korea

First printing

16 15 14 13 12 1 2 3 4 5 6 7 8 9

ISBN-10: 1-59327-414-9
ISBN-13: 978-1-59327-414-6

Publisher: William Pollock
Production Editor: Alison Law
Cover Design: Sonia Brown
Cover Illustration: Michael J. Hammel
Interior Design: Octopod Studios
Developmental Editor: Tyler Ortman
Technical Reviewer: Rolf Steinort
Copyeditor: Irene Barnard
Compositor: Susan Glinert Stevens
Proofreader: Paula L. Fleming
Indexer: BIM Indexing & Proofreading Services

For information on book distributors or translations, please contact No Starch Press, Inc. directly:

No Starch Press, Inc.
38 Ringold Street, San Francisco, CA 94103
phone: 415.863.9900; fax: 415.863.9950; info@nostarch.com; www.nostarch.com

The Library of Congress cataloged the first edition as follows:

Hammel, Michael J.
 The artist's guide to GIMP effects : creative techniques for photographers, artists, and designers / Michael J. Hammel. -- 1st ed.
 p. cm.
 Includes index.
 ISBN-13: 978-1-59327-121-3
 ISBN-10: 1-59327-121-2
 1. Computer graphics. 2. GIMP (Computer file) I. Title.
T385.H329558 2007
006.6'86--dc22
 2007001652

This book is dedicated to my wife and creative partner, Brinda,
for waiting patiently each night for me to exit my cave and
join her for an evening viewing of Jon Stewart and *South Park*.
May we laugh together forever, my dearest love.

About the Author

Michael J. Hammel has been involved with GIMP since version 0.54 and was a contributor to the early development of the program. Hammel wrote a column on GIMP for *Linux Format* for three years and is the author of *The Artists' Guide to the GIMP* (Frank Kasper & Associates, 1998) and *Essential GIMP for Web Professionals* (Prentice Hall PTR, 2001). He is an embedded software engineer living in Colorado Springs.

About the Technical Reviewer

Rolf Steinort is a science teacher in Berlin, Germany. As an amateur photographer before autofocus was invented and a Linux user at the time Tux became its mascot, he is naturally a longtime GIMP user. Since 2007, he has produced *Meet the GIMP* (*http://meetthegimp.org/*), a video tutorial podcast about GIMP and other open source graphic programs.

BRIEF CONTENTS

CONTENTS IN DETAIL

ACKNOWLEDGMENTS

There's no such thing as a one-man project, and this book is no exception. While the tutorials are mine, the ideas and motivations come from all over the world, from many artists and designers with much greater talent that I'll ever possess. To them, I owe my modest artistic accomplishments.

But even before these tutorials could be created, someone had to build the tools. To the GIMP Development Team, with specific thanks to Sven Neumann and Michael Natterer for keeping the project going for many years, I thank you for your years of dedication and hard work.

I owe the staff at *Linux Format* (past and present) a heartfelt thanks for publishing my GIMP tutorials series long enough for me to come up with the ideas in this book.

Of course, my biggest thanks are due to Bill Pollock at No Starch Press for eagerly accepting the idea for this book. And extra thanks go to the rest of the gang at No Starch Press: Alison Law and Tyler Ortman for their editing, and Leigh Poehler and Rachel Waner on the sales and marketing team. Thanks to Rolf Steinort from *Meet The Gimp!* (*http://meetthegimp .org/*) for his technical reviews, video clarifications, and assistance with learning new features in GIMP 2.8. Without all their great help this would be nothing more than a bunch of text files and screenshots.

Thanks to Greg Martin for graciously allowing me to create a GIMP version of his original Photoshop star field tutorial (*http:// www.gallery.artofgregmartin.com/tuts_arts/making_a_star_field.html*).

Additional thanks to my mom for once again letting me use a photo of her from her high school days in the photo restoration chapter. I know I wouldn't want my high school pictures used for anything except fireplace kindling.

Credits

Selected images appear from the following royalty-free collections:

BigStockPhoto.com *http://www.bigstockphoto.com/*

iStockphoto.com *http://www.istockphoto.com/*

PDPhoto.org *http://pdphoto.org/*

morgueFile *http://www.morguefile.com/*

Stock.XCHNG *http://www.sxc.hu/*

Links to all the stock images used in the book are available at the companion website:

http://www.artistsguidetogimp.com/

Many of this book's tutorials are inspired by tutorials presented in countless Photoshop texts. My knowledge of how to use tools like GIMP was born from those early Photoshop tutorials; I learned to translate and reimagine those techniques into the button sequences and pixel pushing required to reproduce the concepts using GIMP. Despite this extensive reading, I never actually used Photoshop until many years later, when my wife started using it. Though I know "where everything is" in Photoshop, I find myself happily using GIMP instead. We all have our comfort zones; use what makes you happy.

INTRODUCTION

I've been writing about Linux and GIMP in particular since 1996. I've written for every kind of publication, ranging from countless print articles and magazine columns to website musings and multiple books. In 2001, I wrote about how Linux and GIMP were starting to make waves in the special-effects industry with the article "Linux Goes to the Movies" in *Salon.com*. Open source has come a long way since then. And so has GIMP.

When GIMP was first started as a class project at the University of California, Berkeley, it was built on top of the venerable Motif toolkit, which at the time was really the only full-featured software library for X11-based windowing systems. Version 0.54 was my first taste of the GIMP in this form. Later, the GIMP Toolkit (GTK+) was born, and it replaced Motif for various technical reasons. Somewhere between version 0.54 and version 0.99, I ported John Beale's Sparkle code to a GIMP plug-in. For that ancient yet still meaningful work, I'm listed as a contributor to the project. It even got me into the Red Hat "friends and family" plan when they had their IPO (I should've sold when it was at its peak—silly me). Eventually, my association with the project led me to write for the *Linux Gazette* and later *Linux Journal*, the latter of which led to my first book on GIMP, in fact *the* first book on GIMP, called *The Artists' Guide to the GIMP*. You might say I've followed Linux and GIMP from day one.

Of course, after all these years I'm no longer the only one writing on this subject, and GIMP is no longer just a class project. Plenty of texts exist that show you which button opens which dialog. In the first edition of this book, I hoped to go where no one else had attempted, beyond the application itself and into what it can do. In this second edition, I'm updating the old tutorials, tossing in some new ones, and giving you a look at how GIMP is evolving.

Linux and GIMP have grown up together, and they are no longer youngsters in the computing world. Linux comes with a serious desktop, and GIMP is a serious application. It's time to get down to business: the business of graphic design. This book is about learning techniques applicable to the real world.

What This Book Is About

This book is about process, not buttons or menu paths. My goal is to show you that the processes required to perform a task can be done with GIMP as easily as with any other graphics editor. It isn't the tool that's important, it's understanding the process. It's far easier to grasp that a mask is a black region blocking out a section of an image than it is to find a use for an alpha channel and a black background. Don't get bogged down in the mechanics of the tool. Focus on the task at hand. I'll point you to the GIMP components necessary to finish the job. By the time you're done with these tutorials, you won't need any more pointing.

If you can't find a dialog referenced in the text, just open the Dockable Dialogs menu, available from the Windows menu. Clicking a menu entry jumps to that dialog quickly if it's already open or opens it if necessary.

This book was written during the development of GIMP 2.8, so it's most relevant to that particular version of GIMP. But I've tried to keep my advice general enough that the book remains useful even as newer versions of GIMP are released.

What This Book Is Not About

In this book, you won't find manual pages for each filter, menu, or feature. I won't be explaining each icon you find or why some dialogs look like they do. Instead, the tutorials presented here show how to use filters as if they were a set of tools in a toolbox.

You seldom need just a hammer for a project. GIMP provides the hammer, the saw, the drill, even the kitchen sink. With this book, I hope you'll learn to use all the tools in the toolbox.

How This Book Is Organized

The book has six chapters, each consisting of multiple tutorials. Each chapter covers a different area of graphic design: Fundamental Techniques, Photographic Effects, Web Design, Advertising and Special Effects, Type Effects, and Creative Inspiration (advanced projects). Each tutorial opens with introductory material on the subject at hand and includes a set of tips related to that area of design.

Chapter 1 provides a set of core tips laid out in an introductory fashion, from the toolbox to common tasks like drawing and text manipulation. Users new to GIMP should read this chapter thoroughly, while more advanced users may glance through it or skip it altogether. Each tutorial after Chapter 1 is an independent project, so try to find a project that strikes your fancy. These tutorials can be completed in any order.

Chapter 2 is for photographers. GIMP's raster processing is ideal for working with photographs and stock imagery. The number of effects you can create is limitless, but this chapter will help you get started with some often-used photographic techniques.

Chapter 3 is all about graphic design for the Web. In many areas of the Web, static images still play key roles. Features like background images, menus and buttons, and logos are all part and parcel of everyday GIMP work.

Chapter 4 will take you to the world of advertising design and special effects. In this chapter, you'll find techniques to create 2-D and 3-D designs for products ranging from posters to cell phones to underwater adventures.

Chapter 5 covers type effects. GIMP is wonderful at turning boring fonts into fantastic logos and 3-D designs. This chapter will walk you through re-creating some commonly used text effects.

Chapter 6 is new to this edition of the book. It provides several advanced tutorials whose primary purpose is to inspire you to new creative heights. Use this chapter as your springboard to advanced use of GIMP.

Each tutorial starts with a project summary, accompanied by reasons for using the technique. The tutorials are designed to allow you to quickly re-create them step by step using the default tools and features that come with GIMP.

A Few More Hints

I won't be referencing keyboard shortcuts very often—with a few exceptions like Select All (CTRL-A) or Deselect All (CTRL-SHIFT-A)—because GIMP allows you to customize the shortcuts any way you like. Instead, I'll reference the default menu locations where necessary. If the feature has a keyboard shortcut, it'll be listed next to that option in the menu. Learn those to speed your work through these tutorials.

Note that the use of the CTRL and ALT keys are shown as they're used with Linux. Users of Windows or Mac can map these keystrokes to their appropriate platform equivalents.

Also note that key presses for the keyboard are always listed with uppercase letters to make the key sequence easier to read. Unless SHIFT is specifically listed with the keystroke, the SHIFT key need not be used.

A Useful Package

GIMP Paint Shop (*http://code.google.com/p/gps-gimp-paint-studio/*) is a package providing additional brushes, palettes, patterns, and excellent tool presets that provide simulated artist's tools and techniques. It's a must-have if you plan on taking your GIMP skills to the next level.

You can check out more ways to extend the power of GIMP at *registry.gimp.org*.

About the Canvas

Unless otherwise noted, assume a default canvas size of 640 × 400 pixels to make the tutorials easier to produce on slower systems. This size works fine on the Web, but you'll need to scale up the process if you intend to use a technique for a print project: increase the amount of blur, adjust the number of pixels to offset a layer, and so forth. The thing to remember in each tutorial is

the basic set of steps: add text, blur, offset a layer, duplicate and rotate, and so on. The amount of each of these varies with the scale of the project, and print projects tend to use significantly larger canvases than the default 640 × 400 pixel, 72 dpi canvas used in these tutorials.

Be sure *not* to create the project at the default canvas size and then try to scale it up at the end! Doing so produces grainy, unsuitable results.

In this book, the terms *canvas* and *image window* are interchangeable. The official GIMP documentation refers to the main drawing area as an image window. I like to use *canvas* because the term *image* is somewhat overused—it can mean more than one thing, depending on context. Besides, artists work on a canvas. They produce images. It just makes sense to me.

1

FUNDAMENTAL TECHNIQUES

The *GNU Image Manipulation Program* (or *GIMP*) is one of the world's most popular open source projects. It allows everyday users on a budget to harness the graphical abilities of virtually any computer. Open source means anyone can improve the program, and it's free to download.

To install GIMP, go to *http://www.gimp.org/* and find the download and installation instructions for your operating system. GIMP runs on all three major platforms: Mac, Windows, and Linux. In fact, if you use Linux, it's probably already installed on your machine. You'll need to run GIMP 2.8 in order to follow along with the tutorials in this book (though the tutorials are

written to be applicable to the older 2.6 version as well). Come back once you've got it up and running! These tutorials provide practice and guidance in using GIMP's features but little hand-holding when it comes to the program's basic tools and features. The book assumes that you'll learn best by experimenting and combining effects. If you're a beginner, read the first section in each chapter carefully, and check out GIMP's official user manual if you get confused (*http://docs.gimp.org/en/*).

For readers transitioning from other image-editing software programs and for those of you completely new to GIMP, this book begins with a quick introduction to the most important elements of GIMP's interface: the toolbox and the image window. If you're already a GIMP enthusiast, you may want to skip ahead to Section 1.1. If you haven't used GIMP before, or if you'd like to refresh your memory, read on.

Multi-Window vs. Single-Window Mode

GIMP 2.8 introduced two ways to work with GIMP windows. The original method used separate windows for everything: toolbox, dialogs, canvas, and so forth. In GIMP 2.8, choose Windows ▸ Single-Window mode to place all windows into a single one. This new method will be familiar to Windows users, while the original Multi-Window mode will be familiar to Mac and Linux users. Throughout this chapter, examples of both modes will be shown where appropriate and meaningful.

NOTE *Throughout the book you'll find the interchangeable terms* image window *and* canvas window. *The official designation is image window, but since the term* image *is often overused, the term* canvas window *was chosen to avoid confusion.*

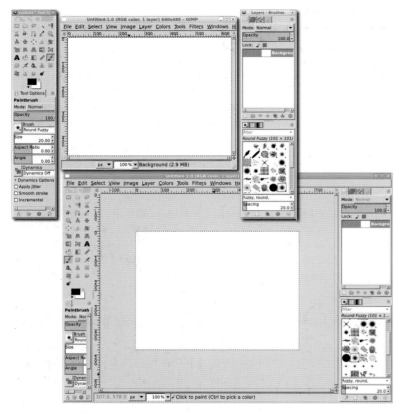

The term dialog *refers to a type of window, usually one that opens upon a specific request for a tool or other feature.*

The table below shows the icons for each tool available in the toolbox and briefly describes that tool's abilities. Each tool also has a Tool Options dialog, which allows you to fine-tune how each tool is applied and achieve exactly the effect you desire. We'll discuss the Tool Options dialog shortly.

Toolbox Icons

Tool		Function
	Rectangle Select	This tool allows you to create editable rectangular selections. Use the Tool Options to specify how the new selection should be combined with existing selections. Hold down the SHIFT key while selecting to create a perfect square.
	Ellipse Select	The Ellipse Select tool is just like the Rectangle Select tool, except that the shape of the selection is elliptical. Hold down the SHIFT key to create a perfect circle.
	Free Select	Another selection tool, the Free Select tool, allows drawing curved freehand and polygon outlines to create a selection. Both types of outlines can be mixed in a single selection.
	Fuzzy Select	The Fuzzy Select tool selects pixels based on their similarity in color and proximity to the point you click in the image window. Using higher Threshold settings in the Tool Options dialog will cause more pixels to be selected. You can change the threshold by moving the mouse while pressing the left mouse button. Check the Sample merged checkbox to choose pixels from the visible canvas (i.e., from all layers combined) instead of from only the current layer.
	Select by Color	The Select by Color tool is similar to the Fuzzy Select tool, except the chosen pixels don't need to be in close proximity to one another.

GIMP's default window layout in Multi-Window mode (upper left) and Single-Window mode (lower right)

The GIMP Toolbox

The default layout for GIMP, from left to right, includes the toolbox, an empty canvas window, and the default docks. The *toolbox* holds all of GIMP's core tools. The canvas window is used to draw, paint, and edit images. Docks are windows that hold one or more of GIMP's various dialogs, such as the Layers, Channels, Brush, and Paths dialogs.

Tool		Function
	Scissors	This is an intelligent tool that finds edges in an image, making it easier to manually outline an oddly shaped figure and create a selection around it.
	Foreground Select	This tool allows you to isolate objects in a single layer from their surroundings, using free selects mixed with paint strokes.
	Paths	Paths are vector components in GIMP[1] and consist of a series of nodes connected by straight or curved lines. You can edit the curve to change the position of nodes and the arc of lines. The Paths tool allows you to create a new path or edit an existing one.
	Color Picker	Use this tool to change the foreground or background colors in the toolbox. With the Color Picker tool active, just click any pixel on the canvas.
	Zoom	Use the Zoom tool to zoom in on or out of a section of an image. Drag a box around an area to zoom in on that spot.
	Measure	Use the Measure tool to measure angles and distances in an image. These measurements are useful when used in combination with the Rotate and Scale tools.
	Move	This tool allows you to move image elements like layers, selections, text, and masks around the image window.
	Align	The Align tool allows interactive alignment of layers.
	Crop	The Crop tool is the best way to crop images quickly. You can also use it to crop individual layers.

1. In simplest terms, *vectors* are lines that include information about the path they travel from one endpoint to another. They have no information about the pixels used to create them in GIMP's image window. Most GIMP tools are raster based, which means they operate on pixels. A *pixel* is a dot with red, green, blue, and transparency levels.

Tool		Function
	Rotate	The transform tools can be applied to layers, selections, and paths. Use the Rotate tool to perform a rotation on any of these.
	Scale	Another transform tool, the Scale tool is used to interactively resize layers, selections, and paths.
	Shear	Use the Shear tool to keep opposite sides of a bounding box (the edges of a layer, selection, or path) parallel while moving pixels within the box left/right or up/down.
	Perspective	The Perspective tool stretches the bounding box as if you're viewing a square photo head-on and you tilt the photo away from you, so that the far edge appears shorter than the near edge.
	Flip	Use the Flip tool to flip a layer, selection, or path horizontally or vertically.
	Cage Transform	A fun distortion tool, but one that won't be covered here. It's of little use to new and intermediate users.
	Text	If you want to add text to a project, you'll need to use the Text tool. The Tool Options dialog allows you to specify font size and family, along with alignment options.
	Bucket Fill	Use the Bucket Fill tool to fill a portion of a layer with a solid color or pattern.
	Blend	The Blend tool applies a smooth color transition (known as a *gradient*) to a layer or selection. Many stock gradients are available, and the Gradient Editor allows creation of custom gradients.
	Pencil	Paint tools use the active brush and the current foreground or background color. The Pencil tool draws hard-edged lines that are not antialiased, even if the brush itself has a soft edge.
	Paintbrush	Use the Paintbrush tool to draw with soft-edged strokes and the active brush.

(*continued*)

Tool		Function
	Eraser	The Eraser tool removes pixels from almost all layers, leaving transparent pixels in their place. When applied to the Background layer, which by default doesn't have an alpha channel, this tool will replace pixels with the background color.
	Airbrush	The Airbrush tool works much like the Paintbrush tool, but the effect is softer.
	Ink	The Ink tool is designed specifically for use with drawing tablets like those from Wacom. It responds to pressure and the tablets' tilt features.
	Clone	*Cloning* is the process of copying pixels from one region of a layer to use in another. To use the Clone tool, press the CTRL key and click the mouse to set the source point you want to clone. Then you can clone pixels using paint strokes.
	Heal	A tool similar to the Clone tool but that does a better job of merging nearby pixels. A common use for this tool is removing wrinkles from photos.
	Perspective Clone	Another Clone relative, this tool can copy an area given a perspective area in which to clone. You could, for example, copy a window on a building to an adjacent location while retaining the perspective of the original window.
	Blur/ Sharpen	The Blur/Sharpen tool functions like the Paintbrush tool and allows you to paint over a layer to sharpen or blur the regions under the brush.
	Smudge	Imagine dragging your finger across wet paint on a canvas. This tool functions the same way, as you drag it in the image window. It's perfect for small touch-ups.
	Dodge/Burn	Similar to the Blur/Sharpen tool, the Dodge/Burn tool can be used to lighten (Dodge) or darken (Burn) the region under the brush.

The Tool Options Dialog

The *Tool Options dialog* gives you access to the active tool's options and settings. This dialog opens as a tab at the top of the two initial docks. Clicking the icon for a GIMP tool does two things: it activates the tool, and it displays the Tool Options dialog for that tool.

NOTE *As well as a Tool Options dialog, many toolbox tools are associated with an additional dialog. These dialogs give easy access to tool-specific features. Click a tool's toolbox icon to access its Tool Options dialog. Click in the canvas to open the tool's associated dialog or use the File menu to access it (File ▶ Dialogs).*

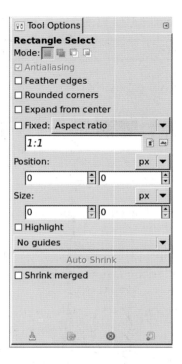

The Tool Options dialog for the Rectangle Select tool

Color Swatches and Tool Previews

At the bottom of the toolbox you'll find the color swatches and the brush, pattern, and gradient previews. If you've enabled it in the Preferences dialog, you'll also see the active image preview.

In the swatches box, you'll find the current foreground color (upper-left box) and the current background color (lower-right box). The color swatches are referenced throughout this book. Clicking either of these will open a dialog in which you can adjust the current colors. Double-clicking the foreground or background color box is required when the alternate box is currently active. For example, if the background color box is active (it appears behind the foreground color box in the toolbox), clicking once on the foreground color box makes it active, and the second click opens the Change Foreground Color dialog.

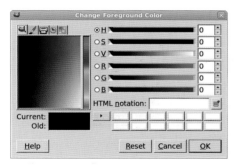

The Change Foreground Color dialog

The curved, doubled-ended arrow in the upper-right corner of the swatches box swaps the current foreground and background colors. Clicking the smaller boxes in the lower-left corner resets the foreground color to black and the background color to white. Pressing D in the canvas will also reset the colors, while pressing X will swap them.

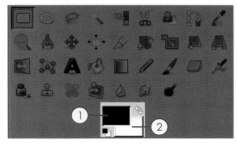

The foreground ① and background colors ②
in the swatches box at the bottom of the toolbox

Brush, Pattern, and Gradient Previews

The brush, pattern, and gradient previews reflect the selection currently active for the Brushes, Patterns, and Gradients dialogs. Click any of these previews to open the associated dialog and change the active selection.

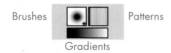

The brush, pattern, and gradient previews in the toolbox.

A gradient is a change in color, often smoothed in a way that simulates lighting changes or curved surfaces when applied to a selection. The Blend tool is often used to apply gradients. You can set that tool to use the current foreground and background colors, choose from a set of predefined gradients, or create your own.

Active Image Preview Window

As you'll soon discover, having several image windows open at once can get confusing. The active image preview window lets you quickly activate the window of your choice. Double-click the preview to open a dialog to choose the active image window.

This feature is not enabled by default, so in order to use it, turn it on in the Preferences dialog. Choose File ▸ Preferences in the toolbox and select Toolbox on the left. Then check the Show active image checkbox. The active image window is displayed here at the bottom of the toolbox.

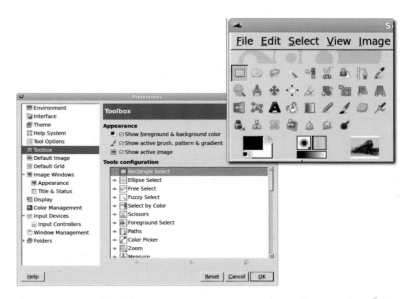

Once you've enabled the active image preview in the Preferences dialog, the preview appears at the bottom of the toolbox. The position will be to the right and/or below the other previews, depending on how you change the size of the toolbox area.

Docking

A *dock* is a window that holds other windows. For example, the toolbox has a dock at its base. Any dialog can be made into a dock. To do this, drag one dialog title into another dialog to dock the two, resulting in a series of tabs. To detach a dialog from one dock and move it to another, drag the tab to a new part of the screen.

Docking windows saves screen space and reduces clutter (left). In Single-Window mode (right), all dialogs are initially docked, but they can be moved to different docks at any time by dragging a tab from one dock to another.

The Image Window

In addition to the toolbox, GIMP's other main window is the *image window*, or *canvas*, where your work is displayed. GIMP allows you to have several image windows open at once, and this is helpful when copying from one window and pasting into another.

Multi-Window mode (left) places each image in its own window. Single-Window mode (right) adds tabs above the canvas area for each image.

Menus

All menus are in the image window. In Multi-Window mode, each image window has a copy of these menus. Most menu items apply to the image window from which the menu was opened. Some menus, like the File menu, apply to the entire GIMP application. In Single-Window mode, the menu bar across the top of the single window applies to the active image window tab or all tabs, as appropriate.

The menu can be accessed in multiple ways. The first is with the menu bar. Another is to right-click the mouse in the canvas area. The last option is to use the menu button in the upper-left corner of the canvas. In this book the menu bar will be used, though advanced users should become familiar with the menu button, as that's the only way to use tear-off menus. Why are there multiple ways to do this? Because there are times when, working with small images (like icons for the web or a computer application), you'll need to zoom in quite a bit. If you resize the window to fit this, you might not have every menu option available at the top of the image window. If that happens, use the right-facing arrow to access the out-of-view menu options. This menu also provides access to tear-off menus, which allow you to access common menu items quickly without having to repeatedly traverse menus. You might use this, for example, when creating guides to start a project.

The image window menus include File, Edit, Select, View, Image, Layer, Colors, Tools, Filters, Windows, and Help. Linux users may also find a Video option in the menu bar, depending on the manner in which their Linux distribution packaged GIMP. However, this option isn't part of the base GIMP package for Windows or Mac users and will not be discussed in this book.

You'll use features from the Edit, View, Image, Layer, Colors, and Filters menus throughout this book. The Select menu is also very useful, but you can use the mouse, the toolbox, and keyboard shortcuts to access most of its options. Don't forget to look at the File menu to familiarize yourself with its Create, Save, Export, and Print options.

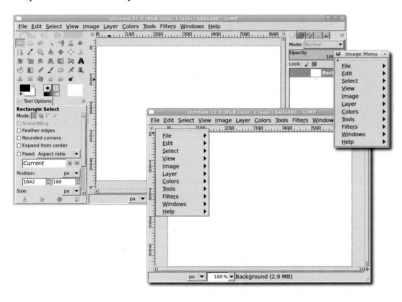

The image window menu bar in Single-Window mode (left), Multi-Window mode (lower middle) showing a menu posted from the menu button in the upper-left corner of the canvas, and a tear-off menu

Even though it's beyond the scope of this book, you should know that you can create your own add-on tools that can be added to any menu. If you're a programmer interested in developing tools for the GIMP, I suggest you review the material on the GIMP developers' website (*http://developer.gimp.org/*), specifically the Plug-In Development section.

Image Window Menus and Features

Menu	Feature
File	The File menu offers operations such as Open, Close, Print, Save, and Export.
Edit	The Edit menu gives you access to the Cut, Copy, Paste, Fill, and Stroke operations. Some of these operations only apply to selections, but others apply to the entire active layer if no selection is present.
Select	The Select menu offers operations that complement the toolbox selection tools, including All, None, Invert, and Save to Channel. Selections can also be feathered, grown, shrunk, and sharpened from this menu.
View	Zoom is just one of the View menu's options. You can also use this menu to toggle between visibility of guides, layer boundaries, selections, and grids of dots. Forcing the image window to shrink-wrap to the zoom level of the image helps you make more room on the desktop when zooming out. Choose View ▸ Full Screen to switch to and from full-screen mode.
Image	Operations that apply to the composite image are found here, including rotation transforms, canvas sizing, and merging all layers into a single layer.
Layer	This menu offers operations that apply specifically to layers. This includes layer ordering; color management for the active layer; and layer transforms, masks, scaling, and alignment.
Colors	Options in the menu include dialogs for adjusting brightness, contrast, hue, saturation, and white/black point levels. Any global or selection-oriented color corrections will use this menu.
Tools	The Tools menu provides access to the toolbox tools, but you'll rarely use it unless you're in full-screen mode. Selecting an item from this menu makes that tool active, as if you had clicked its icon in the toolbox.

(continued)

Image Window Menus and Features (continued)

Menu	Feature
Filters	As you follow along with the tutorials in this book, you'll become familiar with the Filters menu. It offers the tools you'll need to manipulate images in creative ways, applying blurs, lighting effects, cloud renderings, and warping.
Windows	The dialog menu provides quick access to GIMP's many dialogs, including the Layers, Channels, Paths, Brushes, Patterns, Gradients, and Document History dialogs.
Help	Context-based and programming help, along with installed or online help documentation, are accessed through this menu.

NOTE *You don't have to use the File menu to access these options. Try right-clicking instead to bring up a flyout menu containing all of these options. It's much faster!*

Additional Features

There are a few other image window features you should get to know. Each is labeled and discussed briefly here.

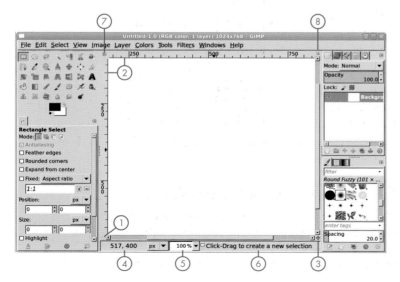

Additional image window features

① Use the Quick Mask to create and modify selections. It's discussed further in Section 1.4.

② Use the rulers to pull out vertical and horizontal guides. Click one of the rulers and drag out to create a new guide, or create one more precisely by choosing Image ▸ Guides ▸ New Guide. Guides are like grid lines you can use to line up objects.

③ Panning around images is easier with the navigation control. Click it while viewing a large image or while zoomed in on a small one to see it in action.

④ The pointer coordinates display the exact location of the cursor in the units (inches, pixels, etc.) you select from the drop-down menu on the right.

⑤ The zoom drop-down menu lets you quickly change the view of your image, but you're usually better off using the keyboard shortcuts plus (+) and minus (–) to zoom in and out. Press 1 to view your image at 100 percent.

⑥ The status area shows useful information, including angle information, when you're dragging to create straight lines.

⑦ You can also use the right-pointing arrow (in the upper-left corner of the image window) to access the image window menu.

⑧ The image window also includes a zoom button, which is shaped like a magnifying glass and located in the window's upper-right corner. Click this button, and then drag the window corners to resize the image. The canvas will zoom in and out to fit the new window size.

The Preferences Dialog

GIMP's user interface is extremely configurable. You can change keyboard shortcuts used to access tools and filters, or you can add shortcuts to features that don't already have them. In addition, you can change the default new image size, specify how your dialogs appear on startup, set your resource consumption preferences, and much more. These options and many others are accessible via the Preferences dialog (File ▸ Preferences).

Shortcuts

One of the best ways to save time while working in the GIMP is to use existing shortcuts. You can also map your own, if you like. Open the Preferences dialog (File ▸ Preferences) and click Interface on the left. Clicking the Configure Keyboard Shortcuts button allows you to map commands individually. If, for example, you often have to blur images, you may want to map CTRL-SHIFT-B to the blur command you need to apply.

Alternatively, you can map shortcuts interactively. Check the Use dynamic keyboard shortcuts checkbox to enable this feature. Then click OK to save your Preferences.

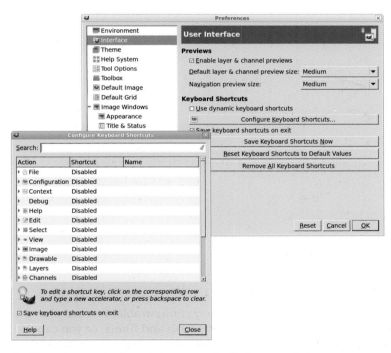

Enabling dynamic keyboard shortcuts in the Preferences dialog

Open the Edit menu in the toolbox. Notice that the Preferences option doesn't have a keyboard shortcut listed to the right of it. To add a shortcut, place the cursor over the Preferences option but don't click it. Instead, press CTRL, SHIFT, and P keys all at once. The Preferences dialog now has a keyboard shortcut, so go ahead and give it a try. Press CTRL-SHIFT-P to return to the Preferences dialog. To remove a dynamic shortcut, mouse over the menu entry and press the BACKSPACE key. Shortcuts are huge time-savers, and they're an easy way to personalize your GIMP experience.

In order to clarify step-by-step instructions, this book will focus on menu selections, not shortcuts. However, as you gain experience, learning to use shortcuts will improve your creative workflow.

Before and after setting a keyboard shortcut for the Preferences dialog

Undo Levels and Other Environment Options

The Preferences dialog can also improve GIMP performance. You can modify features such as image cache size, number of undo levels, maximum memory that can be used for undo operations, and maximum size that can be used for image thumbnails. If

you've got the memory and the inclination, feel free to push up these values. The most-often modified value is probably the tile cache size. Smaller values reduce memory usage by the GIMP but slow processing of large images. If you have lots of memory and work on large images, try increasing the value from 128MB to 256MB. If you're low on memory, another option is reducing the undo levels. The default of five is already low, however. If you reduce this value to save memory, remember to save your work often.

Resource Folders

The Preferences dialog also allows you to configure the directories that hold files for your brushes, patterns, gradients, fonts, and so on. Click the arrow next to Folders to expand all resource folders. If you want to create your own patterns or files, you can use the Preferences dialog to tell GIMP where to save and look for those files. You can also add or remove collections of brushes and patterns this way.

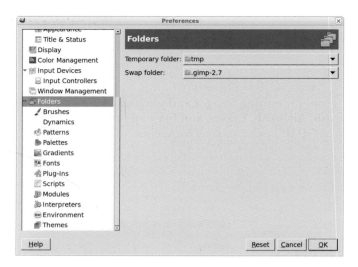

Directory settings in the Preferences dialog

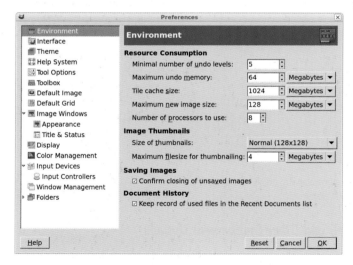

Environment settings in the Preferences dialog

1.1 DRAWING AND PAINTING

GIMP can be used for drawing and painting, even if it's better known as a tool for editing images and photographs. The Pencil, Paintbrush, Airbrush, Eraser, and Ink tools are collectively referred to as GIMP's paint tools. This section of the book introduces these tools to new users. The Basic Tutorials in Section 1.10 will help you get a grasp on using these paint tools so you'll be prepared to experiment with them later in the book.

Paint Tools and Features

Before discussing each of the paint tools, let's examine some features they have in common.

Opacity In the Tool Options dialogs for each of the paint tools, you can adjust the opacity of the brushstroke to be applied. Remember that opacity is the opposite of transparency, so a higher opacity value means the brushstroke will be less transparent.

Mode All the paint tools except the eraser allow you to set the Blend mode for the brushstroke. The Blend mode defines how the stroke blends with the existing pixels in the layer where the stroke is applied. Different modes have different effects. Addition mode adds the brush's colors to those in the image, causing the image to lighten. Multiply mode causes the image to darken. Overlay mode can either lighten or darken the

Setting the mode to Normal in the Paintbrush tool's Tool Options dialog

image, depending on the color or pattern being applied and the existing content in the layer where the stroke is made. Blend modes are also used in layers.

Modes are also used to composite layers. You'll explore modes in more detail in Section 1.2. Don't worry too much about them for now. While you experiment, stick with Normal mode.

Brush The global brush setting is set in the Brush preview in the toolbox. You can also choose a brush for any of the paint tools from the Tool Options dialog. Except for the Ink tool, which uses its own brush, all the paint tools require that you choose a specific brush. The paint tools even remember brushes; you can switch from one to another and back again without losing your settings for either tool. The default configuration is for all paint tools to share the same brush, but this can be changed in the Preferences dialog under Tool Options.

The Preferences dialog shows that brush settings are shared among all of the GIMP's paint tools (the Brush checkbox is checked).

As you can see here, a paint tool's brushstroke can be set to fade as it is applied. The distance the stroke travels before the fade can also be adjusted in the Tool Options dialog, using Dynamics. First, set the Dynamics option to **Basic Dynamics**. Then click **Dynamics Options** to display the Fade Options and adjust the Fade Length value to determine the length of the stroke before the fade. Changing the Dynamics option to Fade Tapering will add a tapered end to the fading stroke, as shown in this example. The Ink tool is the only paint tool that doesn't offer this option.

Specifying how to fade out of a brushstroke using the Paintbrush tool. Note that the Reverse option is required to fade out a stroke as opposed to fade in.

Spacing All brushes have a Spacing setting. This value, measured in percentage of the brush's width, determines how far apart brush images are applied during a brushstroke. You can use the Brush dialog to change the default spacing for any brush. A higher Spacing value allows you to create shapes like wire frames and tubing from ordinary brushes.

Now that you're familiar with the basics, here are the GIMP paint tools used most often in this book's tutorials.

The Pencil Tool

The Pencil tool applies a hard edge, which is important to remember. Making the most of the paint tools requires that you understand the difference between hard and soft edges. When you work with soft edges, levels of gray or fading color in a brush are considered partially transparent and are merged with the existing pixels in the canvas. This creates soft edges around the brushstroke. When working with a hard edge, if a pixel in the brushstroke is more than 50 percent black (or more than 50 percent colored), the pixel in the brushstroke replaces the pixel on the canvas, rather than being merged with it. If a pixel in the brushstroke is less than 50 percent black or colored, the pixel on the canvas is unchanged.

The difference is easy to see here, where both the Pencil tool and the Paintbrush tool are used in conjunction with the Round Fuzzy (101) and Pepper brushes. The Pencil tool uses a hard edge, so there's no antialiasing of the brush edge, whereas the Paintbrush tool uses a soft edge. For this reason, you probably won't use the Pencil much when working with masks or editing photos.

The Pencil tool (top) and Paintbrush tool (bottom) are used to draw lines with the Round Fuzzy (101) and Pepper brushes.

The Paintbrush Tool

Throughout the tutorials, this is the paint tool you'll use most frequently. The Paintbrush tool is perfect for creating layer masks and creating selections by painting Quick Masks. In either case, the soft-edged nature of the paintbrush makes it ideal for closely matching curves.

The Paintbrush tool applies its brush only once over a given point. That is, if the Paintbrush tool is active and you hold the mouse button over the canvas and click, only one brushstroke is applied. More brushstrokes are applied as you drag the cursor around the canvas.

The Airbrush Tool

The Airbrush tool is very similar to the Paintbrush tool, except that it applies a lighter or darker stroke, depending on the Rate and Flow values set in the Tool Options dialog. It also continues applying the brush to a single point if the cursor doesn't move. For these reasons, the Airbrush tool is useful for enhancing shading and lighting in images.

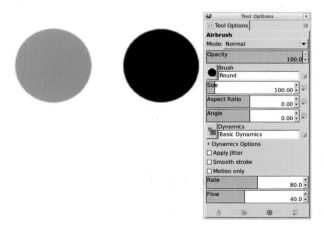

The Rate and Flow values set in the Airbrush tool's Tool Options dialog determine how the brushstroke will look when the tool is applied to the canvas. On the left is a single click. On the right, the mouse button was held down for three seconds.

The Eraser Tool

The Eraser tool is a soft-edged paint tool that removes pixels from a layer in the shape of the current brush. In all layers except the Background layer, the pixels are changed to transparent (or semi-transparent, depending on the brush used). In the Background layer, which by default doesn't support transparency, the erased pixels are changed to the background color in the toolbox.

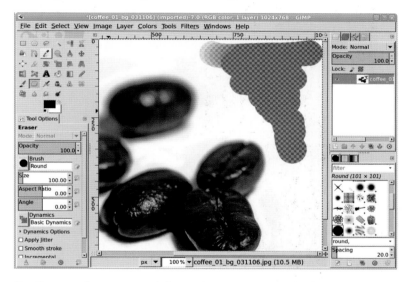

The Eraser tool removes pixels from a layer.

The Eraser tool is a destructive tool; the pixels it changes are gone forever once you save the file. A better way to hide those pixels from view is with a layer mask, which is not destructive. (You'll learn a little more about layer masks and selections in Section 1.4.) You can edit a layer mask at any time in the future to adjust what's hidden. That's impossible with the Eraser tool, so you won't be using it as often.

The same effect is achieved using a layer mask, which leaves layer content intact so it can be reused later if necessary.

The Ink Tool

The Ink tool was specially designed for use with drawing tablets from manufacturers like Wacom. You can use the Ink tool's Tool Options dialog to adjust the shape of the brush tip, the amount of tilt applied to the brushstroke, the speed at which the brush is moved relative to the tablet pen, and much more.

These features are quite helpful to users who do pen drawings, such as manga or similar artwork. Pen drawings are not this author's forte, unfortunately, so the Ink tool won't be used in any of these tutorials.

Brushes

GIMP's stock brushes are fine for most projects, and you'll use them in tutorials throughout this book. But with a little effort, you can greatly expand the selection of styles available. Creating new brushes is almost a no-brainer. Almost.

Discussed here are two types of GIMP brushes: ordinary and colored brushes, and parametric brushes (which are scalable and must be created using the Brush Editor).

NOTE *The easiest way to create a new brush or pattern is to use the clipboard. Select a small region with any selection tool and copy it (Edit ▸ Copy or CTRL-C). The clipboard is shown in the very first box in both the Brushes and Patterns dialogs. This section describes how to have more control over brush creation.*

Creating Ordinary and Colored Brushes

You can create your own GIMP brushes. The simplest is an ordinary or colored brush, which consists of an image that you draw or import and save as a brush file by giving it a *.gbr* extension. Any image that can be opened in the GIMP can be saved as a brush, though some work better than others. Very detailed images don't work well for this purpose, for example. In most cases the image should also be scaled down, because it will become the brush tip.

NOTE *Colored brushes are just like ordinary brushes, except the former have color while the latter are simply levels of gray.*

Ordinary brushes paint with the foreground color wherever there's black in the brush image. Where black fades to white in the brush, the foreground color is mixed with transparency before being mixed with the pixels in the canvas.

To create an ordinary or colored brush, just follow these steps:

1. Open a new image window by choosing **File ▸ New**. Set the size to **25 × 25 pixels**.

2. If you're creating a colored brush, you need to add an alpha channel to the Background layer (Layer ▸ Transparency ▸ Add Alpha Channel). If you're creating an ordinary brush, don't add the alpha channel but instead convert the image to Grayscale (Image ▸ Mode ▸ Grayscale).

3. Use the Paintbrush tool to paint an *X* shape in the canvas. This is painted in color if you created a colored brush, or it appears in grayscale if you converted the image to Grayscale in the previous step.

4. Once you've finished creating your image, export it to a brush directory with a *.gbr* file extension. (Choose **Edit ▶ Preferences** to open the Preferences dialog, and then look under **Folders ▶ Brushes** for the correct path.)

5. When the Export Image as Brush dialog appears, type a brush name into the Description field and set the Spacing value appropriately. A brush is like a stencil applied repeatedly during a brushstroke; its Spacing setting is the percentage of brush width from the center of one stencil application to the next. For most purposes you can accept the default spacing.

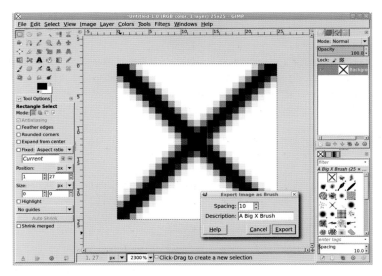

The Export Image as Brush dialog, showing a sample brush. Note the updated Brushes dialog, lower right, with the new brush selected.

6. Open the Brushes dialog (**Windows ▶ Dockable Dialogs ▶ Brushes**) and click **Refresh** to update the Brushes dialog. This causes GIMP to reread all available brush files, and it should find the one you just saved. Your new brush should appear in the palette along with the built-in brushes and any other brushes you've defined. Your new brush is ready to use. Select it and start painting.

NOTE *When using ordinary and colored brushes, it's not uncommon to create multiple versions of a particular brush at different sizes. The best way to do this is to create the largest brush first, and then repeatedly scale down and save the image to create several smaller brushes.*

Creating Parametric Brushes

Parametric brushes are easily modified and can be configured to change in a number of ways as they're being used. Unlike ordinary and colored brushes, you can only create parametric brushes by using the Brush Editor. To open the Brush Editor, click the New icon in the Brushes dialog (it shows a blank sheet of paper). (If the Brushes dialog isn't active, choose Windows ▶ Dockable Dialogs ▶ Brushes.)

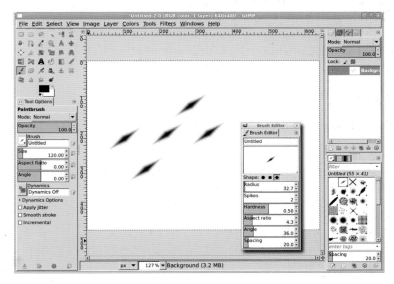

A parametric brush applied to the canvas several times and shown in the Brush Editor window

The Brush Editor window allows you to set a basic brush shape (oval, square, or diamond) and adjust that shape several ways by entering values for a variety of options. The Radius is

the size of the brush in pixels. The Spikes value is the number of lines that run from the center of the brush outward. These lines are obvious in square and diamond shapes but aren't immediately visible in the oval shape until you increase the Aspect Ratio, which exaggerates the effect of the spikes.

The last two options in the Brush Editor are Angle and Spacing. The Angle value is given in degrees and indicates how the spikes should be rotated around the brush center. As is true of other brushes, you can adjust the Spacing for parametric brushes.

The primary usefulness of parametric brushes is that they're easy to change as you work. It's also easy to tweak a particular brush shape to meet very specific needs. This can't be done with other brush types without opening the brush file in a canvas window, editing the brush manually, and saving it as a new brush.

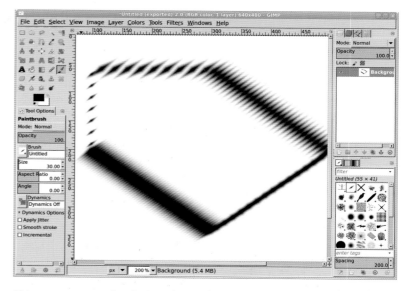

Using a parametric brush to stroke a selection allows you to achieve some interesting effects. In each line, the Spacing value is varied.

1.2 LAYERS AND MODES

Layers in GIMP are like transparent sheets of paper piled one on top of another. Wherever a sheet is transparent, the sheets below it show through. If you lay several transparent sheets on an overhead projector and turn on the projector's light, the colors in each sheet combine to form new colors. That's exactly the way layers in a stack work: they combine to produce what you see in the canvas window. Changes made to layers are immediately reflected on the canvas.

Layers are the building blocks of GIMP projects because they allow you to build up an image one piece at a time, just as cartoons were created by hand before computers took over.

Accessing the Layer menu from the canvas window

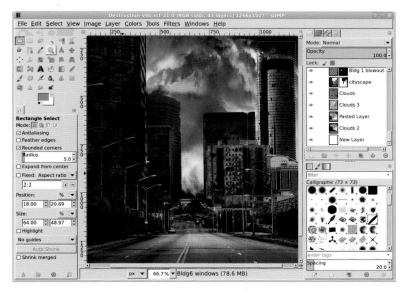

Layers in the Layers dialog and the combined image in the canvas window

The Layers Dialog

You can use either the Layer menu or the Layers dialog to manage layers.

You can move a layer up or down the stack by using the arrow buttons ① at the bottom of the Layers dialog, or you can simply click the layer and drag it to its new position. The other buttons at the bottom of the Layers dialog include the new layer button (single page icon ②), the create layer group (folder icon ③), the duplicate layer button (two page icon ④), the anchor layer button (anchor icon ⑤), and the delete button (an *x* in a red circle icon ⑥). Aside from the anchor layer button, the functions of these buttons are self-explanatory.

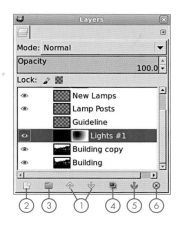

Layers can be created, moved, and managed using the button bar.

The Layers dialog folder icon was introduced in GIMP 2.8. This is used to create a *layer group*, which allows a single action to be performed on more than one layer at a time, such as moving or turning off visibility in the canvas. To create a layer group, click the folder icon in the Layers dialog. A layer group looks just like a normal layer in the dialog except for the hide button, a triangle-shaped icon to the left of the preview that's only available when one or more layers are included in the group. Clicking this button will either show or hide the layers within the group inside the Layers dialog. The layers within the group are included in the canvas window if both the group visibility and the layer visibility are enabled (that is, the eye icon is visible for both).

Layers can be added to the group by dragging them in the Layers dialog and dropping them onto the group layer. Alternatively, select the group layer first, and then create a new layer.

Grouped layers are easier to manage in projects with large numbers of layers.

When you copy and paste something onto the canvas, GIMP creates a temporary layer called a *floating selection*. You can anchor this temporary layer to the current layer (the layer that was active before you pasted the new selection onto the canvas), or you can make it a new layer. Anchoring the layer means the floating

selection contents replace the existing layer contents wherever the two overlap. The anchor layer button is a shortcut for anchoring the floating selection to the current layer. Use the new layer button to make the floating selection a new layer instead. You can also use the new layer button to create a new layer from scratch.

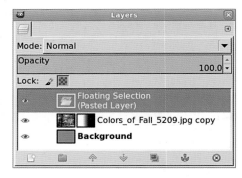

The Layers dialog, with a floating selection

Layers can have masks that hide parts of the layer from being used in the composite image displayed in the canvas. Layer masks will be discussed in "Using a Layer Mask to Colorize an Image" on page 22. All layers in the Layers dialog have a layer content preview. Layer masks are displayed in this dialog as a second preview to the right of the layer content preview.

A layer can be visible or hidden, depending on the state of its visibility icon, the eye icon in the Layers dialog that accompanies every layer. Clicking this icon toggles the layer's visibility. When a layer is not visible, its eye icon is not displayed.

Layers don't have to be the same size as the canvas. Layer boundaries can also be outside the canvas boundary. If that's the case, any part of the layer extending beyond the canvas is not shown on the canvas. To expand a layer to match the canvas size, just right-click the layer in the Layers dialog and choose Layer to Image Size.

You can also use the Move tool to move layers around the canvas. If you want to move more than one layer at a time, anchor them together by clicking each layer's chain link icon. Click and drag on the canvas to move all the layers at once. Note that with GIMP 2.8 and later, you can also group the layers and make the group layer active in order to move all the layers within the group at once. The chain link can now be used to group layers that are not in a layer group.

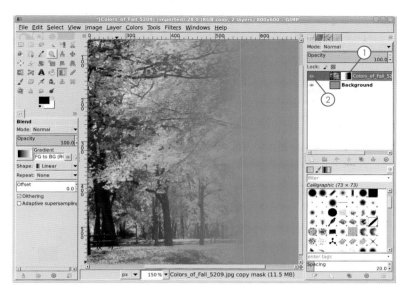

Here, the Layers dialog shows a layer and its mask. The mask is indicated by the black-and-white preview to the right of the layer preview ①. The visibility icon appears on the far left ②. If the layer is hidden from view, this eye icon will not be visible. Just click the spot where the icon should be to bring back the icon and make the layer visible again.

The chain link icon links layers so they can be moved together.

You can make any layer partially opaque by choosing that layer and adjusting the Opacity slider in the Layers dialog. The setting you choose for this Opacity slider combines with any opacity changes you define with a layer mask.

GIMP takes the transparent sheet metaphor a bit further, of course. You can use one of several methods to combine a layer with the layers below it. Each method is called a *layer mode*.

Modes are an important GIMP concept. Besides being applicable to layers, they're also applicable to the paint tools. We'll take a look at paint modes before returning to layer modes, though as you'll see, the two GIMP features are nearly identical.

Paint Modes

Paint modes are available for use with all paint tools, from Blend to Bucket Fill to Paintbrush. A paint mode defines how the paint tool combines what it paints with the pixels already in the layer. This process of mixing the new with the old is known as *compositing*.

A paint mode is a mathematical method of combining colors and transparency in GIMP. The idea is that for each color channel (red, green, and blue), two different pixels are composited in a specified manner using some combination of addition, subtraction, multiplication, and division.

Paint modes (highlighted in red) are available for use with all paint tools.

An important paint mode concept is that color channels only have 256 possible values (0 through 255, where 0 is no color and 255 is full color in that channel). That's because GIMP only uses 8 bits per color channel: 8 bits = 2^8 = 256. And when you combine all three channels, you end up with 2,563 possible colors (not including the alpha, or transparency, channel) for any single pixel. With some modes, the process of adding, subtracting, and so forth can produce values outside this range. In that case the mode either *clamps* (forces) the value back to the minimum value (0) or maximum value (255), or it wraps around to the other side of the range.

Like paint modes, layer modes define how layers are composited. The difference between paint modes and layer modes is that paint modes are applied as painting operations occur, so those changes are immediate and actually change the pixels in layers. Layer modes instruct GIMP how to combine a layer with the layers below it, but this compositing doesn't actually change pixels. It only changes the way the canvas appears, as the layers are composited internally and displayed in the image window.

There are 23 GIMP paint modes, of which 21 can also be used as layer modes (the Behind and Color Erase paint modes cannot be used by layers). The table below lists these modes and briefly describes how each of them works. In this table, the *existing pixel* is the pixel (and its multiple color channels) in the current layer, while the *new pixel* is the one added by the paint tool. Operations performed on pixels affect each channel (red, green, and blue). When you study layer modes in the next section, remember that those modes apply in the same way, except that the existing pixel comes from the current layer and the new pixel comes from the layer below it.

Paint Modes and Functions

Mode	Function
Normal	Normal mode is the default paint mode. The color of the new pixel added by the paint tool replaces the color of the existing pixel in the layer.
Dissolve	Dissolve mode works just like Normal mode, except that random blank areas are added to the stroke while painting. This is similar to dabbing paint on a canvas with the tip of a brush.
Behind	In layers with transparency, this mode only paints the transparent areas. This results in the new pixels appearing as if they were applied behind the existing pixels.
Color Erase	Color Erase mode is similar to the Eraser tool, except that instead of erasing the complete brush shape it only erases pixels that are the foreground color.
Lighten Only	If the existing pixel is less than the new pixel, Lighten Only mode uses the new pixel.

Paint Modes and Functions (continued)

Mode	Function
Screen	Screen mode subtracts each pixel from white (255), multiplies the results together, subtracts that result from white again, and then divides by white. It clamps the color to 255. The resulting pixel is generally much lighter.
Dodge	This mode is similar to Screen mode. It subtracts the existing pixel from white, inverts the result, multiplies the result by the new pixel, and then multiplies by white. It clamps the color to 255. As in Screen mode, the result is a lighter pixel.
Addition	Addition mode adds the two pixels together and clamps to 255.
Darken Only	If the existing pixel is greater than the new pixel, Darken Only mode uses the new pixel.
Multiply	This mode multiplies the current pixel by the new pixel and then divides the result by white. It clamps the color to 0. The result is usually a darker pixel.
Burn	Burn mode subtracts the new pixel from white, multiplies the result by white, and then divides by the existing pixel. Then the result is subtracted from white again. The result tends to be a darker pixel.
Overlay	Overlay mode is a mixture of Multiply and Screen modes. It makes dark areas darker and light areas lighter.
Soft Light	Soft Light mode is another combination of Multiply and Screen modes that produces results similar to those of Overlay mode.
Hard Light	Hard Light mode tests pixels to see if they're closer to black or white before choosing which operations to perform. It's another mixture of Multiply and Screen modes, usually producing opposite results to those of Overlay mode.
Difference	This mode subtracts the existing pixel from the new pixel and takes the absolute value of the result. Because an absolute value is used, no clamping is necessary, and results often appear similar to color negative film.
Subtract	This mode subtracts the existing pixel from the new pixel and clamps to 0.

Paint Modes and Functions (continued)

Mode	Function
Grain Extract	This mode subtracts the existing pixel from the new pixel and adds 128. In many images, the Grain Extract mode tends to produce what look like inverted colors.
Grain Merge	Grain Merge mode adds the existing pixel to the new pixel and then subtracts 128. This generally produces richer colors in photographs.
Divide	This mode divides the new pixel by the existing pixel and then multiplies the result by white. It clamps the color to 255. The result is usually a lighter pixel.
Hue	Hue mode works on pixels by converting from RGB to HSV first, then pulling the Hue from the existing pixel and the Saturation and Value from the new pixel.
Saturation	Saturation mode is similar to Hue mode, except that it pulls the Saturation from the existing pixel and the Hue and Value from the new pixel.
Color	Color mode is similar to Hue mode, except that it takes the Saturation and Hue from the existing pixel and the Value from the new pixel.
Value	Value mode is also similar to Hue mode, except that it pulls the Value from the existing pixel and the Saturation and Hue from the new pixel.

Layer Modes

Using paint tools to mix pixels is an inherently destructive process, as painting with any mode will change the pixels in the layer. That isn't always a bad thing, but what if you need to restore the original pixel information? Using GIMP to create art nearly always involves experimenting, which often means abandoning one set of changes, going back to the source image, and trying something different. What if tomorrow—after having saved and exited GIMP—you want to edit the image differently? Those pixels will have lost their original settings forever.

To keep the original pixel settings, use layer modes instead. A layer mode works by blending the current layer with the pixels in the layers below it. The method of blending is the same as

with paint modes, except that layer modes combine the pixel values as they're displayed on the canvas, without changing pixels in the lower layers. For example, using the Bucket Fill tool to apply a pattern and then switching to Hard Light layer mode doesn't change any of the pixels below the current layer. The current layer can therefore change in any way necessary—at any time—without losing pixel values for any other layer.

To set a layer mode, use the Layers dialog's Mode drop-down menu. Aside from the Behind and Color Erase modes, all modes available for use as paint modes are available for use as layer modes. And layer modes can be changed at any time. Changing layer modes doesn't physically change the pixels (it only affects how the composite image is displayed on the canvas), so it doesn't use up any additional memory or consume any of your undo levels.

The Layers dialog, with the Mode drop-down menu highlighted

NOTE *The Undo command allows you to step back through your recent changes. You can step back as many times as you want until you've used the maximum amount of undo memory, as configured in the Environment section of the Preferences dialog. The default amount of undo memory is 16MB, which is quite sufficient for small images destined for the Web but probably insufficient for poster-sized prints. You can step back through your recent changes by repeatedly pressing CTRL-Z or by choosing Edit ▸ Undo. You'll know you've reached the maximum undo memory allowed if pressing CTRL-Z stops undoing your steps. Instead of being surprised when you reach that point while working on a project, you may want to increase the minimum undo level right away.*

Using a Layer Mode to Colorize an Image

Layer modes appear in many tutorials throughout the book, but here's a minitutorial to introduce you to them. *Colorizing* an image adds color wherever the target area isn't completely black. In this process, the image is *desaturated*—all color content is removed—leaving behind an image still in RGB mode but only containing shades of gray. Only at this point do you add color.

1. Open any image and start by desaturating the original layer (**Colors ▸ Desaturate**). Click **OK**.

2. Add a new transparent layer above it by choosing **Layer ▸ New Layer** and setting the Layer Fill Type to **Transparency**.

3. Click the foreground color in the toolbox to change the foreground color. Choose any color you like, and then drag the foreground color onto the canvas to fill the new layer with the chosen color.

4. Set the mode for this layer to **Color**.

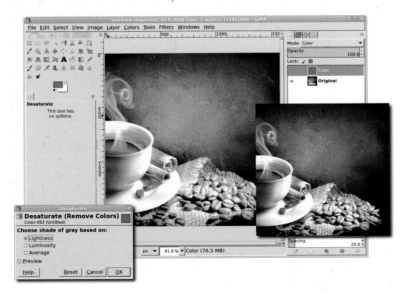

First, desaturate your image. Then colorize the image by adding a layer above the original layer, filling the new layer with color, and setting the new layer's mode to Color.

Because the color is specifically chosen in the Change Foreground Color dialog, this colorization method provides more control than other methods. It also doesn't wash out the image as much as the Colorize dialog (**Colors ▸ Colorize**) does.

Using a Layer Mask to Colorize an Image

With layer modes you can selectively add color to your image by using the technique we just used combined with a layer mask. A *layer mask* prevents portions of a layer from showing through, so only certain parts of it appear in the composite image displayed in the canvas window. Wherever there's white in the mask, that part of the layer is used in the composite image. Any black in the mask results in that part of the layer not being used.

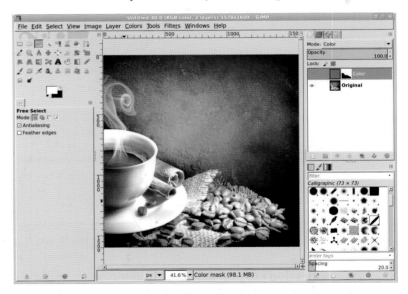

A layer mask—visible to the right of the layer preview—lets us colorize the image. Click the mask in the Layers dialog to make the mask active. Then apply the paint tools to the mask to change the shape of it to suit your needs.

1. Add a layer mask to the colored layer from the previous example (**Layer ▸ Mask ▸ Add Layer Mask**).

2. When prompted, click the **White (full opacity)** radio button.

3. With the canvas selected, press **D** to reset the default foreground and background colors. Then drag the foreground color (black) from the toolbox onto the canvas. This fills the mask with black so none of the colored layer is visible.

4. Make a selection on the canvas, and then drag the background color (white) into the selection. This adds white to the mask inside the selected area, allowing that part of the colored layer to be used in the composite image displayed in the canvas window.

Layer and Layer Mode Tips

By now you should be familiar with the fundamentals of layers and modes. Here are some tips to keep in mind as you experiment.

- Screen and Addition layer modes brighten images. Multiply and Subtract modes darken them. But Overlay mode can do both!

- Remember that differencing white from red gives a different result than subtracting white from red. Subtracting one layer from another will clamp the result to black. Imagine that one layer contains a red value of 100 and a second layer contains a red value of 40. Subtracting the first layer from the second would result in −60, but Subtract mode can't read values below 0 (black). Difference mode takes the absolute value instead.

- For a cleaner effect, try using the Soft Light layer mode instead of the Color layer mode to colorize an image.

- Layer modes don't use up memory. Switching among layer modes will not affect GIMP's overall performance, so go ahead and experiment! (You'll get plenty of practice with layer modes in the upcoming tutorials.)

- Be sure to give layers meaningful names. The default names are never descriptive enough, and it's easy to get lost when working with a dozen or more layers. Just click the layer name in the Layers dialog and type the new, more descriptive name. Press ENTER when you're finished making your changes.

- There are many ways to colorize an image. One way is to use the Colorize tool. This is the fastest method, and the results will be nearly as good as if you'd used a layer mode. Open any image and desaturate it (Colors ▸ Desaturate). Then open the Colorize dialog (Colors ▸ Colorize) and adjust the Hue, Saturation, and Lightness sliders until the preview shows the desired result. But remember that this changes the pixels in the layer. To keep the pixels desaturated, add a new layer above the desaturated layer, fill the new layer with color, and use a layer mode to blend the color with the desaturated layer.

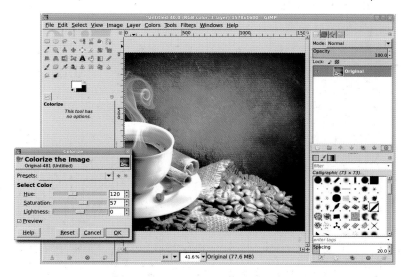

Here the Colorize tool is used to colorize an image. Unlike the Color layer mode, the Colorize tool actually changes the pixel content. Be certain you really want to make the change before using this tool.

1.3 COLOR MODES

When working with images, GIMP uses one of three color modes: RGB, Grayscale, or Indexed. Each mode represents a particular type of *color model*. Color is a very complex subject, but I'll try to summarize it for you.

A color model (the set of colors you can display) is a way of representing colors with a set of numbers that define the colors' component parts. Different color models can map to different *color spaces* (defining the colors you see). Imagine a color space graph inside which you could draw a triangle. The triangle would be the model where each vertex is one of the three primary colors: R (red), G (green), or B (blue). According to this model, when R = 100, G = 100, and B = 100, you have dark gray. If you slide the triangle to the right, taking care to stay inside the graph, you still have a color model with three values at 100, but those values define a different color. To produce a particular color, you need both the color model and the color space.

NOTE *To be honest, color theory is much more complex than this. The mathematics behind it won't be explored here, but as you'll see, the general idea is important.*

There are many different color models and color spaces. GIMP only works within the *sRGB (standard RGB)* color space using the RGB, Grayscale, and Indexed color models. The RGB model is used for displaying work on the monitor because it is an additive model in which components are added together to produce a color. The monitor starts with black (0/0/0), and as you increase the values of each component, the screen grows brighter. If the full amount of each component is added, you get white.

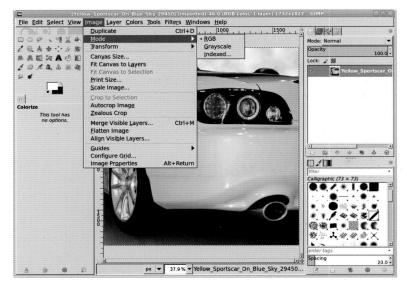

GIMP's image modes: RGB, Grayscale, and Indexed

Another well-known and popular color model is CMYK, used primarily for printing, which GIMP doesn't yet directly support. In contrast to RGB, CMYK is a subtractive model. If equal amounts of C, M, Y, and K are applied, you get black. Just as when you print over and over on the same paper, the ink accumulates until you get a black smear.

You can see why converting from one color model to another is a fairly complex task. You need to know a lot more than just the color of the pixel on your display.

RGB is the most commonly used mode for screen images, and it'll be used throughout this book. The letters R, G, and B stand for *red*, *green*, and *blue* and represent the three color channels of an RGB image. Every pixel in an image is a composite of the pixels in each of the three color channels. Each channel uses 8 bits and can define a color by a set of integer numbers that range from 0 to 255. This gives you a respectable 16 million total colors to work with.

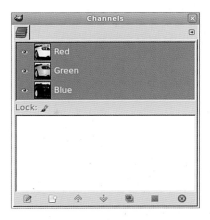

Default color channels for an RGB image

Working in RGB mode (Image ▸ Mode ▸ RGB) means you can also use transparency. *Transparency* is a measure of how much light can pass through a given pixel. The color of a pixel appearing on the canvas is the result of combining that pixel's three channels and then mixing the color of the composited pixel with some percentage of the composited pixels beneath it in the layer stack. Transparency is also the opposite of opacity. If a pixel is 30 percent transparent, it's also 70 percent opaque.

If an RGB image has some transparency, that information is stored in a fourth channel, called an *alpha channel*. When you're asked to choose Alpha to Selection or Add Alpha Channel, you'll be working with the transparency information in an image or layer.

By default, transparent regions in a single layer are indicated by a checkered pattern. The pattern is configurable in the Preferences dialog.

Grayscale mode (Image ▸ Mode ▸ Grayscale), an image setting using a single channel with 256 levels of gray (no color), can be useful for some artistic projects or for black-and-white photographs or scans. You can easily desaturate an image by switching to Grayscale mode, but the channel mixer (Colors ▸ Components ▸ Channel Mixer) is a better choice for converting color photographs.

Indexed mode (Image ▸ Mode ▸ Indexed) is useful when converting an RGB image to a GIF file destined for the Web. The GIF file format only allows for 256 colors in an image. Each image holds a table of index numbers, each one representing a single color. Only one of those index numbers can also be used to specify transparency. For example, if the index number specifying blue is also set to specify transparency in a GIF file, when a program displays the image, it'll display transparency instead of displaying blue. Indexed formats like GIF have only two levels of transparency: on and off. When using Indexed mode, there's no way to specify that a pixel should be semi-transparent.

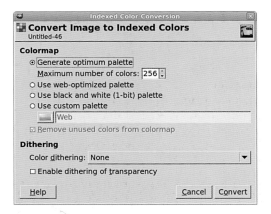

Convert Image to Indexed Colors dialog

Changing from RGB mode to Indexed mode allows you to choose from one of several methods of *dithering*, a way to group similar colors into a single one, thus reducing the total number of colors to less than or equal to 256 (the maximum number of colors allowed in a GIF file). Dithering is required in conversion from RGB mode to Indexed mode because RGB images can have up to 16 million colors, while Indexed images can't have more than 256 colors. The colors in the image can also be mapped to a particular color palette. Both the color palette and method of dithering are selected in the Indexed Color Conversion dialog, which opens when you choose Image ▸ Mode ▸ Indexed.

The GIF format uses a single pixel for transparency, making it difficult to blend round edges next to transparent areas with anything that might be behind them. The GIF format doesn't support *alpha blending*, a technique for mixing pixels along edges that requires multiple levels of transparency for individual pixels. In a GIF file, a pixel is either transparent or it isn't.

A good alternative to the GIF format is the PNG format, which supports multiple levels of transparency for individual pixels, comes with fewer licensing restrictions, and is also supported by GIMP. For all these reasons, GIF files are quickly being replaced by PNG files. I recommend converting Indexed images to RGB and saving them as PNG files.

While many web designers are migrating from GIF to PNG files, older versions of Internet Explorer (IE) still do not properly display PNG files that contain varying levels of transparency. GIMP can correctly save an RGB image with multiple levels of transparency (areas that are semi-transparent and intended to blend with whatever background the image is positioned over). The issue is that older versions of Internet Explorer interpret anything other than complete transparency incorrectly and display such images with a solid color instead. This problem has been corrected in more recent versions of IE.

1.4 SELECTIONS

Want to make the most of your GIMP experience? Master the art of effectively creating selections. Nothing is more important. The perfect selection can meld one image with another or map one image onto another. Or turn day into night. There's not much you can do with an image editor without making selections, and this section focuses on learning how to select as accurately and efficiently as possible.

All GIMP selections are outlined by a set of moving dashes, known as *marching ants*. You can set the speed of the ants by choosing Edit ▸ Preferences from the image window menu and clicking the Image Windows entry. If you want to toggle the visibility of selections within a specific image window, choose View ▸ Show Selection.

Selection Tools

GIMP offers nine different tools for creating selections: Rectangle Select, Ellipse Select, Free Select, Fuzzy Select, Select by Color, Scissors, Foreground Select, Quick Mask, and Paths. Paths are vector outlines that can be converted to selections. Alternatively, selections can also be turned into Paths. Both options can be found in the Paths dialog. Quick Mask allows you to paint in the image window with a colored mask while it's enabled, and then convert the mask to a selection when it's turned off. Quick Masks will be covered in more detail later in this section.

Editing Selections

The Rectangle Select and Ellipse Select tools include interactive editing features. Click and drag within the image window using either tool. Notice that the selection is outlined with a bounding box. Along the edges of this box are hot spots that allow resizing of it, which also resizes the selection. Click and drag inside the

bounding box to move the selection. To remove the bounding box, hit ENTER or just click once inside the selection. To get the bounding box back, click once inside the selection.

Any selection can be edited with these tools, but using them converts the original selection, such as a free selection, into a rectangular or elliptical selection.

Rectangular and elliptical selections can be edited after they've been created. The corners ① change both width and height, while the longer hot spots ② between corners change just width or height.

Selections can also be edited using any of the transform tools (Rotate, Scale, Shear, Perspective, Flip, and Cage). After creating a selection, choose a transform tool. Transforms can be applied to layers, selections, or paths. In the Tool Options dialog, click the Selection box to apply the transform to the selection.

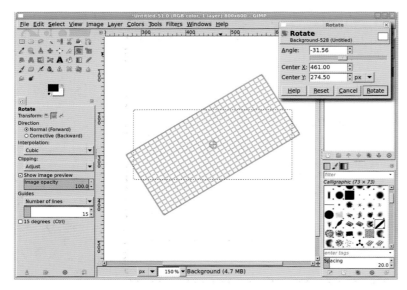

To apply a transform operation to a selection, the selection box must be set in the transform tool's Tool Options dialog before performing the transformation.

Selection Constraints

All selection tools can be configured using the Tool Options dialog. The Rectangle Select and Ellipse Select tools can be constrained in several ways from this dialog. A *selection constraint* defines the shape and size of a selection. Both the Rectangle Select and Ellipse Select tools have an *Expand from center* option. An unconstrained selection will anchor a corner at the point of the first mouse click. The corner that's anchored depends on the direction in which the selection is dragged. Set Expand from center in the Tool Options dialog to anchor the selection's center to the initial mouse-click point.

Fixed is the other constraint option for these two selection tools. It offers four ways to constrain the selection: Aspect Ratio, Width, Height, and Size. Choosing any of these will change the input field just below the options menu to allow setting appropriate values to which the selection will be constrained. For example, selecting Size allows the entry of a width-by-height value. Once this is configured, click in the image window to create a selection of that exact size. The selection cannot be edited until the Fixed option is disabled.

Tool Options constraints aren't the only way to limit selection size and shape. Guides and layer boundaries can also serve as constraint tools.

Guides A *guide* is a horizontal or vertical line that doesn't show up in your final image but can be used to align project elements such as layers and selections. You can drag out guides from the rulers, but you can only position them imprecisely that way. If you need to position guides at absolute pixel offsets (as you'll do in several of this book's tutorials), use one of the options available in the Image ▸ Guides menu.

Layer Boundaries Layer boundaries are indicated by yellow-and-black dashed lines. When a layer is selected, nothing can be drawn beyond its layer boundary. You can easily select a layer's corner: start inside the image window and drag through the corner you want to select and beyond the layer boundary. Only the portion of the selection inside the layer boundary will be selected.

Constraint options in the Tool Options dialog are only available for the Rectangle Select and Ellipse Select tools.

Pull horizontal guides from the top ruler or pull vertical guides from the left ruler. Use the Move tool to drag them out of the window one at a time or choose Image ▸ Guides ▸ Remove all Guides to remove all guides at once. The Image ▸ Guides menu allows you to add guides by percent (New Guide (by Percent)) or by pixel offsets (New Guide). You can also wrap guides around an existing selection (New Guides from Selection).

You can also change the behavior of GIMP's selection tools by holding down various keyboard keys. These keys are known as *keyboard modifiers*, because they modify the behavior of the active tool. If a keyboard modifier is pressed when you click and drag on the canvas to create a selection, the modifier affects the selection constraint.

Pressing the SHIFT key *after* the mouse click and holding it down while dragging, when using the Rectangle Select or Ellipse Select tool, constrains the selection so that the height and the width are always equal. This means rectangular selections are squares and elliptical selections are circles. But this is only true if you release the mouse button *before* you release the keyboard modifier. If you release the SHIFT key first, the constraint is removed.

A yellow-and-black dashed line indicates the layer boundary. If part of a selection lies outside a layer's boundaries, that portion is not actually selected.

As mentioned previously, an unconstrained selection will anchor its left side at the point of the first mouse click. To anchor from the center of the selection, click first, press the CTRL key, and then drag the selection. As with the SHIFT key, the mouse button must be released first to maintain the constraint.

Using keyboard modifiers with selections is an advanced technique not well suited to tutorials. Therefore, this book usually references Tool Options settings when configuring selection tools.

Selection Modes

While selection constraints set the size and shape of a selection, *selection modes* combine two or more selections, regardless of the constraints applied to each. It's often necessary to make several selections and then combine them in different ways. Such merged selections are useful, for example, when selecting unusually shaped objects in a photograph or when outlining a shape before filling it with a color or pattern.

You can use keyboard modifiers to constrain selection shapes. You can also apply transforms to selections using the Tool Options dialog for each transform tool.

Each selection tool's Tool Options dialog gives you access to four mode buttons: Replace, Add, Subtract, and Intersect.

To combine selections, use the mode buttons in the selection tools' Tool Options dialogs. In order from left to right, Replace mode creates a new selection that replaces any existing selections, Add mode adds the new selection to the existing one, Subtract mode subtracts from the existing selection wherever the new selection overlaps it, and Intersect mode creates a selection only where the new and existing selections overlap. If there's no existing selection, Replace and Add modes simply create the new selection by itself and Subtract and Intersect modes do nothing.

The mode buttons in the Tool Options dialog also map to keyboard modifiers. Holding down the SHIFT key while dragging activates the Add mode, while holding down the CTRL key while dragging activates the Subtract mode. Holding down both keys while dragging activates the Intersect mode. These keyboard modifiers apply to all selection tools except Foreground Select. Note that as long as you hold down these keys, the associated

mode button is selected in the Tool Options dialog. If there's no initial selection, the modifiers have no effect, and the Replace mode button stays active.

NOTE *The Foreground Select tool maps these keys to other options in the Tool Options dialog.*

When using the various selection tool modes, the cursor changes depending on which mode is active, as shown here. With experience, you will learn to recognize these cursors, but if you're new to GIMP, you'll want to keep an eye on the Tool Options dialog when working with selections. When working with keyboard modifiers, it's very easy to confuse the mode you're in with the constraint you may (or may not) be trying to apply to a new selection. As with selection constraints, the tutorials in this book will always reference the mode settings in the Tool Options dialog, not the keyboard modifiers.

The cursor changes, depending on which mode is active.

Oddly Shaped Selections

When working with photographs or any existing digital image, you seldom need a perfectly rectangular or oval selection. Instead, you need to outline odd shapes with odd selections. When these shapes have complicated edges, often your only option is to draw the selection by hand. In GIMP, you can use the Free Select tool for this.

The Free Select Tool

To make a freehand selection, choose the Free Select tool from the toolbox, click the canvas, and drag around the shape you want to select. As you drag, a solid line appears, showing the edge of your selection. When you're done outlining the selection, hit ENTER. The solid line is replaced by the familiar marching ants.

Using the Free Select tool to make a freehand selection

To close a Free Select loop, just drag back to the starting point and look for a small yellow circle. This signifies the two endpoints are overlapping and the selection loop will be closed.

Hand-drawn outlines aren't always the easiest way to make a selection. Fortunately, GIMP offers a wealth of alternatives. If the portion of the image you want to select is outlined by a solid color or other obvious edges, the toolbox provides the Fuzzy Select, Select by Color, Scissors, and Foreground Select tools.

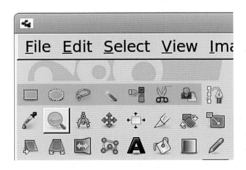

There are several alternatives to the Free Select tool, among them the Fuzzy Select, Select by Color, Scissors, and Foreground Select tools.

The Fuzzy Select Tool

The Fuzzy Select tool works best when a solid color surrounds the object of interest.

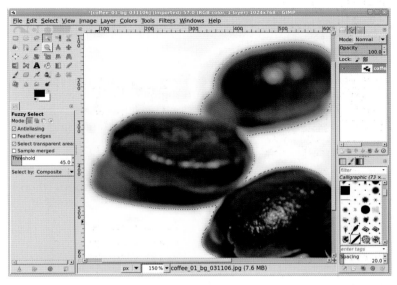

The Fuzzy Select tool allows you to select the beans and their shadows by simply clicking the white area that surrounds them.

The most important option in the Fuzzy Select tool's Tool Options dialog is the Threshold setting. Lower Threshold values mean fewer pixels are selected. The threshold can be adjusted by moving the mouse while keeping the left mouse button pressed. Keep in mind that when you click the canvas using the Fuzzy Select tool, all pixels within the distance specified (a difference in color) and adjacent to each other are added to the selection. It's important to remember that the pixels must be adjacent. Notice that the Fuzzy Select tool always creates one large selection. It'll be oddly shaped, but there'll be just one. The Select by Color tool, on the other hand, creates many selections.

The Select by Color Tool

The Select by Color tool is best at pulling a shape from an image based on groups of pixels that aren't necessarily adjacent to each other. Its Tool Options dialog also offers a Threshold setting that functions just like the Fuzzy Select tool's Threshold setting: it selects all pixels within range of the threshold. When using the Select by Color tool, however, the pixels do not have to be adjacent. Therefore, this tool can potentially create thousands of small, independent selections. In this example, because the white background contrasts so much with the beans and their shadows, the Select by Color tool creates only one selection. Using a low Threshold setting and clicking the white background creates a selection nearly identical to the Fuzzy Select's.

Both the Select by Color and the Fuzzy Select tools can make very precise selections, as long as the contrast between the object of interest and the rest of the image is high. For situations where that isn't the case, you're better off using either the Scissors or Foreground Select tools.

The Scissors Tool

Use the Scissors tool when you need to get down and dirty; it finds the edges of an object by noting dramatic color changes near a line you draw with mouse clicks.

To create a selection with the Scissors tool, click the canvas to drop anchor points around the object of interest. The anchor points are also referred to as *control points* or *nodes*, and the Scissors tool's anchor points are similar to those of the Paths tool. As you drop anchors, GIMP draws a solid line connecting each new anchor to the previous anchors. GIMP computes these lines based on changes in color. In this example, the beans and their shadows have distinct color differences, so clicking near the edge of the bean creates an outline around just the bean, excluding its shadow. To close the outline, click the first anchor you dropped. Then click inside the outline to convert the area to a selection.

You can edit the outline before converting it to a selection by clicking any existing anchor point and dragging it to a new location. You can even add new anchor points by clicking a line

between any two existing anchor points. Adding new anchors and moving existing anchors lets you tweak your outline before converting it to a selection. This might be necessary if you find that GIMP's chosen dividing line doesn't suit your needs.

Clicking along the edges of the shadows sets anchor points automatically connected to wavy lines that'll become the selection when the loop is closed. Scissors could be used to outline the beans (sans shadows) to make a finer-grained selection, though for this particular image it would probably be easier to use Fuzzy Select and increase the Threshold setting.

The Foreground Select Tool

The Foreground Select tool is more complicated than the tools discussed so far, but with practice it can become the best tool for isolating foreground shapes over cluttered backgrounds. Foreground Select uses a multi-step process to specify an object in an image as the foreground. After you choose the tool from the toolbox, the lasso pointer is displayed in the image window. Drag the lasso around the foreground object to create a rough selection. After outlining the object, press ENTER to complete

the first step. By default, the masked area (which is not in the selection) will be highlighted in blue, though this color can be changed in the Tool Options dialog.

The second step is to paint over the foreground object. The current foreground color is used in this step along with a round brush. Hold down the left mouse button and paint near the edges and across any dramatic color changes (dark to light or light to dark) inside the foreground object. The object doesn't have to be completely painted over. When the mouse button is released, the Foreground Select tool will update the masked area based on the pixels that were painted over and the current masked area.

Repeated brushstrokes can be used to refine the selection. The Tool Options dialog allows setting brush size to select contiguous regions or adjustment of color sensitivity. When editing is complete, press ENTER to convert the unmasked area to a selection.

The Foreground Select tool can be very precise when isolating objects in an image. However, in practice this tool does best at creating rough selections that need further refining with the Quick Mask (described in "Using the Quick Mask" on page 34).

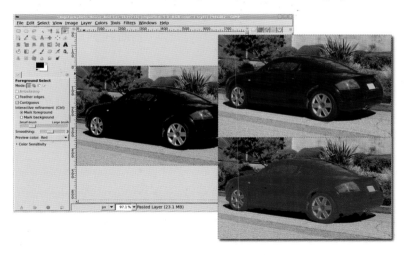

Foreground Select is faster and more accurate than Scissors, but it often requires touch up via Quick Mask.

Creating Masks from Selections

Sometimes a project requires you to isolate an object in an image in order to create a mask of that object. Often this object is not easy to select by itself, but the area around it is.

Look at this rose set against a white background. It's easy to isolate the white area with the Select by Color or Fuzzy Select tools. Once the selection is made, invert it (Select ▸ Invert) to create a selection that only includes the flower. Then all you need to do is create a black mask and fill it with white.

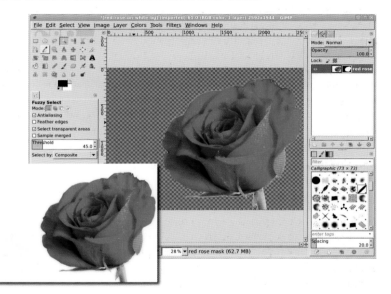

To create a mask of the rose, choose the solid white background, invert the selection, add a black layer mask, and fill the selection with white.

Feathering Selections

Creating a selection to isolate an object in a photograph sometimes requires a little more work. You may need to *feather* the selection. When creating a selection, GIMP offers the use of antialiasing. If antialiasing isn't used, GIMP either includes a pixel or doesn't include it in the selection; there are no partially selected pixels.

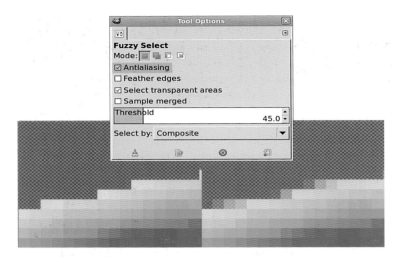

Zooming in on the rose selection without (left) and with (right) antialiasing enabled

Feathering a selection softens its edge by allowing pixels to be partially selected. This means that some pixels are actually partially transparent, so when you copy and paste the selection, its edge blends more easily with its new surroundings.

Feathered selections (right) have soft edges, allowing them to blend into the background when copied and pasted into another image.

You can use the Feather Selection dialog (Select ▸ Feather) to feather a selection you've created. By default, the feathering depth is set in pixels, but you can choose several other units from the drop-down menu in the dialog. The feathering process

straddles this range on either side of the selection, one half outside the selection and the other half inside. The innermost edge of this range is fully opaque, while the outermost edge is fully transparent. As you move from the innermost to the outermost edges of the feathered range, the pixels become increasingly transparent.

The Feather Selection dialog lets you specify the feathering depth in one of several units.

A feathered range is split to straddle the selection boundary. This feathered selection is 6 pixels: 3 to the outside and 3 to the inside of the selection.

Using the Quick Mask

The Fuzzy Select tool works well with images like the rose, where the subject appears against a solid background. But there's an even more intuitive way to make selections of oddly shaped objects,

which can be especially handy when the background isn't solid. Quick Mask allows you to paint over an image to create your selection.

To use Quick Mask, click the Quick Mask button in the lower-left corner of the image window. Doing so gives the image a red tint. Choose any paint tool and any brush. Set the foreground color to white by pressing D and then X while the canvas is selected. Start painting with your chosen paint tool and brush, rubbing away the red in the Quick Mask. Click the Quick Mask button again when you've uncovered the area you want to select. Where you remove the Quick Mask, the painted area is converted into a selection. It doesn't get any easier than that!

The original yellow car is in the upper left. In the lower left, the Quick Mask is turned on and the image is tinted red. In the upper right, the yellow body of the car has been painted with white and the mask color changed to dark green for better contrast. Clicking the Quick Mask button again converts the painted area into a selection and allows us to change the color of the car's body.

Discarding Selections

What do you do after you're done with your selections? You can save a selection to a channel by choosing Select ▸ Save to Channel, or you can discard the selection. Choosing Select ▸ None will discard the current selection. Alternatively, you can press CTRL-SHIFT-A.

The Quick Mask button is in the lower-left corner of the canvas window. When not in use, the button's icon is a square selection symbol. When you click the Quick Mask button, the icon becomes a red square, and all areas outside existing selections are tinted red (unless you've changed the default mask color).

Saving a selection to a channel allows you to retrieve the selection from the Channels dialog later (Windows ▸ Dockable Dialogs ▸ Channels). Simply click the saved channel to make it active, and then click the Channel to Selection button at the bottom of the dialog. We'll use this process a few times in various tutorials later in this book.

The Channel to Selection button is the red square in the lower right.

Working with Selections

Once you have a good selection, you can do just about anything with it. You can fill it with color by simply dragging the foreground or background colors from the toolbox into the selection. You can use any of the paint tools inside the selection without worrying about painting outside the selection area.

Paint in the selection without worrying about affecting anything beyond it.

You can also use selections to isolate regions where filters can be applied. For example, you can apply a motion blur to the rose selection without blurring anything that lies beyond it.

Drag the foreground or background colors from the toolbox into any selection to fill it with color.

Blur the selection without worrying about blurring anything beyond it.

You can also use any paint tool in combination with the foreground color to trace a selection. Tracing a selection in this manner is known as *stroking* the selection, and the Stroke Selection dialog is available by choosing Edit ▸ Stroke Selection.

Stroking the rose selection with a soft-edged brush

Selection Tips

Keep these hints in mind as you practice working with selections:

- If you have trouble remembering how the SHIFT and CTRL keyboard modifiers work, remember that it's easier to use the mode buttons in the selection tools' Tool Options dialog to specify how you want the new selection to interact with the existing one. You can set the aspect ratio in the same dialog, so you can just forget about the SHIFT and CTRL keys.

- You can combine Quick Masks with existing selections. Any existing selections won't have the red tint when you click the Quick Mask button for the first time. Paint as necessary, and then click the button again to combine the selections.

- It's not uncommon for users to find that they can't create a new selection, having forgotten that they chose Subtract or Intersect mode in a selection tool's Tool Options dialog. If this happens to you, just check the Tool Options dialog and make sure the mode is set to Replace. Using the mode buttons sets a selection tool to that mode until you change it manually. That's one reason why experienced users learn to use the keyboard modifiers. The modifiers only apply for the time it takes to make a new selection.

1.5 PATHS

GIMP is a raster image editor. Translated into plain English, that means it works great on photographs by changing the colors of individual pixels. It wasn't initially designed for editing lines or geometric shapes as is a dedicated vector-graphics editor (such as Adobe Illustrator and Inkscape). Of course, vector editors don't do as well dealing with pixels in photographs. But in today's world, the line between raster image editors and vector editors is blurred, since graphics programs written for one type of editing often offer some level of support for the other. GIMP is no exception.

GIMP's vector editing is handled with *paths*. A path consists of at least two points separated by a straight or curved line. The points are known as *anchors*, or sometimes as *control points*. The lines and their anchors are technically known as Bézier curves in honor of the French engineer who popularized their use in designing cars. The lines between anchors can be curved by dragging *handles* out from the anchors. Each anchor has two handles, each associated with either the line coming into or out of the anchor.

The Paths tool in the toolbox is the primary method of creating paths, though they can also be created by converting a selection to a path. The Tool Options dialog is used to set the editing mode for a path. Design mode is used to drop and position new anchors. The mouse cursor changes in the image window when positioned over an anchor or not. Edit mode allows adding new anchors between two existing anchors, splitting the line between them. Anchors can also be deleted using this mode, by holding down the SHIFT key. Move mode is used to move the entire path with all anchors at the same time.

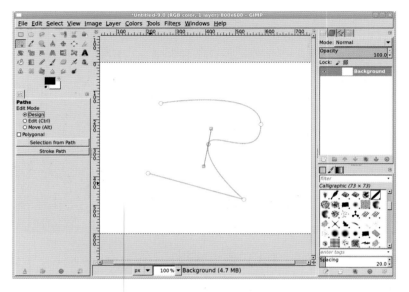

The Tool Options dialog for Paths provides multiple modes for working with anchors and their handles. It can also be used to create a selection from the path or outline the path in the current layer.

Paths are grouped in two ways. First, the path exists as a whole, including all of its anchors. To see this for yourself, choose Move in the Paths dialog, click any point not on a line in the path, and then drag the mouse. The entire path will move. Second, all the anchors on each line are connected. Click any line and drag; you'll see that the connected points move. Text can be converted into a path, but disconnected paths aren't grouped when this is done. Notice that when you move some paths in an *e* or *a* that's been converted to a path, the internal portions of those letters don't move.

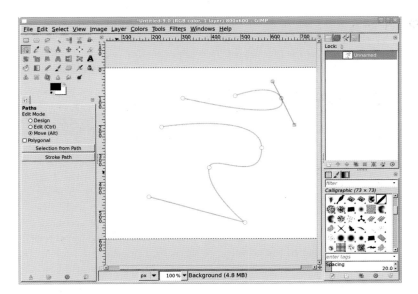

Disconnected paths move independently.

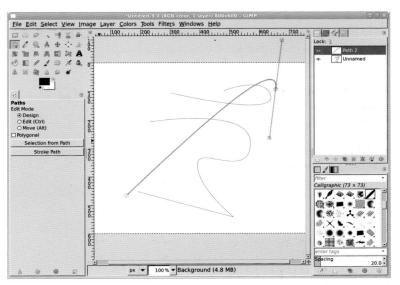

Like its cousin, the Layers dialog, the Paths dialog uses an eye icon to represent a visible path layer.

Paths are created on their own layers in the Paths dialog. Path layers can be given names and reordered just like image layers. However, path layers aren't associated with specific image layers. A single path layer can be applied to any number of image layers and can contain a single path or multiple, disconnected paths.

The Paths dialog allows an existing path to be edited later. First, choose the Path tool. Then click your desired path layer in the Paths dialog, click the visibility icon to show the path in the image window, and click the path in the image window to start editing. When editing is complete, turn off the visibility of the path layer.

Paths are either open or closed. A closed path connects the last control point to the first. This can only be done in Edit mode. Click the last anchor, and then click the first anchor to close the path.

Paths can be converted to selections. Create the path, and then click the Path to Selection button at the bottom of the Paths dialog. All selections are closed, which means when the selection is created, the first and last anchors are connected via the selection even if the path itself is not closed. A selection can also be converted to a path. Create the selection, and then click Selection to Path at the bottom of the Paths dialog, just to the right of the Path to Selection button. One of the hidden GIMP dialogs can be found here. After creating the selection, hold down the SHIFT key and click the Selection to Path button. This opens a dialog of advanced options for converting the selection to a path.

Most transform tools (Rotate, Scale, Shear, Perspective, and Flip—but not Cage) can be applied to paths. After creating a path, turn on its visibility in the Paths layer dialog. Then choose the transform tool from the toolbox. In the Tool Options dialog, there's a line of Affect icons at the top. Click the Path icon at

the end of that line. Click in the image window to open the transform editor and modify the path. Path layers can be linked in the Paths dialog so that transformations apply to all linked path layers, even if the path isn't visible in the image window.

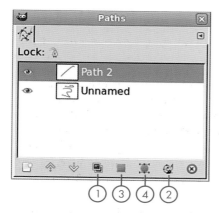

Paths can be duplicated ① and stroked ② as well as converted to selections ③. Selections, in turn, can be converted to paths ④. This can be useful for creating logos, manga, or comics.

NOTE *It is important to note, especially with respect to scaling a path, that transforming paths applies to an entire path layer. If a path is to be scaled up a large amount, zoom out of the image window first, click in it to open the transform editor, and perform that transformation on the path.*

Paths are visible but not rendered (that is, drawn or applied) in the image window. They must be stroked or converted to a selection to be applied to the image window. To stroke the path, select a path layer in the Paths dialog. Then either select Edit ▸ Stroke Path or click the Stroke button at the bottom of the Paths dialog, to the right of the Selection to Path button. The Stroke Path dialog will open. The path can be stroked with a solid line or pattern using a specified width or style, or it can be stroked using the currently active brush and one of the available paint tools.

Paths are useful for creating designs that need to be rendered at different sizes, such as logos or comics. They're designed to provide scalable shapes within GIMP, where scaling of layers would normally affect the quality of the image.

Paths are an advanced topic and, as such, won't be covered by the tutorials in this book.

1.6 DRAWING BASIC SHAPES

The most common question new GIMP users ask is, "How do I create basic shapes?" In this section you'll explore two methods: stroking selections and using the Gfig plug-in.

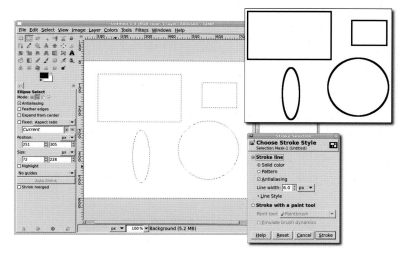

Stroking selections to draw simple shapes

Drawing a Straight Line

Straight lines are easy. Choose any drawing tool and click once in the canvas to start the line. Hold the SHIFT key down and move the cursor to the end point and click again. To constrain the line to multiples of 7.5 degree angles, hold down the CTRL key with the SHIFT key.

Drawing Simple Shapes

If the shapes you need to draw are relatively simple, your best bet is to stroke selections.

1. Choose the **Rectangle Select** tool or the **Ellipse Select** tool from the toolbox, and then drag to create a selection. Press the SHIFT key as you drag to constrain the selection so its width and height are equal (producing a perfect square or circle), and then release the SHIFT key to create the selection.

2. Select the **Round (101)** brush from the Brushes dialog. Choose the **Paintbrush** tool and set the size to **2.00** in the Tool Options dialog.

3. Choose **Edit ▸ Stroke Selection** and in the Stroke Selection dialog, click the **Stroke with a paint tool** radio button. Select **Paintbrush** from the Paint Tool drop-down menu. This gives the selection nice, clean edges.

4. Click **Stroke** to stroke the selection.

 Triangles require a little special handling.

1. Configure the image grid (**Image ▸ Configure Grid**). For this 800 × 600 image, a grid with spacing of 100 pixels in width by 100 pixels in height is used.

2. Choose the **Paths** tool from the toolbox, and then click any three intersections of the grid lines to mark the vertices of the triangle.

3. In the Tool Options dialog, click the **Stroke Path** button. This will draw the shape.

NOTE *If the triangle needs to be rotated, choose Selection from Path instead of Stroke Path, then rotate the selection and stroke it with Edit ▸ Stroke Selection.*

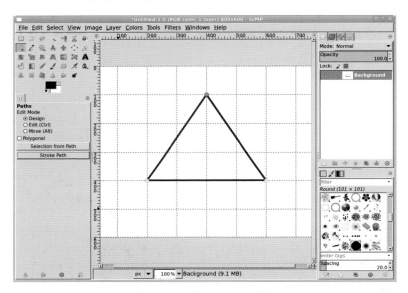

Use a grid or guides with paths to draw a triangle.

The mode buttons in the selection tools' Tool Options dialogs let you combine selections in various ways before stroking them.

Drawing Irregular Shapes

Creating closed irregular shapes can be simple, or it can be complicated, depending on the project. The easy way to create such shapes is to subtract from and add to existing selections. For example, start by creating a rectangular selection. Then hold down the CTRL key to subtract from the existing selection, or hold down the SHIFT key to add to the existing selection. As an alternative, you could also use the selection tool's Tool Options dialog, clicking the appropriate mode buttons instead.

Using the Paths tool to create irregular selections is more difficult than simply adding to and subtracting from selections, but it's also more accurate. Pull out horizontal and vertical guides that intersect where the vertices of your irregular shape should be, and then use the Paths tool to outline the shape. Stroke the path or convert it to a selection, and then fill as desired. This method works well when you need to isolate multiple buildings in a photo.

Outlining a shape with the Paths tool

Drawing Predefined Shapes

Gfig is a primitive vector-drawing tool that offers a set of predefined shapes, including stars, spirals, curves, polygons, and arcs. For simple shapes like squares and triangles, it's faster to use the techniques we discussed earlier in this section, but Gfig can come in handy when you need to create something more complex. Go ahead and experiment a bit with it:

1. Add a new layer to the image (**Layer ▸ New Layer**).
2. Open Gfig (**Filters ▸ Render ▸ Gfig**).
3. Click the **Create Star** button on the button bar. Change the Sides setting to **5 sides**.

4. Click the middle of the preview and drag toward the lower-right corner of the preview. The star will be created using the brush that's currently selected.
5. If you need to move the star once it's been created, click the **Move an Object** button (three buttons to the right of the star), and then drag the star around the preview.
6. Modify the brush and fill options as necessary, and then click **Close** to render your shape on the canvas.

Before you render them on the canvas, the objects you create in Gfig are in vector format and have a stacking order. You can use Gfig to change this order, or you can render each shape on a new layer and change the stacking order later by moving around the layers in the Layers dialog.

You can use Gfig to edit shapes you've rendered to layers, even after you've applied effects to those layers. Those effects will be lost when you use Gfig to edit the shapes, however, so plan your workflow carefully.

Gfig allows editing of shapes within a Gfig layer until effects are applied to that layer.

The problem with Gfig is that it's a very simple vector editor. A regular polygon created with Gfig, for example, doesn't have editable points at its vertices. You can only move the center point or resize the polygon. And brush selection is limited to selection of the brush, not its size, opacity, or other settings found in other paint tool options. Finally, Gfig isn't the most stable GIMP plug-in either. It has a tendency to crash if you try to create a lot of objects or edit objects repeatedly.

If you need real vector-editing capabilities, you're better off using a tool like Inkscape (*http://www.inkscape.org/*). Just create the shape and then export it as a PNG or SVG for use in your GIMP project.

Basic Shape Tips

Here are a few words of wisdom you should take away from this section.

- By default, selections *want* to attach to guides! As you've seen, this simplifies tasks like outlining a city skyline. But you can disable this behavior if necessary; just toggle View ▸ Snap to Guides.

- Want to rotate a shape? Use the Rotate tool on a selection or path. Alternatively you can rotate the layer after the shape is rendered.

- Draw shapes in new, transparent layers instead of drawing over existing layer content. It's always easier to delete a layer later than to recover pixels that have been overwritten. Be sure the Lock Alpha Channel option is turned off for the transparent layer. If you don't, you won't be able to draw over the transparent parts of the image.

The Lock Alpha Channel (known in previous versions as Keep Transparency) option is located in the Layers dialog. If the box is checked, you won't be able to make changes to the transparent parts of the layer.

- Stroking with a brush that's 1 pixel wide and the default foreground color (black) won't produce a solid black outline because of the antialiasing of the brushstroke. Just repeat the process once or twice to get a darker line. Larger brushes don't have this problem. Or, create a selection like a square or circle, fill it with a color, shrink the selection (Select ▸ Shrink) by 1 pixel, and then delete it. This will produce a very clean 1-pixel-wide outline of the shape.

- Don't forget that you can fill a selection with a pattern or solid color instead of stroking it. Use the Bucket Fill tool for patterns, or drag the foreground or background color from the toolbox into the selection to fill the selection with a solid color.

1.7 PATTERNS AND GRADIENTS

Patterns are image files you can use to fill selections or layers. They are most commonly used to create textures for three-dimensional objects like castle walls or a scaly creature's skin. *Gradients* are formed when two or more colors blend together. You can use gradients for a variety of purposes, from simulating tubes, pipes, and poles to applying wave distortions to cloth or water.

GIMP provides a wide range of stock patterns and gradients. Most of the stock patterns are suitable for Web images but are probably too small for larger print projects. The stock gradients are plentiful, and you'll use several of them in tutorials later in this book.

This section is an introduction to creating your own patterns and gradients. You won't be creating any for this book's tutorials, but learning how to do so is useful for when you strike out on your own.

Patterns

Patterns, like brushes, can be made from any image. A pattern that's designed correctly is *tileable*—many copies of the pattern blend together seamlessly. Tiled patterns are often used as background images for web pages and textures for three-dimensional projects.

You can access the Patterns dialog and see all the patterns available to you by choosing Windows ▸ Dockable Dialogs ▸ Patterns. Any image can be saved as a pattern, and a pattern can be any size. Patterns can be saved in any file format. The GIMP-specific extension is *.pat*, but there's no advantage to using one file format over another.

If you want to access a pattern file through the Patterns dialog, it must be saved in one of GIMP's pattern directories (choose Edit ▸ Preferences and select Folders ▸ Patterns on the left).

If a pattern is large, the Patterns dialog will only display a thumbnail of the image. Click the pattern and hold down the left mouse button to view it at full size.

New GIMP users often underestimate the usefulness of patterns. And to be honest, the built-in patterns *are* a little boring. But it isn't difficult to create reusable patterns that simulate the textures of concrete and cloth. It just takes a little imagination.

The Patterns dialog displays thumbnails of uniform size, but if you click a thumbnail and hold down the left mouse button, the thumbnail will enlarge.

Patterns don't have to come from the Patterns dialog. GIMP's render filters (Filter ▶ Render) also make very good patterns, and you can save the resulting images as pattern files for use in project after project. The tutorials in this book often ask you to generate patterns on the fly, but it's good to know there are so many options.

Concrete Texture

One of the easiest textures to create is a simple concrete background. Such textures can be used to turn a basic box into a cement block or to turn any flat surface into a sidewalk or road. Now you can walk through the steps:

1. Open a new white canvas window by choosing **File ▶ New** from the image window menu.

2. Add a transparent layer (**Layer ▶ New Layer**) and use the Plasma filter to fill it with colored clouds (**Filters ▶ Render ▶ Clouds ▶ Plasma**). The default settings should be sufficient for this texture. Click **OK** to apply the filter.

Use the Plasma filter to add clouds to the canvas.

3. Choose **Filters ▶ Noise ▶ RGB Noise** from the canvas menu to use the RGB Noise filter to apply some noise to this image. Make sure the Correlated noise and Independent RGB checkboxes are not checked. Set the Red, Green, and Blue sliders to **0.20** to apply a visible but not overwhelming amount of noise to the layer. Click **OK** to apply the filter.

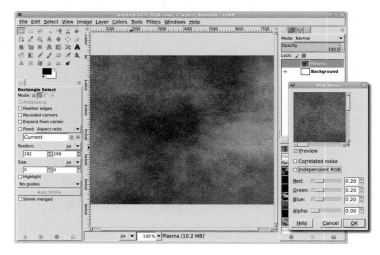

Add noise to the clouds. More noise gives the image a rougher texture.

4. Desaturate the layer (**Colors ▶ Desaturate**) using any of the available options. This removes the color content and makes the image look more like concrete. Click **OK**.

5. To give the texture some depth, open the Bump Map filter (**Filters ▶ Map ▶ Bump Map**). Keep an eye on the preview window as you play with the Azimuth, Elevation, and Depth values. Pan around the preview to see how each adjustment affects the image. Choosing Linear, Spherical, or Sinusoidal from the Map type drop-down menu also alters the effect, but this setting is less important than the others. Click **OK** to apply the filter to the desaturated layer.

NOTE *Variations on this technique include using different noise filters and increasing the Turbulence setting in the Plasma filter's Tool Options dialog.*

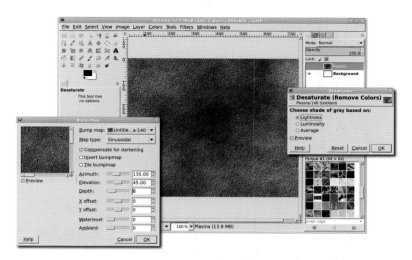

The concrete texture gets some depth from the Bump Map filter.

6. While the result is a fairly realistic concrete texture, adjustments to the contrast and brightness (**Colors ▸ Brightness-Contrast**) can soften the effect and give you a jumping-off point for even more complex textures like skin.

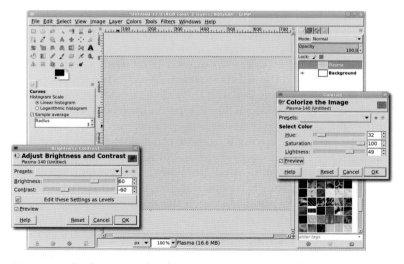

Contrast and colorization changes can turn concrete into skin.

Simulated Cloth

Creating a cloth texture starts with noise. Start with a new white canvas window of **300 × 300 pixels**. Because you'll soon be rotating one of the layers, a square image works best.

1. Open the RGB Noise filter again (**Filters ▸ Noise ▸ RGB Noise**), but this time increase the Red, Green, and Blue values to **0.90**. Click **OK** to apply this filter.

A cloth texture starts with random noise.

2. Open the Motion Blur filter (**Filters ▸ Blur ▸ Motion Blur**). Set the Blur Type to **Linear**, the Length to **130 pixels** or more, and the Angle to **0 degrees**. Click **OK** to apply this filter layer.

3. Repeat the previous step, this time setting the Angle to **180 degrees**. This cleans up the edges of the layer.

4. Duplicate the Background layer (**Layer ▸ Duplicate Layer**). The duplicate layer will become the new active layer.

5. In the Layers dialog (**Windows ▸ Dockable Dialogs ▸ Layers**) change the duplicate layer's mode to **Multiply**. This composites the two layers in such a way that the image appears darker.

Motion-blurred noise makes soft lines in the image.

6. Rotate the duplicate layer by 90 degrees (**Layer ▸ Transform ▸ Rotate 90° clockwise**).

The cloth has a cross-weave texture (contrast enhanced to be visible in print).

7. You can now flatten the image (**Image ▸ Flatten Image**) and colorize it as you like.

Adding color to the cloth is easy with the Colorize dialog.

Creating Tileable Patterns

To create a tileable pattern, offset an image by one-half of its width and height by choosing Layer ▸ Transform ▸ Offset and clicking the Offset by x/2, y/2 button. Click Offset. Use the Clone tool to patch the seams as shown here. To use the Clone tool, first press the CTRL key, and then click the source location (which can be in any layer). The Clone tool works by taking a source copy of the image at one point (where you've clicked while pressing CTRL) and copying it to some other destination location in the image. The copy is in the shape of the active brush. When you click a destination location, hold down the left mouse button, and drag, the source is copied to the destination. Additionally, the angle and distance between the destination and source remain constant, which means the source location changes as you drag. Take a moment to play with the Clone tool, as it's one of the most powerful GIMP tools.

You don't have to use the Clone tool to create tileable patterns. The Tileable Blur filter (Filters ▸ Blur ▸ Tileable Blur) and the Make Seamless filter (Filters ▸ Map ▸ Make Seamless) work more quickly but give you less precise results.

The Layer Offset dialog allows you to automatically offset the layer by one-half of its width and height.

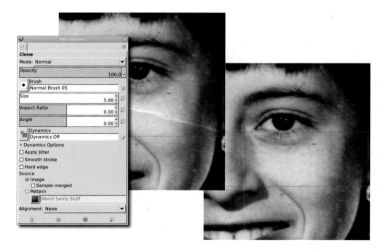

The Clone tool's default settings are shown in the Tool Options dialog. The Clone tool can be used to remove a tear in an old photo.

Gradients

Gradient files are different from pattern and brush files in that they don't contain image data. Instead, they're text files that describe how color should be applied across a range of pixels. The gradient preview in the Gradients dialog (Windows ▸ Dockable Dialogs ▸ Gradients) shows you how the colors would be blended if you chose a Linear Shape, but the preview shows only the definition of the gradient. You can use the Blend tool to apply the gradient in many different ways.

Choosing a different gradient updates both the Gradients dialog and the Tool Options dialog for the Blend tool. You can also select gradients directly from the Gradient menu in the Tool Options dialog for the Blend tool.

NOTE *Keep in mind that the terms* gradient *and* blend *are often used interchangeably.*

Using the Shape Setting with Gradients

The Blend tool's Tool Options dialog includes an important feature: the Shape setting. The Shape drop-down menu allows you to define the direction and shape the gradient takes when

applied to a layer, mask, or selection. You'll use Linear, Bi-linear, and Radial in this book's tutorials. Choosing Linear applies a smooth gradient that starts where you press the left mouse button and begin dragging and ends where you release the mouse button. The Bi-linear effect is similar, but it resembles applying two brushes at the same time, each of which moves in the opposite direction. Choosing Radial applies the color to the left side of the gradient at the start point and radiates the color out to the point where you stop dragging and release the mouse button.

The Radial Eyeball Blue gradient applied with a Linear Shape

Choosing Linear (top), Bi-linear (middle), and Radial (bottom) from the Shape drop-down menu produces very different results, even when you apply the same FG to BG gradient.

A gradient is a color transition. Most of the gradients in this book are made up of smooth, gradual color transitions. But the transition doesn't have to be slow and smooth. It can be abrupt. Consider the Radial Eyeball Blue gradient. When you choose Linear from the Shape drop-down menu and apply this gradient, the effect is an abrupt change from white to blue to black. But when you choose Radial and apply the same gradient, the result looks like an eyeball.

The Radial Eyeball Blue gradient applied with a Radial Shape over a black background—now you know how this gradient got its name!

Experimenting is the only way you'll discover all of the ways your projects can benefit from gradients. You can choose Radial from the Shape drop-down menu and use the FG to BG (RGB)

gradient to create balls or spheres. Choosing Linear and using the Blinds or Crown Molding gradients can simulate undulating waves when used in layers below a color layer.

Applying the Blinds (top) and Crown Molding (bottom) gradients directly to a layer without blending them with other layers

The Crown Molding gradient is applied with a Bi-linear Shape in a layer beneath a colored layer. The layer's mode is set to Multiply.

So why use gradients? In this book we use them primarily for two reasons: to create layer masks and to apply textures to other layers. Applying a gradient to a layer mask can create a smooth transition from the image in one layer to the image in the layer below it. After applying a gradient in a layer by itself, you can also use one of the layer modes to blend it with another layer. This latter method is used when creating wave patterns, though you can also use it to blend colors in a pattern.

Blending two images together by applying a gradient to a layer mask

Using the Gradient Editor

While you won't need to do so for any of the tutorials in this book, it's possible to create your own gradients. At the bottom of the Gradients dialog is a set of icons. Click the second icon from the left ① to open the Gradient editor and create a new gradient.

The Gradient Editor allows you to edit existing gradients, such as the Caribbean Blues gradient shown here. Use the Edit button in the Gradients dialog to open the Gradient Editor.

Below the preview window in the Gradient Editor window is a set of triangles. These are handles. There are two black handles on either end of a segment and a white handle between them. Initially there's only one segment in the preview. Right-click this segment to open the Gradient Editor menu. In this menu you can set the colors for each side of a segment (Right and Left Endpoint colors), add new segments (Split and Replicate menu options), and adjust the way color flows across the segment (Blending menu options).

The Gradient Editor's default settings are shown here. Note the segment with two black handles and one white handle.

Right-click the segment to open the Gradient Editor menu.

Now you can play around with creating gradients for your own projects. Just remember that you can create as many gradients as you like and then use the Gradients dialog to delete them when you don't need them anymore. Go ahead and experiment. You've got nothing to lose!

Pattern and Gradient Design Tips

Think you've got a handle on patterns and gradients? Here are some tips:

- You can use patterns to stroke selections. Make a selection, choose Edit ▸ Stroke Selection, and then choose the pattern option in the Stroke Selection dialog.

- Besides using patterns to fill your layers and selections, you can use them as the source image for a bump map. Fill one layer with the pattern, and then apply the Bump Map filter (Filters ▸ Map ▸ Bump Map) to another layer by using the first layer as the bump map image.

- Sometimes a pattern is very small when compared to a canvas. Applying the texture to the canvas gives you several tiled versions of the pattern. Want to scale a pattern to fit the canvas without tiling it over an entire layer? Make a small selection, fill it with the pattern, copy and paste the selection as a new layer, and then scale the layer to the size of the image.

- You can use the Bucket Fill tool's modes to blend patterns with existing layer content. But an even better, nondestructive method is to fill a layer directly above the target layer with the pattern, and then set the layer blend mode accordingly. (See Section 1.2 to learn more.)

- As you'll see in later chapters when making balls and buttons, gradients are often used to simulate lighting because they can represent gradual changes from dark to light. However, the appearance of a smooth gradient can be lost if you save it in the wrong file format. GIF files, for example, are not well suited for images with gradients, because the GIF format reduces the number of colors and can cause banding (streaks of colors). If you're saving your gradient image for use on the Web, try using the JPEG format instead and use little to no compression.

- When using gradients to create spheres, always have the gradient flow from a lighter color on the left to a darker one on the right. In the Tool Options dialog for the Blend tool, check to make sure the Gradient option shows it this way. If this isn't the case, try clicking the Reverse button just to the right of the Gradient option.

Using a pattern as the source image for a bump map

The first edition of this book often used multiple layers to create multi-line offset text. This technique was required because GIMP's text-editing capabilities were somewhat limited. While the usual font selection, size, and even letter spacing were available, it wasn't possible to have a single layer with text containing different font settings.

All that changes with GIMP 2.8. An on-canvas editing box allows you to set font characteristics for individual text letters, words, and phrases, including positioning relative to other text in the same layer. This means a single layer can now hold an entire text project, a process you'll be able to try for yourself in Section 3.5.

Creating Text

Click the Text tool in the toolbox, and then click and drag in the canvas to open an *editing box*. This box, also called a *bounding box* or *text frame*, will stretch to fit any text you type. But it can also have its size fixed by setting the Box value in the Tool Options dialog to Fixed. A fixed width can be used to wrap paragraphs without newlines within the bounds of a layer. The default setting, Dynamic, allows the box to grow to fit text added to the frame.

Above the editing box is the *Style Editor*. This has two rows of options used to change font characteristics of any text selected in the editing box. This includes the font, font size, baseline, and kerning features. See how this works with the following example.

1. Open a new canvas, using the default size. Choose the **Text** tool from the toolbox.

2. Click and drag in the canvas to create the editing box and open the Style Editor.

3. Type the phrase *GIMP is cool* in the editing box. Select the word **GIMP**.

The editing box has handles on the corner and along the edges to allow dynamic resizing while editing is still in progress. Note the Box option in the Tool Options for fixing the editing box size. Clicking on a handle will resize the box to fit the current text.

4. In the far-left field in the first row of the Style Editor, type a few letters of the name of any font known to exist on your system, such as Sans Serif or Times. A list of matching font names is displayed below this field. Select a font from this list.

5. In field to the right of this, type a number (or use the mouse scroll wheel) to change the font size.

At this point the selected font should be different from that of the rest of the phrase. The Style Editor can be used to change the color of the selected word, or another selection can be made to apply different settings.

Selected text in the editing box is yellow and, depending on the Style Editor settings, may not always align properly with the text.

The Style Editor can be used to change most of the same options available in the Tool Options dialog. However, line spacing can only be changed in the Tool Options dialog and is always applied to all lines in the editing box, even if they're not currently selected.

The first row of options in the Style Editor is for font ①, font size ②, and unit of font size ③. The second row provides font styles (bold, italic, etc. ④), baseline position ⑤, letter kerning ⑥, and color options ⑦. The far-left button in the second row can be used to remove text that is currently selected in the editing box.

Changes to the baseline cause space to be added below the selected text. This feature is useful if you create an oversized first letter or word on a line and want to raise the rest of the letters to the top edge of the first letter. Kerning adjustments are used to adjust the spacing between letters in the selected text.

All but the letters in the first word are selected, and the baseline value is increased to align the tops of those letters with the first word. Kerning is increased to spread the letters to fit the width of the box.

The Tool Options Dialog

The Tool Options dialog offers some features that are also in the Style Editor. The Tool Options affect all text in a text layer that hasn't been changed using the Style Editor. For example, changing the font in the Tool Options dialog will change the font for all text in the previous example except the word *GIMP*. The same is true for font size and color.

Certain options are only available in the Tool Options dialog. This includes features such as antialiasing, hinting, and justification. Changes to these options affect all text in the editing box.

Tool Options can be used to make global changes to text in a layer, unless the text has been previously edited with the Style Editor.

The Text Editor

Before the editing box, GIMP provided text-editing features in a dialog called the *Text Editor*. This dialog works just like the in-canvas editing box, with the added benefit of having an icon at the top for loading files (the editing box requires use of the context menu). Changes to the Text Editor are reflected immediately in the editing box.

To open the Text Editor, click Use Editor in the Tool Options dialog. To close the editor, click its Close button or uncheck the Text Editor option in the Tool Options dialog.

The original Text Editor dialog is still available and offers WYSIWYG previews outside the canvas. Whether you use the Text Editor dialog or the editing box is currently a personal choice, though the Text Editor can sometimes behave poorly when you try to change font types or sizes.

Text, Paths, and the Context Menu

Text can be aligned with a path, creating text that flows along a curve or box. This feature can be hard to find. When editing text in the canvas, right-click the text to bring up the context menu. Select the Text along Path option. This converts the letters in the text layer to a series of paths shaped like the letters and flows those paths so the middles of the letters align with the currently active path in the Paths dialog. To move the text farther down the path, add a few spaces to the front of the text.

These outlines are paths generated from the text layer using the context menu. Aligning text along a curve may require adding spaces to the front of the text and/or adjusting the letter spacing in either the Tool Options dialog or the Style Editor.

Since the text is now a series of paths, you'll need to convert them to a selection and fill that with color to get the letters back.

The Path from Text option is similar to Text along Path, except the paths created are in the same position as the original text.

Text Tips

- If loading a file into the editing box, first set the box to Fixed in the Tool Options dialog. If you don't, lines from the file without carriage returns will flow out to the right in one long line.

- Use baseline adjustments to align multi-sized text on a single line. Use line-spacing adjustments to align text on multiple lines.

- Covert text to paths to make it easier to scale up a logo design. Paths are vector objects, and making them larger doesn't affect their quality, while enlarging rendered text will cause jagged edges. You could just increase font sizes in the text layer, but if you have many font types and sizes, you may find it easier to scale a path version of the text and then fill in appropriate colors.

- New fonts can be added to GIMP by installing to any directory and then updating the Font folder in the Preferences dialog. Changes to the font configuration require a restart of GIMP.

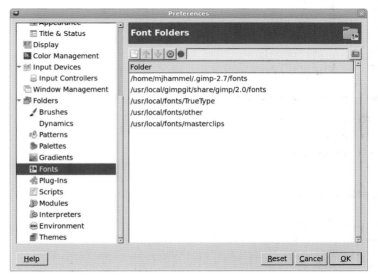

The Fonts folder allows you to add new fonts to GIMP.

If you've graduated from flatbed scanners, then you're ready for digital cameras. Digital cameras provide you with a simplified method of acquiring images for use in GIMP. You no longer need to worry about converting from film to digital files but instead can work with digital files directly. No more boxes of prints and negatives. The digital life is much easier.

Yet with new technology comes new processes. Scanners are typically connected using USB. Digital cameras use solid state devices (SSD) like flash memory cards. While scanners don't know anything about the camera that took the image, digital images contain metadata to help with mapping colors from one device to another. There is new software to consider, as well as new issues with the files you load into GIMP.

Cameras today generate images that are GIMP ready by storing digital image files on a memory card. Many phones have integrated cameras that can produce high-quality images. To get these images on your computer, remove the card from the camera (don't forget to charge the battery while you have your camera open) and insert it into an appropriate slot in your computer or USB card reader. On most computers, the card will be automatically detected, and an appropriate program for organizing your digital files will open. On Linux you can choose from Shotwell, F-Spot, digiKam, Darktable, and others. There are a many options available for Mac OS X and Windows users. Copy the files onto your hard disk using your own personal organizational method, such as one folder per day or one folder per event.

If you still use film or have old images that you want to process, you'll need a flatbed scanner to get them into GIMP. Scanning is not difficult on Mac and Windows systems but can be more involved under Linux. Once the scanner is connected to your system, experimentation is key. Getting a good scan can take a lot of practice.

A Digital Camera Primer

Most modern digital cameras provide very high-resolution photographs. The number of megapixels combined with the aspect ratio determines the actual size of the photograph. A 4 × 3 aspect ratio on a camera with 12-megapixel resolution produces photos roughly 4000 × 3000 pixels. At 250 dpi, these would print at 16 × 12 inches, significantly larger than the old 3 × 5-inch prints you got from the local supermarket photo booth. (Changing the aspect ratio is easy using GIMP's crop tool, so it doesn't really matter what ratio your camera provides.)

Multimedia cards come in many forms, though most digital cameras can be accessed directly using a simple USB cable.

NOTE *Linux users: if the multimedia card is not automatically mounted, look for a device with a name similar to* /dev/ mmcblk0 *and try mounting that manually.*

File Formats

Now that you can access the files on the camera, you should know a little something about them. First and foremost: file formats. All digital cameras support JPEG-formatted files. Since it's a lossy format, it's not ideal for image-editing processes. JPEG images are compressed by an algorithm that takes human visual perception into account. It removes a lot of the details that you can't see. For example, our eyes can't differentiate among unlimited shades of blue in the sky, so the compression algorithm reduces these shades to a lower number. But when you later change the color of the sky in GIMP to get a more dramatic image, you'll get bands of uniform color where a gradient should be.

If you want to process your JPEG images in GIMP, you should set your camera to neutral colors, low compression (or larger file size), and low sharpening and noise reduction. Your images will look bland and boring out of camera, but these settings will provide you more options when editing in GIMP.

Some cameras support the TIFF format, a lossless format that can also be compressed. What's the difference? A lossless format doesn't lose any image information when compressed, so opening a compressed TIFF image will restore the original image. The same is not true of uncompressing a compressed JPEG image.

But neither of these formats comes close to the image quality you get from the native file format for the camera. The general term for this format is RAW, but RAW formats are camera specific. They have file extensions like NEF, CR2, RAF, and more. Only high-end cameras are able to export the RAW file to memory cards. Consumer-grade cameras store it only in the camera's memory until they have processed the image.

Since most cameras have low processing power, they use less sophisticated software to process from RAW to JPEG than tools for your desktop computer. This processing from RAW format may include destructive processes you'd rather apply manually, if at all. These may include effects like noise reduction, color correction, or sharpening. So working with RAW is generally considered the only way to go for professionals—even a "lossless" TIFF will have been processed by your camera.

That said, getting RAW images is not always easy. GIMP's plug-in (UFRaw, itself based on the dcraw software) for processing these images doesn't actually retrieve the images from the camera. Additionally, RAW files are larger than their JPEG or TIFF counterparts and generally require more memory and better processors. This is why the average desktop consumer might be better suited to using JPEG images, especially if your camera can set the amount of compression used on those photos. Again, JPEG is not completely ideal, but for lower-end consumer-grade cameras, it may be your only option without modifying your camera's firmware.

NOTE *Information on using UFRaw and dcraw, along with the cameras they support and options for modifying camera firmware, can be found at the appropriate websites:*

UFRaw http://ufraw.sourceforge.net/

dcraw http://www.cybercom.net/~dcoffin/dcraw/

Camera Metadata: EXIF

Once imported, files can be opened directly by GIMP. Most cameras will record some level of textual information about photographs in the image files. This is usually done as EXIF (Exchangeable Image File) format metadata. Alternative metadata formats include XMP (Extensible Metadata Platform) and IPTC (International Press Telecommunications Council), with XMP being the standard toward which camera makers are headed.

Access to photo metadata in the EXIF and XMP formats is provided by the Image Properties dialog (File ▶ Properties) in the Advanced tab, which allows viewing and editing of the metadata. EXIF data is saved by default when saving to GIMP's native XCF format and to JPEG files, but the resolution may change to match the default setting in the GIMP preferences. EXIF data may not be saved to other file formats, since they do not all support it.

NOTE *Support for EXIF data in GIMP is only available if GIMP was built with the required libraries. If you don't have the File ▶ Properties menu option, then your version of GIMP doesn't support EXIF data.*

The Image Properties dialog of a Canon PowerShot JPEG includes a large amount of information related to how the photograph was taken.

GIMP Photo Processing

While there are other tools for viewing camera images, GIMP is ideal for photo processing when you need to manually color correct an image, blend images together, or perform complex operations like depth of field or color swapping. Take a look at these basic operations as performed in GIMP.

Color enhancement is a common requirement for digital photographs. The problem in this example is the poor lighting on the subject at the time the photograph was taken. In the original photograph the color is somewhat washed out. Running this through F-Spot's color correction produces an improved image, but GIMP produces the most accurate color. In both cases various levels and saturation were adjusted, but in GIMP an additional step through the Channel Mixer produces the best results.

| Original | F-Spot | GIMP |

F-Spot does a good job of color-correcting the washed-out image, but even better results come from the plethora of color-correcting tools available with GIMP.

Image alignment is necessary when the subject of a photo is angled from the (possibly imaginary) line of horizon. Rotation is required to align the image, but rotation of a rectangular image will produce a larger image with some areas filled with the background color (or transparency). Alignment therefore requires two steps: rotation and cropping.

Rotation in GIMP has improved with the addition of a live preview shown in the image window. In this image the building is at an angle. You can straighten this by placing a horizontal guide so it touches the higher end of the roofline on the left side of the image, using the Measure tool to determine a rotation angle, and then using the Rotate tool to make the roofline parallel to the guide. After rotating, the image includes transparency at the corners that must be cropped out.

Red eye is now directly supported by GIMP filters. In this image the camera flash has reflected off the backs of the eyes, causing the pupils to appear red. Make a selection around the eyes using the Free Select tool, being careful not to include any of the skin (which also has a red tint to it). Then open the Red Eye Removal filter (Filters ▸ Enhance ▸ Red Eye Removal). The default settings work well for this image, so you don't need to make any additional adjustments.

Transparency is automatically filled in by GIMP (checkered area, upper-left corner of image) after rotating areas where no pixels remain from the original image.

Digital Camera Tips

- Linux users: the most recent, updated releases of Linux distributions such as Ubuntu, Fedora, OpenSUSE, and Debian should have good support for card readers.

- Flash media can be slow to access, so your best bet is to simply copy the files off the media to a local hard drive before working with the photos.

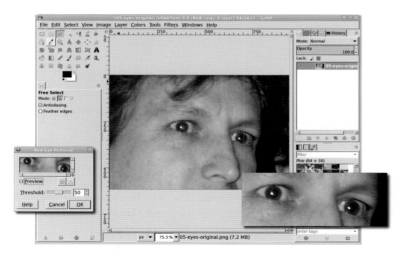

Red eye is caused by light reflected from the back of the eye through a pupil. It's a common problem for casual photographers, but easily remedied with GIMP.

If you're new to the GIMP, the best way to get started is to familiarize yourself with some common processes that you can apply to different projects. These tutorials aren't as detailed as the ones in the rest of the book, but they'll help you master techniques applicable to all kinds of designs. If you can't find all the menu items or dialogs mentioned here, don't fret. These are just quick tutorials. The tutorials throughout the rest of the book will walk you through the processes in greater detail.

Clouds

Some of the most artistic GIMP effects involve merging layers in random ways. A grunge image, for example, might mix several textured layers resembling a collage of torn pages. Creating the texture in each layer is an artistic experiment in itself. But how do you then tear the layers? It's easier than you might think. You just apply a layer mask filled with random shapes to each layer. The layer masks block out sections of the layers, making it look as though they've been torn away.

What kinds of random shapes work well as layer masks? You can use brushes to draw in layer masks and produce customized results. But the process is often time-consuming, and it's difficult to achieve random shapes with similar brushstrokes. You need something fast that gives more randomness than hand-brushed strokes ever would. Like clouds.

Clouds are very effective graphic design tools. While creating grungy textures might not be your thing, you can simulate increased depth of field in any design project by applying a cloud as a layer mask and then using it to create selective blurs. As you've already seen, you can also use clouds as the starting point for various textures, including skin and cloth. And, of course, clouds can be used simply as clouds, to create everything from wispy cigarette smoke, to light steam rising over a cup of coffee, to those big white balls of cotton in the sky.

GIMP provides four filters for creating clouds: Difference Clouds, Fog, Plasma, and Solid Noise. While you can use each filter on its own to create interesting cloud shapes, you may find that combining any two or more results in more realistic effects.

The Plasma Filter

The Plasma filter (Filters ▸ Render ▸ Clouds ▸ Plasma) produces a colored smoke screen. Most of the tutorials in this book involving clouds use the Plasma filter, precisely because it provides random noise. In many of these tutorials, you'll apply the Plasma filter to a layer mask.

The Plasma filter dialog and the colored cloud the filter renders. As with most filters, the Preview in the dialog matches the shape of the layer or selection where the filter is applied.

The initial application of the filter won't resemble a cloud, however.

1. To remedy this, first desaturate the layer (**Colors ▶ Desaturate**). Choose any option from the Desaturate dialog and click **OK**.

2. Adjust the curves to increase the black space (**Colors ▶ Curves**). The curves adjustment is a curve initially shown as a diagonal line. Click the line near its middle and drag down to increase the layer's black content. You can also click other sections of the line, dragging down for more black or up for more white. In this example, one section of the line (left of center) was dragged down, while another section (right of center) was dragged up.

At this point, the desaturated plasma cloud looks a bit like fog at night.

3. Add a new layer (**Layer ▶ New**) and move it below the plasma layer in the Layers dialog.

4. Fill the new layer with sky blue and then change the layer mode of the plasma layer to **Screen**. This creates wispy clouds that can be manipulated for other cloud effects.

Adjust the Curves dialog at two points. Dragging the curve down makes gray more black, while dragging it up turns grays into white.

Lowering the Plasma filter's Turbulence setting produces more uniform cloud coverage, resulting in something that looks more like fog than clouds. Increasing this setting is useful for achieving more complex effects, like simulating fire (see Section 4.12).

The Solid Noise Filter

Clouds in the sky often have a little more puff to them, like cotton balls. The Solid Noise filter helps create more substantial clouds.

1. Start with a sky-blue Background layer.

2. Add a new layer and apply the Solid Noise filter (**Filters ▶ Render ▶ Clouds ▶ Solid Noise**), using a low X size value (about 1.0) and higher Y size value (about 4.0) to stretch the clouds horizontally. Click **OK**.

3. Adjust the curves to increase the black area of the cloud layer. Set this layer mode to **Screen**. Duplicate the layer to emphasize the effect.

The Solid Noise filter produces wispy clouds.

Difference Clouds

When you use the Difference Clouds filter, you'll see the Solid Noise dialog show up instead. This is because Solid Noise forms the basis for the Difference Clouds filter. The only difference between the two is that Difference Clouds applies Solid Noise to a new layer just above the active layer, changes the layer mode for the new one to Difference, and merges it with the active one.

Fog

The Fog filter is actually a Python script that allows you to apply color to a desaturated Plasma filter. It also allows you to automatically name the fog layer, which the Plasma filter does not. It's basically a convenience filter that allows you to perform the multiple steps you'd normally do with Plasma using just a single filter.

Combining the Filters

While the solid noise effect is good, it could be better.

1. Add a desaturated **Plasma** cloud layer with its layer mode set to **Screen** above these layers to add some random wisps to the clouds.

2. Add a white layer mask to the Plasma layer. Then copy and paste a Solid Noise layer into the mask by choosing **Edit ▸ Copy**, **Edit ▸ Paste**, then **Layer ▸ Anchor**.

3. Adjust the layer mask's curves to increase the white content. As a result, the cloud patterns should appear fluffier.

Apply the Plasma filter in addition to the Solid Noise filter to give otherwise smooth clouds a cottony appearance.

Creating a Steam Effect

To create steam such as might rise from a cup of coffee, first use the Solid Noise filter to create puffy vertical clouds.

1. Choose **Filters ▸ Render ▸ Clouds ▸ Solid Noise**, set the Y size to **1.0** and the X size to **4.0**, and click **OK** to apply the filter.

Adding vertical clouds of smoke with the Solid Noise filter

Using a Bi-linear gradient in the layer mask isolates a scant few horizontal streaks (shown here with a black background to make them more visible after applying the layer mask)

2. Add a white layer mask to the cloud layer (**Layer ▸ Mask ▸ Add Layer Mask**). Type **D** in the canvas area to reset the foreground and background colors.

3. Choose the **Blend** tool from the toolbox. In the Tool Options dialog set the Shape to **Bi-linear** and the mode to **Multiply**, and then drag from the image's middle to its right edge.

4. Drag again, from the near-left edge to the left edge, then from the near-right edge to the right edge.

5. Apply the layer mask (**Layer ▸ Mask ▸ Apply Layer Mask**).

6. Copy and paste the noise layer into an image of a coffee cup (available from an online stock image archive). Name the layer *Steam*.

7. Use the **Move** tool to position the wisps of steam over the cup.

8. Use the **Scale** tool to adjust the size of the Steam layer as needed. Use Distort filters (**Filters ▸ Distorts**) such as Ripple or IWarp to create waves in the steam.

9. Add a layer mask to the Steam layer to mask out steam overlapping the outside of the cup.

10. Set the layer mode for the Steam layer to **Screen** or **Grain Merge**.

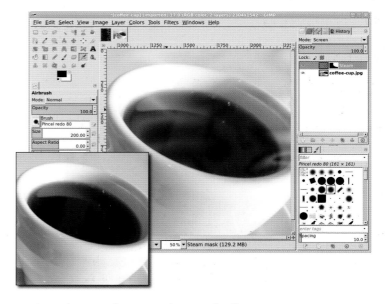

Applying the steam layer over the cup of coffee

Cloud Tips

These suggestions will help you take your cloud effects to the next level:

- Use the IWarp filter (Filters ▸ Distorts ▸ IWarp) to add swirls to your smoke and clouds. This filter provides more control over the swirls' location than the Whirl and Pinch filter (Filters ▸ Distorts ▸ Whirl and Pinch).

- When the wisps of smoke you've created are drowned out by light or busy backgrounds, duplicate the smoke layers. Set the layer modes for those layers to Screen, Addition, or Grain Merge.

- You can apply most GIMP filters to both layers and layer masks. Before rendering a cloud, make sure to click the appropriate thumbnail in the Layers dialog!

Rips and Cracks

Rip effects are popular, but they're often difficult for new GIMP users to reproduce. The technique is actually very simple and amounts to nothing more than careful use of layer masks and selections. A similar process adds cracks (or other patterns) to an image. Again, layer masks make it all possible.

Ripping an Image's Edges

Start by creating the colored background layer that will show through the ripped edges. Open the image you want to use to practice ripping (this tutorial uses a colorful beach photograph). This process works for images of any size, but start by practicing on a small image no larger than 500 × 800 pixels.

1. Add an alpha channel to the Background layer (**Layer ▸ Transparency ▸ Add Alpha Channel**).

2. Add a new layer (**Layer ▸ New Layer**), fill it with white, and then move the colored layer below the Background layer in the Layers dialog.

Move the colored layer below the one containing the photograph. The color will show through where the edges of the photograph are "ripped."

3. Add a white layer mask to the original image layer (**Layer ▸ Mask ▸ Add Layer Mask**).

4. Create a rectangular selection of the entire image layer by choosing **Layer ▸ Transparency ▸ Alpha to Selection**. This instructs GIMP to select all the opaque pixels in the image. Because this image is entirely opaque, this operation selects the whole image. (Pressing CTRL-A also works.)

5. Shrink your selection (**Select ▸ Shrink**) by **135 pixels**. Round the corners of the selection (**Select ▸ Rounded Rectangle**) by **35 percent**. This creates a boundary area of the photograph that remains unchanged when you create the layer mask.

6. Feather the selection (**Select ▸ Feather**) by **32 pixels**. This allows the rips to meld with the image.

7. Invert the selection (**Select ▸ Invert**) to isolate the area where the rips are applied.

The amounts necessary for the Shrink and Feather operations depend on the size of your original image. Smaller images will need smaller Shrink and Feather amounts.

The edges of the original photograph appear ripped.

8. Type **D** in the canvas to reset the foreground and background colors.

9. Click the layer mask for the original image layer in the Layers dialog to make it active. Fill the selection with black by dragging the background color from the toolbox into the canvas.

10. Use the **Paintbrush** tool and select a brush to paint with black in the layer mask. (The Galaxy (AP) brush works well: move the **Spacing** slider to **60.0 pixels** for an image of this size and adjust the size of the brush in the Tool Options as necessary.) Paint with various-sized brushes along the inside edges of the selection, focusing less on them and more on the edges of the image.

 Because you're working on a layer mask and not modifying the actual image, feel free to experiment. Try using a different brush along the outer edges of the layer mask to change the shape of the ripped edge.

Ripping Tips

Think rips might be just what your project needs? Here are a few more tips:

* To get the right effect, you need the right brush. If GIMP's stock brushes don't suit your needs, consider creating a few new ones. The process is described in Section 1.1.

* Want to use layer masks to create text effects? The quickest way is to choose Layer ▸ Transparency ▸ Alpha to Selection to select the area around the text for use as a layer mask region. Fill the layer mask with a grungy, scratched texture. Then invert the text selection and fill it with white. This only applies the effects inside the text area.

Photographic Effects

2

PHOTOGRAPHIC EFFECTS

As a raster image editor, GIMP loves to play with points of color, both individually and in blocks and blobs grouped together in selections. This makes the program perfect for working with photographs. Both your digital camera and GIMP work with pixels, so no data conversion is required. The days of scanning your photos are a thing of the past.

Now that your images are in digital format, there's no end to the magic you can perform. Going from average photos to studio-quality productions requires just a few techniques that anyone can learn to use. Many techniques are based on simple color corrections like those provided by the Curves, Levels, and Color Balance tools.

In addition, you can use various GIMP filters to enhance photographs. The Retinex tool (Colors ▸ Retinex), for example, normalizes colors in order to enhance focus. Originally produced by NASA's Langley Research Center to enhance images taken through smoke and haze, this filter has interesting possibilities for portrait enhancement.

Setting a steep curve increases color contrast, while changing the color balance maintains the color contrast.

This levels histogram shows that the darkest pixels aren't completely black. Moving the left and right sliders toward the middle produces the dramatic lighting change shown here.

The following tutorials describe techniques that photographers will find useful. Along the way you'll create vignettes, add focal blurs, adjust color, insert lighting, simulate depth of field and motion, and use cloning methods to clean up damaged photos. Unlike previous tutorials, these won't start with a blank canvas at the default dimensions and walk you step-by-step through a repeatable process. Instead, I'll start with a few basic images and apply standard processes that you can use with your own images.

The Retinex filter produces a sharper image than the desaturated original (upper left). Applying the Colorize tool and the Filter Pack filter produces further variations.

We're not all professional photographers or graphic artists. You may not have $5,000 digital cameras or fancy studios, but you do have access to many of the same digital effects professionals use: selections, blurs, masks, and layer modes. Taken by themselves these don't seem like powerful tools. But when you apply them to your own photographic masterpieces, they become the tools of a new graphic artist—you.

2.1 SOFT FOCUS

The soft-focus technique has long been used to soften hard edges between shadows and light, allowing a foreground image to fade into the background. This is especially true for studio portraits, where backgrounds are often just painted canvas. Blending foreground and background can pull the eye toward the foreground, if done correctly.

In photography, the soft-focus effect originated as a result of flaws in camera lenses. Later, with the use of lens filters, the effect was often incorporated into glamour images because it smooths skin wrinkles. In the digital age, soft focus is a handy trick that can remove blemishes while adding charm to any image.

Fortunately for digital photographers, soft focus is a technique that raster-based programs like GIMP now provide, using common processes such as blurring. But it is also an effect that can be easily overused.

This tutorial will show you how to soften the focus of a studio portrait. Techniques like this require only modest experience with selections combined with colors tools and the Gaussian Blur filter.

Getting Started

The easiest way to perform this effect is with a *high pass filter*. A high pass filter lets high frequencies pass while blocking low frequencies. In an image, a high pass filter will enhance the areas of greatest contrast. You can use this knowledge to find blemishes, blur them out, and blend with the original image.

The stock GIMP distribution doesn't provide a high pass filter, though one is available from the GIMP Plugin Registry. Fortunately, a high pass filter can be simulated very easily with just a couple of layers and some color adjustments, so there's no need to download and install the filter from the registry.

Start with a portrait. The portrait I've chosen looks fine as it is, but it could look even better—softer and more dreamy. Its best features are the boy's eyes and the high contrast between the focal points (the faces) and the background and clothing. Be sure to find an image with similar contrast for your own experiment.

A soft focus (right) draws the viewer into the subject more than the original (left).

The original image is well executed, but you can improve it by softening the focus.

1. Open the image and duplicate the Background layer.
2. Name the duplicate layer *High Pass.*
3. Duplicate the High Pass layer once.

4. Click **OK** to apply the blur to the layer.
5. In the Layers dialog, set the Opacity slider to **50 percent**.

Two copies of the original layer are required to create the high pass filter. The second gets blurred and merged with the first before additional color adjustments are applied.

This process will soften the high-contrast areas in preparation for blending with the original image. The blur radius for the Gaussian Blur can be increased or decreased as needed. Higher blurs will increase the softness of the final image. Beware, however, that too much blur will just result in a mess.

Preparing the High Pass Filter

The high pass filter starts by blurring the top layer and changing its opacity so it blends with the next layer down.

1. If it's not already selected, click the top layer in the Layers dialog to make it active.
2. Open the Gaussian Blur filter (**Filters ▸ Blur ▸ Gaussian Blur**).
3. Set the Blur Radius, both Horizontal and Vertical, to **30 pixels**. Keep the Blur Method set to **RLE**.

Merging Layers

Blurring and transparency are just the first part of the simulated high pass. The next step is to invert the blur layer and blend it with the second layer, which is a copy of the original image.

1. The top layer should still be selected in the Layers dialog. If not, select it.
2. Invert (**Colors ▸ Invert**) the colors of this layer.
3. Merge (**Layer ▸ Merge Down**) the top layer with the layer below it.

The steeper the middle part of the S curve, the less the original image will be brightened.

Note that the merged layer retains the name of the lower layer, in this case High Pass. When the top layer's colors are inverted and merged down, the result is a mostly gray layer with high detail in the areas of interest (eyes and mouth, for example). You'll exaggerate the high contrast areas with the next step.

Adjusting Light and Shadow in the High Pass Layer

The High Pass layer is ready for color, or rather lightness, correction. To do this, the Curves dialog will be used, followed by the Brightness-Contrast dialog.

1. The High Pass layer should still be active in the Layers dialog.

2. Open the Curves dialog (**Colors ▸ Curves**).

3. Adjust the diagonal line so it has an S shape similar to the one shown here.

4. Click **OK** to apply the changes to the layer.

5. Open the Brightness-Contrast dialog (**Colors ▸ Brightness-Contrast**).

6. Set the Brightness slider to **−95**. Leave the Contrast slider at **0**.

7. Click **OK** to apply the changes to the layer.

The result of this step is similar to applying an edge-detect filter to the image. But none of the edge-detect filters in GIMP provide this kind of detail.

Blending Layers

Now the High Pass layer can be merged with the original image.

1. Invert the colors of the High Pass layer.

2. Set the layer mode to **Soft Light**.

The results show the original image with more reflected light, like the glow movie studios add around aging starlets.

Fine Tuning

But the soft focus has taken away some of the important features of the portrait, namely the eyes and mouth. To get these back, a layer mask is added and filled with black where the High Pass layer should not be applied.

1. The High Pass layer should be active in the Layers dialog. If not, select it.

2. Type **D** in the image window to reset the foreground color to black.

3. Add a white layer mask (**Layer ▸ Mask ▸ Add Layer Mask**) to this layer.

4. Choose the Airbrush from the Toolbox.

5. Select a soft-edged brush, such as Round Fuzzy.

6. In the Tool Options dialog, adjust the size of the brush to fit the area to be masked, such as the eyes or lips.

7. In the image window, brush over the boy's eyes and lips.

It's not necessary to be exact using the airbrush in the mask. It won't be immediately obvious that much is happening in the image window. Continue painting until the blur fades and the eyes and lips become distinct. Adjust the size of the brush for different eyes and lips, and then repeat.

The color of the iris is more vivid and the eyelashes more pronounced after masking the high pass filter.

Further Exploration

The high pass layer in this tutorial (and the steps that created it) blurred the background, which also simulated a decreased depth of field. You'll learn more about how to simulate this effect in Section 2.5. This method of edge detection is also used for selective sharpening.

2.2 PHOTO TO SKETCH

This next technique is for all the would-be artists among us. What you can't do with a pen and pencil, you can now do with a camera and GIMP. Although an inkjet print on textured paper isn't quite the same as a fine hand-drawn sketch, it's close enough for the digital crowd.

Converting a photo to a sketch basically means detecting the edges in an image and applying a slightly irregular line, one that looks like it might have been drawn by hand. This process isn't exact—you might substitute a different edge-detect filter or use the Curves or Levels tools to adjust the desaturated layers before applying filters. But these basic steps will get you started.

The subject of this image is a room with lots of lines and shapes but few odd patterns.

Is it pen or pencil? Actually, it's just a little GIMP magic.

Getting Started

The original image you choose for this effect shouldn't be too busy. Soft lines are useful, but intricate patterns such as paisley would be problematic. Although I chose a still-life image for this example, the trick also works well with formal portraits and other pictures of people.

Converting the Image to a Sketch

1. First, desaturate the image (**Colors ▸ Desaturate**).
2. Duplicate the layer twice (**Layer ▸ Duplicate Layer**). Name the first duplicate *Burn* and the second duplicate *Hard Light*.
3. Turn off the visibility of the two duplicate layers by clicking the eye icon for each one in the Layers dialog. Then select the Background layer again.

NOTE *The Background layer can also be duplicated once more before the next step. This will allow further experimentation by keeping a copy of the desaturated layer. If you do this, be sure to turn off the visibility of the Background layer and apply the next step to this last duplicate layer.*

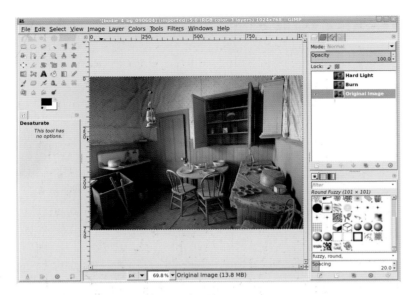

The names of the duplicate layers hint at the layer modes to be used later. The Background layer has been renamed to Original Image here to make it easy to identify in the layer stack.

4. Open the Sobel filter (**Filters ▸ Edge Detect ▸ Sobel**). The Sobel filter is an edge-detect filter that looks for nearly horizontal and vertical lines in the layer and keeps those in the resulting image.

5. Keep the default settings and click **OK** to apply them to the Original Image layer. The default settings for this filter, as opposed to the other edge-detect filters available in GIMP, will work best with this image because they'll produce more solid and distinct lines that appear hand-drawn. However, you may get better results using another edge-detect filter if your image doesn't look right after applying the Sobel filter.

6. The white lines may need to be enhanced. Use the Levels dialog (**Colors ▸ Levels**) and pull the White Point slider to the left.

7. Invert the colors (**Colors ▸ Invert**) for this layer to produce black lines on a white background.

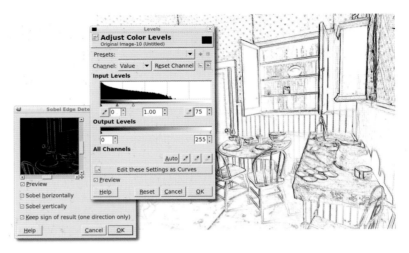

The Sobel filter creates nice outlines of the image's important shapes. Other edge-detect filters might work better for your image, so you should experiment.

Adding Depth to the Sketch

1. Click the **Burn** layer in the Layers dialog to make it active, and click its eye icon to make it visible once again.

2. Open the Gaussian Blur filter (**Filters ▸ Blur ▸ Gaussian Blur**).

3. Set the Horizontal and Vertical Blur Radius to **10 pixels** and apply this filter to the layer.

4. Set the layer mode to **Burn**. This makes dark areas in the background even darker, so the hand-drawn appearance looks as though it was achieved with a dark pencil.

5. In the Layers dialog, click the **Hard Light** layer to make it active, and then click its eye icon to make it visible.

6. Again, open the Gaussian Blur filter (**Filters ▸ Blur ▸ Gaussian Blur**).

7. This time, set the Horizontal and Vertical Blur Radius to **15 pixels**. Click **OK** to apply these settings to the layer.

8. Set the layer mode to **Hard Light**. This will simulate the smudged charcoal appearance you get when rubbing your finger over a pencil mark on paper.

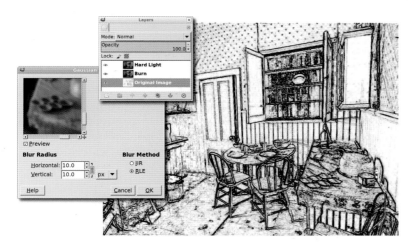

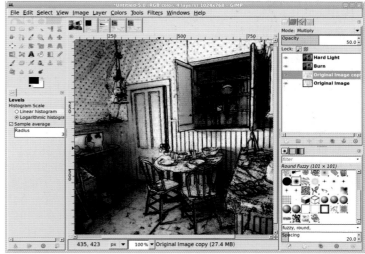

Adding the Finishing Touches

1. Let's take this particular image a little further. Start by dupli-cating the Original Image layer (**Layer ▶ Duplicate**).

2. Set the layer mode of this duplicate layer to **Multiply**.

3. Set the Opacity to **50 percent**. This brings out the image's lines even more without making the drawing look artificial.

Blending with a blurred original using Burn mode darkens outlines created by the edge-detect filter.

Adding this last layer is optional, but it helps to emphasize the lines in this particular image.

Further Exploration

This simple technique has numerous variations, including hand-smudging the charcoal layer using the Smudge tool and manually tinting the strokes with the Colorize tool to simulate drawing with colored pencils. You can also use the Oilify filter (Filters ▶ Artistic ▶ Oilify) to produce impressionistic images, or you can use the Curves, Levels, or Posterize tools to produce images that look more like line drawings. When creating duplicates of the original image layer, make more than one for each type of edge-detect filter and try variations of the filter settings. Larger blurs can soften the pencil strokes.

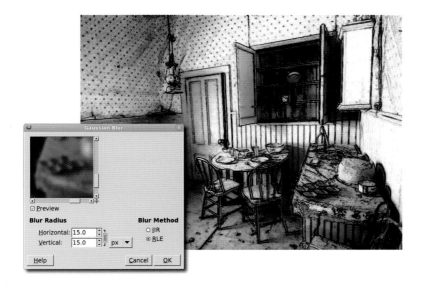

Applying the Hard Light mode lends the image a smudged charcoal appear-ance, just like when you smear a pencil mark with your finger.

Antique photos come in two flavors: black and white or tinted. Coloring black-and-white photos is easy with GIMP: you simply choose a color, pick a layer mode, and apply a Bucket Fill. There's nothing to it. The tricky part is making it look right—adjusting the contrast in the grayscale image appropriately and then choosing the right layer mode.

Most people associate tinted pictures, rather than plain black-and-white ones, with antique photos. This may be because more old sepia-toned photos have survived. The processing chemistry for sepia prints converts the silver metal, which forms the image in black-and-white prints, into silver sulfide. Silver sulfide is more stable than silver metal. Thus, converting the silver to sulfide gives the photographs a much longer shelf life.

Sepia prints get their name from the range of brown tints produced by the development process, which resemble the ink of the cuttlefish (*sepia* in Latin). Re-creating true sepia tones digitally therefore limits us to a small set of dark brown colors, some with a slight tint of red. Similar processes could be applied using colors other than shades of brown, though the resulting images would not mimic true sepia prints.

In this tutorial you'll try out some possible variations as you produce sepia-toned images using different combinations of colors, contrast, and layer modes.

Getting Started

This tutorial's original image comes from an online image archive (available from BigStockPhoto.com) and has been desaturated using the Channel Mixer (Colors ▸ Components ▸ Channel Mixer). Alternatives to using the Channel Mixer dialog are using the Desaturate dialog or converting the image to grayscale (Image ▸ Mode ▸ Grayscale) and then back to RGB (Image ▸ Mode ▸ RGB).

The primary difference between these latter two methods is that the Desaturate dialog only works on the current layer. If your image has more than one layer, the Desaturate dialog won't convert all of those layers at once. For multiple layers, it would be more appropriate to convert the image to grayscale and then back to RGB.

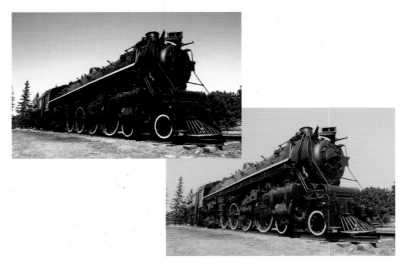

Converting an image from full color to sepia is a fairly simple process.

But the Channel Mixer is the best option for this tutorial. Old photographs often owe their appearance to the use of *orthochromatic* film. Orthochromatic emulsions cause blue tints to appear brighter and reds darker. The Channel Mixer provides a higher degree of control in setting these channels when converting from color to a monochromatic image.

1. Open the original image.

2. Open the Channel Mixer dialog (**Colors ▸ Components ▸ Channel Mixer**). For this image, set the Red channel to **47**, the Green to **0**, and the Blue to **73**, and click the **Monochrome** option to convert the image to black and white.

A slight blur helps remove crisp reflections from modern photographs.

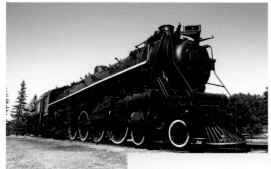

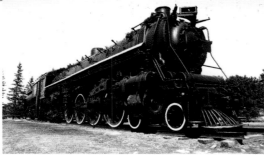

Desaturate the original image using the Color Mixer.

Since the original image is very crisp, and most old photos are not, a slight blur is applied next.

1. Open the Gaussian Blur filter (**Filters ▸ Blur ▸ Gaussian Blur**).

2. Set both the Horizontal and Vertical Blur Radius to **2.0 pixels**. Only a small amount of blur is necessary, enough to remove bright reflections on the locomotive's outer shell.

3. Apply this setting to the desaturated image.

Increasing the Middle Grays

Sepia toning works primarily by colorizing the gray region of the desaturated image. Dark pixels are relatively unaffected, and lighter pixels just get a bit lighter. The locomotive in the image is very dark, so we'll lighten it using the Levels tool to maximize the sepia tone's effects.

1. The first step in getting more gray into the image is to adjust the Levels histogram (**Colors ▸ Levels**). There are two types of histograms available: Linear and Logarithmic (see the small icons to the right of the Reset Channel button). The Logarithmic histogram shows a greater number of dark (left side) and light (right side) pixels, and relatively fewer gray (middle) pixels.

2. To increase the amount of gray in the image, we lighten the darker pixels by sliding the middle (gray) slider under the histogram to the left.

3. Apply this change to the image by clicking the **OK** button in the Levels dialog.

4. Looking at the Levels histogram again shows that there are now gaps in the graph on the dark side and spikes on the light side. There are also small spikes in the center area. This shows us visually how darker pixels have been changed to lighter pixels.

There is a wide tonal range in this image. A slight levels adjustment (left) makes it an excellent candidate for application of sepia tones. The result of applying this change is evident when the Levels histogram is checked again.

5. As an additional measure, you can also reduce the contrast in the image (**Colors ▸ Brightness-Contrast**). Reducing the contrast simulates the fade that the years will have brought to an old photograph.

Reducing the contrast and brightness will make the image appear more aged when the sepia tones are applied.

Adding the Sepia Tone

The image is now ready for a sepia tone. Sepia is a brown color with a slightly reddish tint, varying from light to dark shades. You can use many RGB value sets to achieve a sepia tone, and an Internet search will help you find them. For this image you'll apply 135/96/40 to two separate layers. Each colored layer will be blended using a different layer mode.

1. Duplicate the original layer (**Layer ▸ Duplicate Layer**) and name the duplicate layer *Sepia Screen*.

2. Fill the new layer with the appropriate sepia tone. To do this, first click the foreground color box to open the Change Foreground Color dialog. Enter your RGB values in the appropriate fields, and then click **OK**. (In this example I used RGB values of 135/96/40 for the sepia tone.)

3. Select the **Bucket Fill** tool, and in the Tool Options dialog set the Mode to **Multiply** and the Affected Area to **Fill Whole Selection**. Click in the duplicate layer to colorize the layer with the sepia tone.

4. To combine this new layer with the original, set the mode for this colored layer to **Screen**.

5. Duplicate the Sepia Screen layer. Name the duplicate layer *Sepia Overlay*. Change the layer mode to **Overlay**.

The screen layer lightens the image by adding color to it, while the overlay darkens only the dark areas by also infusing color.

Further Exploration

Further aging of the image can be accomplished by adding a selective blur to the far end of the locomotive, adding a depth of field common in old photographs. Further blurring of the entire image can also help mimic a faded, aged photograph.

The sepia toning process lends itself well to experimentation. Use multiple layers with different tinting and layer modes applied, and then flash back and forth between them using the eye icon in the Layers dialog to compare the results.

Remember that layer modes and Tool Option blend modes can produce distinct results. Blend a solid-colored layer with the layer below using a layer mode from the Layers dialog. Then turn off the solid-colored layer visibility and colorize the lower layer using the Bucket Fill tool with its blend mode in the Tool Options dialog set to the same mode. Compare the results of both techniques and note the difference. Using the layer modes makes it easier to change the sepia tone without altering the original image, and the result may be truer to the faded colors in old photographs.

Photographers are often asked to change the color of one or more elements in an image. How easy this process is depends entirely on how easy it is to isolate the objects that need updating.

This tutorial looks at two examples of color swap. The first is an image in which the color change doesn't require difficult selections. The second image requires a more delicate hand.

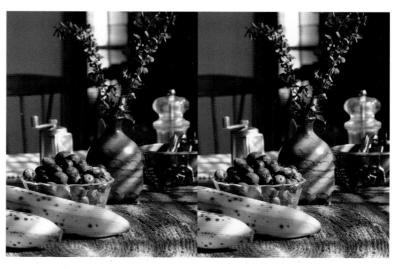

Color swapping is more complicated when the object you want to change is difficult to select. This project uses the Quick Mask to change the color of the vase.

Successful color swaps are all a matter of good selections. This image is fairly easy to work with because the items we want to change are easy to isolate.

A Simple Color Swap

The first example is a collection of boats on a beach. There's a plethora of color here. Let's change the yellow trim on some of these boats to a light blue.

Isolating the Object

To change the color of only certain objects in an image, you'll need to isolate those objects from objects of a similar color elsewhere in the image. It's obvious that some of the boats are yellow. Yellow isn't so apparent in the rocks and trees in the background, but it's plentiful there too.

1. To isolate the boats, use the **Rectangle Select** tool to make a simple selection encompassing the majority of the boats.

2. Add smaller rectangular selections to squeeze in the highest prow without selecting the rocks around it. Here the unselected region is made darker so you can more easily see what's selected.

You don't need to isolate the yellow elements from their immediate surroundings; you just need to isolate the lower half of the image (shown here with the Quick Mask enabled). If you include the upper half of the image, the yellow in the trees and rocks will be also be changed to blue when you swap colors.

Choosing the Destination Color

1. Open the Hue-Saturation dialog (**Colors ▸ Hue-Saturation**). You can use this dialog to edit multiple channels, including the familiar red, green, and blue channels and their counterparts in the world of digital printing: cyan, magenta, and yellow.

2. Choose the yellow channel and adjust the **Hue**, **Lightness**, and **Saturation** sliders until a soft blue replaces the yellow.

This process works because the color to be replaced—yellow—is not a major part of the other colors contained within the selection. An exact selection isn't necessary to swap the color yellow with the

color blue. The only places that might be problematic are the log and sand on the beach. Brown contains some yellow, so after the Hue-Saturation changes are applied, the log and sand have a blue tint. This is easily fixed by removing the log from the selection using any of the selection tools, including the Quick Mask. The sawhorse on the beach near the middle of the picture also has heavy yellow content and needs to be handled in a similar manner (unless you want it painted blue as well). Keeping the sand out of the selection requires a more complex process, such as the one in the following tutorial.

Use the Hue-Saturation tool to swap yellow with blue.

A More Complex Color Swap

The same trick doesn't work on the next image. Let's say you want to change the color of the vase to a shade of yellow. The problem is that although the vase's reddish-brown color contains a lot of red, red also appears throughout the rest of the image. In fact, if you made the same change to this image's red channel as you did to the boat image's yellow channel, you'd change the color of the background chair, the berries, and the table.

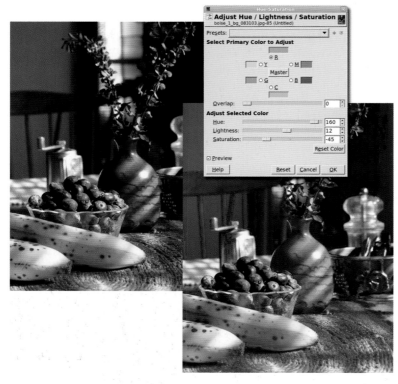

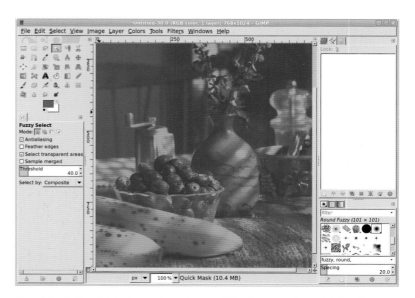

The previous technique doesn't work here because the color you want to change appears throughout the entire image.

Creating a Complex Selection

1. This image requires a complex selection. Start by using the **Fuzzy Select** tool with the Threshold set to **40**. Clicking the middle right part of the vase creates an initial selection.

2. To finish off the selection, use the **Quick Mask** and some soft-edged brushes. The problem with using the default Quick Mask in this situation is that it uses a red tint to highlight what isn't selected, but we're trying to select objects that have lots of red in them. This makes the selections created with the Fuzzy Select tool difficult to see when converted to the Quick Mask.

The default Quick Mask is red, making it difficult to see the reddish selections.

Changing the Quick Mask Color

1. This problem is easily fixed. Right-click the **Quick Mask** button in the lower-left corner of the canvas window. A menu opens.

2. Keeping the right mouse button held down, drag to the bottom of the menu to select **Configure Color and Opacity**.

3. In the Quick Mask Attributes dialog, click the preview window (it shows the color and transparency of the mask) to open the Edit Quick Mask Color dialog.

4. Here you can change the RGB values used for the Quick Mask as well as the opacity for the mask (by adjusting the A slider below the B slider). Choose a color for the Quick Mask that contrasts with the colors in the object to be selected. A higher opacity value makes it easier to see what's been selected but also makes it harder to see what needs to be selected. Here I've chosen a cyan mask with an opacity of 70 percent instead of the default 50 percent. The result is that the selected parts of the vase are much easier to see, while the parts of the vase that need to be selected are still visible.

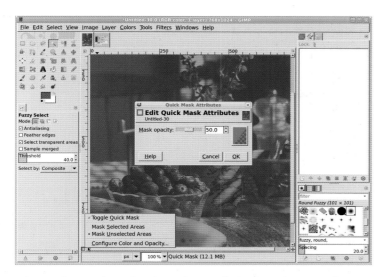

Change the Quick Mask color in the Quick Mask Attributes window.

5. When you're satisfied with the mask color, click **OK** in the dialogs to close them.

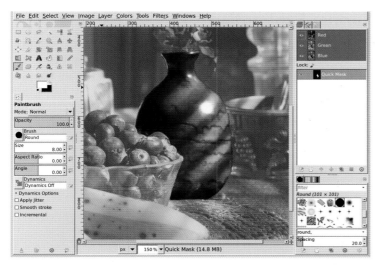

Cyan is a high-contrast color for this image, which makes working with the Quick Mask much easier.

Painting the Selection

You learned in Section 1.4 that using the Quick Mask is the most effective way to select oddly shaped objects. Here's a chance to try it out.

1. Zoom in on the vase by pressing the + key.
2. Draw straight lines in the Quick Mask with the **Paintbrush** tool's small, hard-edged brushes by clicking at one endpoint of the line, holding down the SHIFT key, and then clicking at the other end of the line. When painting (or drawing) with the Quick Mask, you must paint with black or white. Set the foreground color to white to paint over what should be included in the selection, and set the foreground color to black to paint over what shouldn't be in the selection. When you're finished, click the **Quick Mask** button again to convert the mask to a selection.

Select the vase by painting carefully in the Quick Mask. Remember that whatever you paint with white in the mask will be included when you convert the Quick Mask to a selection.

3. Grow the selection by **1 pixel** (**Select ▸ Grow**), and then feather it by **2 pixels** (**Select ▸ Feather**). Save the selection to a channel (**Select ▸ Save to Channel**) in case you later decide to undo your color change and edit the selection again.

Working in a Duplicate Layer

Working in a duplicate layer saves you the headache of making mistakes in the original layer. If you don't like your changes in the duplicate layer, just try again.

1. After saving your selection, click the original layer in the Layers dialog to make it active again.

2. Copy the selection and paste it as a new layer (**Layer ▸ To New Layer**). Name this layer *Vase* and make sure it's active.

3. At this point you could use the Colorize tool (**Colors ▸ Colorize**) to change the color of the vase, but the vase has varying shades of red and yellow in it, and the Colorize tool will completely wash out those variations. Instead, use the Hue-Saturation tool again. Open the Hue-Saturation dialog (**Colors ▸ Hue-Saturation**).

4. Choose the red channel and move the Hue slider to the right to change the red content of the vase to a more yellow color. Then click the yellow channel and do the same. Be sure to make both changes before clicking **OK**. The results will be much greener if you adjust the red channel first, click **OK**, reopen the dialog, and then adjust the yellow channel.

5. Deselect all (**Select ▸ None**) when all color changes are completed.

The vase's color can be changed using the Hue-Saturation tool once the color has been isolated with the Quick Mask selection.

Further Exploration

Swapping the color of objects in stock photos is a very common practice. Objects that have colors not found in the rest of the image are the easiest to change, as we saw with the image of boats on a beach. Changing the color of a vase or shirt or some other oddly shaped subject requires complex selections created using the Fuzzy Select tool, the Quick Mask, and other GIMP selection tools. These selections are more difficult but not impossible.

Mastery of the Quick Mask tool will help in the next tutorial, in which you'll use a set of complex selections to add depth to a photograph.

2.5 CHANGING DEPTH OF FIELD

Take a look at any of your personal photos. If you've used a consumer-grade camera, you'll notice that the photo has a deep depth of field. That is, if your subject is more than a few yards away, most of the photo is in focus. Changing the depth of field can alter the feeling an image conveys. If your intended subject is not centered in the frame or not completely obvious, a depth-of-field change can draw attention to the subject and expose the true meaning of the photo.

Making the depth of field shallow can also make a normal scene appear as if it was a miniature, as you'll see in Section 2.11.

In reality, computer-aided depth-of-field trickery is no more than a selective blur. You've probably seen this trick used in automobile advertisements, where the car is in focus but the background is blurred beyond recognition. In this tutorial you'll pull a building to the forefront of a photo using modest depth-of-field changes.

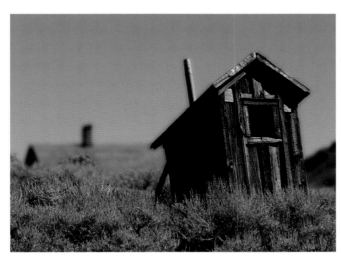

Changing a photograph's depth of field is a simple process of selecting and blurring. As is often the case in photography, the trick is making a good selection.

Getting Started

This tutorial begins with an image that has a relatively flat depth of field and is completely in focus. The solid blue sky will allow you to create selections of the buildings easily. You'll still have to make some manual selections, but the solid blue sky will save some time.

NOTE *The image used in this tutorial is in the public domain and is available from PDPhoto.org.*

A solid blue sky makes the initial selections easy.

Isolating the Foreground

The original image is in focus and has an obvious foreground object—the outhouse. Start by creating a selection that includes the outhouse and some of the grasses in front of it. Here the unselected areas are tinted red to better show the selection.

1. Choose the **Fuzzy Select** tool from the Toolbox. Click the blue sky to create an initial selection. If one click doesn't select the entire sky, click somewhere in the unselected area while holding down the SHIFT key.

NOTE *Moving the mouse to the right while keeping the left mouse button pressed also enlarges the selection, though this method can sometimes be a little harder to use.*

Because the sky is a solid color and contrasts so dramatically with the land, you should be able to select the sky using the Fuzzy Select tool in no more than three clicks. Here, the sky selection is shown using the Quick Mask.

2. Invert the selection (**Select ▸ Invert**), and then click the **Quick Mask** button. As you've seen, unselected areas are tinted red when the default Quick Mask properties are in use (Section 2.4 showed you how to change the default color).

3. Select the **Paintbrush** tool and press **D** in the image window to reset the default foreground and background colors, making the foreground black.

4. Paint over the house on the left, some of the background grasses, and the rocky hill on the right. Use smaller brushes until the Quick Mask looks similar to that shown. Everything you paint over will be excluded from the selection.

5. Click the **Quick Mask** button again to convert the mask back into a selection.

6. Save the selection to a channel (**Select ▸ Save to Channel**). Then click the channel name in the **Channels** dialog and change the name to *Outhouse Selection*. Saving selections to a channel allows you to easily recall them for further editing should you decide the original selection wasn't sufficient for your project. Later in this tutorial you'll retrieve the saved selections and invert them for use with areas outside the original selection.

7. Select the original layer in the Layers dialog (**Windows ▸ Dockable Dialogs ▸ Layers**). Feather the selection by **10 pixels** (**Select ▸ Feather**), and then copy (**Edit ▸ Copy**) the selection and paste it (**Edit ▸ Paste**) as a new layer (**Layer ▸ To New Layer**).

NOTE *Alternatively, combine the paste with the new layer creation using **Edit ▸ Paste As ▸ New Layer**.*

8. Click the new layer name and change it to *Outhouse*.

9. In the Channels dialog (**Windows ▸ Dockable Dialogs ▸ Channels**), click the **Outhouse Selection** channel, and then click the **Channel to Selection** button.

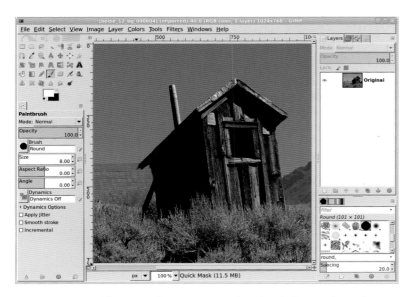

The outhouse and foreground grasses are isolated with the Quick Mask.

10. Select the **Background** layer in the Layers dialog to make that layer active. Invert the selection to select everything except the original outhouse and foreground landscape.

11. Click **Select by Color** in the toolbox. Adjust the **Threshold** level in the Tool Options dialog as necessary (I set it to 50 for this image).

12. Hold down the CTRL key and click in the blue sky to remove the sky from the selection, leaving just the background grasses, the house, and the hill. Use **Quick Mask** to remove the house and hill from the selection, leaving some of the grasses. Click the **Quick Mask** button once more to convert the mask to a selection. Save the selection to a channel named *Grasses Selection* (**Select ▶ Save to Channel**).

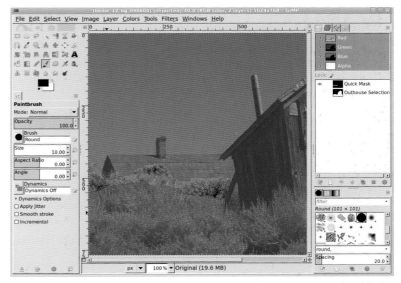

The grasses between the foreground outhouse and the background roof are selected in this step. This allows you to blur the middle (grasses) and background (roof) subjects to different degrees, exaggerating the depth of field.

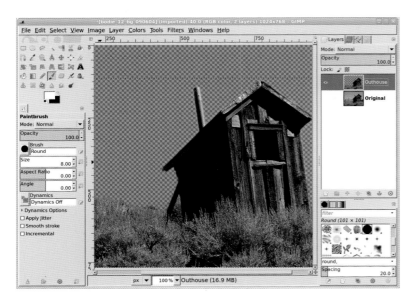

The outhouse and foreground grasses are copied to their own layer so that blur operations you perform later won't affect them.

13. Select the **Background** layer to make it active again. Feather the selection by **10 pixels** (**Select ▶ Feather**), and then copy and paste the selection as a new layer. Name this layer *Grasses* and move it below the Outhouse layer in the Layers dialog. The layer order should be, top to bottom: Outhouse, Grasses, Background.

14. This process has created a secondary focal point that is not in the foreground but not completely in the background.

Adding Depth of Field

1. Now let's increase the depth of field. Select the **Background** layer.

2. Open the Gaussian Blur filter (**Filters ▶ Blur ▶ Gaussian Blur**). Apply a blur of **20 pixels** to the **Background** layer. Then select the **Grasses** layer and apply a blur of **5 to 10 pixels**.

3. Adjust the levels (**Colors ▶ Levels**) for the **Grasses** and **Background** layers to darken them slightly and add to the photo's sense of depth.

The grasses behind the outhouse are blurred slightly, and the roof behind those grasses is blurred even more.

Further Exploration

This process works well on this image because making the initial selection was easy: the sky contrasts dramatically with the outhouse and grasses. This process is often applied to outdoor portraits, and those projects work just like this one, though selecting the foreground object (the bride in a wedding photo, for example) is more difficult. Again, the Quick Mask will be a big help. You can also try the Foreground Select tool, which is designed to make selecting irregularly shaped objects even easier.

2.6 REFLECTIONS ON GLASS

Simulating the reflection of an object on a glassy surface is actually pretty simple. In this example I'll use a yellow rose. The vertical orientation of the rose—stem to flower—will make the reflection easier to see.

GIMP makes this rosy reflection easy.

Getting Started

In the original image, a yellow rose is set against a garden background. This image offers high contrast around the edges. When you create reflections using images like this, it's best to remove the darker edges and leave the lighter color of the object. This allows you to place the selection on just about any background.

NOTE *The image used in this tutorial is available at PDPhoto.org.*

Using the Fuzzy Select tool and the Quick Mask is the fastest way to accurately select the rose.

Preparing the Image

1. Using the **Fuzzy Select** tool and the **Quick Mask** in combination, make a selection around the rose.

2. Feather the selection (**Select ▶ Feather**) by **3 pixels**. Copy the selection, paste it to its own layer, and name the layer *Rose*. Delete the original layer (**Layer ▶ Delete Layer**).

3. Add a new layer (**Layer ▶ New Layer**) with a black background and call it *Black Background*. Move it below the Rose layer.

4. The rose doesn't leave enough space on the canvas for a full reflection, so it needs to be scaled down. Select the **Rose** layer to make it active. Choose the **Scale** tool from the toolbox, select the **Keep Aspect** option in the Tool Options dialog, and then click the canvas. Drag in the canvas to scale the rose to about half its original size.

5. Using the **Move** tool, position the Rose layer in the upper half of the window.

The rose is selected and copied to its own layer. The Black Background layer replaces the original image layer.

Scale down the rose to about half the size of the canvas to make room for its reflection.

Creating the Reflection

1. Duplicate the Rose layer (**Layer ▶ Duplicate Layer**) and name the duplicate layer *Rose Reflection*.

2. Enlarge the layer boundary (**Layer ▶ Layer Boundary Size**) by **20 percent**—choose **Percent** from the drop-down menu next to the Current Height field—and click the **Center** button in the Layer Boundary Size dialog.

3. Make sure the **Lock Alpha Channel** box is unchecked for the Rose Reflection layer (the Lock Alpha Channel box is just below the Opacity slider in the Layers dialog).

4. Open the Gaussian Blur filter (**Filters ▶ Blur ▶ Gaussian Blur**) and blur the Rose Reflection layer by **8 to 10 pixels**.

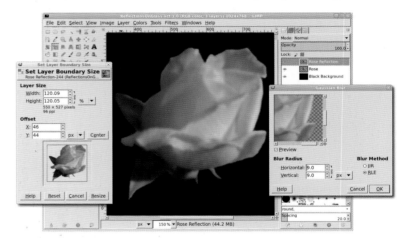

Increasing the layer boundary size of the Rose Reflection layer gives us some extra room for blurring. If we didn't resize, the blur might bump up against the edge of the original rose.

Adding a Surface for the Reflection

1. Next let's add a visible surface. Add a new transparent layer (**Layer ▶ New Layer**) and name it *Surface Gradient*.

2. Press **D** and then **X** in the toolbox to set the background to black.

3. Double-click the foreground color box to open the Change Foreground Color dialog. For the cyan color shown here, type *cyan* in the HTML notation field and click **OK**. This color has aesthetic value, as well as contrasting with the color of the rose. Using a high-contrast color for the surface will emphasize the reflection even more.

4. To create the gradient effect shown, select the **Blend** tool from the toolbox. In the Tool Options dialog, set the Gradient to **FG to Transparent** and select the **Reverse** option. Then drag from the middle of the flower to three-fourths of the way down in the image window to apply the cyan gradient to the Surface Gradient layer. Move the Surface Gradient layer beneath the Rose layer, just above the Black Background layer.

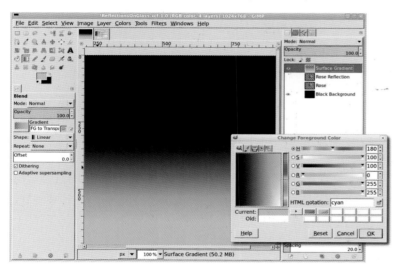

The rose will be reflected on the surface created by the cyan gradient.

Placing the Reflection on the Surface

1. Click the **Rose Reflection** layer in the Layers dialog to make it active.

2. Select the **Flip** tool from the toolbox. In the Tool Options dialog select **Vertical** for the Flip Type, and then click the canvas to flip this layer.

3. Use the **Move** tool to position the reflection beneath the rose on the canvas. Press the CTRL key during the move to move straight down (or at any 45 degree angle).

4. Reduce the Opacity of the Rose Reflection layer to **50 percent** and lower this layer between the Rose layer and the Surface Gradient layer.

The reflection effect is nearly complete, but a real reflection would include a shadow cast by the reflected object.

Adding a Shadow

Because the rose would block any light shining directly overhead, you must add a shadow to the surface. And because light would shine in multiple directions above the rose, more than one shadow would be cast. Next you'll create these shadows.

1. Add a transparent layer named *Shadow 1*.

2. Choose the **Ellipse Select** tool from the toolbox and create an oval selection just below the rose.

Blurring and reducing the opacity of a simple black oval creates an initial shadow.

3. Feather the selection by **10 pixels** (**Select ▸ Feather**) and fill it with black. Deselect the oval (**Select ▸ None**).

4. Open the Gaussian Blur filter (**Filters ▸ Blur ▸ Gaussian Blur**) and apply a blur of **45 pixels** to the Shadow 1 layer, and then set the layer's Opacity to **65 percent**. Move this layer to just above the Rose Reflection layer.

5. Duplicate the Rose layer, name the duplicate layer *Shadow 2*, and increase the layer boundary size by **10 percent** (**Layer ▸ Layer Boundary Size**).

6. Create a selection of the rose (**Layer ▸ Transparency ▸ Alpha to Selection**), and then grow the selection by **2 pixels** (**Select ▸ Grow**).

7. Press **D** in the canvas to reset the foreground color to black. Then fill the selection with black by dragging the foreground color box from the toolbox into the selection. Deselect all (CTRL-SHIFT-A).

8. Open the **Gaussian Blur** filter and apply a blur of **45 pixels** to the Shadow 2 layer.

9. Use the **Flip** tool to flip the layer vertically, and then use the **Scale** tool to reduce the height of the layer by half.

10. Move the Shadow 2 layer beneath the Rose layer (**Layer ▸ Stack ▸ Lower Layer**), and then position it using the **Move** tool so the shadow appears below the yellow rose.

11. Reduce the Opacity of the Shadow 2 layer to **35 percent**.

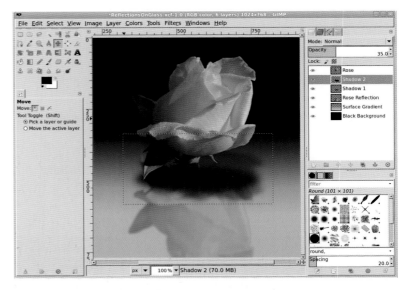

The shaped shadow merges with the oval shadow, making the area directly beneath the rose darkest but also allowing the shadow to mimic the shape of the rose.

Further Exploration

This technique for creating reflections on glassy surfaces can be extended to surfaces that aren't quite as flat or reflective. You can also add texture to the surface to distort the reflected shape or change the direction, color, and lighting to make the reflection less distinct. In the next tutorial I'll show you how to add waves to the surface of a reflection to create a lake effect.

2.7 LAKE REFLECTION

The previous tutorial showed you how to create reflections on glass, but much more can be done by expanding on the technique. That section's tutorial made only slight modifications to the object being reflected (a rose). But what about adding texture to the reflective surface? How can we create a reflection on a surface—like water—that isn't perfectly flat?

An easy way to add surface texture is to grab it from another image. A photo that shows the surface of a lake or ocean will work well for this tutorial. Once the sampled image is desaturated and blended with the reflection, it turns a glassy surface into a realistic reflection.

The lake looks real, but it has been added digitally using GIMP.

This tutorial turns a lawn into an undulating lake. In the real world, creating exactly the image you want usually requires the application of more than one effect, so let's start by enhancing the colors in the original photo.

Getting Started

The image we'll use in this tutorial is perfect for this kind of project. The building makes a dramatic focal point, and the grassy area in front is large enough to provide space for the lake. However, the color of the bricks could be more intense, so you'll increase the color saturation before reflecting the image of the building. If the image you choose needs similar tweaks, it's best to handle them now.

1. First, auto-adjust the Levels histogram. Open the Levels dialog (**Colors ▶ Levels**) and click the **Auto** button, and then click **OK** to close the dialog.

2. Next, open the Hue-Saturation dialog (**Colors ▶ Hue-Saturation**). Click the **R** button just below the red box at the top of the dialog so we only adjust the red colors in the image. Then increase the Saturation to **75** to bring out the details in the building.

3. Finally, open the Brightness-Contrast dialog (**Colors ▶ Brightness-Contrast**) and set the Brightness to **30** and the Contrast to **25**.

Adjust the saturation and brightness of the image to make the building's colors more vivid.

Creating the Initial Reflection

1. Make a square selection around the subject—in this case, the building. Also, include some of the grassy area in front of the building. The selection covers from the top of the image to just below where the grass lawn meets the building. Copy the selection and paste it into a new layer. Click the layer name and change it to *Reflection*.

2. Select the **Flip** tool from the toolbox. In the Tool Options dialog set the Flip Type to **Vertical** and click the canvas to flip the layer.

3. Use the **Move** tool to drag the Reflection layer down on the canvas. If the Reflection layer does not span the width of the canvas, select the **Scale** tool and then click the canvas to scale the layer manually.

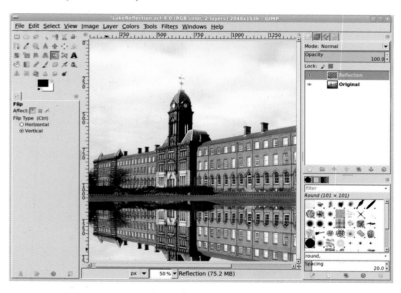

A simple rectangular selection includes the building and some of the grassy area. This selection is copied and pasted to a new layer, and then the layer is flipped vertically. Finally, the new layer is dragged down on the canvas until positioned as shown here.

Adding Ripples

1. To look realistic, the reflected image should be more blurred and less saturated than the original. Open the Hue-Saturation dialog (**Colors ▸ Hue-Saturation**) and click the **Master** button. Reduce the Saturation level to **−45** for this image (your project may require different settings).

2. Open the Ripple filter (**Filters ▸ Distorts ▸ Ripple**). Set the Orientation to **Vertical**, the Edges to **Smear**, the Period to **60**, and the Amplitude to **2**, and then apply this filter to the Reflection layer. Repeat this process with the Ripple filter once more, this time setting the Orientation to **Horizontal**, the Period to **7**, and the Amplitude to **5**. Applying the Ripple filter twice applies ripples to ripples, just as waves in water cause interference patterns.

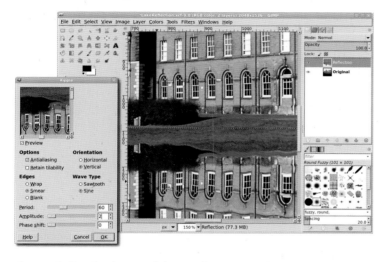

The Ripple filter lends an undulating effect to the reflection, though we'll improve upon this shortly.

3. Open the Gaussian Blur filter (**Filters ▸ Blur ▸ Gaussian Blur**). Set both the Horizontal and Vertical Blur Radius to **10 pixels** and apply the blur to the Reflection layer.

4. Duplicate the layer (**Layer ▸ Duplicate Layer**). Name the layer *Color*.

5. Click the foreground color box to open the Change Foreground Color dialog. For the dark blue shown here, set the RGB values to **5/24/83** and click **OK**. Then drag the foreground color into the layer. Finally, move the layer below the original Reflection layer and reduce the Opacity of the Reflection layer to **80 percent**.

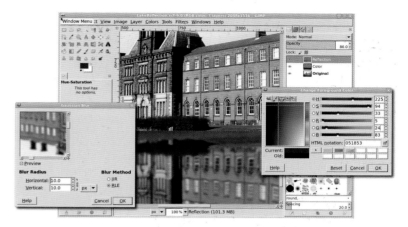

Adding a blue layer beneath the Reflection layer makes the reflection look more like a lake.

Adding Waves

The Ripple filter makes the lake's surface somewhat more realistic, but adding waves would improve the texture even more. To add waves, you can grab a selection from another photo.

1. Make a selection in a photo of real water waves, and then copy and paste it into a new layer named *Water* in the original project images. Use the **Scale** tool to scale the layer as necessary.

2. Desaturate the Water layer (**Colors ▸ Desaturate**).

3. Open the Brightness-Contrast dialog (**Colors ▸ Brightness-Contrast**) and set both sliders to **70**. This will enhance the waves for use as a bump map. Turn off the visibility of the Water layer in the Layers dialog.

4. Click on the Reflection layer in the Layers dialog to make it active.

5. Open the Bump Map filter (**Filters ▸ Map ▸ Bump Map**). Set **Bump Map** to the Water layer, the Azimuth to **145**, the Elevation to **20**, and the Depth to **3**. Click **OK** to apply this to the Reflection layer.

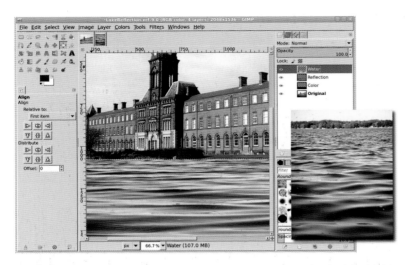

Waves are copied and pasted into the project image to make the lake look even more realistic.

Further Exploration

This particular image lends itself well to further enhancement. The high contrast between the building and the sky allows you to make changes to the weather, perhaps even changing a sunny day into a starlit evening. Try converting this image to a nighttime scene. The Fuzzy Select tool can be used to capture most of the sky, and what is missed can be picked up easily using the Quick Mask. But be warned: the lake reflection will need to be changed too!

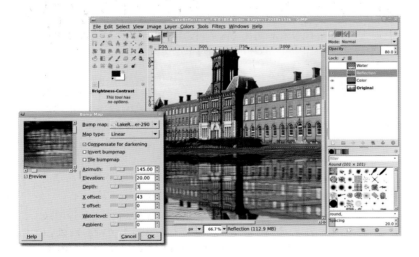

Bump map uses the source image (the Water layer) to distort the active layer (the Reflection layer). Adjusting the source image brightness and saturation and the various Bump Map settings can dramatically affect the final result.

Photo restoration and retouching—the art of preserving and enhancing old photographs folded from misuse or cracked and faded with age—is a form of digital image manipulation that is often overlooked. As you'll see in this tutorial, GIMP's tools enable you to achieve high-quality photo restoration.

A number of tricks can be used to restore damaged photos, but the most common technique involves cloning similar areas to use in replacing damaged areas. GIMP's Clone tool allows you to use brushstrokes of any shape on copied and pasted areas. However, this method is only appropriate for minor cleanup work such as removing specks of dust or hiding thin, short scratches. Cloning is also destructive because it occurs in the layer where the damage exists. If the patches are not to your liking, you may not be able to reverse them easily.

A better strategy for correcting larger blemishes is to make a selection, copy and paste the selection as a patch layer, and then blend this into the original layer using the Airbrush tool in a layer mask. This approach has the advantage of allowing additional changes to be made later, by either modifying the layer mask or replacing the patch layer completely. Of course, no matter which approach you take, you'll want to preserve your original damaged art for experimentation. In this tutorial, we'll look at the copy-and-paste method of fixing heavily damaged images. We'll also discuss when to use large selections to patch large areas and when to divide a blemish into pieces and patch them individually.

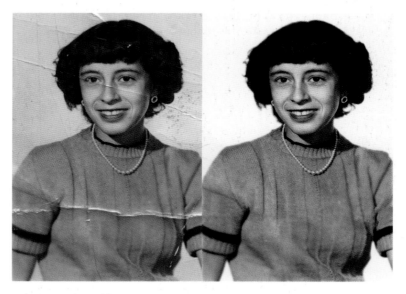

What was once old is new again.

Your candidate for restoration is likely to have many of the same problems, but they may occur in different areas of the image, presenting different challenges. Scanning the original image at a high resolution, such as 250 dpi, will allow you to create a high-quality print once your image has been restored.

Getting Started

This image was scanned from a 60-year-old photo that had been creased several times, with one crease actually leaving a slight tear along the subject's midsection. There are several problems to fix here: correct the black-and-white points in the faded image, remove the creases, and clean up the background.

Enhancing the Scanned Image

1. Let's start with some basic image enhancement. To correct the black-and-white points, click the **Auto** button in the Levels dialog (**Colors ▸ Levels**). This automatically moves the left slider (black) to the first entry on that end of the histogram and moves the right slider (white) to the first entry on that end. This increases the image's contrast so the darkest pixels become black and the lightest pixels become white, making the image clearer overall.

2. The image has also taken on a brown tint as it's aged. Fix this by desaturating the image (**Colors ▸ Desaturate**).

3. As is the case with most scanned images, some sharpening is required (**Filters ▸ Enhance ▸ Sharpen**). The Unsharp Mask filter (Filters ▸ Enhance ▸ Unsharp Mask) could also be used, but isn't best for this image because there are very few straight lines.

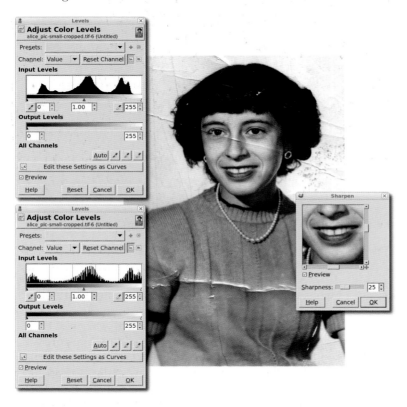

Sharpen the scan and adjust the levels before you start to patch the blemishes. If you make these changes after the patches are in place, the edges of your patches may be visible.

Correcting with a Single Patch

The big scratch across the woman's sweater is an example of the kind of damage you can fix with a simple copy-and-paste correction that consists of a single patch. There is enough undamaged sweater in the photo to allow us to use this technique.

1. Choose the **Free Select** tool and draw an outline around part of the scratch that traverses the woman's midsection, and then press ENTER to convert this to a selection. This will give you the size of the area that must be patched. Choose the **Move** tool from the Toolbox. In the Tool Options dialog, click on the **Selection** option for the Move setting.

2. Click inside the selection and drag the mouse to move the selection to an unblemished area near the scratch.

3. Feather the selection by **10 pixels** (**Selection ▸ Feather**).

4. Copy the selection and paste it in a new layer (**Layer ▸ To New Layer**), and then position the new layer over the scratch. In this case, the sweater's pleats help us align the patch, but your images will probably provide similar guides. (To show where the patch has been applied, the original image is tinted red.)

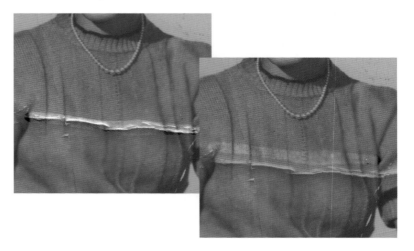

The Free Select tool is used first, and then the selection is moved to a nearby unblemished area to create a patch.

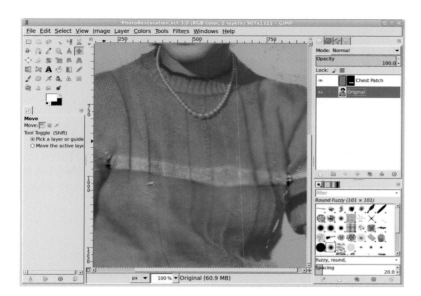

This patch covers the blemish quite well because it was taken from a nearby part of the image. The farther away you go from the blemish, the less likely the patch will fit as cleanly.

5. In this example, the pleats don't align perfectly, but this can be fixed by using the Scale tool or the IWarp filter (**Filters ▸ Distorts ▸ IWarp**) to make minor adjustments. If the patch doesn't align along its edges with the original layer, add a layer mask (**Layer ▸ Add Layer Mask**) and use the **Airbrush** tool to spray black in the mask along the edges of the patch.

6. If the patch's tonal qualities don't match those of the damaged area, you can use the Curves tool (**Colors ▸ Curves**). Make sure the patch layer (not its mask) is active by clicking the layer preview in the Layers dialog. To see if the patch lines up well with the original image, turn the layer visibility for the patch on and off quickly (using the eye icon in the Layers dialog). As you do this, it should appear that the pleats (or other guides) are in place and only the scratch is removed.

Flash the patch layer's visibility on and off to see how well the patch fits.

Correcting with Multiple Patches

The scratches across both of the woman's sleeves pose a more difficult problem. There's no single unblemished area large enough to cover these scratches, so they require several smaller patches. Use multiple small patches to fix the scratch on the left sleeve, creating each small patch just as the previous large patch was created.

1. Use the **Free Select** tool from the Toolbox to select part of the scratch, move the selection over a nearby unblemished region, copy and paste the selection as a new layer (CTRL-C, CTRL-V, CTRL-SHIFT-N), and move that layer over the scratch. If necessary, use a layer mask (**Layer ▸ Mask ▸ Add Layer Mask**) on the patch to blend it with the surrounding areas.

2. In this photo, the dark area between the woman's sleeve and midsection has a very complex pattern. The patch requires use of the Curves tool (**Colors ▸ Curves**) because the patch was taken from a region with different tonal qualities. A

simple blend with a layer mask isn't sufficient to meld the patch over the scratch. The Curves adjustment modifies the tonal qualities so the patch blends seamlessly when combined with the mask.

3. After all the sleeve patches are created and blended, merge them (**Layer ▸ Merge Down**) one at a time into a single patch.

For small disconnected blemishes like this one, especially in high-contrast areas, use a series of small patches.

Correcting Facial Blemishes

Scratches on a subject's face are more difficult to fix than those on clothing. It's easier to spot differences between the patch and the surrounding face than it is to spot those between the sweater and its patches. Even so, facial scratches are best handled by using the Free Select tool, as we've done so far. The main difference is that you must make even smaller selections, bounded by high-contrast lines. Areas between the face and the hairline or between the bridge of the nose and the shadowed sides of the nose work especially well. The woman's eye poses a particular challenge because that part of the image is so complex.

1. Make a selection of the eye, and copy and paste it to a new layer as a patch (**Layer ▸ To New Layer**).

2. Use the **Clone** tool to manually paint out the scratch. In this case it's safe to use the Clone tool because we're working on a copy of the original, blemished subject.

3. To use the Clone tool, first specify a clone source location by holding down the CTRL key and clicking the image. The click point indicates the region that will be copied from, so make sure it's a reasonable match to the region you're patching. Then, once the clone source is established, choose the clone destination. Click and drag the mouse over the scratch. The source is copied over the destination as you drag.

It's more difficult to fix blemishes on faces than on clothing. The process is the same, but make careful Curves adjustments and blend your patches using layer masks.

When you use the Clone tool, the length and direction of the line between the clone source and the initial clone destination (where you first click when you start to clone the image) always remains uniform. When you drag a line over the scratch, that same line is cloned, positioned to start at the clone source

location. This means that if you drag far enough from the initial clone destination, you can cause the clone source to fall over another blemish. The trick is to keep your brush strokes small and reset your clone source point frequently.

This scratch is fixed using several cloning operations, so more than one clone source is used. In fact, each clone source is used for a very small part of the scratch. This allows the cloned areas to blend seamlessly into the rest of the image.

It's also possible to clone from another layer. In the Tool Options dialog, check the Sample Merged option. With this option you can clone from any layer that is being used to display the composite image.

Cleaning Up the Background

Cleaning up the background is a no-brainer.

1. Make a selection using the **Quick Mask** and an appropriate brush. Paint inside locks of hair where the background shows through. The painted areas (which are no longer tinted red) will become the selected area when you click the **Quick Mask to Selection** button in the lower-left corner of the canvas window.

2. Feather the selection by **15 pixels** or more (**Select ▶ Feather**). In previous tutorials the feather values were only 1 or 2 pixels, but higher feather values should be used when your image resolution is higher, as it is when restoring a photograph.

3. Use the **Color Picker** tool to select a color from the existing background inside the selection. Drag the foreground color into the selection to fill it with this color. This takes care of all problems in the background.

The background is selected using the Quick Mask instead of the Fuzzy Select tool because there's too much variation in the background, which has faded so much that parts of it match the hair's outside edges.

All the other large blemishes can be fixed with the same processes used for the sweater and face. In this case, the final results are dramatic. When the original image is scanned at a high resolution, an image restored using GIMP's tools should produce a high-quality print. The results won't always be so dramatic, but with practice some people are able to make a living doing this kind of work.

A single pixel is chosen from the background and used to fill the selection.

Further Exploration

Professional image restoration depends upon proper use of selections and layer masks, but it also relies heavily upon other tools in GIMP's arsenal, including the IWarp filter, Feather command, Curves tool, and Clone tool. As a process, image restoration doesn't lend itself to automation, so designers who understand how to make the most of these techniques will always be in high demand.

Restoring old photographs is a time-consuming but rewarding process. In the next section, we'll discuss a technique that requires far less time but is just as rewarding.

2.9 CASTING LIGHT THROUGH A WINDOW

Adding a light source to a photograph can increase the photograph's dramatic impact—especially when the light is shining through a paned window. But setting up a shot like the one shown here can be time consuming and usually requires a specific location. It would be easier if we could use software to add the light source to any image.

Fortunately, GIMP allows us to merge multiple shots to achieve this effect. Start with any stock photograph and use an image of a window as a stencil for the shadow. The process is so simple, you'll probably have more trouble finding suitable stock images than you will producing the effect in GIMP.

It would be difficult to set up a shot like this one, but GIMP makes it easy to merge two stock photographs and achieve a dramatic effect.

Getting Started

This shot was created from two stock photographs. The first photo shows a model posing against a wall. Let's call this layer *Source Image*. The second image shows light shining through an oddly shaped window. Let's call this layer *Shadow Mask*. You can certainly create a mask in whatever shape you like, but you'll save time if you can find a suitable stock photo.

Two source images are used in this project. The window provides the shadow mask for the light you'll cast on the model.

Setting Up the Shadow Mask

Start by opening up a source image and an image to use as the shadow mask, both from their respective stock image files. If only a portion of the shadow mask image is intended to cover the source image, make a selection around that part of the shadow mask image and paste it into the source image as a new layer. This example doesn't require a selection, because we want to use the entire shadow mask image, so we can just copy and paste it into a new layer in the source image.

1. Copy the shadow mask image (**Edit ▸ Copy**) and paste (**Edit ▸ Paste**) it into the source image as a new layer (**Layer ▸ To New Layer**) as shown here.

2. Reduce the Opacity of the Shadow Mask layer to **65 percent**, and then use the **Move** tool to position the window over the subject. The Shadow Mask was also scaled taller and wider with the **Scale** tool so only a single crosshair in the window is visible.

Copy and paste the Shadow Mask into the Source Image layer.

3. To make the window look more like a shadow, you'll need to desaturate and blur it. Desaturate the Shadow Mask layer (**Colors ▸ Desaturate**), and then open the Gaussian Blur filter (**Filters ▸ Blur ▸ Gaussian Blur**). The Blur Radius should be set according to the image size. In this example, the Source Image is 2794 pixels wide, so the Blur Radius is set to 90 pixels. That gives roughly a 32:1 ratio, though you may find that a smaller ratio is more appropriate for smaller images.

A blur softens the light areas of the shadow mask, making it look as though light is being cast through a paned window.

4. Expand the Shadow Mask layer to fit the full image (**Layer ▸ Layer to Image Size**). Make sure the **Lock Alpha Channel** box in the Layers dialog is not set.

5. Using the **Fuzzy Select** tool, click the transparent regions of the layer to the left and right of the window image. This may require multiple clicks with the SHIFT key held down.

6. Grow the selection (**Select ▸ Grow**) by **20** to **50 pixels**.

7. With the canvas selected, press **D** to reset the foreground and background colors. Then drag the foreground color (black) into the selection to extend the shadow cast by the wall in which the window is set. If any lighter color lines are still visible along the edges of the selections, undo the drag (CTRL-Z) and grow the selection some more, and then drag from the foreground color again.

After resizing the Shadow Mask layer to fit the canvas, fill the transparent areas with black. This works here because the area around the window is black. For other images, you may need to make some levels adjustments to the Shadow Mask layer first.

8. Deselect all (**Select ▶ None**).

9. Set the Shadow Mask layer mode to **Multiply**. In this example, the result is good, but more contrast would help. Use the **Fuzzy Select** tool and click in the darker areas of the Shadow Mask. Invert this selection (**Select ▶ Invert**) to select just the windowpanes. Shrink (**Select ▶ Shrink**) the selection a bit.

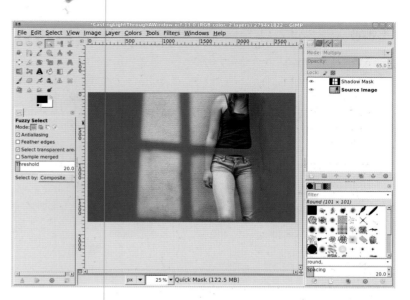

Select the windowpanes of the shadow mask, shown here with the Quick Mask enabled so the selection is easier to see.

Increasing the Light

1. Create a new transparent layer (**Layer ▶ New Layer**) and call it *Light*.

2. Drag the background color (white) into the selection.

3. Deselect all (**Select ▶ None**).

4. Open the Gaussian Blur filter (**Filters ▶ Blur ▶ Gaussian Blur**) and set the Blur Radius to **90 pixels**.

5. Setting the Light layer's mode to **Overlay** completes the effect. Adding a layer mask (**Layer ▶ Mask ▶ Add Layer Mask**) to the Light layer and applying a black-to-white gradient using the **Blend** tool softens the lower edge. It may also be necessary to apply a black-to-white gradient to the Shadow Mask layer, with the layer mode set to Multiply.

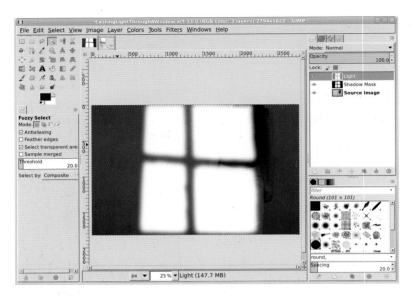

Fill the selection with white in a new layer.

Further Exploration

To take this tutorial further, you might add shadows that are cast by objects outside the window. Imagine a tree, for example. Its shadow would also be cast through the window and onto the source image. The process for adding the tree's shadow would be similar, except that the tree would be farther away and cast a lighter, more blurred shadow.

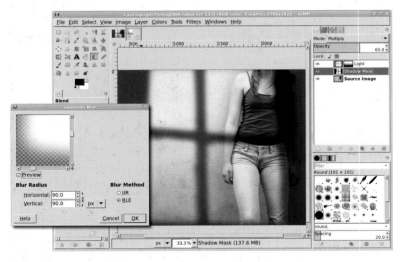

The additional light layer increases the contrast between the shadowed and illuminated areas on the wall and model.

Lighting alters the mood of an image. So far you've added lighting to a project by casting light through an unseen window. Now you'll combine that idea with artificial effects. This project will add flowing streaks of light to a stock photo. These will dramatically change the mood with only a modest amount of work.

There isn't a great trick to this process; getting the best results is mostly a matter of trial and error. The process starts with a little understanding of how to create and stroke paths. Paths are distinct from image layers. This allows paths to be edited without affecting the composite image and to be applied multiple times to any number of image layers.

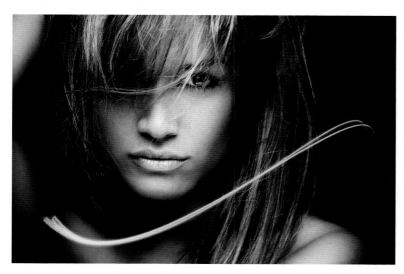

Light streaks are based on the application of multiple stroked paths to stock imagery.

NOTE *This tutorial requires some knowledge of using both the Paths tool and the Paths dialog. If you aren't comfortable with either, check out Section 1.5 for a basic introduction.*

Getting Started

The process starts with a stock photograph that's dark enough that a streak of light will be a noticeable change. Creating an initial streak is a straightforward process with minimal edits of a single path.

1. Open the stock image. Add a transparent layer (**Layer ▸ New Layer**) and name it *Streak 1*.

2. Choose the **Paths** tool from the Toolbox.

3. Click the lower left of the image to drop an anchor. Click the middle right side to drop the opposite end of the path. Click the path near each anchor and drag to bend the line and pull out handles from the anchors. Drag the handles to make a skewed S shape.

This is the initial path to stroke. Multiple paths will be created from it and modified slightly to create the initial streak.

4. In the Paths dialog, click the Unnamed path and change the name to *Streak 1.*

5. Select the **Paintbrush** tool from the Toolbox. In the Tool Options dialog, choose the **Calligraphic brush**. Set the Size to **20**, enable **Basic Dynamics**, set the Dynamics Options Fade length to **100,** and set the Gradient to **FG to Transparent**. Enable a Smooth stroke of **Quality 20** and **Weight 50**.

6. Type **D**, then **X** in the image window to set the foreground color to white.

7. To stroke the path, click the **Paint Along Path** icon (second from right) at the bottom of the Paths dialog. The Stroke Path dialog will open. Choose the **Stroke with a Paint Tool** option. Make sure the Paintbrush is selected and Emulate brush dynamics checkbox is checked. Then click the Stroke button.

The Stroke Path dialog is also found under the Edit menu (Edit ▶ Stroke Path). Stroking the path allows to you apply a brush stroke to a specific shape—in this case a wavy line.

NOTE *The size of the brush depends on the size of the stock image, which in this tutorial is 1600 × 1067 pixels. Adjust the brush size so it produces a moderately thin stroke. Additional strokes in later steps will fatten the streak.*

Adding an Outer Glow

The initial streak is a nice touch, but it needs to glow a bit, reflecting some of the color from the stock image. The glow comes from duplicating, blurring, and then applying color to the streak.

GIMP doesn't have an outer glow filter, so the process must be performed manually. Fortunately, an outer glow is a very simple effect.

1. Duplicate the Streak 1 layer. Name the duplicate layer *Outer Glow.*

2. Open the Gaussian Blur filter (**Filters ▶ Blur ▶ Gaussian Blur**). Set both Horizontal and Vertical Radius settings to **20.0 pixels** and apply to the Outer Glow layer.

3. Duplicate this layer. Merge the duplicate (**Layer ▶ Merge Down**) onto the Outer Glow layer.

4. Choose the **Color Picker** tool from the Toolbox. Enable the **Sample Merged** option in the Tool Options dialog. Click on the model's face to pick a tone to apply to the glow.

5. Choose the **Bucket Fill** tool from the Toolbox. Set the Mode to **Multiply**, Fill Type to **FG color fill**, and Affected Area to **Fill whole selection** in the Tool Options dialog.

6. Click the image window to apply the color to the Outer Glow layer. Move the Outer Glow layer below the Streak 1 layer in the Layers dialog.

Duplicating the Outer Glow layer after blurring, and then merging the duplicate is a quick way to increase the intensity of that layer by combining two sets of blurs into one. The duplicate layer mode could also be changed to Addition before merging to increase the intensity even more.

Adding an Inner Glow

GIMP doesn't have an inner glow filter either, though several options exist in the Plugin Registry for those interested in using off-the-shelf solutions. Like the outer glow, however, the inner glow is very easy to produce manually in just a few short steps.

1. Duplicate the streak layer and name the duplicate layer *Inner Glow*.
2. Choose the **Fuzzy Select** tool from the toolbox. In the Tool Options dialog, enable the **Select Transparent Areas** option. Click anywhere in the image except on the streak to create a selection. Invert the selection (**Select ▸ Invert**) to select just the streak.
3. Drag the foreground color from the toolbox into the selection.

4. Shrink the selection (**Select ▸ Shrink**) by **3 pixels**. Cut the selection (**Edit ▸ Cut**). This removes the selected area, leaving just a thin outline in the Inner Glow layer. Clear the selection (**Select ▸ None**).
5. Open the **Gaussian Blur** filter again. Apply a **5-pixel** radius blur to this layer.

The inner glow is essentially a blurred outline of the original streak that varies the intensity of the streak.

Selecting and then inverting the transparent area allows selecting the entire streak. If the streak itself had been selected with the Fuzzy Select tool, the semitransparent areas might not have been selected.

Enhancing the Initial Streak

This single streak can be improved by adding similar streaks to it. The process used to create the original streak is repeated, except that the path used will be an edited duplicate of the original path.

1. Open the **Paths** dialog. Duplicate the Streak 1 path by clicking the fourth button from the bottom left. Name the new path *Streak 1B*. Click the eye icon in the Paths dialog so the eye is visible. This will make the path visible in the image window, but without the anchors or handles.

2. Choose the **Paths** tool from the Toolbox. Click the path in the image window to show the anchors and handles. Click the anchors to move them slightly. Click the handles to bend the curve a little more or a little less. The changes to the Streak 1B path should not be overly dramatic.

3. Add a transparent layer to the image and name it *Streak 1B*.

4. Repeat the stroke, outer glow, and inner glow steps from the first streak.

Further Exploration

The ends of each streak can be adjusted using layer masks on streak layers. Variations in the lighting of the streaks can be produced by changing layer blend modes. More dramatic streaks can be applied by varying the size of the brush when stroking paths.

Blurs were used in this tutorial to simulate glows around the streaks. In the next tutorial you'll see how blurs can be used to turn the grown-up world into a child's toy.

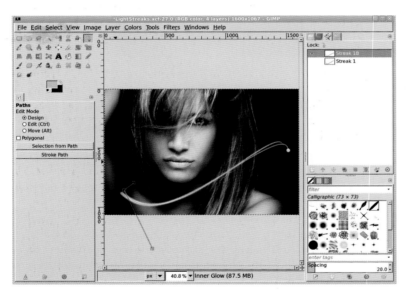

The length and curve of the streaks are varied by editing copies of the original path.

2.11 MINIATURIZING A SCENE

An often underappreciated feature of GIMP is the blur filters. A small amount of blur can be used to soften the focus in a photograph, as was shown in Section 2.1. Section 2.5 demonstrated how varying amounts of blur can be used to move the background away from the foreground. And long blurs can apply streaks to an image that simulate high-speed flight.

This tutorial will use blurs to take the very big and make it appear very small. Even better, the process is very simple. This is yet another effect that gives a photo a shallow depth of field. Traditional photographers can achieve this effect with a technique called *tilt-shifting*. We'll get similar results without the fancy equipment.

From real world to small world is just a blur away.

Getting Started

The best images for this effect are bird's-eye views of a city. This particular image is perfect because the focal point of the effect is centered and easy to isolate. Also, miniatures often have highly saturated colors from hand painting with glossy paints. This process will increase the saturation of the stock photo, and then isolate areas outside the focal point of the image.

1. Open the stock image. Open the Hue-Saturation dialog (**Colors ▸ Hue-Saturation**) and increase the saturation. For this image the saturation was increased to its maximum setting of 100 percent. Apply this setting to the image.

2. Click the **Quick Mask** button in the lower left of the image window. This will tint the image red where no selection currently exists.

3. Type **D** in the canvas to reset the foreground and background colors.

4. Choose the **Blend** tool from the Toolbox. In the Tool Options dialog set the Shape to **Bi-linear** and the Gradient to **FG to BG (RGB)**, and leave other options at their default settings. Use the Reset button at the bottom of the dialog if you need to reset defaults.

5. In the image window, click the floor of the stadium and drag up to just above the top of the stadium. Click the **Quick Mask** button again to convert this to a selection of the image's upper and lower regions.

6. Copy and paste the selection as a new layer. Name the new layer *BG and FG*.

NOTE *This image is 1600 × 1067 pixels. Adjust the blur radius accordingly for images of different sizes.*

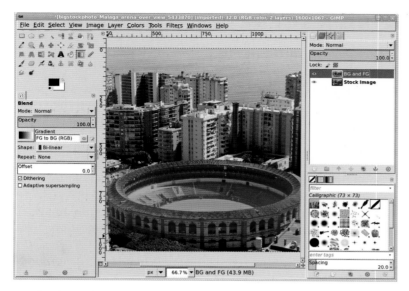

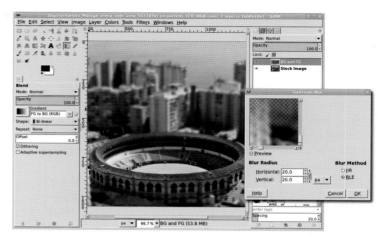

A single blur will take the foreground and background out of focus and make it look like you're zoomed in on a tiny model of the city.

A Bi-linear gradient in the Quick Mask, running black to white, is all that's required to select the foreground and background.

Blurring to Miniaturize

Using a copy of the original layer allows experimentation with the blur process without affecting the original image. If you mess up the copy, just make the selection of the original image layer again and copy and paste another new layer to continue experimentation.

1. Open the Gaussian Blur filter (**Filters ▸ Blur ▸ Gaussian Blur**). Apply a **20-pixel** blur to the new layer.

2. If the first selection failed to select much of the foreground, make another selection with the **Quick Mask** and **Blend** tools, this time using a **Linear Gradient** instead. Drag from the stadium floor straight down to the bottom of the windows in the second floor of the stadium. Convert the **Quick Mask** to a selection, and then copy and paste as a new layer and blur again. Add a layer mask to this new layer and spray-paint black in it where the stadium and some of the greenery in front is out of focus.

Graphic design work is a series of little touch-ups like this foreground blur.

Further Exploration

This stock photograph provided a perfect example of the miniaturization effect. Other images are not so well suited. In those cases the selection may require alternative methods. Try using a Radial Gradient with the Blend tool, or the Rectangle or Ellipse select tools with large amounts of feathering.

TIPS FOR PHOTOGRAPHIC EFFECTS

Now that you've practiced the basic techniques for working with photographs in GIMP, you're probably eager to get started on your own photo projects. When you do, keep the following suggestions in mind.

Autolevel Option

You can autolevel all scanned and digital images using the Levels tool (Colors ▸ Levels). This flattens the color histogram and automatically makes the darkest pixels black and the lightest pixels white. But this isn't absolutely required every time. If you don't like the results, just undo it with CTRL-Z.

Sharp Scans

Nearly all scanned photos can benefit from a little sharpening. Digital photos don't normally need to be sharpened, but scanned photos usually do. The Unsharp Mask filter (Filters ▸ Enhance ▸ Unsharp Mask) works best for photos, though you can also get good results using the Sharpen filter (Filters ▸ Enhance ▸ Sharpen).

Selections, Selections, Selections

Learn to love 'em (and make them effectively, as described in Section 1.4). When you're working with photographs, you can't do much without them.

Add More Contrast

Duplicate an image layer and set the new layer to Soft Light. Adjust the opacity to modify the contrast in the original layer.

Soft Light and Overlay Modes

Add mood to your photos. Fill layers with any color on the color wheel and blend them using the Soft Light or Overlay layer modes.

Sepia Means Brown

Sepia tones are shades of brown, and they can lend your images an antique quality. Try applying RGB value sets like 124/81/61, 140/89/51, or 181/145/124 to your photographs.

The Color of Kelvin

Are you using ordinary halogen lamps for indoor shoots? Lighting color is measured in degrees Kelvin, with the sun at sunrise being about 2,500 degrees and the sun at noon being about 5,000 degrees (a bright white). A typical halogen lamp might be around 3,000 degrees, making its light a bit more yellow. Many photographers add a color-correction gel—which can be ordered from various online sources—to change the color of halogen bulbs.

If you can't fix a shot with proper lighting, you can try to digitally remove yellow tints from your photos using the Color Balance tool (Colors ▸ Color Balance) or the Hue-Saturation tool (Colors ▸ Hue-Saturation).

Experimentation

It can take a long time to make color adjustments to an entire image using tools from the toolbox. To experiment first, select a small part of the image and preview the color adjustments on that selection. When you've decided on the optimal values, undo the operation and adjust the entire image. Alternatively, try duplicating the image, scaling it down, and then experimenting with color adjustments on the smaller image.

3

WEB DESIGN

Graphic designers see the Web as one more medium in which to present their work. Consumers see it as a place to buy music and sell used cameras and lawnmowers. Big business sees it as a platform on which to develop new kinds of applications.

Any way you look at it, the Web has changed the world of graphic design. In the earliest days of the Internet, content was king, plain old HTML got the job done, and website design was, at best, a hack. These days, the best website designs utilize *Cascading Style Sheets (CSS)*. CSS is an established style sheet language that separates layout from content. This separation allows the designer to create visual consistency while somebody else works to create compelling content. CSS designs also make effective use of graphics, and that's where GIMP comes in. It provides designers with the raster images required by the Web.

NOTE *css Zen Garden (http://www.csszengarden.com/) has some excellent examples of CSS in action and shows you how the same content might look in several different designs.*

One traditional limitation of the Web, at least from the designer's point of view, has been its static nature. Animated GIF images were an early hack, but they didn't provide real interactivity. Today, Adobe Flash works well with raster images, but it also offers web designers a wealth of vector support. GIMP isn't the best tool for vector work, but if your web designs use raster images, Flash and GIMP make a great team.

NOTE *If you're interested in vector design, you can try Inkscape (http://www.inkscape.org/), another open source graphics tool.*

Working in a Native Medium

Some of the previous tutorials have started with the default canvas size of 640 × 400 pixels. This has made it easy to re-create the tutorial image quickly, but you'd need to work with larger canvas sizes to make those images suitable for print or other media formats.

Well, that all changes now. Throughout this chapter, the image resolution of your desktop (72 ppi for most CRT displays or 98 ppi for LCD displays) will also be the image resolution of the medium. That means the images created in this chapter won't need to be re-created at larger sizes. In fact, some will probably need to be scaled down (or re-created at a smaller scale) to be useful on the Web.

The focus of these tutorials will be the creation of simple graphics for the Web, specifically navigational aids, backdrops, advertisements, and logos. To find techniques for achieving more sophisticated photographic effects you can then incorporate into Flash or complex CSS designs, see Chapters 2 and 4.

GIMP Tools for Web Design

When working on the Web, you'll find yourself using a variety of the GIMP's tools and filters. Two of the tools you'll use for nearly every project are the Text tool and Blend tool.

Most web pages are made up of text and images. The text is often composed in WordPad, OpenOffice.org Writer, or vi, and web developers assume that the reader's browser will have access to the fonts required to display the text. The web designer can request a particular font, but if the browser doesn't have it, the browser gets to choose which font it will use instead. Because the various desktop platforms (Windows, Mac, and UNIX/Linux) don't all have the same fonts, you can't guarantee readers will see your web pages exactly the way you do. In short, because the Web still doesn't support cross-platform font management very well, you can never be 100 percent certain that the font you request will be available on the system running the web browser.

NOTE *Support for web standards relating to typography is still too new for most web designers to depend on.*

One solution to this problem is to use rasterized text for some text elements. Using the GIMP to render text into an image guarantees that everyone who sees the image will see it as you do. This little trick is only suitable for titles and small captions, however. It makes little sense to render entire paragraphs into an image because image files are much larger than text files, and editing the text would require working with graphics programs that aren't as well suited to text editing as HTML editors. Despite this, it's quite common to render text for headers, buttons, and title bars into images in order to guarantee that those elements will look the way the designer wants them to look.

Creating a text logo in GIMP ensures that all the website's visitors see the same logo, no matter which browser is used.

The Blend tool and the Bucket Fill tool make it easy to colorize images and clipart. Sometimes adding a splash of color is the best way to give your client's ordinary image a unique identity.

Gradients are easy to create, but be careful when using them: they don't work well in GIF images! If you use them, export your image as a JPEG or PNG instead.

All your web design projects will use multiple layers. In addition to the familiar Layers dialog and Layer menu, the Colors menu will play a big role as well.

If you've been following along, you should be quite familiar with layers by this point, but I'll continue guiding you through the menu selections where appropriate.

Finally, when designing web interface elements such as navigation aids, effective use of selections is crucial (see Section 1.4 if you need a refresher).

3.1 GEL BUTTONS

Website buttons come in many shapes, sizes, and colors. Not every button makes sense in every design. Rectangular buttons are popular because they can be changed easily without having to worry about how they blend into background pages. Gel buttons, on the other hand, generally require a lot of page space. Their nonrectangular shape also requires antialiasing the background color and makes it difficult to switch the background on a whim. Despite these shortcomings, many clients want websites with gel buttons.

Should you decide to use gel buttons in a web design, you're in luck. They're easy to create with GIMP. As is true of most 3-D effects, the trick is to play with light and dark regions to simulate depth and reflection.

This tutorial will walk you through the creation of a simple gel button. The technique is essentially the same for any type of gel effect. The tutorial in Section 5.2 shows a similar effect applied to text. Here you'll see a more general version of the process, but the possibilities are endless. It's not hard to imagine extending this effect to an oozing tube of toothpaste, for example. Just cycle the results through a wave filter.

A simple gel button

Getting Started

1. Start by opening a new white canvas window, set to the default width and height (640 × 400 pixels).

 NOTE *If the default image window size is not 640 × 400, set it in the Preferences dialog and then restart GIMP. The 640 × 400 default image size is used for many tutorials in this book when creating new image windows.*

2. Create a new transparent layer in this canvas by choosing **Layer ▶ New Layer** and setting the Layer Fill Type to **Transparency**. Name the new layer *Light Pill*.

3. Add vertical guides at **10 percent** and **90 percent** (**Image ▶ Guides ▶ New Guide (by Percent)**). Add horizontal guides at **35 percent** and **65 percent**.

4. Choose the **Rectangle Select** tool and use it to create a selection in the center rectangle that's outlined by these guides. In the Tool Options dialog, check the **Rounded corners** checkbox and set the Radius to **90 percent** to provide a high level of arc on the ends of the selection. (The Radius specified is actually a percentage of half the width or height of the selection, whichever is smaller.)

5. Remove all guides (**Image ▶ Guides ▶ Remove All Guides**).

When creating this rectangular selection with rounded corners, Radius values greater than 90 have little effect on the curved ends.

Adding Colored Layers

1. With the canvas selected, press **D** to reset the foreground and background colors.

2. Click the foreground color icon to open the Change Foreground Color dialog. Set the RGB values to **17/95/239** for the bright blue shown here, and then click **OK** to close the dialog.

3. Drag the foreground color icon from the toolbox into the selection to fill it with this color.

You can use any name you'd like for the selection. You don't even have to change the default name since this is the only saved selection in this tutorial.

4. Shrink the selection by **20 pixels** (**Select ▶ Shrink**) and save it to a channel (**Select ▶ Save to Channel**). You can keep the default channel name, *Selection Mask copy.*

5. Return to the Layers dialog and click the **Light Pill** layer to make it active.

6. Clear the selection (CTRL-SHIFT-A).

7. Duplicate the Light Pill layer (**Layer ▶ Duplicate Layer**). Name the new layer *Dark Pill.*

8. In the Layers dialog, check the **Lock alpha channel** box (the small, gray checkered box in the "Lock:" row). Click the foreground color icon to open the Change Foreground Color dialog. Set the RGB values to **11/0/97** for the dark blue shown here, and then click **OK**.

A layer mask is later used to allow the lighter layer to show through the darker one.

9. Drag the foreground color icon from the toolbox into the Dark Pill layer. Because the Keep Transparency option is selected, only the pill should be filled with the new color.

NOTE *The colors chosen for this tutorial can be changed to any colors you choose. There are various color mixer utilities available on the Web that allow you to choose matching colors for your design.*

Adding a Lower Highlight

1. Create a new transparent layer by choosing **Layer ▸ New Layer** and setting the Layer Fill Type to **Transparency**. Name the new layer *Lower Highlight*.

2. In the Channels dialog, click the **Selection Mask copy** channel, and then click the **Channel to Selection** button (red square with dotted outline).

3. Return to the Layers dialog and select the **Lower Highlight** layer to make it active.

4. Feather the selection by **20 pixels** (**Select ▸ Feather**).

5. With the canvas selected, press **D** and then **X** to set the foreground color to white, and then drag the foreground color icon into the selection. Clear the selection (CTRL-SHIFT-A).

The highlight is made from the selection saved in the Channels dialog.

6. Open the Gaussian Blur filter (**Filters ▸ Blur ▸ Gaussian Blur**) and apply a blur of **50 pixels** to the Lower Highlight layer.

7. With the canvas selected, press **M** to activate the Move tool, and then drag the Lower Highlight layer down so its lower white edge just touches the Dark Pill layer's lower edge. Set the layer mode for the Lower Highlight layer to **Grain Merge**.

8. Click the **Dark Pill** layer. Select the nontransparent region (**Layer ▸ Transparency ▸ Alpha to Selection**), and then invert the selection (**Select ▸ Invert**).

9. Click the **Lower Highlight** layer to make it active. Press CTRL-X to cut off any bits of the highlight that may overflow the bounds of the button when it's moved down.

 We're beginning to see the 3-D effect, but you still need to bring out the highlights from the Light Pill layer showing through the Dark Pill layer. Do that with a layer mask on the Dark Pill layer. As a result, there'll be more light reflection on the front of the pill and less reflection along its sides.

10. In the Channels dialog, click the **Selection Mask copy** channel, and then click the **Channel to Selection** button.

11. Click the **Dark Pill** layer in the Layers dialog. Add a white layer mask (**Layer ▸ Mask ▸ Add Layer Mask**), and then feather the selection by **50 pixels** (**Select ▸ Feather**).

The button starts to take on depth when soft lighting (the Lower Highlight layer) is added.

12. Press **D** to reset the foreground and background colors.

13. Drag the Foreground color box into the canvas to fill the selection with black.

A layer mask lets the light blue layer show through the dark blue layer and blends in with the blurred Lower Highlight layer.

Adding an Upper Highlight

1. Add a new transparent layer by choosing **Layer ▸ New Layer** and setting the Fill Type to **Transparency**. Call the new layer *Top Highlight*. If it is not at the top of the layer stack, move it there by clicking and dragging it up in the Layers dialog.

2. With the selection still active and the canvas selected, press **M** to activate the Move tool. In the Tool Options dialog, click the **Selection** button (red square with dotted outline in the "Move:" row). In the canvas, drag the selection up until its upper edge meets the pill's upper edge. Be sure to reset the Move setting to **Layer** in the Tool Options dialog when you're done to avoid confusion the next time you use the Move tool.

3. In the canvas window, press **L** to choose the Blend tool from the toolbox. In the Tool Options dialog, choose the **FG to Transparent** gradient.

4. Press **D** and then **X** in the canvas window to set the foreground color to white. Drag in a straight line from the top of the selection to the bottom.

The highlight comes from a gradient this time, so it blends with the Lower Highlight and Background layers more easily.

Stretching the Upper Highlight

Reflections of light off of a shape like this one aren't always uniform. To make this design more realistic, you need to stretch the upper highlight so it's a little wider at the bottom. You can do this with the Perspective tool. This tool changes the angle between the sides of a rectangular area while keeping the sides straight. For an oval selection, imagine the selection is tied to the sides of a box bounding the selection. When the bounding box is stretched, the oval selection is stretched to keep it proportionally distanced from the sides of the bounding box. In this case you'll be transforming the layer itself, not a selection, but you'll use the selection to create the bounding box used to perform the transform.

1. Choose the **Perspective** tool. In the Tool Options dialog, select the Transform option to **Layer**.

2. Click the canvas. Drag the bottom handles horizontally until the highlight touches the left and right sides of the canvas window. You may need to zoom out first before attempting this so you can drag the handles past the edges of the canvas. You may also want to reduce the number of guide lines to 1 in the Perspective Tool Options dialog to make it easier to see the previewed changes.

3. Click the **Transform** button. Anchor the layer (**Layer ▸ Anchor Layer**).

The Perspective tool is used to stretch the bottom of the layer.

4. Click the **Light Pill** layer. Select the nontransparent region (**Layer ▸ Transparency ▸ Alpha to Selection**), and then invert the selection (**Select ▸ Invert**).

5. Click the **Top Highlight** layer to make it active. Press CTRL-X to cut off any bits of highlight that overflow the bounds of the button.

Adding Text to the Button

Now add some text to the button. Be sure to choose a legible font. I've used Utopia, set to 65 pixels and colored black. If the foreground is not black, type D in the canvas to reset it. (If your website will have multiple gel buttons, size the font so the longest piece of button text will fit comfortably.)

1. Clear the selection (**Select ▸ None**).

2. Click the canvas and type *Push Me*.

3. Use the **Move** or **Align** tool to center the text on the pill. Make sure the Push Me layer is active in the Layers dialog.

4. Add a drop shadow (**Filters ▸ Light and Shadow ▸ Drop Shadow**). In the Drop Shadow dialog, set the Offset X and Offset Y fields to **2 pixels**, the Blur Radius to **3 pixels**, and the Opacity to **80 percent**. Check the **Allow resizing** checkbox.

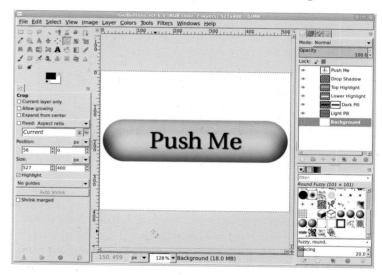

Add a text layer so the button can be used to navigate a website. The small offsets and radius make the drop shadow a very subtle effect.

Further Exploration

Remember that reflected light is seldom uniform across an object, even if the object is perfectly shaped. This is what gives brushed metal its appearance and why gel buttons don't look like metal tubes. To achieve an even more realistic look, try adding nearly transparent shadow layers in addition to the highlight layers.

3.2 METAL BUTTONS

The gel button technique is easy to master, but generating metallic buttons is even easier. This technique is very generic and simple to reproduce, with the only variation coming from how you colorize the button in the last step.

In this tutorial, you'll create buttons that fill the 640 × 400-pixel canvas. In a real application, you'd probably scale down the steps in this tutorial to create smaller buttons. Alternatively, if creating buttons at such a small size is difficult, you can create them at the default canvas size and then scale them down to fit your website. If you choose to scale down the buttons, be sure to apply a little sharpening to bring out the reflective detail.

One simple process can be used to produce metal buttons of many colors.

Getting Started

1. Open a new canvas at the default size (640 × 400 pixels).

2. Add a new transparent layer by choosing **Layer ▸ New Layer** and setting the Layer Fill Type to **Transparency**. Name the new layer *Button.*

3. Choose the **Ellipse Select** tool from the toolbox. In the Tool Options dialog check the **Fixed** checkbox and choose the **Aspect Ratio** option in the menu next to it. Be sure the text field below this shows 1:1, which should be the default. Drag from the upper-left corner down toward the bottom-right until your circular selection is as tall as the canvas window. Make sure the selection is completely inside the canvas boundaries. Alternatively, set the Size of the selection in the Tool Options dialog to 394 × 394 and the Position to 123 × 3.

If the circular selection isn't perfectly centered on the canvas, you can center it by clicking inside the selection and then dragging the selection to the center of the canvas. If the selection isn't exactly circular, click the Reset button in the Tool Options first, and then set the Fixed option and try again.

4. With the canvas selected, press **D** and then **X** to set the foreground color to white.

5. Press **L** to select the Blend tool from the toolbox. In the Tool Options dialog, set the Gradient to **FG to BG (RGB)** and the Shape to **Radial**.

6. Click inside the selection, about one-fourth of the width from the left side of the selection, and drag across the width of the selection. This creates the basic reflective highlight, but the reflection is a bit too perfect. (Recall from Section 3.1 that light reflects unevenly off of most surfaces.) The next step is to add some variance to this perfectly reflecting sphere.

When you click just left of the circle's center and drag to the far side of the selection using a Radial gradient, it's easy to achieve this 3-D effect.

Adding More Reflections

1. Add a new transparent layer by choosing **Layer ▸ New Layer** and setting the Layer Fill Type to **Transparency**. Name the new layer *Darken*.

2. With the canvas selected, press **X** to set the foreground color to black.

3. With the **Blend** tool still active, set the Gradient to **FG to Transparent** and the Shape to **Linear** in the Tool Options dialog. On the canvas, click the top of the selection and drag down to its midpoint.

4. Add a new transparent layer by choosing **Layer ▸ New Layer** and setting the Layer Fill Type to **Transparency**. Name the new layer *Top Reflection*.

5. With the canvas selected, press **X** to set the foreground color to white.

6. The selection should still be active, so shrink it by **10 pixels** (**Select ▸ Shrink**).

Adding a shaded area on top of the button increases the button's shiny appearance.

7. The **Blend** tool should also still be active. Click the top of the selection and drag to its midpoint. Deselect all (CTRL-SHIFT-A).

8. In the Layers dialog, set the Top Reflection layer's Opacity to **75 percent**. The light now reflects differently around the sphere, providing visual texture and giving the appearance of a smooth, glassy surface.

The Top Reflection layer sits above the Darken layer.

9. Duplicate the Top Reflection layer (**Layer ▸ Duplicate Layer**) and name the new layer *Bottom Reflection*.

10. Use the **Flip** tool to flip this layer vertically.

11. Using the **Move** tool, with the Tool Toggle set to **Move the active layer** in the Tool Options dialog, drag this layer so that its bottom white edge is just above the button's bottom edge.

12. Open the Gaussian Blur filter (**Filters ▸ Blur ▸ Gaussian Blur**). Set the Blur Radius to **5 pixels**. Click **OK** to apply the blur. Set the Opacity to **60 percent**.

The reflection layers, both top and bottom, can be blurred further for more dramatic effect. If the blur is more than a few pixels, be sure to use a mask to cut out any blur that might overlap the edges of the sphere in the Button layer.

13. Click the **Top Reflection** layer to make that layer active.

14. With the canvas selected, press SHIFT-T to activate the Scale tool. In the Scaling Information dialog, choose **%** (**percent**) from the measurement unit drop-down menu. Change the Width and the Height to **85 percent** and click the **Scale** button.

15. Use the **Move** tool to realign the layer so its upper left is just inside the upper left of the button.

16. Open the Gaussian Blur filter (**Filters ▸ Blur ▸ Gaussian Blur**) and set the Blur Radius to **5 pixels**. Apply this blur to the Top Reflection layer.

Though we don't do it in this tutorial, duplicating the Bottom Reflection layer increases the contrast between light and dark areas and can create a flattened appearance at the bottom of the button.

Adding Color

1. Click the **Button** layer in the Layers dialog to make that layer active.

2. Open the Colorize dialog (**Colors ▸ Colorize**).

3. Set the Hue to **35** and the Saturation to **90**. You can create countless variations on this basic button by modifying the Hue and Saturation settings for this layer.

NOTE *You use the Colorize dialog in this tutorial, but color can be added in a number of ways. You could add a new layer filled with color and set its layer mode to Soft Light or Color. You could also use the Bucket Fill tool on the Button layer and choose either of those same modes.*

Further Exploration

Creating a colored sphere might seem like a simple project, but it's important, and it can be the basis for many more sophisticated designs. In fact, it serves as the foundation for another project in this book. Be sure to save this project as an XCF file (GIMP's native file format) so you can use it again later.

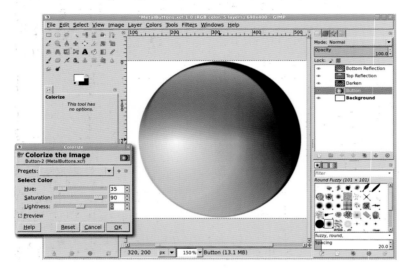

Use the Colorize dialog to put the finishing touch on the metallic button.

Gel and metallic buttons can liven up a web page, but practical considerations are often more compelling design criteria. Round buttons can take up valuable screen space, for example. A more compact design might include the use of notebook tabs. Fortunately, using GIMP to create tabs is even easier than using it to create buttons.

This is one of the most straightforward tutorials in the book. It only takes a few minutes from start to finish, and the effect is easy to reproduce. You'll also learn how to create multiple tabs and colorize them in ways that help visitors navigate your website.

Tabs are small images, but they can affect your web designs in a big way.

Getting Started

1. Open a new white canvas at the default size (640 × 400 pixels).

2. Add vertical and horizontal guides at **10 percent** and **90 percent** in each direction by selecting **Image ▸ Guides ▸ New Guide (by Percent)**.

3. Choose the **Rectangle Select** tool from the toolbox. Select the **Rounded Corners** option in the Tool Options dialog and set the Radius to **25 percent**. Create a selection in the center rectangle that's outlined by these guides.

Use guides to make it easier to center the selection.

4. Remove the guides (**Image ▸ Guides ▸ Remove All Guides**).

5. Select **Image ▸ Guides ▸ New Guide (by Percent)** to add a new horizontal guide at **70 percent**, just above where the corner begins to be rounded.

6. With the **Rectangle Select** tool still selected, in the Tool Options dialog set the Mode to **Subtract** (third from left of "Mode:"). Disable the **Rounded Corners** option in the Tool Options dialog. Drag a rectangular selection that passes through the existing selection and is bordered on top by the guide, and then press ENTER to accept the updated selection. We now have the basic tab shape.

The Rectangle Select tool's Subtract mode lets you drag to create a second selection that's then subtracted from the existing selection.

Adding a Gradient

1. Add a new transparent layer by choosing **Layer ▸ New Layer** and setting the Layer Fill Type to **Transparency**. Name this layer *Tab*.

2. In the canvas, press **D** to reset the foreground and background colors to black and white, respectively.

3. Select **Image ▸ Guides ▸ New Guide (by Percent)** to add a new vertical guide at **50 percent**.

4. In the canvas, press **L** to activate the Blend tool. In the Tool Options dialog, set the Blend tool's Opacity to **70 percent**. Be sure the Gradient in the Tool Options dialog is set to **FG to BG (RGB)**.

5. Click the canvas near the top of the selection and on the center vertical guide, and drag down to the bottom of the selection along the vertical guide to apply the gradient.

NOTE *Alternatively, press CTRL while dragging to keep the gradient straight.*

6. Save the selection to a channel by choosing **Select ▸ Save to Channel**. Name the saved channel *Selection Mask copy*. There's no need to change the name for this tutorial.

7. Deselect all (CTRL-SHIFT-A) and remove all guides (**Image ▸ Guide ▸ Remove All Guides**).

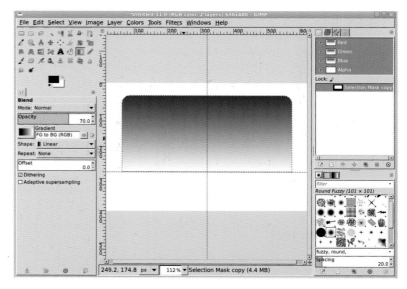

A gradient fills the selection.

Giving the Tab Some Depth

1. In the Layers dialog, click the **Tab** layer to make it active. Duplicate the Tab layer (**Layer ▸ Duplicate Layer**), and then click the original **Tab** layer in the Layers dialog to make it active again.

2. Open the Gaussian Blur filter (**Filters ▸ Blur ▸ Gaussian Blur**). Set the Horizontal and Vertical Blur Radius to **7 pixels**, and then apply this blur to the original Tab layer.

3. Click the **Tab copy** layer in the Layers dialog to make that layer active.

4. Open the Bump Map filter (**Filters ▸ Map ▸ Bump Map**).

5. Set the Azimuth to **180 degrees,** the Elevation to **60**, and the Depth to **30**. Be sure to select the original **Tab** layer from the Bump Map drop-down menu at the top of the dialog.

6. Click **OK** to apply the Bump Map filter and rename the Tab copy layer *Bump Map*.

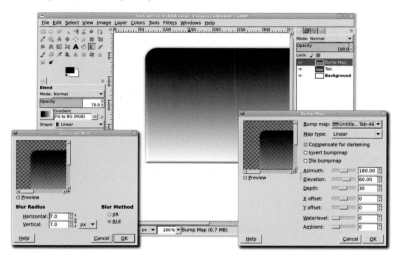

The blurred original tab is used to give depth to the copy layer.

Adding Color and Highlights

1. Duplicate the Bump Map layer (**Layer ▸ Duplicate Layer**). Name this layer *Colorized*.

2. Open the Colorize dialog (**Colors ▸ Colorize**). Set the Hue to **180**, the Saturation to **90**, and the Lightness to **70**. This should produce a hazy, aqua-colored effect.

3. Retrieve the saved selection by clicking **Selection Mask copy** in the Channels dialog and clicking the **Channel to Selection** button (second from right) in the button bar of that dialog. Add a horizontal guide at **30 percent**.

4. Choose the **Rectangle Select** tool, set the Tool Options Mode to **Subtract**, and drag a box with its upper edge along the horizontal guide to cut off the bottom of the existing selection. (Be sure to change the Rectangle Select tool's Mode back to **Replace** when you're done.) Then shrink the selection by **10 pixels** (**Select ▸ Shrink**).

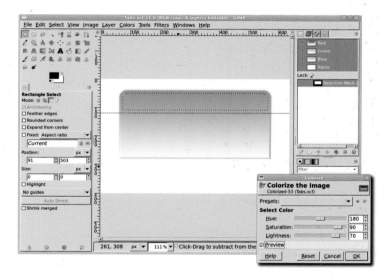

Saving selections to channels is an easy way to re-create a shape long after the shape has changed.

5. Add a new transparent layer by choosing **Layer ▸ New Layer** and setting the Layer Fill Type to **Transparency**. Call the new layer *Highlight*. Click the new layer in the Layers dialog, then set the layer's Opacity to **70 percent**.

6. Drag the background color (white) into the selection to fill the selection.

7. Deselect all (CTRL-SHIFT-A).

8. Open the Gaussian Blur filter (**Filters ▸ Blur ▸ Gaussian Blur**) and apply a blur of **5 pixels** to the Highlight layer to soften the reflected highlight.

Remove the selection (CTRL-SHIFT-A) before blurring the Highlight layer.

After the addition of a drop shadow, the text appears to rest on a semi-transparent tab.

Adding Text

The basic tab is now complete. Now just add some text.

1. Remove all guides (**Image ▸ Guide ▸ Remove All Guides**).

2. Select the **Text** tool from the toolbox. Choose an appropriate font (this tutorial used Serif Bold set to 120 pixels with a black color). As when you choose a font size for button text, your font size here should allow the longest piece of tab text to fit. Keep in mind that a sans-serif font might be more appropriate if you plan to scale down the tab's size.

3. Click the canvas to open the Text Editor. Type some text.

4. Use the **Move** tool to position the text in the center of the tab.

5. If you like, add a drop shadow (**Filters ▸ Light and Shadow ▸ Drop Shadow**). Set the Offset X and Offset Y values to **3 pixels**, the Blur Radius to **8 pixels**, and the Opacity to **80 percent**.

Creating More Tabs

In the real world, web pages usually have multiple tabs. A colored tab could indicate the page being viewed while gray tabs represent other pages available to your website visitor.

1. To create a series of tabs, start by turning off the visibility of the Background, Drop Shadow, and text layers. Then merge the visible layers (**Image ▸ Merge Visible Layers**), expanded as necessary.

2. Duplicate the merged layer and name the new layer *New Tab*.

3. Use the **Move** tool to move this tab to the left of the first tab you created.

4. Resize the canvas (**Image ▸ Fit Canvas to Layers**), and then resize the canvas window (CTRL-SHIFT-J).

5. Move the **New Tab** layer so it aligns with the left and bottom edges of the original Tab layer. The **Align** tool can be used to align the top edges of the two layers. Then zoom in, select the **Move** tool in the Toolbox, and use the arrow keys on the keyboard to make fine adjustments left or right.

6. Desaturate the New Tab layer if it should have a different color (**Colors ▸ Desaturate**), and then colorize it using the Colorize dialog (**Colors ▸ Colorize**).

7. Add additional text as needed, and then turn visibility back on for the text and Drop Shadow layers for your original button.

NOTE *If your Background layer doesn't fill the entire canvas, you can delete it (Layer ▸ Delete) and add a new white layer (Layer ▸ New) that you drag to the bottom of the stack in the Layers dialog.*

Fine adjustments to position can be performed by zooming in and using the arrow keys with the Move tool.

Further Exploration

Tabs can be placed on websites vertically instead of horizontally. Merge all visible layers, and then rotate the image 90 degrees counterclockwise (see Image ▸ Transform). Making text that reads vertically (where the letters are vertical but the word reads from top to bottom instead of from left to right) is more difficult because GIMP's text alignment features are limited, but you could use a carriage return after each character.

3.4 WEBSITE BANNERS

If you've got a small business on one of the many online collectives such as CafePress.com or Shopify.com, or a blog or business running under WordPress.com, chances are you need professional-looking banners and product images to go with your website. Fortunately, GIMP solves this problem in just a few short steps.

The primary requirement for banners and product images is the size of the image. Most web-hosting sites provide configurable themes so users can customize their web presence. The theme selected defines the specifications for images. This includes the banner at the top of the page, slide show images, and extras such as backgrounds or images for specific divisions within a page. The trick is to use theme specifications to create visually appealing product displays and a professional appearance that separates your site from the competition.

This tutorial will focus on the tasks involved in creating a professional banner for a website with an artistic and a technical focus. The processes outlined here can also be applied to images used in scrolling slide shows and static product images.

As with the Photographic Effects tutorials, much of the work with banners starts with stock images.

A professional appearance for a website starts with a high-quality banner.

Getting Started

The first thing to do is find information about the banner dimensions for the theme you'll be using on your site. All banner dimensions are in pixels. Etsy.com, a shopping mall for handmade items, recommends a banner size of 760 × 100 pixels. Cafepress.com, a site for creating custom prints on a variety of products, suggests a maximum of 500 × 200 pixels. WordPress,

an open source package for blogging and content management, provides a default theme that supports a maximum size of 940 × 198 pixels. Since it's impossible to know what size display resolutions your visitors will have, it's often wisest to keep the width under 1024 pixels. The height of the banner is usually restricted to the design limitations of the website theme.

NOTE *Banner sizes for the various websites are current as this book goes to press.*

In this tutorial you'll use the dimensions for the WordPress banner because WordPress is easy to install on the desktop, making it easy to test designs without having to access a remote shop.

Cropping the Background Graphic

1. Open a stock image at least 1024 pixels wide. This one comes from BigStockPhoto.com. It's a fairly large and detailed image at 2536 × 2302 pixels. If necessary, zoom out (**View ▸ Zoom Out**) to see the whole image.

2. Choose the **Crop** tool from the Toolbox. Drag an initial bounding box in the canvas, and then in the Tool Options dialog set the size to **940 × 198 pixels**.

3. The image is so large that nothing meaningful fits into the crop boundaries. To fix this, scale the image by **50 percent** (**Image ▸ Scale Image**). Zoom in on the image (+ or CTRL-SHIFT-J if using Single-Window mode) if necessary. In the canvas, click in the middle of the bounding box and drag the box until it's over the area of interest.

4. Press ENTER to accept the crop. The image will be cropped to the area selected.

5. Open the Unsharp Mask filter (**Filters ▸ Enhance ▸ Unsharp Mask**) to sharpen the image. Set the Radius to **3.5** and the Amount to **0.35**.

Scaling the image doesn't change the scale of the crop bounding box.

Allowing the colored tree to show through the black-and-white layer creates a simulated glow around one tree (shown here with a close-up to better see the effect).

Enhancing the Glow

The image colors are dull. We need to adjust the image to intensify them.

1. Duplicate the Background layer (**Layer ▸ Duplicate Layer**). Name this layer *Desaturated BG*. Desaturate the duplicate layer (**Colors ▸ Desaturate**). Add a white layer mask (**Layer ▸ Mask ▸ Add Layer Mask**).

2. Add a Horizontal guide at **50 percent** (**Image ▸ Guides ▸ New Guide (by Percent)**). Type **D** in the canvas window to reset the foreground color to black.

3. Choose the **Blend** tool from the Toolbox. In the Tool Options dialog set the Mode to **Normal**, the Shape to **Bi-linear**, and the Gradient to **FG to BG (RGB)**. Drag along the horizontal guide from the middle of the image to near the right edge. Switch the Mode in the Tool Options to **Multiply**, then repeat the drag twice.

Adding a Foreground Graphic

The foreground graphic is an open laptop computer. The background will show through the display of the monitor.

1. Open a stock image of a laptop at least 500 pixels wide. This one comes from BigStockPhoto.com and was chosen because of the high contrast between the background and the edges of the computer. That'll make the laptop easier to isolate. Scale the image down to **247 × 185 pixels** (**Image ▸ Scale Image**), which maintains the aspect ratio.

2. Choose the **Fuzzy Select** tool with the Threshold set to **12** in the Tool Options dialog. Click the white area outside the computer, then invert (**Select ▸ Invert**) the selection. This will select the laptop and may include a small amount of the background. Use the Quick Mask to clean up the selection. Copy this selection (**Edit ▸ Copy**).

3. In the Layers dialog, click the **Desaturated layer**, on the image icon, to make the image layer active (instead of the layer mask).

The Fuzzy selection is not perfect because the contrast between the background and object (laptop) isn't sufficient, so it needs to be cleaned up using the Quick Mask (shown here in red).

4. Paste (**Edit ▸ Paste**) the copy into the glowing tree image as a new layer (**Layer ▸ To New Layer**) named *Laptop*. Use the **Move** tool to position the new layer over the glowing colored section of the trees.

5. Close the original laptop image so it doesn't get in the way of the rest of the tutorial.

Colorizing the Laptop

1. Desaturate the laptop layer. Click the foreground color box in the Toolbox and set the RGB values to **122/0/31**. Alternatively, choose a color from the Background layer using the Color Picker tool.

2. Choose the **Bucket Fill** tool from the Toolbox. In the Tool Options dialog, set the Opacity to **100 percent**, the Fill Type to **FG color fill**, the Affected Area to **Fill whole selection** and the Mode to **Soft Light**. Click the canvas window over the laptop twice.

3. Change the Mode to **Overlay** and the Opacity to **50 percent**. Click once in the canvas window.

4. Reset the colors by pressing **D** in the canvas window, then click once more in the canvas window.

If the colors for the laptop aren't ideal, use the undo option (CTRL-Z) to go back to the desaturated laptop and try again using a different color and/or different layer modes.

Opening a Window on the Trees

The next step is to allow the trees to show on the laptop monitor.

1. Add a white layer mask to the Laptop layer.

2. Use the **Rectangle Select** tool (make sure the Mode is set to **Replace** in the Tool Options dialog) to draw a selection outline in the laptop display. The outline should be slightly smaller than the display, leaving a small black space between the selection and the laptop display frame. Feather the selection (**Select ▸ Feather**) by **2 pixels**.

3. Change the foreground color to a dark gray by setting the RGB values to **94/94/94**. Drag the foreground color box from the Toolbox into the selection.

The trees show through the mask and appear to be displayed on the laptop monitor.

Exporting and Saving

Before exporting as a JPEG for use in the website, save the file as an XCF file. XCF is GIMP's native file format, and saving the banner as an XCF image allows you to edit it later. After saving as an XCF file, export the image (**File ▸ Export**) as a JPEG.

Further Exploration

Banner sizes vary from site to site and are presented in different locations on the page. The Etsy banner for a single shop is smaller than the WordPress banner and is displayed off center. Choosing eye-catching components for the banner will draw website visitors to your content and away from the hosting site's peripheral imagery.

Since font handling on the Web is still inconsistent, it can be useful to add text to the banner. By rendering text in the banner you're assured it's displayed the same by every browser on every platform. Future advances in HTML will help address this problem, but for the foreseeable future adding text to banners is still a useful practice.

Logo design is one of the most enjoyable branches of graphic design. For a smaller or newer company, the logo needs to graphically express the company's main product or purpose. For a more established enterprise, the logo might be a unique symbol that has come to be identified with that company and its products. Think of the Nike swoosh or the AT&T globe.

Because they're small, logos are also among the hardest designs to create. Expressing a corporate identity in such a small space is never easy. Fortunately, with a small amount of work, a logo can say a lot.

Custom logos are a snap with GIMP.

On the Web, small and simple logos work best. At roughly 72–98 ppi, this medium doesn't leave much room for busy designs. Logos are generally small (but they don't have to be), because they appear on all the website's pages. When you scale down a large, busy design, detail can be lost, so it's best to keep things simple.

GIMP provides tools to create logos of all types. For small companies with modest identity needs (web pages and perhaps stationery and business cards), these tools are often sufficient. For larger companies that will use logos in banner advertising, GIMP is best used only as a prototyping tool. You'll want to transfer the design to vector art later so that it can be scaled to large print sizes easily.

This tutorial will design a simple logo for a small, fictitious biotechnology company named Argonix. The design criteria are that the logo must be no more than two colors, must emphasize the company name, and must include a tag line and icon that represent the company's association with bioengineered plants. The

logo will be used on the company's website and must fit in a space that is 400 × 145 pixels. The images for this tutorial are zoomed in to make them easier to see in print.

Getting Started

1. Type **D** in the canvas to reset the foreground and background colors. Start with a new white canvas sized to **400 × 145 pixels**.

2. Choose the **Text** tool from the toolbox. In the Tool Options dialog, click on the **Reset** button on the lower right, and then choose a serif font. I use Serif Bold Italic in this example. (A sans-serif font is easier to trace with a vector tool, should this design need to be converted to vector format later, but I prefer the look of serif fonts.) The choice of font should also reflect the requirements of the client. For example, grungy text might be appropriate for a gaming company, but it probably wouldn't suit a home furnishings chain.

Creating Text

1. Click and drag in the canvas to create a bounding box for the text. The initial size of the box doesn't matter. It will grow to fit the text as needed.

2. In the bounding box, type the word *ARGONIX*, in uppercase, followed by a newline. Type the phrase *Bioengineering for a hungry world*. Don't worry about colors or text sizes. These will be changed in a moment.

3. After you type the text, the Box setting in the Tool Options may have changed to Fixed. If so, be sure to set the Box type to **Dynamic**.

4. Double-click on the word *ARGONIX* to select it within the bounding box. In the Style Editor, type **55** in the Font Size field and hit ENTER. Click the **Color** button in the Style Editor to change the color of this word to RGB values of **207/0/0**.

5. Select just the letter *A* in *ARGONIX*. Use the Style Editor to change the font size to **70 pixels**.

NOTE *Remember that the Style Editor is the rectangular box of editing options displayed on the canvas directly above the text. This editor is new in GIMP 2.8 and is separate from the Tool Options and the Editor Dialog that can be opened from the Tool Options. See Section 1.8 for an introduction to GIMP's text features.*

6. Click three times quickly on the second line of text to select all of that line. Use the Style Editor to change the Font to **Nimbus Sans L Bold** or similar thin-lined font. Font selection in the Style Editor is aided by typing a few letters of the font name. The Style Editor will show a filtered list of matching fonts from which to select.

7. Use the Style Editor to change the font size of the selected text to **15 pixels**.

All text for this project goes into a single layer. Previous versions of GIMP required multiple text layers.

The Style Editor allows changes to individual characters, words, or phrases.

Changing the font and size will change the alignment of the text within the bounding box. This will be fixed next.

8. The letter kerning in the second line will need adjustment. The line should still be selected, so set the kerning field to **2.5** and hit ENTER. The letters will spread out slightly, nearly (though not exactly) aligning with the left and right ends of the first line.

9. Select just the first letter of the second line. Change the kerning value to **–5** and hit ENTER. Now the ends of the second line should align with the first.

10. Optionally, adjust the line spacing for this text layer by setting the Line Spacing to **–20** in the Tool Options dialog. Notice that changes to this field in the Tool Options apply to all lines in the text layer, not just the selected lines.

The amount of kerning adjustments is tied directly to the font and font sizes you choose. Your project may require different kerning settings.

Adding Borders and Clipart

1. Add a new transparent layer by choosing **Layer ▶ New Layer** and setting the Layer Fill Type to **Transparency**. Name the new layer *Borders*.

2. Add two new horizontal guides at **15 percent** and **85 percent** by choosing **Image ▶ Guides ▶ New Guide (By Percent)**. Then add two vertical guides at **5 percent** and **95 percent**.

3. Click the **Paintbrush** tool and choose **Calligraphic** from the Brushes dialog. In the Tool Options set the Size to **10**. Click once at the upper-left intersection of the new guides. Hold down the SHIFT key and click the upper-right intersection to draw a straight line between the two intersections. Repeat this process with the lower-left and lower-right intersections. We'll adjust the text layer position later.

Use guides and a small brush to draw the horizontal borders in a separate layer.

4. Remove all guides (**Image ▶ Guides ▶ Remove All Guides**).

5. For the leaf icon that appears behind the logo text, you'll use clipart. Open any appropriate clipart file (there are many freely available on the Internet, but be sure to check the copyright license for their use in your projects). Be sure the clipart is a black-on-white image.

6. Copy the clipart into the logo project canvas as a new layer. Make sure the **Lock Alpha Channel** box in the Layers dialog

is checked for this new layer. You may need to scale down the art to fit the available space. In this example, the space between the two borders comfortably fits a clipart image that's 90 pixels high.

7. Desaturate that layer (**Colors ▸ Desaturate**).

8. Choose the **Bucket Fill** tool and in the Tool Options dialog set the Mode to **Screen**, the Opacity to **100 percent**, the Fill Type to **FG color fill**, and the Affected Area to **Fill whole selection**.

9. Open the Change Foreground Color dialog again, make sure the RGB values are set to **207/0/0** to match the red used for the text, then close the dialog.

10. Click the layer to colorize the clipart.

11. Assuming an original clipart of black-on-white, set the layer mode to **Multiply**. Otherwise, either choose a more appropriate layer mode to mask the background or select the background by color, add a layer mask, and fill the selection in the mask with black to mask the background of the clipart.

12. Use the **Move** tool to manually align the clipart layer between the top and bottom borders on the left side of the logo image.

A piece of clipart is scaled down to fit between the logo's borders.

NOTE *If you can't find appropriate clipart on the Internet, try looking for clipart books at your local bookstore. The Dover collections, for example, offer many images that can be photographed with your camera and easily cleaned up with GIMP.*

Adding a Watermark

1. Click the **Background** layer in the Layers dialog to make it active.

2. Add a transparent layer by choosing **Layer ▸ New Layer** and setting the Layer Fill Type to **Transparency**. Name the new layer *Watermark*.

3. Create a rectangular selection through the middle of this layer. The size of the rectangle makes no difference.

4. In the Change Foreground Color dialog, set the RGB values to **142/142/142** for a neutral gray and close the window.

5. Drag the foreground color into the selection, and then deselect all (CTRL-SHIFT-A).

The watermark starts as a gray selection in a layer placed above the Background layer but below all other layers.

6. To convert the new gray background into a watermark, open the Waves filter (**Filters ▸ Distorts ▸ Waves**). Set the Amplitude to **85 pixels** and the Wavelength to **50 pixels**. Click **OK** to apply this filter to the Watermark layer.

7. Open the Curve Bend filter (**Filters ▸ Distorts ▸ Curve Bend**). Adjust the Upper and Lower curves so they form a figure 8 on its side, then click **OK** to apply them to the layer.

8. Open the Gaussian Blur (**Filters ▸ Blur ▸ Gaussian Blur**) and apply a blur of **1.5 pixels** to the layer. Set the layer Opacity to **50 percent**.

9. If desired, use the **Scale** tool to stretch the layer larger or smaller. Then fit the layer to the image (**Layer ▸ Layer to Image Size**).

Some simple distortions turn the solid gray rectangle into a wavy watermark.

Centering the Text

1. Click on the **Text** layer in the Layers dialog.

2. Select the **Move** tool from the Toolbox. In the Tool Options dialog make sure the **Move the Active Layer** option is selected. Click and drag in the canvas to move the text layer left or right and up or down till it centers visually between the top and bottom border lines. You may find it easier to do this with the layer boundary turned off (**View ▸ Show Layer Boundary**).

Further Exploration

You might think that an alternative design choice for this project might have the first letter of the company name span both lines of text. To do this, the first line (without its first letter) would have its baseline adjusted to move it up, and the second line kerning and baseline would be adjusted to fit below this but to the right of the *A* in *Argonix*. However, the baseline adjustment will not allow the second line to overlap the first. Instead, the Line Spacing adjustment in the Tool Options dialog allows the second line to overlap the first.

Creating prototype designs in this way makes it easy to trace the image in a vector program later, should you need to scale the design for larger print media.

This is just one example of how you might create a logo for a small business. And the best part is there's plenty of logo design work out there. Designing simple logos like this for personal use or for small businesses, lawyers, doctors, and other professionals can keep any graphic designer busy.

3.6 ICONS

Buttons, tabs, and logos aren't the only graphics found on the Web. Just like the desktop, the Web makes heavy use of icons. Icons help identify current position within navigable pages and provide easily recognizable references for commonly referenced sites. Icons can be used for brand identification or product labeling.

Icons can be created larger than their display size by letting the browser or JavaScript size the image for you. This automatic scaling isn't recommended for large images, but with small icons—especially on pages that use only a few icons at a time—it allows the icon designer to work with larger images. This makes it easier to create icons, because GIMP users can work in a larger canvas.

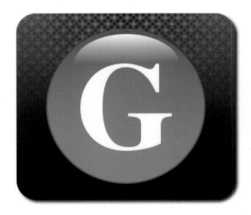

If you want to speed the loading of your web pages, scale your canvas to the same size as the icon that will be displayed in a browser.

In this tutorial I'll visit the icon world and walk you through the design of icons suitable for use on the Web. Only basic knowledge of GIMP is required, such as using layers and understanding the default layout of the toolbox. No outside stock images are required. However, unlike previous projects, this project will require working with multiple GIMP canvases at once.

Getting Started

1. Reset the foreground and background colors by typing **D** in the image window. Open a new, 640 × 400-pixel image window (**File ▸ New**). Click the background color swatch in the Toolbox to open the Change Background Color dialog. Set the RGB values to **121/121/121** and close the dialog. The black and gray colors will be used as the background gradient for the icon.

2. Add a transparent layer (**Layer ▸ New Layer**) and name it *Icon Background*. Choose the **Rectangle Select** tool from the Toolbox. In the Tool Options dialog, set the **Rounded Corners** option with a Radius of **25**. Draw an initial selection in the image window—its position and size don't matter at this point. In the Tool Options dialog, set the Size to **274 × 240 pixels** and the Position to **183 × 80 pixels**. This will be the icon size, plus some transparent padding. The size was computed based on experimentation, so feel free to make this selection larger to create a larger icon.

The Tool Options for the Rectangle Select tool allow for precise positioning and sizing. Selecting the Rounded Corners option will display the Radius setting.

Adding a Gradient Fill

1. Add a vertical guide at **50 percent** (**Image ▸ Guides ▸ New Guide (by Percent)**).

2. Choose the **Blend** tool from the Toolbox. In the Tool Options dialog set the Mode to **Normal**, Opacity to **100 percent**, Gradient to **FG to BG (RGB)** with the **Reverse** option checked, and the Shape to **Linear**. Drag in the image window from the top of the selection to the bottom, following the guide.

3. Clear the selection (**Select ▸ None**). Add a drop shadow (**Filters ▸ Light and Shadow ▸ Drop Shadow**) offset by **3 pixels** and blurred by **5 pixels**.

Using a gray-to-black gradient allows the icon background to serve as a wall against which an application-specific icon can be displayed.

Creating a Checkered Pattern

1. Open a new image window that is **16 × 16 pixels**. In the image window that opens, hit the + key 10 times to zoom in.

NOTE *You can also zoom in on an image by using the zoom control in the status bar at the bottom of the image window.*

2. Add a grid (**Image ▸ Configure Grid**) with **4-pixel** spacing for width and height. This divides the window into 12 blocks. Enable snap to grid (**View ▸ Snap to Grid**).

3. Set the Foreground color RGB to **103/103/103**. Use the **Rectangle Select** tool (be sure Rounded corners is not set) to outline and fill the blocks at the following row/column positions: 1/1, 1/3, 2/2, 2/4, 3/1, 3/3, 4/2, and 4/4 with the Foreground color. Press the SHIFT key to add to the selection as you select each block.

4. Change the Foreground RGB to **67/67/67**, then select and fill the blocks at the following row/column positions: 1/2, 1/4, 2/3, 3/2, 3/4, and 4/1. If you selected all the previous blocks at once, then invert the selection to fill these blocks.

5. Change the Foreground RGB to **141/141/141** and fill in blocks **2/1** and **4/3**.

The grid can be made visible with View ▸ Show Grid, but with the Snap to Grid option set it isn't really necessary, since the image is very small and zoomed in.

6. Export (**File ▸ Export**) this file as *IcondBG.pat* to your GIMP patterns directory giving a **Description** of *Web Icon BG*. Open the Patterns dialog (**Windows ▸ Dockable Dialogs ▸ Patterns**) and click the **Refresh** button to add the new pattern to the list of patterns. Close the *IcondBG.pat* window.

Adding a Pattern

1. Back in the icon image window, add a transparent layer and name it *Pattern*.

2. Click on the **Background** layer in the Layers dialog and create a selection of the icon (**Layer ▸ Transparency ▸ Alpha to Selection**).

3. Click the **Pattern** layer in the Layers dialog to make it active. In the Patterns dialog (**Windows ▸ Dockable Dialogs ▸ Patterns**), drag the Web Icon BG pattern into the image window to fill the selection with the new pattern.

4. Add a white layer mask (**Layer ▸ Mask ▸ Add Layer Mask**) to the Pattern layer.

5. Type **D** in the image window to reset the foreground and background colors. Choose the **Blend** tool from the Toolbox. Set the Opacity to **75 percent** and the Shape to **Radial** in the Tool Options dialog. Drag from the top of the icon to roughly the middle in the image window. In the Tool Options dialog, switch the Shape to **Linear** and the Mode to **Multiply**. Drag from the middle of the icon to the bottom edge in the image window. Drag again from the top to the middle of the icon.

6. Apply the layer mask (**Layer ▸ Mask ▸ Apply Layer Mask**).

7. Clear the selection. Remove all guides (**Image ▸ Guides ▸ Remove All Guides**).

The checkered pattern gives the icon a textured appearance.

Clicking and dragging on a line connecting two anchors will also cause the handles to appear.

Masking the Bottom of the Icon

1. Add a white layer mask to the Pattern layer.

2. Add vertical guides at 183 and 457 and horizontal guides at 80 and 200.

3. Use the **Paths** tool from the Toolbox and place anchors on each corner starting at the lower left intersection of the guides, with one extra anchor just to the right of the first one. This will create five anchors.

4. In the Tool Options dialog, change the Edit mode to **Edit**. Click the last anchor and drag to the left to move the first handle out of the way. Click it again and drag the handle toward the upper middle of the icon. This causes the path to bend. Click the next-to-last anchor and drag right to move the first handle out of the way. Click that anchor again and drag toward the bottom middle of the icon. Click **Selection from Path** in the Tool Options dialog. Invert the selection (**Select ▸ Invert**). Fill the selection with black.

Creating the Application Sphere

The icon backdrop is ready. Now it's time to add application-specific identifiers. This can be done multiple times to create a series of applications using the same backdrop.

1. Add vertical guides at 220 and 420 and horizontal guides at 100 and 300. This makes a perfect square to bound a sphere.

2. Add a transparent layer and name it *Sphere*. Be sure this layer is at the top of the stack in the Layers dialog. Choose the **Ellipse Select** tool from the toolbox. Click the upper-left guide intersection and drag to the lower right.

3. Reset the foreground and background colors by typing **D** in the image window. Open the Change Foreground Color dialog. Set the RGB values to **74/164/75**. Click the background color swatch in the Toolbox to switch to the Change Background Color dialog. Set the RGB values to **28/130/29**. Close the color dialog. The green shades will be used as the gradient for the application sphere.

4. Choose the **Blend** tool from the Toolbox. Set the Shape to **Radial** and the Gradient to **FG to BG (RGB)** in the Tool Options dialog and be sure the Mode is set to **Normal** and the Opacity to **100 percent**. Drag from the center of the selection to the outside edge of the selection.

Unlike the shapes in other tutorials, this sphere isn't shiny—yet.

Adding Highlights

1. Add a transparent layer and name it *Lower Highlight*. Be sure this layer is at the top of the stack in the Layers dialog. Shrink the selection (**Select ▸ Shrink**) by **2 pixels**. Reset and invert the foreground and background colors (type **D** and then **X** in the image window) so the foreground is now white.

2. Select the **Blend** tool from the Toolbox. In the Tool Options dialog set the Shape to **Radial** and the Gradient to **FG to Transparent** with **Reverse** button set, and then drag from the center of the selection to the outside edge of the selection.

3. Add a white layer mask to the Lower Highlight layer. Reset the foreground and background colors in the Toolbox. Choose the **Blend** tool from the Toolbox and set the Shape

to **Linear** and the Gradient to **FG to Transparent** (with the **Reverse** button turned off) in the Tool Options dialog. Drag in the image window from the top of the icon to the bottom.

4. Change the Lower Highlight layer's mode to **Overlay**.

5. Add a transparent layer and name it *Upper Highlight*. Be sure this layer is at the top of the stack in the Layers dialog. Shrink the selection by **2 pixels** more.

6. Choose the **Ellipse Select** tool from the Toolbox. Click in the selection in the canvas to activate it. In the Tool Options dialog, set the Size to **134 × 80** and the Position to **254 × 107**. This creates a small flat oval selection at the top of the green sphere. Click over the selection to finish editing it.

7. Reset and invert the color swatches in the Toolbox to make the foreground color white. Use the **Blend** tool with a **Linear** shape and **FG to Transparent (no Reverse)** gradient, and then drag from the top of the selection to the middle of the selection.

8. Clear the selection.

A variation on this design might include rotating the Upper Highlight 45 degrees to the left or right.

Adding the Application ID

1. Choose the **Text** tool from the Toolbox. Choose any font—Nimbus Roman No.9 L Bold (commonly available on Linux systems) is used here. Set the Font size to **160** and the Color to **White** in the Tool Options dialog. The font size might be different on your system depending on the selected font.

2. Click the center of the sphere and type an uppercase **G** (for GIMP), centering it over the sphere with the **Move** tool.

Icons are typically quite small. While you can certainly place more than one letter in the icon, avoid writing complete words or phrases because they'll just appear as clutter if the icon is made smaller.

Further Exploration

To save the icon itself, delete the white background layer and use the Crop tool to crop the image, leaving a small amount of transparent space around the icon. Export the image as *GIMPIcon.png* or *GIMPIcon.jpg*. Scale the icon down as needed before placing it in your website.

The background and sphere can be used to create a common theme for your icons. To reuse the background and sphere, turn off the visibility of the Text and Background layers, then merge the visible layers. Drag the resulting layer onto the Toolbox to open a new image with just the merged contents. Export this as *IconBG.png*. Don't save as a JPEG because that format doesn't support transparency!

Later you can reopen the image, add the text layer, and export as a new icon.

TIPS FOR WEB DESIGN

GIMP is a tool capable of producing high-quality images for any design project—no matter what the medium—and its core support for RGB and indexed images makes it ideal for web design. Keep the following tips in mind as you begin using GIMP to create images for your websites.

Use GIMP for Images, CSS for Design

GIMP gives you the tools to create website images, but you need something more sophisticated to provide layout rules and organize your creations for a coherent user experience. CSS is it. Web design is now as much about layout as it is about graphics. Good web design encompasses both CSS and GIMP.

The Right Units

Web design requires images intended for viewing on video displays. Most monitors today, including smartphones, use LCD or LED technology, so most images should be scaled to 72 ppi or 98 ppi. Before doing web design work, be sure to set your resolution preferences (Edit ▸ Preferences ▸ Default Image) to 72 pixels or 98 pixels, instead of print units such as inches or millimeters.

Add Contrast Where Necessary

If you're placing text over a background in an image bound for the Web, be certain there's sufficient contrast between the edges of the text and the background. A low-contrast image might look good on a designer's high-end display, but you can't guarantee that all visitors to the website will see the image in the same way. Adding a drop shadow or outline can help separate the text from the background. A text screen is another option. For a more detailed discussion on screening text, see Section 2.7.

Avoid Busy Backgrounds

Backgrounds should be seen but not heard. A loud background is a bad design choice. If your eye is drawn to a background, chances are the background is distracting your visitors from the web content. To make your text pop, first reduce the contrast in the background image. Then desaturate the image and fill it with a light color using the Bucket Fill tool with its Mode set to Color or Grain Merge. You may need to choose a low setting for the Opacity.

Choose File Formats Wisely

There's a reason so many different image file formats have been developed: not every format works well in every situation. If you have solid text in an image with no gradients, use the GIF format. Because it uses only 8 bits per pixel for color information, the GIF format works well for images that have only a few colors (256 or less) and strong contrast (like black text on a white background). The GIF format also provides *lossless compression*, which means it compresses the image as much as possible without sacrificing image quality. But skip the GIF format if you have photographs to display.

They're better handled with the JPEG format, which was specifically designed for photographs based on how the human eye perceives color. Using 24 bits (three 8-bit RGB channels) to represent each pixel, the JPEG format easily handles up to 16 million colors. Unlike the GIF format, the JPEG format's compression is described as *lossy*, which means (theoretically, at least) that by using it you're throwing away data. The actual data loss is usually trivial, however, and you can specify how much to compress an image, depending on the degree of quality loss you're willing to accept. A bigger disadvantage for some GIMP artists may be that the JPEG format doesn't handle transparency information. The GIF format does, but it can only interpret transparency as on or off for any given pixel, leading to "stairsteps" in nonrectangular regions of your image.

The PNG format, on the other hand, can handle various levels of transparency and millions of colors. It also offers *lossless compression*, so no data is sacrificed. Not all browsers fully support the PNG format, though modern browsers, such as those provided with Windows Vista, Mac OS X, and any recent Linux distribution, should have no problem. For example, some older versions of Internet Explorer can't display PNG images if they contain transparency information. If only all website visitors used Firefox!

Another option is to force visitors to use an external program to view your images. Firefox's MIME Type Editor extension allows the visitor to configure external programs to handle various file types. Designers or photographers who provide sample hi-res copies of their work in private web galleries may choose this option. Full-color TIFF images might be appropriate in such a case, though thumbnail previews would still need to be GIF, JPEG, or PNG files because they would be displayed by the browser.

Choose file formats wisely. Using JPEG images for every project isn't a good enough solution. And if you think choosing among these options is annoying, just wait until the Web (and all those browsers) finally support vector images. Viva la SVG!

Scan for the Web

If you can't find suitable clipart on the Internet or in a book, you can always scan real-world objects, desaturate the resulting image, and then reduce the image's color range using the Levels, Curves, or Posterize tools. Windows and Mac users have built-in system support for scanners. Scanner support for Linux is available from the SANE project at *http://www.sane-project.org/*. The XSane plug-in is required to scan directly from GIMP and is available at *http://www.xsane.org/*. SANE and XSane are included in most recent Linux distributions (such as Fedora and SuSE), though they still require manual configuration. Read the man pages or check the project websites for more information about configuring your scanner.

Subtle Gradients

The use of gradients in background images is generally overlooked by visitors, but it can mean the difference between an average website and a professional design. Sections 3.1, 3.2, and 3.3 used gradients in website buttons. Consider using extremely subtle, desaturated gradients in background images, with a light dusting of desaturated noise for texturing.

Transparency in Web Design

Transparent images using PNG allow for seamless blending with their backgrounds. CSS and JavaScript allow styling the background of images based on conditions, such as time of day. Mixing a well-constructed transparent PNG image with time-based backgrounds allows the same image to be used for different effects.

Choosing the Right Colors

Web design also encompasses the use of proper color mixing. Choosing a color scheme for a website is just as important as the images you display. Choosing the right color mixture has a lot to do with how color affects individuals though processes. Reds can be stimulating and incite aggressive behavior—or spur the viewer to action—while blues then to invoke sensitive responses.

Study the psychology of color's effects on behavior when choosing a color palette for the Web. Search the Internet for online color-mixing tools. Here are some of my favorites:

Color Mixers *http://www.colormixers.com/mixers/cmr/*
EasyRGB *http://www.easyrgb.com/*

Export Safely

GIMP 2.8 changed File ▸ Save so that it no longer saves to anything but GIMP's native XCF file format. To save to some other file format, use File ▸ Export. If you'll be using your image in a web design, export it to the appropriate file format: JPEG, GIF, or PNG. When you export a layered image to an image file format suitable for the Web, GIMP will automatically merge all visible layers. This costs you nothing in effort and won't change your existing layered canvas. But don't forget to save the layered version as an XCF file as well, just in case you need to edit the layers later.

4

ADVERTISING AND SPECIAL EFFECTS

Advertising is about presenting a message to a target audience as effectively as possible, for the least possible cost. GIMP can't help you rein in your media costs or identify your target audience, but it can help you present a compelling product message. The tutorials in this chapter utilize GIMP tools you've already encountered in this book, building on skills you've developed and teaching you how to apply those skills to common advertising tasks.

Print vs. Web

An advertisement's destination dictates its design. Understanding the requirements and limitations of the destination medium is an important part of the advertising design process. Creating web ads doesn't require as much time, effort, or computer memory as creating print ads, but the nature of the Web limits advertising in many ways.

Web ads are designed to be viewed on computer monitors, so the images are usually small and measured at the monitor's resolution, typically 72 or 98 ppi. Web ads are also displayed in the same RGB format in which the images were created. For these reasons, they're a bit easier to create than print ads, but because the monitor resolution and screen space are limited, web ads can't show as much detail.

In comparison, print ads are usually larger and measured at higher resolutions (150 dpi to 300 dpi), which require far more computer memory to produce. Additionally, print ads created in RGB generally must be converted to the CMYK format the printer requires. Because GIMP doesn't currently support direct manipulation of images in CMYK, your ads will be created in RGB, and the conversion process will have to be handled by the printer or a third-party service bureau.

NOTE *If you're not afraid of the command line, you can also try using the ImageMagick suite of command-line tools to handle image color conversion. If RGB images are built with the Little CMS (LCMS) library, the Convert tool can convert them to CMYK using International Color Consortium (ICC) profiles. Your personal printer probably has ICC profile files, and GIMP supports their use even if it doesn't work directly with CMYK color.*

Stock Images

Most web and print advertising work starts with stock images. Luckily, the Internet has opened up stock image collections to the masses and reduced the cost of those images in the process. These images are ideal for use in web ads because they're inexpensive, of reasonable quality, and available in many sizes. Most stock image collections provide images in GIMP-supported formats such as TIFF and JPEG, and prices on low-cost stock image websites like BigStockPhoto.com, iStockphoto.com, and CanStockPhoto.com range from $1 to $5 per image.

You can use low-cost stock images for some print ads, though for projects like posters and banners it may be best to use images from professional stock image collections instead. Professional stock image services usually offer much larger images, ones that are big enough to suit large-scale print projects. In addition to per-file downloads, professional stock image services may also sell complete CD collections or provide monthly subscriptions. Prices vary greatly, however. A single image might cost $80 to $200, while a CD collection might cost around $500. Websites like ThinkStockPhotos.com and GettyImages.com charge approximately $199 per month and $1,200 per year for subscriptions.

Online stock image collections typically offer each image in a few different sizes. These image sizes are generally given in pixels, and you'll want to buy the largest version of the image you can afford. This will allow you to scale down the image to a size appropriate for your project. Remember that the dots per inch (dpi) value for print ads (150 dpi to 300 dpi) is different from pixels per inch (ppi) for web ads (72 ppi or 98 ppi). An image that is 1,200 pixels wide is 4 inches wide when printed at 300 dpi for a magazine (300 dpi × 4 inches = 1,200 pixels), but it's over 16½ inches wide when printed at 72 dpi for the Web!

NOTE *In practice, there is no difference between dpi and ppi; both are references to points of color per inch. Dpi is generally used in printing, whereas ppi is used for monitors.*

Another issue to consider when using stock images is licensing. Many low-cost stock image collections license all of their images for a wide range of uses, but some allow each photographer to specify his or her own license parameters. Professional stock image services have very specific licensing policies. You'll need to read the licenses carefully to determine whether or not you can use the image as you'd like.

The issue of model releases is also tricky. A *model release* is written permission to use the likeness of a person, place, or identifying mark (such as a logo) that might otherwise have limited rights of use. Model releases are most often used in connection with photos of people and are required if the individual's face is recognizable.

Most stock image websites require that anyone submitting a photo of a person also include a model release giving permission to use the likeness in other projects. A model release allows a designer to use a stock image for a wide range of purposes but protects the model's image from misuse.

NOTE *A very detailed guide to model releases is available at* http://www.danheller.com/model-release.html.

Most advertising projects make use of stock photos.

Color, Contrast, and Grayscale

Flip through any glossy trade magazine, and you'll see how color and contrast are used effectively in print advertising. GIMP offers several tools for enhancing existing colors, among them the Curves, Levels, and Hue-Saturation tools. Each of these can be used to add pizzazz to an image or to alter an image's mood. The Brightness-Contrast tool is often used in conjunction with these other tools to make overall ambient lighting changes.

While color grabs the viewer's attention, you can choose Colors ▸ Desaturate to remove color from an image, leaving just contrasting white, black, and gray to achieve a subtler effect. The level of contrast in a grayscale image sets the mood: a high-contrast grayscale image conveys energy, while a softly blurred grayscale image evokes a feeling of calm and lends the subject a sense of style and class. GIMP offers many tools for controlling contrast in grayscale images, including numerous layer and tool blend modes.

Use the Curves tool to increase contrast and achieve more dramatic lighting effects.

Used in this context, grayscale is not the same as the Gray-scale mode (Image ▸ Mode ▸ Grayscale). In Grayscale mode an image has no color content, because it only has a gray channel. In the case of desaturated RGB images, the color content has been removed, but because the image is still in RGB mode, color can be added back in.

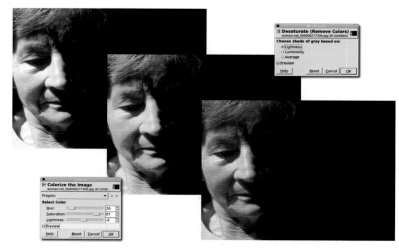

Desaturated images (like the one on the left) are RGB images where the Saturation is set to 0. The Hue and Lightness may be set to any value. The colorized images (center and right) result from changing all three settings.

Lighting plays an important role in advertising, whether the images are color or grayscale.

There's another reason to consider desaturating images with GIMP: you can add color back in at any time—any color you choose. Colorizing a desaturated image is one more way to set the mood for an advertisement. A range of blues can be cold and harsh, while rich reds and yellows are warm and energetic.

It's Up to You

GIMP gives the graphic designer many ways to create eye-catching advertisements. The tutorials in this chapter are less about learning new techniques than they are about practicing what you've already learned. Tutorials elsewhere in this book show you how to create 3-D images and reflections or enhance color and lighting. Try applying these techniques to stock photographs and you'll soon find that in the hands of a creative designer, the possibilities are endless.

4.1 CREATIVE TEXT DESIGN

The ordinary becomes extraordinary, with a little help from GIMP.

GIMP is first and foremost a tool for working with raster images. Most desktop users will prefer to work with GIMP when dealing with their digital photographs but might choose other tools like Inkscape or Scribus when working with text. Yet GIMP does a great job with text effects in ways that people might think can only be done with those vector applications.

In this tutorial I'll walk you through a little text trick I stumbled upon in a design magazine. The goal of the project is to map an image onto text but keep the original image recognizable. In the original magazine article, the process was handled using Adobe InDesign, a vector layout tool. It does clever things with text using boxes to align and block objects within the layout. Fortunately, this particular effect turns out to be even easier to produce with GIMP than with InDesign.

Projects like this have important periphery components beyond just the text. This design requires a source image with sufficient color and contrast. Without color and contrast, the shapes within the image won't be recognizable through the text.

The project also requires a suitable font. The font should be thick and without any serifs. Serif fonts clutter the final image and in most cases won't allow as much detail from the source image to be displayed, even when bold versions of the serif font are used. Serif fonts can also make text from the image difficult to recognize.

GIMP's text features make actual design possible in a few minutes, with a limited sequence of steps. Before diving in, take a look at some of those periphery issues.

Selecting a Stock Image

To start the project, select an appropriate portrait from one of the many stock image sites on the Internet. The one in this tutorial comes from BigStockPhoto.com. The picture should ideally include two important features. The first is a solid-colored background. A multicolored or otherwise cluttered background makes it harder to isolate the subject of the image when you apply your text effect.

The second important feature is color contrast. An all-black image would work but would end up being mere shadow-filled text. For this project, I selected a woman in a black dress with enough skin tones to provide some color contrast. Later you'll add to that contrast with a soft vignette.

Choosing a Font

This effect works best with thick, straight-edged fonts (script fonts don't show the image well, even when boldface type is used). In this tutorial, I'm using the ErgoeExtrabold Thin font, but any sans bold font, such as Tahoma Bold, will suffice.

1. Select the **Text** tool and open the Tool Options dialog (**Dialogs ▸ Tool Options**). Near the bottom of the dialog are three options: Indent, Line Spacing, and Letter Spacing. You won't be using the Indent option but will use the other two.

2. Line Spacing sets the space between lines. You want to decrease this (to negative values) so the lines of text will be as close together as possible, without overlapping.

3. Letter Spacing just sets the area between letters. This is similar to kerning but not exactly identical. Again, the technical explanation isn't important here. You just want to reduce this setting (also to negative numbers) to reduce the space between letters, the closer the better.

Lorem ipsum dolor sit amet, consectetur adipiscing elit. Proin ac quam nisi, sit amet sodales mauris. Pellentesque habitant morbi tristique senectus et netus et malesuada fames ac turpis egestas. Integer quis vulputate leo. Maecenas blandit pellentesque mauris, ac porttitor enim pellentesque eget. Cras neque mi, faucibus at pharetra ut, ultrices id orci. Cras ac ipsum ut ligula rhoncus varius. Pellentesque aliquet elit scelerisque massa eleifend aliquam. Sed sed eros vitae lectus molestie pharetra id a justo. Etiam at ullamcorper dui. Maecenas nunc felis, auctor a pretium vel, accumsan sed lacus.

Tahoma Bold

Lorem ipsum dolor sit amet, consectetur adipiscing elit. Proin ac quam nisi, sit amet sodales mauris. Pellentesque habitant morbi tristique senectus et netus et malesuada fames ac turpis egestas. Integer quis vulputate leo. Maecenas blandit pellentesque mauris, ac porttitor enim pellentesque eget. Cras neque mi, faucibus at pharetra ut, ultrices id orci. Cras ac ipsum ut ligula rhoncus varius. Pellentesque aliquet elit scelerisque massa eleifend aliquam. Sed sed eros vitae lectus molestie pharetra id a justo. Etiam at ullamcorper dui. Maecenas nunc felis, auctor a pretium vel, accumsan sed lacus.

ErgoeExtraBold Thin

Lorem ipsum dolor sit amet, consectetur adipiscing elit. Proin ac quam nisi, sit amet sodales mauris. Pellentesque habitant morbi tristique senectus et netus et malesuada fames ac turpis egestas. Integer quis vulputate leo. Maecenas blandit pellentesque mauris, ac porttitor enim pellentesque eget. Cras neque mi, faucibus at pharetra ut, ultrices id orci. Cras ac ipsum ut ligula rhoncus varius. Pellentesque aliquet elit scelerisque massa eleifend aliquam. Sed sed eros vitae lectus molestie pharetra id a justo. Etiam at ullamcorper dui. Maecenas nunc felis, auctor a pretium vel, accumsan sed lacus.

Times New Roman Bold

All three samples are set to 51 pixels. Tahoma Bold is commonly available on Windows systems and available from the Wine Fonts collection under Linux or free font archives on the Internet.

Adding a Vignette

Now you're ready to start the tutorial. The first thing is to add a soft vignette. This makes the final image more colorful while keeping the woman's shape recognizable.

1. Add a transparent layer above the main layer (**Layer ▸ New Layer**) and name this new layer *Vignette*.

2. Choose the **Ellipse Select** tool from the Toolbox and draw an oval selection in the canvas around the girl. Then feather the selection (**Select ▸ Feather**) by **100 pixels**.

3. Choose a warm color, such as the **231/127/35** used here, from the Change Foreground Color dialog that opens by clicking on the foreground color box in the Toolbox.

4. Choose the **Gradient** tool from the Toolbox. In the Tool Options dialog, set the Gradient to **FG to Transparent** and the Shape to **Radial**. Click and drag in the canvas from the middle of the selection to just past the top of the selection. Set the Vignette layer's mode to **Multiply**.

The vignette will add a splash of color to the final image. Experiment with different color choices to see how it affects the design.

5. A little noise can be added here for artistic effect, but this step is optional. Open the HSV Noise filter (**Filters ▸ Noise ▸ HSV Noise**) and set the Holdness to **2**, the Saturation to **255**, and the Value to **255**. The default setting for Hue should be left at **3**. Apply this to the Vignette by clicking **OK**. The noise will be applied within the selection and only to colored pixels, not transparent ones.

6. Clear the selection (**Select ▸ None**) and merge the Vignette and Background layers (**Image ▸ Flatten Image**).

The vignette will add some additional color to the final image. Adding noise is optional and may not be visible, depending on the font thickness.

Adding a Text Layer

The text used for this tutorial can be from any source. Since most of the text won't be visible, it doesn't help to use text you expect to read, though many letters will be legible. The text here amounts to 1,500 words from the Lorem Ipsum Generator formatted with no line breaks, which was then loaded into the Text Editor window. If this isn't long enough, copy and paste it again below the first block of text.

1. Reset the default colors in the Toolbox by typing **D** in the canvas. Choose the **Text** tool from the Toolbox and then click and drag in the image. This displays the editing box in the canvas where you can type text. Drag the handles in the editing box so it covers the girl and vignette. Click inside the editing box and paste the Lorem Ipsum text copied from your browser.

2. In the Tool Options dialog, set the font (ErgoeExtrabold Thin is used here), size, line spacing, and letter spacing as discussed previously. (Set the font and size before changing the spacing.) You'll also want the text in black so you can see it in the canvas. Set the line spacing to **–12** and the letter spacing to **–3**. This is sufficient to push the letters up against each other horizontally and vertically without overlapping, at least for this specific font and size.

Initially the text may not be aligned with the rest of the image, but that can be fixed with the Align Tool.

3. Drag the Text Box handles so the text covers the entire image, making the bounding box larger than the canvas.

4. Use the **Align** Tool to align the text layer with the top and left sides of the image window.

5. Make the text layer fit the size of the image window (**Layer ▸ Layer to Image Size**).

With the canvas zoomed out, the text layer is visibly larger than the background layer. This will provide some flexibility to find just the right fit for your mask.

Creating a Mask Layer

Now you're ready to create your mask. Unlike with other projects, you won't use the Layer Mask feature of GIMP. Instead, this mask is simply a white layer over the text layer. What you're going to do is paste over the original image with a white layer with text stamped out of it. Where the text is stamped out, the original image shows through.

1. Add a white layer to the image (**Layer ▸ Layer New**) and name it *White*. Drag this layer in the Layers dialog below the background layer with the woman in the black dress. Drag the text layer below the background layer too.

2. Click the text layer in the Layers dialog to make it active. Create a selection of the text (**Layer ▸ Transparency ▸ Alpha to Transparency**). Invert the selection (**Select ▸ Invert**).

3. Click the **White** layer in the Layers dialog to make it active. Copy the selection (**Edit ▸ Copy**). Paste the copy (**Edit ▸ Paste**). This creates a Floating Selection in the Layers dialog. Convert this to a new layer (**Layer ▸ To New Layer**).

4. Turn off the visibility of the text layer by clicking the Eye icon to the left of the layer thumbnail in the Layers dialog.

5. Click the Original layer containing the woman in the Layers dialog to make it active. Choose the **Move** tool from the Toolbox. Hold down the SHIFT key and click and drag in the canvas to move the woman and vignette around under the mask. Zoom in, if necessary, to get a closer look at the result.

This is the final image, except you may want to adjust the position of the mask over the background image.

Further Exploration

Moving the source image around under the mask may not be sufficient to get a quality result. You may need to adjust the text layer font size or the line or letter spacing. You may even need to try a different font. If any of this becomes necessary, turn off the visibility of the mask layer first and then duplicate the text layer. Adjust the font settings in the text layer duplicate. Then repeat the selection, invert, copy, and paste process to create a new mask. Keeping multiple versions of the text layer and masks lets you compare the masks and return to the version that looks best without having to re-create it later.

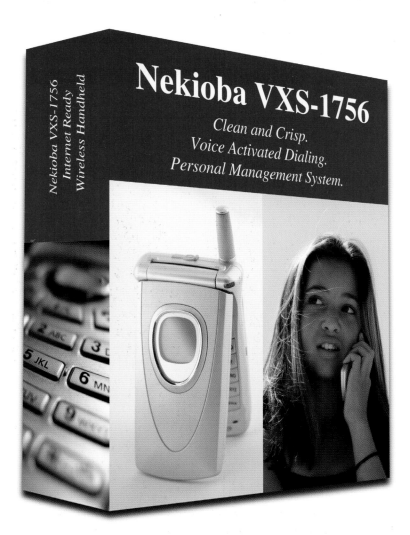

Three-dimensional objects are a snap to create using the Perspective tool.

Sometimes an ad needs to include a 3-D object that you don't have available to photograph, such as a product package. There are many ways to use GIMP to simulate three dimensions. The most common method uses drop shadows to simulate a light source and add a sense of depth. But drop shadows only place one plane above another. They can't add depth to the image itself.

Fortunately, light and shadows aren't the only tricks available to GIMP users. You can also play with perspective. The Perspective tool in GIMP's toolbox provides a simple interface that allows you to change the direction from which an object is viewed; for example, you might choose to view the image head-on or to rotate it and view it at an angle. If you need to use 3-D packages in your designs, it's best to get familiar with the Perspective tool.

In this tutorial you'll create a 3-D product package for a fictitious mobile phone manufacturer. You take a set of images, arrange them to form the front and sides of the box, align the sides, and then angle the box away from the viewer. As is often the case, you'll save a lot of time if you choose stock images wisely. The actual layout and perspective changes are relatively simple tricks that bring the stock images to life.

This project is scaled for use on the Web, which generally uses 98 ppi for images. To produce the same effect for a print project, leave the original canvas at 300 dpi and scale up the processes accordingly.

Preparing the Front of the Box

1. Open a new canvas window by choosing **File ▸ New** in the tool-box. In the Create a New Image dialog that pops up, choose the **US Letter** template. Making this choice will change the settings in the Advanced Options section. For this project, which is bound for the Web, change the resolution to **98 ppi**.

2. Add a vertical guide (**Image ▸ Guides ▸ New Guide (by Percent)**) centered on the canvas. This will be a visual cue to center the stock photos on opposite sides of the canvas.

3. Open your two stock images and scale each one to about 5 inches wide—a little more than half the width of the new canvas (**Image ▸ Scale Image**). In this example I use a photo of an older-model mobile phone and a photo of someone using a phone.

You can scale the stock images before you copy and paste them, or you can copy and paste them and then scale the new layers by choosing Layer ▸ Scale Layer. Use the method easier for you, because the result will be the same.

4. Copy and paste each stock image into the canvas as a new layer by choosing **Layer ▸ New Layer** after pasting each image. Name one layer *Mobile Phone* and the other layer *Girl*.

5. Use the **Alignment** tool from the Toolbox to left-align the Mobile Phone layer and to right-align the Girl layer, both along the bottom edge of the canvas. To use this tool, first choose the tool, and then click the layer in the canvas. Using the arrow buttons in the Tool Options dialog, align the layer relative to the image at the correct canvas edges.

6. Arrange the layer stack so the Mobile Phone layer is on top in the Layers dialog. If necessary, use the **Move** tool to manually adjust the Mobile Phone layer so the phone is roughly centered on the left half of the canvas.

7. Click the **Mobile Phone** layer in the Layers dialog.

8. Add a white layer mask (**Layer ▸ Mask ▸ Add Layer Mask**).

9. Use the **Rectangle Select** tool to create a selection to the right of the guide that encloses the Girl layer.

The layer mask on the Mobile Phone layer is used to mask out any part of the layer overlapping the right half of the canvas.

10. With the canvas selected, press **D** to reset the foreground and background colors to black and white, respectively.

11. Make sure the layer mask is still active for the Mobile Phone layer by clicking the mask, and then drag the foreground color (black) from the toolbox into the selection. This will mask out the part of this layer overlapping the Girl layer.

12. Clear the selection (**Select ▸ None**).

13. With the Girl layer now properly visible, be sure to center the image of the girl on the right half of the canvas as necessary.

When the Girl layer is active in the Layers dialog, that layer's left edge is hidden by the Mobile Phone layer. There's no need to trim off that portion of the Girl layer because it'll never be seen.

NOTE *Another way to test if the layer mask is active is to check whether the layer boundary in the canvas is green instead of yellow.*

Creating a Patch

At this point we need to remove the white strap on the girl's shirt because it distracts from the image. (Even if the image you're using for this project doesn't require a similar fix, you can use this technique whenever you need to remove some distracting element.) While coloring the strap is an option, a much simpler solution is to clone some of the girl's hair and use it to cover the strap.

NOTE *For more cloning practice, see Section 2.8.*

1. Turn off the visibility of the Mobile Phone layer in the Layers dialog while patching the Girl layer. Click the **Girl** layer to make it active.

2. Zoom in on the image and use the **Free Select** tool to draw a selection around the white strap. Use the **Move** tool, changing to **Selection** in the Tool Options dialog, to drag the selection up till it covers just the girl's hair.

3. Feather the selection by **3 pixels** (**Select ▸ Feather**), and then copy and paste it as a new layer (**Layer ▸ To New Layer**).

4. In the Layers dialog, move the new layer down to just above the Girl layer, and then use the **Move** tool, changing back to **Layer** in the Tool Options dialog, to position the new layer so it covers the white strap.

5. Add a white layer mask, and then use the **Airbrush** tool to paint black over the patch and blend the new layer with the original image.

6. Merge down (**Layer ▸ Merge Down**) the patch layer with the original Girl layer.

7. Turn the visibility of the Mobile Phone layer back on.

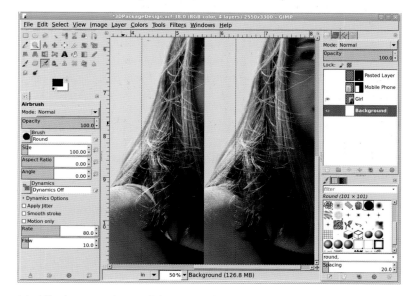

It's difficult to spot the patch because it blends so well with the Girl layer.

Adding Text to the Front of the Box

Now that the images have been cleaned up, you can create the upper half of the package, the portion that contains the product text.

1. Click the **Background** layer to make it active.

2. Click the foreground color box to open the Change Foreground Color dialog. Set the RGB values to **6/6/155** for the blue shown here, and then click **OK** to apply the change.

3. Drag the foreground color into the Background layer to add a blue bar that runs across the top of the box.

The product name will be placed inside the blue bar that runs across the top of the box.

4. Choose the **Text** tool from the toolbox. With the canvas selected, press **D** and then **X** to reset and then swap the foreground and background colors. Choose an appropriate font and size for the product name and description—I used Nimbus Roman No9 L Italic sized to 90 pixels.

5. Click the canvas to open the Text Editor window. Type a fictitious manufacturer name and model number like *Nekioba VXS-1756.*

6. Use the **Move** tool to center the text layer manually, and then add another text layer containing some descriptive text set in smaller type.

7. Save this image as *front.xcf*, and then flatten the image (**Image ▸ Flatten Image**). Scale the image (**Image ▸ Scale Image**) to **80 percent** of its current size.

Use a larger font for the manufacturer name and model number. Tag lines fill the empty space below.

Creating the Side of the Box

1. Open a new image, again using the **US Letter** template set to **98 ppi**. Scale down this canvas to **3 inches** in width but leave the height at 11 inches.

2. Click the foreground color box and select the blue used earlier from the presets or set the RGB values to **6/6/155**. Close the Change Foreground Color dialog, and then drag the foreground color onto the new canvas. If you like, add another stock photo to the bottom of the canvas.

If you add a stock photo, scale it to slightly more than half the height of the new image and align its bottom edge with the image window. Use Layer ▸ Layer to Image Size to crop the stock photo layer to the size of the image window.

3. With the canvas selected, press **D** and then **X** to reset the foreground color to white.

4. Choose the **Text** tool from the toolbox. Choose an appropriate font and size—I used Nimbus Roman No9 L Italic sized to 40 pixels. Retype the text that appears on the front of the box, or modify it if you prefer.

5. Rotate the text layer counterclockwise by 90 degrees (**Layer ▸ Transform ▸ Rotate 90 degrees counter-clockwise**) and then use the **Move** tool to manually position the text in the blue area on the side of the package.

6. Save this image as *side.xcf.*

7. Flatten the image (**Image ▸ Flatten Image**) and then scale down the image to **80 percent** of its original size.

First create the text for the side of the package, and then rotate the text. If the text doesn't fit the space well, press CTRL-Z to undo the rotation, choose the Text tool from the Toolbox, click the text layer, adjust the text in the Tool Options dialog, and rotate the text once more.

Merging the Front and Side Panels

1. With the toolbox selected, press **D** to reset the background color to white. Open a new white canvas using the **US Letter** template set to **98 ppi**.

2. Copy and paste the front and side images into this canvas as new layers (**Layer ▸ To New Layer**). Name the new layers *Front* and *Side*, respectively.

3. Add a vertical guide **3 inches** (3 × 98 = 294 pixels) from the left edge and then add a horizontal guide **1 inch** from the top.

4. Click the **Front** layer and use the **Move** tool to align the left and top edges of the layer with the intersection of the guides. Click the **Side** layer and drag to align the right and top edges of that layer with the intersection of the guides. Both images will fit on the canvas vertically. Don't worry if the sides spill over the edges of the canvas. Just press the minus key to zoom out and make it easier to work on the canvas.

You can also drag guides out of the rulers, though by default the rulers measure in pixels. You can change the units of measure by choosing from the drop-down menu in the lower-left corner of the canvas window.

5. Add another vertical guide at **8 inches**. This marks where the front right edge of the box will end up.

6. Click the **Front** layer in the Layers dialog to make it active.

7. Choose the **Perspective** tool from the toolbox, and then click the canvas. Drag the top and bottom control points on the right side of the Front layer toward the horizontal center of the canvas until they line up with the vertical guide at 8 inches and slightly toward the vertical center of the image. Click the **Transform** button in the Perspective Transform dialog to apply the changes.

A perspective transformation makes the front of the box appear to be closer on the left and farther away on the right, as it would be if the box were angled away from the viewer.

8. Add a vertical guide **1.5 inches** from the left edge of the canvas to mark where the left side edge of the box will end up.

9. Click the **Side** layer in the Layers dialog to make it active.

10. Choose the **Perspective** tool from the toolbox, and then click the canvas. Drag the top and bottom control points on the image's left side toward the horizontal center of the canvas until they line up with the vertical guide at 1.5 inches and slightly toward the vertical center of the image.

Adding perspective to the side panel transforms the flat images into a realistic box. But we're not quite done with this project.

A drop shadow gives the box an even more three-dimensional appearance.

Cleaning Up the Edges

1. Remove all guides (**Image ▸ Guides ▸ Remove All Guides**).

2. Merge (**Layer ▸ Merge Down**) the Front and Side layers by first clicking on the higher layer in the Layers dialog—this will merge the front and side panels into a single layer and leave the merged layer separate from the background.

3. Add a drop shadow (**Filters ▸ Light and Shadow ▸ Drop Shadow**), setting the Offset X value to **0 pixels** and the Offset Y value to **12 pixels** to cast a shadow that simulates a light source directly in front of and above the box. The Opacity should be set to **80 percent** so the background can show through it slightly. The Blur Radius is dependent on the size of the image. For this image, which is bound for the Web, a blur of **15 pixels** produces a very soft-edged shadow.

Further Exploration

In the first edition of this book, this tutorial had additional steps to clean up jagged edges after the perspective transforms. The latest version of GIMP no longer has this problem, making this tutorial that much easier.

For added effect, consider changing the location of the shadow or adding additional shadows to make light appear to come from different directions. A rectangular selection modified with the Perspective tool, filled with black, and then placed behind the box with the bottom edges closely aligned can give the appearance of a light source shining directly on the front of the box and that the box is set atop a surface. Adjusting the brightness of the side panel is another trick that you can play with lighting in this project.

Advertising is a name game, and attention spans are running short. If you want to get your message across, you'll need to establish the *who* and the *what* quickly. A logo is the centerpiece of a corporate identity, and it can do a lot to increase name recognition. While logo designs themselves are often quite simple, they can be placed near or inside other objects for added effect. Glass can reflect a company's identity in a big way.

Glass effects are really just tricks with lighting and shadows. In previous tutorials you used lighting to simulate depth in an image. Shadows, too, provide a sense of depth by implying that another surface exists behind or below the main subject. Reflections can also be used to lend texture to a surface. In this tutorial you'll learn how to use reflections to simulate a rounded, glassy surface.

This technique is easy to learn, but you may need to experiment to get the reflections just right. The trick is to create cutouts from an existing selection. And notice the use of paths in this tutorial—the two endpoints of a path will be connected when they are converted to a selection, and in this tutorial you want the line between those two endpoints to be outside an existing selection.

Getting Started

To make sure that the default colors are being used, press **D** in the canvas area to reset the foreground and background colors. Start with a white canvas set to 640 × 480 pixels. The techniques used in this tutorial scale up easily enough, so it's okay to work with a canvas that's set to a small size and 98 ppi until you get it right.

Reflective surfaces can add an unmistakable polish to your logos.

Adding a Border

1. Open the New Guide dialog (**Image ▸ Guides ▸ New Guide**). Select **Vertical** from the Direction drop-down menu and set the Position to **40 pixels**. Click **OK** to add the guide.

2. Repeat this process to add another vertical guide at **600 pixels**. Then choose **Horizontal** from the Direction drop-down menu and add guides at **20 pixels** and **460 pixels**.

3. Choose the **Ellipse Select** tool from the toolbox. Drag from the upper-left intersection of the guides down toward the lower-right intersection of the guides so the selection touches each of the guides. (The selection should snap to the guides. If it doesn't, verify that **View ▸ Snap to Guides** is set.)

Guides form a bounding box for the elliptical selection. Because the guides are precisely positioned, it's easy to center the oval on the canvas.

When you drag the foreground color from the toolbox into the selection, the yellow you've chosen fills the selection in the new transparent layer.

4. Feather the oval selection by **3 pixels** (**Select ▸ Feather**).

5. Add a new transparent layer by choosing **Layer ▸ New Layer** and setting the Layer Fill Type to **Transparency**. Name the new layer *Border*.

6. Click the Foreground color box in the Toolbox to open the Change Foreground Color dialog. Set the RGB values to **243/217/1** for a bright yellow. Click **OK** to set the foreground color, and then drag the foreground color from the toolbox into the selection.

7. You don't need the guides anymore, so you can remove them (**Image ▸ Guides ▸ Remove All Guides**).

8. Add a new transparent layer by choosing **Layer ▸ New Layer** and setting the Layer Fill Type to **Transparency**. Name this new layer *Edge*.

9. Shrink the selection by **5 pixels** (**Select ▸ Shrink**).

10. With the canvas selected, press **D** to reset the foreground color to black. Drag the foreground color into the selection.

Adding a new layer filled with black does not change the yellow oval (shown here with a transparent background to make it easier to see). This allows you to make minor changes to the border width by modifying the black layer, even after you've completed the rest of the steps in this tutorial.

Creating a Glassy Surface

Now that you have a border, use the Radial gradient to create a glassy surface inside it.

1. Add a new transparent layer by choosing **Layer ▸ New Layer** and setting the Layer Fill Type to **Transparency**. Name this new layer *Green Glass* and be sure it's at the top of the layer stack in the Layers dialog.

2. Shrink the selection by **2 pixels** (**Select ▸ Shrink**) to leave a thin black edge between the yellow border and green glass.

3. Click the foreground color box in the toolbox to open the Change Foreground Color dialog again. This time, set the RGB values to **17/157/43** for the bright-green end of the gradient, and then click **OK** to apply the change.

4. Click the background color box in the toolbox to open the Change Background Color dialog. Set the RGB values to **0/85/16** for the dark-green end of the gradient, and then click **OK** to apply the change.

The two shades of green are very similar, but the background color is a bit darker. Higher-contrast colors produce a surface that either looks more reflective or appears closer to a strong, tight beam of light.

5. Choose the **Blend** tool. In the Tool Options dialog, set the Gradient to **FG to BG (RGB)** and set the Shape to **Radial**.

6. Drag inside the selection from the left focus of the oval (just left of center) to the right edge of the oval.

Shrinking the selection slightly and filling it with the Radial gradient simulates a curved surface with an edge that looks like it's in the shadow of a raised yellow border.

Adding Reflective Highlights on the Right

The gradient already simulates lighting changes on the surface of the emblem, but adding highlights will exaggerate this effect even more.

1. Save the selection to a channel (**Select ▸ Save to Channel**).

2. Click the **Green Glass** layer in the Layers dialog to make it active.

3. Add a new transparent layer named *Highlight Right*.

4. Reset the foreground and background colors by pressing **D** while the canvas is selected.

5. Choose the **Ellipse Select** tool from the toolbox. In the Tool Options dialog, click the third button from the left to select the **Subtract** mode.

6. Drag over the existing selection to create a new oval that covers all but the lower-right and right edges of the selection. It may take a little experimentation to get this just right. If your first attempt fails, press CTRL-Z to undo the change and try again.

It may take a few attempts to make a cutout from the selection that comes close to the one shown here. Note that this new selection can be interactively edited before hitting ENTER to accept the change it applies to the original selection.

7. Once you have the selection cutout just right, drag the background color box (which should be white) from the toolbox into the selection. Deselect all (CTRL-SHIFT-A).

8. Open the Gaussian Blur filter (**Filters ▸ Blur ▸ Gaussian Blur**). Set the Blur Radius to **10 pixels** for both the Horizontal and Vertical directions, then click **OK** to apply the blur.

9. Reduce the Opacity of the Highlight Right layer to **20 percent**.

10. Reset the Ellipse Select tool's Mode to **Replace**.

The white area is blurred, then that layer's Opacity is reduced. This immediately makes the rounded surface look more like glass.

Adding Reflective Highlights on the Left

1. Add a new transparent layer and name it *Highlight Left*.

2. Open the Channels dialog (**Windows ▸ Dockable Dialogs ▸ Channels**). Click the saved channel, which is the last item on the list. Convert this channel to a selection by clicking the **Channel to Selection** button second from the bottom right of the dialog.

3. Return to the Layers dialog and click the **Highlight Left** layer to make it active.

4. Choose the **Path** tool from the toolbox. Click outside the selection, and then trace a path similar to the one shown here. Make sure the first and last grab points in the path form a straight line outside of the existing selection. While holding down the CTRL and SHIFT keys, click the **Selection from Path** button in the Tool Options dialog.

NOTE *If you have trouble working with paths, take a look at Section 1.5.*

Holding down the CTRL and SHIFT keys allows you to use the Paths tool to create multiple selections that intersect the existing oval selection. These become additional reflections on the rounded surface.

5. With the canvas selected, press **X** to swap the foreground and background colors and set the foreground color to white.

6. Choose the **Blend** tool from the toolbox. In the Tool Options dialog, set the Gradient to **FG to Transparent** and set the Shape to **Linear**. Drag from the upper-left edges of the selections to the lower-right edges of the selections. Deselect all (CTRL-SHIFT-A).

7. Open the Gaussian Blur filter (**Filters ▸ Blur ▸ Gaussian Blur**). Apply a blur of **3 pixels** and reduce the Opacity of this layer to **50 percent**.

8. Add a new transparent layer and name it *Highlight Left 2*.

9. As before, retrieve the selection by converting from the saved channel and then shrink the selection by **20 pixels** (**Select ▸ Shrink**).

After you apply a Gaussian blur and reduce the opacity of the Highlight Left layer, the surface of the object appears to be reflecting a panel window.

10. Click the **Highlight Left 2** layer to make it active again.

11. If the foreground color is not white, press **D** and then **X**, and then drag the foreground color box into the selection to fill the selection with that color. Deselect all (CTRL-SHIFT-A).

12. Open the Gaussian Blur filter (**Filters ▸ Blur ▸ Gaussian Blur**) and apply a blur of **5 pixels**.

13. Add a white layer mask (**Layer ▸ Mask ▸ Add Layer Mask**).

14. Open the Paths dialog (**Windows ▸ Dockable Dialogs ▸ Paths**). An unnamed path should exist, created when you used the Paths tool earlier in this tutorial. Click the **Path to Selection** button at the bottom of the dialog (fifth from the left).

15. Invert the selection (**Select ▸ Invert**).

16. Click the layer mask in the **Highlight Left 2** layer to make the mask active, and then fill the selection with black. Deselect all (CTRL-SHIFT-A).

17. Open the Gaussian Blur filter (**Filters ▸ Blur ▸ Gaussian Blur**) and apply a blur of **5 pixels** to the mask.

The layer containing the white oval will be merged with the Highlight Left layer in the next step.

18. In the Layers dialog, set the layer mode to **Grain Merge** and the Opacity to **50 percent**, and then drag the **Highlight Left 2** layer down below the Highlight Left layer.

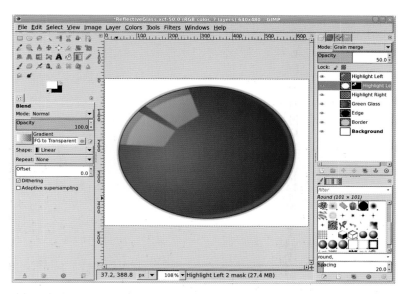

After you've created the layer mask, all that's left of the oval highlight is the area overlapping the window-shaped highlights.

Adding Text and a Drop Shadow

1. With the canvas selected, press **D** and then **X** to set the foreground color to white.

2. Choose the **Text** tool from the toolbox. In the Tool Options dialog, choose an appropriate font and size. Click the canvas and type *Griznak*. Make sure the text layer is at the top in the Layers dialog.

3. Use the **Align** tool to center the text on the canvas.

4. Add a drop shadow (**Filters ▸ Light and Shadow ▸ Drop Shadow**). Set the Offset X and Offset Y values to **2 pixels** and set the Blur Radius to **2 pixels**. Make sure the Allow resizing checkbox is not checked. Then apply the drop shadow by clicking **OK**.

5. Move the text layer and the Drop Shadow layer below both of the Highlight Left layers in the Layers dialog.

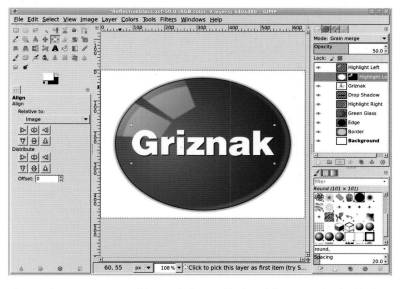

The text layer is positioned beneath the Highlight Left layers so the highlights can affect the drop shadow, giving the appearance that the text is under the glass.

Further Exploration

This effect works well with oval emblems such as this one, though there's no reason why it wouldn't work on a rectangular emblem as well. The key is the soft white layers that simulate reflections of light. These could be reflections of light coming through a window, or they could be the reflections of a nearby surface.

The emblem could also reflect another object, as shown in Sections 2.6 and 2.7. Imagine this is a car dealership's emblem and a car zooming down the road is reflected in it.

Popping is the term used to describe filling a portion of an image's background with white so the image's subject seems to pop off of the monitor or printed page. Advertisements use this technique extensively. It works much as a type screen does, except that in the case of popping, the screen is a solid color and its layer is actually placed between the image's subject and background.

This extreme tutorial will take your GIMP skills to the next level. Radical!

Getting Started

Much of the work in this tutorial involves using the Fuzzy Select tool to make a cutout of the subject—in this case, a skateboarder (sans wheels). The process is relatively simple because there's a high contrast between the background and the foreground. Hold down the SHIFT key, click a few times, and you'll be able to select the background fairly quickly. This may not be true of the stock image you decide to use for this project, but the basic process will remain the same.

Isolating the Boarder

Start with an image of an airborne skateboarder with blue sky in the background. The image will be used to advertise a skateboard invitational in the Rocky Mountain region of Colorado. What's missing in the original image is some indication of where the event will take place. Along with popping the boarder from the image, we need to replace the blue sky with a mountain scene.

The blue sky in the background makes for a nice photo, but it'll need to be replaced for this project.

1. Open the boarder image in GIMP and choose the **Fuzzy Select** tool from the toolbox. Hold down the SHIFT key and click in various places to the left of the boarder and below the board until a nearly solid selection is made. Use the **Quick Mask** to fine-tune the selection.

2. When the entire area left of and below the boarder has been selected, turn the Quick Mask off and invert the selection (**Select ▸ Invert**).

3. Shrink the selection by **1 pixel** (**Select ▸ Shrink**) and feather it by **2 pixels** (**Select ▸ Feather**).

4. Copy and paste the selection as a new layer (**Layer ▸ New Layer**) and name it *Boarder*.

5. Open the Unsharp Mask filter (**Filters ▸ Enhance ▸ Unsharp Mask**). Set the Radius to **5 pixels** and the Amount to **0.50**. Click **OK** to apply the changes.

After you make the selection and copy and paste to a new layer, the Unsharp Mask will enhance the detail in the Boarder layer.

Enhancing the Board Details

The highlights under the board need to be evened out so the board doesn't look so washed out.

1. Use the **Fuzzy Select** and **Quick Mask** tools to make a rough selection of the board's bottom.

2. Grow the selection (**Select ▸ Grow**) by **1 pixel**, repeating this process until most of the board's underside is selected.

3. Feather the selection by **3 pixels** (**Select ▸ Feather**).

4. Use the **Levels** tool (**Colors ▸ Levels**) to modify the white balance on the board by dragging the right-most slider under the histogram slightly to the left, dragging the left-most slider to the right, and making sure the middle slider stays centered. Modifying the black-and-white balance this way will brighten the darker areas of the board and make the hazy underside of the board appear clearer. Click **OK**.

5. Deselect all (CTRL-SHIFT-A).

The bottom of the board appears hazy because of a problem with the lighting. Fix this by selecting the board and moving the left and right sliders in the Levels histogram.

Removing the Background

We've isolated the boarder, but there are still patches of sky and clouds between the boarder's legs and along the sides of his torso. These patches need to be removed so we can swap in the Rocky Mountain background.

1. Use the **Fuzzy Select** tool to make selections of the sky on either side of the boarder's torso and in the space between his right arm and each leg.

2. Feather the selection by **3 pixels** (**Select ▸ Feather**).

3. Add a white layer mask (**Layer ▸ Mask ▸ Add Layer Mask**) and fill the selections with black. Deselect all (CTRL-SHIFT-A). Apply the layer mask (**Layer ▸ Mask ▸ Apply Layer Mask**).

4. Add a new transparent layer and name it *White Backdrop*.

5. Pull a vertical guide from the left ruler until it's just to the right of the boarder's right foot. Unlike in other tutorials, this guide is positioned without an exact pixel location. Choose the **Rectangle Select** tool from the toolbox—be sure the **Replace** mode is set in the Tool Options dialog. Use the guide as the right edge for a selection covering the left side of the layer. Fill the selection with white.

6. Move the **White Backdrop** layer down so it's below the Boarder layer in the Layers dialog.

7. Deselect all (CTRL-SHIFT-A), and then hide the guide (**View ▸ Show Guides**).

When we isolated the boarder, we left some patches of sky and clouds around the body. Use the Fuzzy Select tool to isolate those areas.

The White Backdrop layer is placed below the Boarder layer. This small detail is what makes the boarder seem to pop out of the Rocky Mountain scene and enter the white poster area.

Adding a Drop Shadow

A drop shadow adds to the pop effect.

1. In the Layers dialog, click the **Boarder** layer to make it active.
2. Add a drop shadow (**Filters ▸ Light and Shadow ▸ Drop Shadow**). Set the Offset X and Y values to **5 pixels** and the Blur Radius to **15 pixels**. Set the Opacity to **80 percent** and uncheck the **Allow resizing** checkbox. Click **OK** to apply these settings and create the Drop Shadow layer.
3. Click the **Drop Shadow** layer in the Layers dialog. Add a white layer mask (**Layers ▸ Mask ▸ Add Layer Mask**).
4. Click the **White Backdrop** layer in the Layers dialog to make it active. Create a selection of the transparent region by choosing **Layer ▸ Transparency ▸ Alpha to Selection**, and then choosing **Select ▸ Invert**.
5. Click the **Drop Shadow** layer mask to make it active. Drag the foreground color (which should be black) from the toolbox into the selection. This will hide the drop shadow everywhere except over the white backdrop.
6. Deselect all (CTRL-SHIFT-A).

The drop shadow makes it appear as though there's some distance between the boarder and the white background.

Replacing the Background

We want it to be clear from the advertisement that the event is being held in the Rocky Mountain region of Colorado. Let's add in the mountains as a background layer.

1. Click the **Boarder** layer to make it active.
2. Open an appropriate background image, such as this one of the Rocky Mountains. Copy and paste the image into a new layer (**Layer ▸ To New Layer**) and name it *Mountain*.
3. Use the **Scale** tool to resize the layer so it's as big as the canvas, then move the **Mountain** layer below the White Backdrop layer in the Layers dialog. Adjust the placement of the **Mountain** layer as appropriate.
4. Open the Motion Blur filter (**Filters ▸ Blur ▸ Motion Blur**). Set the Blur Type to **Linear**, set the Length to **5 pixels**, and set the Angle to **180 degrees**. Click **OK** to apply these settings to the Mountain layer.

After you remove the sky background, replace it with an image that's more appropriate for the project. A light motion blur adds depth to the new background and assures that the mountains don't distract from the boarder.

Adding Text

It's time for the finishing touches. Let's add text to the poster. Use the **Text** tool and type your text in black using any font. Duplicate the text and color the top version yellow. Offset the two layers by a few pixels to simulate depth. Make sure your text layers are at the top of the layer stack so you can see them over the layer masks and background images.

If the font and color you choose makes it difficult to read the text, you may want to add a drop shadow over the boarder's leg.

Further Exploration

Projects like this are sometimes the most fun because they aren't particularly difficult. As is true of many techniques described in this book, the hard part is creating good selections that isolate your intended subject. The Quick Mask tool is your best bet for objects that have many curves and edges, as this boarder's leg does. If the object you're trying to isolate has straighter edges and the background is a solid color, you can try using the Scissors tool.

Whether you're designing a T-shirt, a website, or a letterhead for the company office, you're probably going to use some kind of identifying symbol. While printed symbols are often easier (and cheaper) to create in solid colors, designing for the Web allows a bit more flexibility. Color is king on the Web, and because high-resolution, 16M-color monitors are the norm, three-dimensional effects are equally widespread.

Even a solitary letter can benefit from reflective techniques.

Symbols play an important role in design, and they can make or break a product or company image—better known in the graphic arts industry as an *identity*. The symbol itself may be flat and solid, flat and textured, or three-dimensional with light effects and shadows. Visual identities are the symbols of the companies we know—just think about McDonald's Golden Arches, a Red Hat for Linux, or IBM's Big Blue.

Logos usually include text set in a specific font, which is often accompanied by a shape representing the company, group, or individual. As part of an overall identity campaign, logos are sometimes embedded within other shapes to create emblems.

One of the easiest emblems to create is a round, reflective logo that resembles glass. A glass logo uses soft gradients with little or no grain visible. Many white ovals (or partial ovals) are layered and placed over the logo to simulate reflections. Sometimes these round reflections are even outlined with distinct edges to simulate a frame in which the logo is set.

A metallic logo is even easier to create. The technique is based on the fact that reflections in metal aren't as wide as reflections in glass, and they have more high-contrast areas between light and shadow. In the case of a metallic logo, the metal might be the focal point—as in a belt buckle or lapel pin—or you might just use metallic edges to accent a nonmetallic design, which is what you'll do in this tutorial.

Getting Started

When you're designing these emblems, it helps to examine real-world objects like glass buttons or even silver spoons. Notice how the light and colors reflect. One trick is to blur your eyes a little—try to see the reflections without focusing on the shape of the object. Then try to reproduce the effect with GIMP.

Adding reflectivity and color not only adds style to your design, it's also incredibly easy to do with GIMP. In this tutorial you'll work on a small canvas to demonstrate the ease of the technique. Remember that raster images—like those you create in GIMP—don't scale up to larger sizes very well, so start with a larger canvas and scale up the *technique* if you need a bigger emblem.

Creating a Metallic Border

1. With the toolbox selected, press **D** to reset the foreground and background colors to black and white, respectively.

2. Select **File ▸ New**. In the Create a New Image dialog, set the dimensions to **500 × 500 pixels** to create a square canvas. Click **OK** to open the new canvas window.

A square canvas will allow centering a round emblem more easily.

The Crown Molding gradient is applied to the selection in its own layer. This provides a layer to which a drop shadow can be added later.

3. Create a new transparent layer (**Layer ▶ New Layer**) and name it *Border*.

4. Choose the **Ellipse Select** tool from the toolbox and make sure the Mode is set to **Replace**. Click and drag on the canvas to create a circular selection. In the Tool Options dialog, set the size to **490 × 490** and the position to **5 × 5**. Click inside the selection to accept these settings.

5. Choose the **Blend** tool from the toolbox. In the Tool Options dialog, choose the **Crown Molding** gradient. Click and drag from the upper left to the lower right of the selection.

6. Add a new transparent layer by choosing **Layer ▶ New Layer** and setting the Layer Fill Type to **Transparency**. Name the new layer *Ring Color*.

7. Click the foreground color box to change the foreground color. In the Change Foreground Color dialog, set the RGB values to **0/159/0** for the green shown here, and then click **OK** to close the dialog. The circular selection should still be active, so just drag the foreground color into the selection.

8. In the Layers dialog, set the Mode to **Soft Light** and the Opacity to **50 percent**.

Use the Soft Light layer mode to blend the colored layer with the circular selection that's been filled with a gradient. Because you use a separate color layer, you can change the color of the image by simply changing the color in that layer.

Creating an Emblem

1. Add another new transparent layer by choosing **Layer ▸ New Layer** and setting the Layer Fill Type to **Transparency**. Name this new layer *Emblem Color*.

2. Shrink the selection by **15 pixels** (**Select ▸ Shrink**), and then feather the selection by **4 pixels** (**Select ▸ Feather**).

3. Open the Change Foreground Color dialog again, set the RGB values to **169/7/7** for the red shown here, and then close the dialog. Drag the foreground color into the selection.

A red selection covers most of the Crown Molding gradient in the Background layer. Where the gradient shows through, the red selection appears to have a metallic border.

Adding an Inner Border

At this point, you have the basic metallic emblem. The rest of the tutorial shows how to get creative with this basic shape. Start by adding a slight brushed-metal effect.

1. Add a transparent layer and name it *Brushed Metal*.

2. Open the Hurl filter (**Filters ▸ Noise ▸ Hurl**). Set the Random Seed to **10**, the Randomization to **35 percent**, and the Repeat to **3 times**. Click **OK** to apply this to the new layer.

3. In the Layers dialog set the Mode to **Screen** and the Opacity to **50 percent**.

4. Open the Gaussian Blur filter (**Filters ▸ Blur ▸ Gaussian Blur**). Apply a **2 pixel** blur both horizontally and vertically.

5. Open the Motion Blur filter (**Filters ▸ Blur ▸ Motion Blur**). Set the Length to **20 pixels** and the angle to **45 degrees** and click **OK** to apply the blur.

You will simulate brushed metal in Section 5.1, using the same technique as you do here.

6. Add a transparent layer and name it *Inner Ring*.

7. Shrink the selection by **25 pixels** (**Select ▸ Shrink**).

8. With the toolbox selected, press **D** to reset the background and foreground colors. Fill the selection with black by dragging the foreground color into the selection.

9. Shrink the selection by **4 pixels**.

10. Press CTRL-X to cut out the selection from the Inner Ring layer and leave behind a thin, black ring.

11. Clear the selection.

Unlike the outer ring, the inner ring is created by cutting out a selection from a black circle.

12. Open the Gaussian Blur filter (**Filters ▸ Blur ▸ Gaussian Blur**). Set the Blur Radius to **5 pixels**, and then apply the blur to the Inner Ring layer.

13. Create a selection from this layer by choosing **Layer ▸ Transparency ▸ Alpha to Selection**.

14. Add a layer mask to the Emblem Color layer by choosing **Layer ▸ Mask ▸ Add Layer Mask**. In the Add Layer Mask dialog, click the **Selection** radio button and check the **Invert mask** checkbox. This automatically creates a mask in the shape of the black ring.

The black ring is used as a layer mask that's applied to the emblem layer.

Adding Raised Lettering

1. Click the **Inner Ring** layer and invert its colors (**Colors ▸ Invert**).

2. Set its layer Mode to **Grain Extract**. Clear the selection.

3. Choose the **Text** tool from the toolbox. In the Tool Options dialog, choose a large, thick font. This example used Utopia Bold sized to 310 pixels.

4. Click the canvas and type an uppercase *M*. Use the **Align** tool to center the text layer in the image window.

5. Duplicate the text layer (**Layer ▸ Duplicate Layer**), and then invert its color to white by choosing **Colors ▸ Invert**. Name the duplicate layer *White Outline*.

6. Choose **Layer ▸ Transform ▸ Offset** and set the Offset X and Offset Y values to **–2 pixels**.

The raised letter starts out as a solid black M in the center of the emblem.

The white letter becomes a highlight for the black letter, making it look as though the letter is raised.

7. Duplicate the original text layer again, naming the duplicate layer *Black Outline*.

8. Choose **Layer ▸ Transform ▸ Offset** once more, but set the Offset X and Offset Y values to **2 pixels**.

9. In the Layers dialog, move the original text layer so that it's between the White Outline and Black Outline layers.

10. Click the **White Outline** layer to make it active.

11. Open the Gaussian Blur filter (**Filters ▸ Blur ▸ Gaussian Blur**) and apply a blur of **5 pixels** to the White Outline layer.

12. Set the White Outline layer size to match the image size (**Layer ▸ Layer to Image Size**).

13. Click the original text layer and create a selection by choosing **Layer ▸ Transparency ▸ Alpha to Selection**.

14. Click the **White Outline** layer to make it active again.

15. Press CTRL-X to cut out the selection from the White Outline layer.

16. Click the **Black Outline** layer to make it active, and then cut out the selection from that layer.

17. Set the original text layer's mode to **Overlay** and its Opacity to **66.7 percent**.

18. Set the RGB values for the foreground color to **172/172/172** for the red shown here.

19. Click the **Emblem Color** layer mask to make it active.

20. Drag the foreground color from the toolbox into the selection and then deselect all (CTRL-SHIFT-A).

Further Exploration

A letter with curves that match the curve of the emblem might look more impressive than this somewhat ordinary *M*. You can also convert paths to selections to create your own curvy letters. If you do so, remember to save the selections so you can recall them when it's time to create the white highlight and black shadow layers.

Create a white border by cutting out the original letter from the blurred and offset White Outline layer.

The offset black shadow works with the white highlight to complete the raised-letter effect.

4.6 WINE BOTTLE

By now you're all familiar with how GIMP can be used to manipulate stock photos. But photo editing is only half a story, like a wine glass with no wine. To get the whole story, you need the wine bottle: graphics created from scratch using GIMP's vector tools.

This tutorial shows you how to draw using nothing but guides, a grid, and paths. Guides are straight lines that allow you to accurately position points, bound selections, or simply trace with drawing tools. Paths are vector components of an image that can be edited anytime to change their shapes using control points and drag handles. Path edits don't immediately affect the image window; you have to retrace the paths or convert them to selections for use in the image.

Paths are to drawing what layers are to photo editing. You create multiple paths in a single path layer and then create multiple path layers to create a drawing. Since paths are editable curves, not just straight lines, they're perfect

We've done surface reflections. This tutorial uses that technique with color to simulate a reflection through the bottle.

for drawing manga or other types of cartoons. But there's more to paths than cartoons. You're going to use them as the basis for a 3-D shape.

This tutorial is for both new and experienced GIMP users who haven't yet ventured into the world of drawing from scratch. You'll need basic knowledge of GIMP's windows—the Toolbox, image windows, and dialogs—though I'll provide menu locations where needed. You should be familiar with creating new layers and naming them.

What you'll get is a thorough understanding of how guides can perfectly align your design elements, how drawings don't have be done in color initially, and how 3-D effects are just a matter of simulated lighting.

Drawing the Bottle Shape

The bottle outline is created by outlining the left half using a path and then duplicating and flipping this to create the right half. Guides are used to precisely align the path control points. Four vertical and five horizontal guides are required for this part of the drawing.

1. Start with a new **800 × 600** image window (**File ▸ New**). Configure the grid (**Image ▸ Configure Grid**) with a spacing of **10 × 10 pixels** and a Line style of **Intersections (dots)**. Then enable the Snap to Grid feature (**View ▸ Snap to Grid**). The grid should also be visible (**View ▸ Show Grid**) when editing curves.

2. Add a vertical guide (**Image ▸ Guides ▸ New Guide...**) with an offset of 400 pixels, half of the canvas width. Additional vertical guides should be positioned at 320, 340, and 370. Horizontal guides should be positioned at 40, 200, 280, 520, and 560. These positions are all pixel offsets.

Guides will align the outline of the bottle, and the grid gives you the ability to exactly position path handles.

3. Choose the **Paths** tool from the Toolbox. In the Tool Options dialog, set the Edit mode to **Design**. In the image window, click on the following guide intersections (the vertical guide is listed first) to drop path control points: 400/40, 370/40, 370/200, 320/280, 320/520, 340/560, 400/560. This gives a straight-edged outline, which needs to be rounded.

4. In the Tool Options dialog, set the Edit mode to **Edit**. Click and drag straight up two grid dots on the control point at the guides intersecting at 370/200. This is the handle for the *incoming curve* to this control point, but you don't need it, so just move it out of the way. Click again on the control point and drag the handle for the *outgoing curve* down 3 grid dots and left 1 grid dot. Repeat for the control points at the following grid intersections using the specified drag amounts:

 - 320/280: incoming handle up 4 grid dots
 - 320/520: outgoing handle down 3 grid dots
 - 340/560: incoming handle up 1 and left 2 grid dots

Handles are pulled from control points in order: the first handle is for the line coming into the control point from the previous control, the second handle is for the line leaving the control point. You may have to drag the first handle out of the way before you can edit the handle of interest.

5. In the Paths dialog, click the path name to rename this path *Left Border*. In the Tool Options dialog, click **Selection from Path**.

6. In the Layers dialog, add a transparent layer (**Layer ▸ New Layer**) and name it *Bottle Shape*. Type **D** in the canvas to reset the foreground color and then fill the selection with black.

7. Copy the selection (**Edit ▸ Copy**) and paste it (**Edit ▸ Paste**) as a new layer (**Layer ▸ To New Layer**). Using the **Flip** tool from the Toolbox, flip this copied layer horizontally. Use the **Move** tool and click and drag in the image window to move the layer so the left edge of the bottle in this layer aligns with the right edge of the bottle in the Bottle Shape layer. Merge the copied layer with the Bottle Shape layer (**Layer ▸ Merge Down**).

You can also precisely position the copied, flipped layer using Layer ▸ Transform ▸ Offset by specifying an X offset of 80 pixels.

Adding Highlights

Rendering the bottle into 3-D is done simply by adding some lighting effects in the form of colored filled and blurred selections. The highlights require six selections: two on the left side of the bottle and throat will act as reflected white light, and four on the right side will simulate light shining through the bottle and its contents.

1. Create a transparent layer and name it *Highlights-Left Bottle*. Make it the top of the stack in the Layers dialog.

2. Choose the **Rectangular Select** tool from the Toolbox. Drag a selection in the image window starting at the intersection of the guides at 340/280 and dragging to the intersection of guides at 400/520. In the Tool Options dialog, change the Size to **40 × 240** and the Position to **350 × 280**. Choose the **Rounded Corners** option and set the Radius to **70 percent**.

3. Fill the rectangle with white. Remove the selection (**Select ▸ None**). Apply a Gaussian Blur (**Filters ▸ Blur ▸ Gaussian Blur**) that's **30 pixels** in both the X and Y directions. Reduce the Opacity of this layer to **40 percent**.

4. Create a transparent layer and name it *Highlights-Right Bottle*. Make this the top of the layer stack.

5. Create a selection like the previous one, but set the Position to **420 × 280**. Click the foreground color box in the Toolbox and set the RGB values to **198/31/31**, respectively. Fill the selection and then remove it, but don't blur yet. Set the layer Transparency to **40 percent**.

6. Choose the **Ellipse Select** tool from the Toolbox. Create an oval selection starting at the intersection of guides at 340/200 to 400/280. In the Tool Options dialog, set the Position to **400 × 210**.

7. Choose the **Rotate** tool from the Toolbox. In the Tool Options dialog, set the Transform option to **Selection**. Click in the image window and in the Rotate dialog that opens, set the Angle to **−40 degrees**, and then click the **Rotate** button to rotate the selection.

8. Shrink the selection (**Select ▸ Shrink**) by **10 pixels** and feather it (**Select ▸ Feather**) by **5 pixels**. Fill the selection with the same color as the previous selection, then remove the selection. Finally, apply a Gaussian blur to the layer of **30 pixels**.

9. Add a transparent layer named *Highlights-Throat*. Drag a rectangular selection from the intersection of guides at 320/40 down to 340/200. In the Tool Options dialog, change the Size of the selection **20 × 120** and the Position to **380 × 60**. Round the selection, feather it by **5 pixels**, and fill it with white. Remove the selection.

10. Repeat this selection on the same layer, but set the position to **408 × 60** and its size to **15 × 90**. Feather again and fill with the red color from the right-side selections created previously. Remove the selection.

11. Finally, blur this entire layer by **20 pixels** and set the Opacity to **40 percent**.

The white and red selections are not identical, simulating variations in the shape and thickness of the bottle's glass.

Making a White Label with Gold Trim

What would a wine bottle be without its label? Boring, at least. This bottle's label will once again be outlined with guides, but it will be created using some new tools: gradients and the Colorize dialog. The label will be edged with multiple pieces of gold trim. The trick with these will be to create multiple, disconnected selections and apply the trim fill and coloring all at once.

1. Create a transparent layer named *White Label* and put it at the top of the layer stack. Add vertical guides positioned at offsets of 200, 480, and 600 pixels. Add horizontal guides at 340 and 410. Choose the **Rectangle Select** tool from the Toolbox, making sure the Rounded Corners option is disabled in the Tool Options dialog, and drag a selection from the guide intersection of 320/280 to 480/410.

2. Reset the foreground and background colors by typing **D** in the canvas. Choose the **Gradient** tool from the Toolbox. In the Tool Options dialog, set the Shape to **Bi-linear**. Set the

Gradient to **FG to BG (RGB)** and click the **Reverse** button. In the image window, drag from the the guide intersection of 370/340 left to the intersection at 200/340. Clear the selection.

Dragging from an off-center vertical guide moves the lighting on the label to match the highlights created earlier.

3. Create a transparent layer named *Gold Trim* at the top of the layer stack. Add horizontal guides at 415, 445, 450, and 515. Use the **Rectangle Select** tool to create a selection starting at the intersection of 320/410 and dragging to the right at intersection 480/415. In the Tool Options dialog, set the Mode to **Add** (second icon from the left). Now create selections 320/445 to 480/450 and 320/515 to 480/520. This creates three separate selections.

4. Use the **Gradient** tool with the same settings as the White Label and drag from the horizontal guide at 370 left to the guide at 200. Open the Colorize dialog (**Colors ▸ Colorize**) and set the Hue to **50**, the Saturation to **86**, and the Lightness to **0** and apply these settings. Finally, apply a Levels adjustment (**Colors ▸ Levels**) by setting the Input Levels midpoint value to **0.25**. Clear the selections.

Try creating a more complex gradient with multiple levels of gray to give the gold trim a more sophisticated appearance.

Making a Blue Stripe and Gold Wrapper

A thick blue stripe on the label will add color, as will a gold wrapper around the throat of the bottle. These will be made like the white label and gold edges.

1. Start with a transparent layer named *Blue Stripe* at the top of the layer stack. Create a rectangular selection (set the Mode to **Replace** in the Tool Options dialog for the **Rectangular Select** tool), starting at the intersection at 320/450 and dragging down and to the right to the intersection at 480/515.

2. Choose the **Gradient** tool from the Toolbox. Choose the **FG to BG (RGB)** gradient and make sure the **Reverse** button is set. Make sure the Shape is set to **Bi-linear**. Drag on any horizontal guide starting at the vertical guide at 370 and over to the left to the vertical guide at 200.

3. Finally, use the **Colorize** dialog to paint the label dark blue. Set the Hue to **200**, the Saturation to **77**, and the Value to **−30**. Adjust the midpoint slider in the Levels dialog to **0.25**. Clear the selection.

4. Create a transparent layer named *Gold Wrapper* at the top of the layer stack. Add a horizontal guide at 140 and vertical guides at 390 and 430. Create a selection, starting with the intersection at 370/40 and dragging to 430/140. Create a gradient using the same settings as the Blue Stripe but drag left to right this time, from the vertical guide at 390 to the vertical guide at 480. Use **Colorize** with the Hue, Saturation, and Lightness set to **50**, **86**, and **0**, respectively. Finish this part of the tutorial by adjusting the Levels on this selection, setting the Black Point to **175** and the Mid Point to **0.15**.

Applying the gradient starting on the guide allows the wrapper reflection to align with the one on the neck of the bottle.

Further Exploration

That's the basic bottle. The splash image for this tutorial takes this further by adding a bottle cap, text, and creative graphics to the labels. The cap is created using more guides but the same selection and gradient process as the labels. The graphics are cut from stock icon books and stock photography, desaturated, and blended with the bottle and labels. All these processes are extensions of techniques you've already learned in previous tutorials. Just give them a try!

Working with GIMP is not unlike working with wood. If you build a chair, you certainly don't build it out of a single piece of wood. You cut and shape pieces, then put them together one at a time until you have the final product.

Complex GIMP projects are created the same way: by combining component parts into a unified whole. You start by crafting image pieces by hand or from stock photography, which you later combine as layers into your final draft. The final draft gets a coat of varnish or other "color corrections" before you sit on it or, rather, hang it on the wall. Maybe using GIMP isn't exactly like carpentry, but you get the idea.

For example, say you wanted to create a handmade mechanical clock in GIMP. You'd perhaps start with a single gear, just like the one you'll create in this tutorial. This gear can be duplicated and rearranged, as well as reused in entirely new projects.

This project won't require any outside stock photography or specialized graphics knowledge. You should be able to follow along whether you're a GIMP guru or just hammering out your first GIMP gear.

Original graphics like this are the result of simple rotations and precisely sized and positioned selections.

Making the Gear Cogs

The small teeth around the edge of a gear are called *cogs*. You'll start this project by creating 32 uniformly spaced cogs around a circle. Later you'll connect the cogs with metallic rings, and then you'll finish off the project by adding depth to give the whole gear a 3-D appearance.

The process for the cogs is so simple, I'll explain it before you even start. You create a single cog at the top of a square canvas window in a layer by itself. You duplicate the layer and rotate it 90 degrees. Then you merge the duplicate with the original. Repeat this once to end up with cogs positioned at 12, 3, 6, and 9 o'clock. Then repeat the process but halve the rotation amount. Each successive repetition halves the rotation again. Now you can see this process in action.

1. Open a new image and set the Width and Height to **480 pixels**. The background color should be white to make it easier to see what you're doing. Choose **Image ▸ Guides ▸ New Guide (by Percent)**. Add a horizontal guide at **50 percent** and a vertical guide at **50 percent**. Then use **Image ▸ Guides ▸ New Guide** to add horizontal guides at **10 pixels** and **470 pixels**. Then add vertical guides at the same offsets.

2. Create a transparent layer. Name this layer *Cogs*. Choose the **Rectangle Select** tool from the toolbox. Drag a rectangular selection anywhere in the image window. The size and location of the selection don't matter at this point; you're about to change these manually.

3. In the Tool Options dialog, set the selection Size to **20 pixels** wide by **40 pixels** tall and the Position to **230 pixels** and **10 pixels**. This will place the 20 × 40 pixel selection at the top center of the image window. Round the corners of the cog by clicking the **Rounded Corners** option in the Tool Options dialog. This will display a slider to set the radius of the rounded corners. Move the slider all the way to the right, setting the Radius to **100.0**.

A square image window will make rotating the cog layers easier.

4. Click the foreground color box in the toolbox and change the foreground color to gray by typing *808080* in the HTML notation box. Click **OK**, close the dialog, and then drag the foreground color box from the toolbox into the selection.

5. Copy the selection and paste it into the image window. Convert the floating selection to a new layer (**Layer ▸ To New Layer**). Change the layer to match the image size (**Layer ▸ Layer to Image Size**).

6. Rotate the layer by 180 degrees (**Layer ▸ Transform ▸ Rotate 180**). Note here that if you hadn't expanded the layer to match the image size, the rotation would have been around the center of the cog. Instead, with the layer boundaries expanded to match the square image window, you've rotated the layer around the center of the image window. The result is that the duplicate cog is now at the 6 o'clock position.

7. Merge the new layer with the layer below it (**Layer ▸ Merge Down**). The new layer will inherit the original cog layer name of *Cogs*.

The first cog is positioned at the 12 o'clock setting and aligned horizontally in the center of the image window. This alignment will allow for exact positioning of the rest of the cogs as you build your gear.

When merging two layers, the new merged layer will always inherit the lower-level (as shown in the Layers dialog) layer name.

Having created two cogs, you make the rest simply by duplicating the existing cog layer, rotating the duplicate an appropriate amount, and merging the two cog layers again.

8. Duplicate the Cogs layer. Rotate this layer by 90 degrees (**Layer ▸ Transform ▸ Rotate 90 degrees clockwise**) to add the cogs at the 3 o'clock and 9 o'clock positions. (For this step it doesn't matter if you rotate clockwise or counterclockwise.) Merge this layer with the previous one.

Each time you rotate a layer, the rotation amount is half of the previous rotation.

If you didn't catch it, the last rotation of 90 degrees was half of the first rotation. That pattern of reducing the rotation by half each iteration will continue from now until you have all the cogs you want.

9. With 4 cogs in place, you move to 8 cogs by duplicating the layer, rotating by 90/2 = 45 degrees, and merging the layer. The trick here is that you no longer have a simple menu option to select "rotate by 45 degrees." Instead, you choose **Layer ▸ Transform ▸ Arbitrary Rotation**. The dialog that opens has an input field labeled Angle. Instead of using the slider, it's easier to just type in the amount (*45*) and click the **Rotate** button. Don't forget to merge the layers.

10. There are two rotations left, and they follow the same process as the last step. For 16 cogs: duplicate the layer, rotate by 45/2 = **22.5 degrees**, and merge the layers. For 32 cogs: duplicate the layer, rotate by 22.5/2 = **11.25 degrees**, and merge the layers. That's enough cogs for this gear.

11. The rotations have a side effect on the final layer: its layer boundaries are larger than the image window. To fix this, choose **Layer ▸ Layer to Image Size** once again.

After the 90-degree rotation, you need to use the Arbitrary Rotation dialog to set the angle of rotation. The final 32 cogs (lower left) should be equally spaced around the image.

Creating the Outer Ring

The next step in your gear design is to connect all those cogs. Do this by creating a solid disk and then cutting out an inner disk to create a ring in its own layer. You can then merge the ring and Cogs layers. Start by adding a transparent layer. Name this layer *Outer Ring*.

1. Choose the **Ellipse Select** tool from the toolbox. Use the guides to create a perfect oval that aligns properly with the outside edges of the cogs. In the image window, click the upper left intersection of the top and left guides, then drag to the lower right intersection of the bottom and right guides. The circular selection this creates overlaps the cogs completely, so reduce the size of the selection. The cogs are 40 pixels high, so reducing the selection by half that amount should do nicely. Choose **Select ▸ Shrink** and set the size to **20**. Then click **OK** to shrink the selection.

The outer ring is the piece of metal that connects the cogs. The gear doesn't have to have an outer ring and inner disk, of course. The gear could just as easily be one solid piece of metal.

2. The foreground color should still be the same color you used for the cogs, so go ahead and drag it into the selection. Now you want to cut a disk out of this selection. Remember that the height of the cogs is 40 pixels, so you need the outer ring to be at least 20 pixels (20 + the 20 pixels we shrunk in the selection the first time = the inside edge of the cogs). Give yourself a little extra room and shrink the selection by **25 pixels**. All that's left to finish the outer ring is to cut the selection from the existing gray disk. At this point you can merge the Cogs layer with the Outer Ring layer.

The cogs and outer ring are complete, but a gear like this needs to spin on something, so you'll add an inner disk to the design.

Next you'll add an inner disk to the gear. Keep in mind that other than the cogs, the shape of the gear (inner rings and decorations) is completely an artistic choice. To hone your skills, you could attempt to duplicate a real gear down to the smallest detail. Or you could create shapes inside the outer ring that aren't uniform disks and rods. For your first gear, however, keep it simple and use shapes that are easily created and duplicated.

3. The inner disk of your gear starts with another oval selection. The easiest way to create this is to select the transparent area inside the outer ring of the Cogs layer. The Cogs layer is active, so start by choosing the **Fuzzy Select** tool from the toolbox. Click inside the image window in the area inside the outer ring. This creates a selection that follows the inside edge of that ring. Add a transparent layer in which you'll create the inner disk and name the layer *Inner Disk*. You want a disk significantly smaller than this selection, however. It's time for a little math.

4. Remember that the image window is a square 480 pixels on each side. Also, you created a 40-pixel-tall cog placed 10 pixels down (vertically) in the image window. That means the bottom edge of the cog is 50 pixels down from the top of the image window. The vertical center of the image window is at 480/2 = 240 pixels. That means the current selection has a radius of 240 − 50 = 190 pixels (not including the 5-pixel extra space you added when creating the outer ring). Let's halve that to 95 pixels, shrinking the selection by **95 pixels**, and fill it with gray. Clear the selection.

Projects like this, using square image windows and rotation to position graphic elements, often require a little math.

Connecting the Disk and Ring

1. Before merging the inner disk, you'll add some connecting rods between the inner disk and the outer ring. You can use similar techniques to the ones used to create the original cog, manually sizing and positioning a selection to create the first rod, then duplicating the layer and rotating each duplicate layer.

2. Choose the **Rectangle Select** tool from the toolbox and draw an initial selection in the canvas. In the Tool Options dialog, set the Size to **20 pixels** wide by **115 pixels** tall and set the Position to **230 pixels** and **45 pixels**. This centers the selection on the central vertical guide between the outer ring and inner disk. This time you can disable the Rounded Corners option (click it so the check mark is removed). Add a transparent layer named *Rods*, and then fill the selection from the foreground color.

The connecting rods are created with the same process used to create the cogs, though you'll only need four connecting rods.

3. The selection is still active, so copy and paste it as you did with the original cog. Convert the floating selection (created

when you pasted) into a new layer. Set the layer boundaries to the image size. Now flip the pasted layer vertically (**Layer ▸ Transform ▸ Flip Vertically**). Merge the two rod layers. Duplicate the merged layer again. Rotate the layer by **90 degrees**. Merge the two rod layers again. Finally, merge the rod layers with the Inner Disk layer, and then merge the Inner Disk layer with the Cogs layer.

That's the template for your gear. Now you can add depth and texture to it.

The basic gear shape is easy enough. The fun starts when you add texture and depth.

Adding Depth and Texture

1. Duplicate the Cogs layer and name it *Cogs Blur*.

2. Apply an RLE Gaussian Blur of **5 pixels** horizontally and vertically. Turn off the visibility of the blurred layer in the Layers dialog.

3. Select the **Cogs** layer. Open the Bump Map filter (**Filters ▸ Map ▸ Bump Map**). Set the Bump Map option to the **Cogs Blur** layer. Set the Azimuth to **135**, the Elevation to **45**, and the Depth to **30**. Click **OK** to apply these settings. This will give the Cogs layer some depth.

The 3-D effect is easy. Just blur a copy of the item, and then use the blurred version as a bump map.

4. With the **Cogs** layer active, select the entire gear (**Layer ▸ Transparency ▸ Alpha to Selection**). Create a transparent layer and name it *Noise*. Use the RGB Noise filter (**Filters ▸ Noise ▸ RGB Noise**) to fill the selection with noise. Disable the **Independent Noise** button and move all the sliders to the far left (setting their values to **0**) except the Alpha slider, which should be moved all the way to the right.

5. Add a motion blur (**Filters ▸ Blur ▸ Motion Blur**) to the Noise layer. Set the length to **10** and the angle to **45**. Apply this to the **Noise** layer. Merge the Noise layer with the Cogs layer. Open the Colorize dialog and choose an appropriate color for the gear. Clear the selection (**Select ▸ None**).

You can try other types of textures, like rust or shiny metal. These are just variations on the brushed metal effect shown here.

Further Exploration

There are lots of variations you can try with this tutorial. Try creating square cogs and placing them closer together (hint: you need to create more cogs). Other shapes you can try are sawtooth, or, if you're really adventurous, you can try curved cogs. You can also be creative in how you connect the cogs. Instead of a ring and disk, you might try connecting the cogs to a ring that uses swirled shapes where the disk and rods are used in this tutorial.

For ideas on gear designs, try doing an Internet search for gears, clocks, and watches. Also, clipart books have lots of unusual shapes you can use to replace the connecting rods and inner disks.

What if the last tutorial was a bit too artistic for your project's needs? You could turn to stock imagery for a much more recognizable, if two-dimensional, cityscape. Or you could ditch high art and have a little more fun. Maybe you need something with a little toon style to it. Maybe what you need is Cube City.

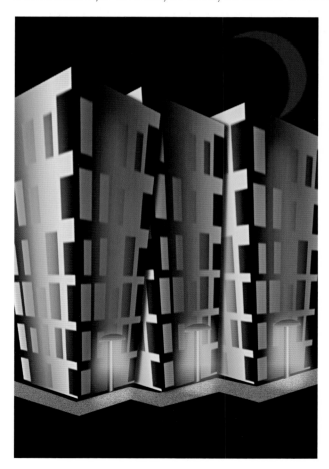

Cartoon buildings are an easy effect to achieve with GIMP.

In this tutorial you'll create three buildings from simple 3-D cubes, and then bend the buildings a bit to give the design a cartoonish look. The entire image takes only a few minutes to put together—once you're familiar with the tricks of the trade.

The process starts by generating a single 3-D cube that's duplicated and stretched to create each of the three buildings. Despite GIMP's obvious bias toward 2-D artwork, creating the cube is far easier than it might seem. This design is created at 250 ppi to produce a print that's 4 × 6 inches. If you're after a larger print, you'll need to create a larger cube. You can scale down the original cube for smaller prints, but the windows in the buildings will become difficult to see if you do, so it's best start with a smaller version of the cube for smaller prints.

Getting Started

Open a new transparent canvas (**File ▸ New**) **2 × 2 inches** at **250 ppi**. This image will be used to create the 3-D cube for the main project. For comparison's sake, note that if you were planning to create a cube city 420 × 300 pixels at 72 ppi, you'd start with a layer that was 60 × 60 pixels.

Creating the Building's Face

1. Choose the **Blend** tool from the toolbox. In the Tool Options dialog, set the Gradient to **FG to BG (RGB)** and the Shape to **Linear**. The rest of the options should be set to their default values.

2. With the canvas selected, press **D** to reset the default foreground and background colors, and then drag horizontally on the canvas from left to right.

3. Create a 6 × 5 grid (**Image ▸ Configure Grid**) by setting the width to **0.4 inches** and the height to **0.33 inches**. Be sure to turn on the visibility of the grid (**View ▸ Show Grid**) and

enable snapping to the grid (**View ▸ Snap to Grid**). If necessary, press SHIFT-+ to zoom in and get a better look at the gradient layer. Click **OK**.

The building starts with a gradient and grid that help outline the windows.

4. Add a new transparent layer by choosing **Layer ▸ New Layer** and setting the Layer Fill Type to **Transparency**. You'll merge this layer with the background as soon as you're done with it, so don't name it.

5. Choose the **Rectangle Select** tool from the toolbox. Using a grid intersection point as the corner of a selection, drag to create a square selection that's inside a rectangle created by the grid but doesn't cover that entire grid rectangle. The extra space between the selections is the wall between adjacent windows.

6. Repeat this process for most of the grid boxes within this cube layer, leaving a few blank. Selections on the right side of the gradient will be more apparent in the final image, so

don't leave those blank. Hold down the SHIFT key as you drag or set the Mode to **Add** in the Tool Options dialog. This will add new selections to the existing selections. The selections needn't all be the same size. This is, after all, a cartoonish design.

7. After all the selections have been created, click the **Blend** tool again to make it active. Drag from right to left across the width of the layer to fill the selections. Deselect all (CTRL-SHIFT-A).

8. Open the Gaussian Blur filter (**Filters ▸ Blur ▸ Gaussian Blur**), set the Blur Radius to **3 pixels**, and click **OK** to apply the blur to the windows.

9. In the Layers dialog, set the layer mode to **Hard Light** and merge this layer with the Background layer (**Layer ▸ Merge Down**).

10. Hide the grid (**View ▸ Show Grid**) and disable snapping to it (**View ▸ Snap to Grid**).

Leaving a few spots blank (without windows) adds some variation to the texture of the cartoonish building.

Making the Face a Cube

1. Open the Map Object filter (**Filters ▸ Map ▸ Map Object**). Choose **Box** from the Map to drop-down menu and check the **Transparent background** checkbox. Make sure the **Enable antialiasing** checkbox is also checked.

2. On the **Orientation** tab, set the Y Rotation to **45 degrees**. If the preview doesn't show your rectangle converted into a nice cube as shown here, check the Box tab and make sure the correct layer (cube) is selected for each of the sides' drop-down menus.

3. On the **Box** tab, set the Y slider to **0.75**, and then click **OK** to apply the Map Object filter.

4. Select the whole canvas (**Select ▸ All**) and press CTRL-C to copy the cube. If you want, you can then close this image to save memory.

NOTE *Before continuing, you should save this image (File ▸ Save As) as an XCF file so you'll always have a copy of the source cube for future Cube City projects. Saving subcomponents of a project like this is common practice and will, over time, help you build a library of small components suitable for multiple projects.*

The Map Object filter simplifies this project because it converts the single building face into a cube, giving you a building almost instantly.

Multiplying the Buildings

1. Open a new canvas that's **4 × 6 inches** at **250 ppi**.

2. With the toolbox selected, press **D** to reset the foreground and background colors, and then drag the foreground color onto the canvas to fill the canvas with black.

3. Paste the cube you copied onto the black canvas as a new layer by pressing CTRL-V and then choosing **Layer ▸ To New Layer**.

4. Choose the **Scale** tool from the toolbox. Click the cube layer and drag up a bit to make the building taller. Click the **Scale** button in the Scaling Information dialog to apply the change.

5. Duplicate this layer twice by choosing **Layer ▸ Duplicate** twice. Name the three layers *Left*, *Middle*, and *Right*.

6. Click the **Left** layer to make it active, and then use the **Move** tool to drag it left of center on the canvas (hold down the SHIFT key if necessary). Then click the **Right** layer and move it right of center. Adjust the layers so the **Left** layer overlaps the **Middle** layer, which overlaps the **Right** layer.

The gradient, which is black on the left and white on the right, works well to simulate shadowed areas on the sides of each building.

7. Choose the **Perspective** tool from the toolbox. In the Layers dialog, click the **Left** layer to make it active. Then click the canvas to display the drag points around the layer. Drag the top-left and top-right points outward from the center of the layer. In the Perspective Transform Information dialog, click the **Transform** button to apply the change.

8. Repeat this process for the **Right** and **Middle** layers.

9. When all three buildings have been completed, use the **Move** tool to adjust the layers so the bottom edges of the buildings line up.

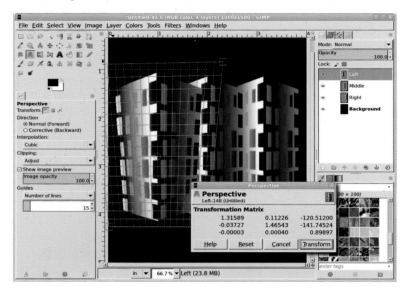

Changing the perspective of the buildings lends the cityscape a cartoonish effect. Because each building's perspective is changed by a different amount, the buildings aren't identical.

Adding Color

The buildings should be different colors, but you don't want the colors to clash.

1. For each layer, open the Colorize dialog (**Colors ▸ Colorize**).

2. For the Left layer, set the Hue to **33**, the Saturation to **66**, and the Lightness to **–15**. For the Middle layer, set the Hue to **180**, the Saturation to **60**, and the Lightness to **–15**. For the Right layer, set the Hue to **100**, the Saturation to **50**, and the Lightness to **–15**.

3. At this point, you can use the **Sharpen** filter or the **Unsharp Mask** filter (**Filters ▸ Enhance**) to reduce any fuzziness that was introduced when you modified the perspective.

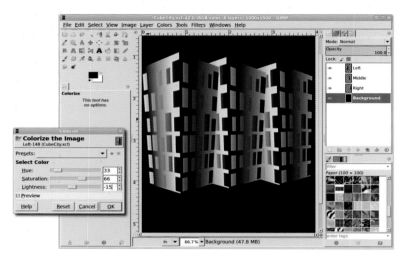

Using the Colorize tool is the easiest way to add color to the buildings, although you could also use the Bucket Fill tool with its mode set to Color or Grain Merge.

Adding Highlights

1. Add a drop shadow to the Left and Middle layers by choosing **Filters ▸ Light and Shadow ▸ Drop Shadow**. Set the Offset X value to **15 pixels**, the Offset Y value to **3 pixels**, and the Blur Radius to **15 pixels**. Click **OK** to apply the drop shadow.

2. Click the foreground color box to open the Change Foreground Color dialog. Set the RGB values to **252/255/0** for the yellow shown here and click **OK**.

3. Click the **Left** layer to make it active, duplicate the layer (**Layer ▸ Duplicate Layer**), and name the new layer *Left Yellow Oval*. Press CTRL-A and then CTRL-X to clear the layer contents.

4. In the Layers dialog, uncheck the **Lock Alpha Channel** box as shown.

A drop shadow adds even more depth to the image.

5. Choose the **Ellipse Select** tool from the toolbox and use it to create an oval selection on the left side of the building.

6. Feather the selection by **30 pixels** (**Select ▸ Feather**), and then drag the foreground color box into the selection to fill it with yellow.

7. Use the **Move** tool to drag the selection to the right side of the building. Drag the foreground color box into the new selection. Deselect all (CTRL-SHIFT-A).

8. Open the Gaussian Blur filter (**Filters ▸ Blur ▸ Gaussian Blur**) and apply a blur of **60 pixels**.

9. Set the layer mode to **Grain Merge** and reduce the Opacity to **35 percent**.

10. Duplicate the Left Yellow Oval layer (**Layer ▸ Duplicate Layer**). Name the duplicate layer *Middle Yellow Oval*.

11. Use the **Move** tool to move the **Middle Yellow Oval** layer over the middle building, and then in the Layers dialog move the **Middle Yellow Oval** layer to just above the Middle layer. Repeat this process for the **Right** layer, naming the last duplicate layer *Right Yellow Oval*.

12. Adjust the Yellow Oval layers' **Opacity** and **Layer Mode** and, if necessary, scale them to fit the buildings.

Yellow highlights add a sense of lighting, even though there are no streetlamps in the image. This is, after all, a cartoon.

Further Exploration

It's incredibly easy to create 3-D objects in GIMP. As you've seen, it's simply a matter of using gradients and shadows mixed with colored highlights.

And it's easy to take this project to the next level. The first image in this section shows that a sidewalk and some street lighting have been added to the cityscape. Additional elements can be added from icon collections, pasted into the image, and colorized.

4.9 UNDERWATER

We've already discussed how setting the mood in an advertisement is crucial to getting your message across. In Section 4.6 you saw how light can reflect both from inside and outside of a bottle.

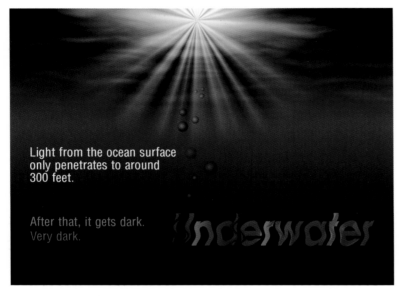

This ad's ominous message is enhanced by a murky, watery effect.

One place we can go to set an eerie mood is underwater. Undersea atmosphere is a complex mixture of diminishing light, distorted visuals, and inverted surfaces. In the land of GIMP, however, the underwater realm is easy to create.

In this section you'll create an underwater image for use in a print ad. The effect isn't particularly difficult to produce, but it does take some patience and experimentation to get a realistic result. If you don't succeed on the first try, make subtle changes to the Solid Noise filter's settings and try again.

Getting Started

1. Open a new canvas sized to **1024 × 768 pixels**.

2. Press **D** and then **X** to reset and then swap the default fore-ground and background colors. In the toolbox, click the foreground color box to open the Change Foreground Color dialog. Set the RGB values to **23/137/125** for the aqua green shown here, and then click **OK**.

3. Choose the **Blend** tool from the toolbox. In the Tool Options dialog, set the Gradient to **FG to BG (RGB)**, set the Shape to **Linear**, and choose **None** from the Repeat drop-down menu. Drag vertically from the top of the canvas window to the bottom.

4. In the Layers dialog, temporarily turn off the visibility of the **Background** layer. You'll turn it back on when you're done creating the desaturated waves.

The lightest color is at the top of the canvas so that the waves you add over-head will be visible.

Creating Waves

You'll start by using the Solid Noise filter to generate the waves. Increasing the detail setting in this filter will increase the contrast in parts of the image, and stretching the effect horizontally will help simulate water instead of clouds.

1. Add a new transparent layer by choosing **Layer ▸ New Layer** and setting the Layer Fill Type to **Transparency**. Name the new layer *Surface*.

2. Open the Solid Noise filter (**Filters ▸ Render ▸ Clouds ▸ Solid Noise**). Check the **Randomize** checkbox, set the Detail to **5**, set the X Size to **5**, and set the Y Size to **10**. Click **OK** to apply the filter.

3. Repeat this process four more times, creating four new layers and making sure to uncheck and check the **Randomize** box on each layer so that a new random value changes the shape of each rendering. Set the Mode to **Difference** for every layer except the original Surface layer.

Because the Randomize box is checked in the Solid Noise filter's dialog, your waves won't look exactly like this. You may find that only 1 noise layer is sufficient, or you may need 10 noise layers. If you aren't achieving the look you want, try selecting a different Random Seed.

4. Merge the visible layers into a single layer (**Image ▸ Merge Visible Layers**). Set the merged layer's mode to **Grain Merge**.

5. Turn back on the visibility of the **Background** layer.

6. If necessary, adjust the Brightness and Contrast of the Surface layer to sharpen or soften the edges between the crests and troughs of the waves (**Colors ▸ Brightness-Contrast**). While the mouse is in the canvas window, press the minus (–) key to zoom out.

7. Choose the **Perspective** tool from the toolbox. Click the canvas to display the drag points at the four corners of the Surface layer. Pull up the lower-left and lower-right points to approximately one-third to one-half the height of the canvas.

8. Drag the upper-left point to the left and drag the upper-right point to the right, as shown here. In the Perspective Transform Information dialog, click the **Transform** button to apply these changes to the layer.

9. If the waves appear too small or crowded, use the **Scale** tool to stretch the layer. When this is completed, zoom back in by pressing SHIFT-+.

10. At this point you can use the Gaussian Blur filter (**Filters ▸ Blur ▸ Gaussian Blur**) to apply a blur of **2 to 5 pixels**. You can also use the Ripple filter (**Filters ▸ Distort ▸ Ripple**) to add distortion. Neither of these steps is required—use your own judgment to get the most out of this effect.

11. Add a white layer mask (**Layer ▸ Mask ▸ Add Layer Mask**).

12. Reset and swap the default foreground and background colors by pressing **D** and then **X** while the canvas is selected.

13. Choose the **Blend** tool from the toolbox. In the Tool Options dialog, use the same settings you used earlier. Drag vertically, starting between the top and middle of the layer, to near the bottom of the layer. This will fade the Surface layer into the background, making it look as though the surface is disappearing into the distance.

14. Turn off the Layer Boundary (**View ▸ Layer Boundary**) so you can see the underwater effect more clearly. This is also a good time to save a copy of the project for future use (**File ▸ Save As**).

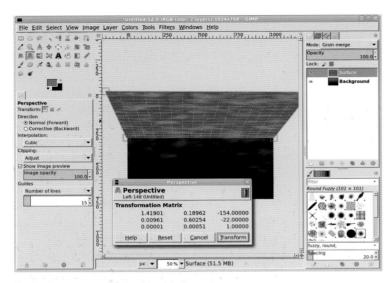

Dragging beyond the edges of the canvas with the Perspective tool doesn't cost you anything unless you save to the XCF format. When you export the file as a TIFF, JPEG, or other image file format, the excess isn't saved.

The Perspective change altered the size of the Surface layer. But without the mask, the distance has a distinct edge.

Adding Diffused Light

Now it's time to add a light source that appears above the water.

1. Add a new transparent layer by choosing **Layer ▸ New Layer** and setting the Layer Fill Type to **Transparency**. Name the layer *Light Source*.

2. Choose the **Blend** tool from the toolbox again. Set the Gradient to **FG to BG (RGB)**, set the Shape to **Radial**, and choose **None** from the Repeat drop-down menu. Click the top of the canvas near its middle and drag down through the canvas about halfway.

Choosing the Radial shape for the white-to-black gradient is an easy way to create a sphere. In this case, you're creating a radiating light source.

3. Add a white layer mask to this layer (**Layer ▸ Mask ▸ Add Layer Mask**).

4. With the **Blend** tool still active, set the Shape to **Linear** in the Tool Options dialog. Then drag vertically from the top of the canvas to the middle.

5. Set the Mode for this layer to **Grain Merge**. The black in the layer will darken the waves a bit, but the white will also lighten some of them—giving the overall appearance of a nighttime underwater scene.

A layer mask prevents the light from shining beyond a certain depth.

Adding Rays of Light

Now you can really make this scene shine.

1. Click the **Background** layer to make it active.

2. Choose the **Rectangle Select** tool from the toolbox. Drag through the top half of the canvas to create a square selection. The selection should cover the entire light source.

3. Copy and paste the selection, and then choose **Layer ▸ To New Layer** to make the pasted selection a new layer. Name it *Light Rays*. You won't use the content of the copied layer, but this is a simple way to create an appropriately sized layer. Make sure the layer boundary is visible (**View ▸ Layer Boundary**).

4. Choose the **Blend** tool again. This time set the Gradient to **Flare Rays Size 1**, set the Shape to **Bi-linear**, and choose **Sawtooth wave** from the Repeat drop-down menu. Drag horizontally from left to right through the middle third of the new layer.

The Flare Rays gradients are similar to the Crown Molding gradient, although the vertical shades of light and dark are closer together in the Flare Rays gradients.

5. Open the Polar Coordinates filter (**Filters ▸ Distorts ▸ Polar Coordinates**). Set the Circle depth in percent to **0** and adjust the **Offset angle** so the most visible lines from the edges of the original layer (if any) are at the bottom of the preview. The **To polar** checkbox and the **Map from top** checkbox should be checked, but the **Map backwards** checkbox should be left unchecked. Click **OK** to apply the filter.

6. Choose the **Scale** tool from the toolbox. Click the canvas to display the drag points on the layer corners. Click near the bottom of the layer and drag down until the center drag point meets the original layer's bottom, as shown here. Drag to extend the sides out toward the edges of the canvas as well.

The scaling doesn't have to be exact at this point. Click the center drag point and move it up near the top center of the canvas. Click **Scale** in the dialog to apply the scaling changes.

The center point of these radial lines should be moved to the top center of the canvas. This ensures that the lines seem to radiate from the light source you created earlier.

7. Add a white layer mask (**Layer ▸ Mask ▸ Add Layer Mask**). Then press **D** and then **X** to reset and swap the default foreground and background colors.

8. Choose the **Blend** tool from the toolbox. In the Tool Options dialog, set the Gradient to **FG to BG (RGB)**, set the Shape to **Radial**, and choose **None** from the Repeat drop-down menu. Drag from the top of the canvas to the middle to blend the rays of light into the background.

9. Blend this layer with the Background layer by setting the Light Rays layer's mode to **Grain Merge**.

Setting the Light Rays layer's mode to Grain Merge blends the light areas with the Background layer. The layer mask causes the rays to fade as they get farther from the light source.

Intensifying the Light

1. Add a new transparent layer by choosing **Layer ▸ New Layer** and setting the Layer Fill Type to **Transparency**. Name this new layer *Sunlight*.

2. The **Blend** tool should still be active. In the Tool Options dialog, change the Gradient to **FG to Transparent** but leave the other settings unchanged. Click the top center of the canvas and drag down through one-fourth to one-third of the canvas. Set the layer mode to **Grain Merge**.

3. If the light source is still too dark, then duplicate this layer (**Layer ▸ Duplicate**). If using the Grain Merge setting for these two layers doesn't produce the effect you seek, try changing the layer mode to Soft Light or Overlay.

Because the layer mode is set to Grain Merge, the extra light sources merge with both the rays of light and the Background layer. Don't be afraid to experiment with different layer modes to find the one that produces the most compelling effect for your project.

Further Exploration

Some variations on this effect can be achieved by changing the color of the water or the location of the light source above it, but it's what you add below the surface that'll really make your ocean come alive. If you like, experiment on the final image by applying both the Gaussian Blur filter (Filters ▸ Blur ▸ Gaussian Blur) and the Ripple filter (Filters ▸ Distorts ▸ Ripple) to the Light Rays layer. Both filters will help soften the light rays. You can even add a text layer, as shown in the first image in this section, or cut and paste some ocean life into the scene to complete the project. For something special, look for stock brushes or images or fonts that include bubbles!

4.10 COLORED LIGHTING

Whether in a portrait studio or while working in GIMP, colored lighting effects can set the mood. Different colors can evoke different feelings—blues are cool, reds are warm, yellow sets the stage for a sunny day, and green makes you think of spring.

Colored lighting can be applied so the light is directed at the subject and not the background. But for the most dramatic effect, colored lighting should be ambient lighting. It should be applied to the room, the background, even the open air around the subject.

Digital colored lighting effects are created using radial gradients and a variety of layer modes. The most suitable stock images have distinct left and right sides to the subject. This allows you to simulate light sources on either side without risk of overlapping.

In this tutorial you'll add colored lighting to a studio portrait without desaturating the original image. The colored lighting you add will blend with the model's original skin tone.

Yellow and blue tones enhance the model's skin, hair, and eye color.

Getting Started

1. Open the original image file in GIMP. The image in this example is very bright, and adding colored lighting will only make it brighter.

2. First, use the Levels dialog to reduce the brightness (**Colors ▸ Levels**). Move the black point about one-third of the way to the right, move the gray point even farther to the right, and click **OK** to apply the levels changes. Not all images will require this kind of adjustment, and with some images you'll get better results using the Curves or Brightness-Contrast tools instead.

Lowering the midpoint of the Levels histogram will darken the image while keeping the contrast high.

Adding Cool Lighting

You'll want to enhance this image by adding both cool and warm lighting, starting with the cool lighting.

1. Add a new transparent layer by choosing **Layer ▸ New Layer** and setting the Layer Fill Type to **Transparency**. Name the new layer *Left Side - Cool*.

2. Click the foreground color in the toolbox to open the Change Foreground Color dialog. Set the RGB values to **25/59/225** for the blue used in this example, and then click **OK**.

3. Choose the **Blend** tool from the toolbox. In the Tool Options dialog, set the Gradient to **FG to Transparent** and the Shape to **Linear**.

4. We want to add a blue-to-transparent gradient in the new layer, but in which direction should the gradient flow? Imagine a straight line starting at the model's right ear (left side of the image) and running along the edge of the model's jaw. Starting in the lower-left corner of the canvas, drag a line passing through and perpendicular to the imaginary line. This will apply the gradient to the Left Side - Cool layer.

5. Set the layer mode to **Color** to blend the color in the gradient layer with the colors in the original layer.

6. This lighting only lights the left side of the image. You'll need to add a similar lighting effect on the right side. Add another new transparent layer by choosing **Layer ▸ New Layer** and setting the Layer Fill Type to **Transparency**. Name the new layer *Right Side - Cool*.

7. This time, imagine a line that goes along the model's left cheek (on the right side of the image). Starting in the lower-right corner of the canvas, drag a line passing through and perpendicular to the imaginary line. Set this layer's mode to **Color**.

8. The coloring on this side should be a bit darker than on the other side, so duplicate this layer once (**Layer ▸ Duplicate Layer**).

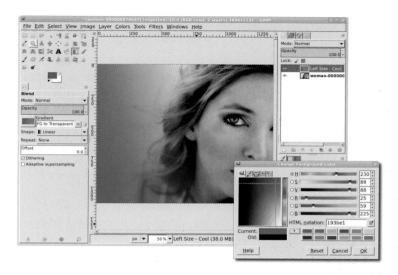

The gradient, shown here before changing the layer mode to Color, runs from the lower-left corner of the canvas to the upper-right corner and is perpendicular to the model's jawline.

Another gradient runs from the lower-right corner of the canvas up toward the model's left eye.

Adding Warm Lighting

Now add the warm lighting.

1. Add another new transparent layer and name it *Warm Lighting*. Open the Change Foreground Color dialog again and set the RGB values to **255/222/3** for the warm yellow shown here.
2. The Blend tool should already be active, but you should change the Shape to **Radial** in the Tool Options dialog before proceeding.
3. To apply the warm lighting, click the model's right temple and drag down to the middle of her neck. The result of applying the Radial gradient is shown here in the smaller window before changing the layer mode. Change this layer's mode to **Soft Light**.
4. To enhance this light further, duplicate the layer once (**Layer ▸ Duplicate Layer**).

Warm lighting is applied just above the model's right temple so that the brightest points don't overwhelm the color of her eyes.

Adding a Highlight

One more highlight is needed. Use the Blend tool to add it.

1. Add another new transparent layer and name it *Warm Highlight*.
2. Reset the foreground color to white by pressing **D** and then **X** in the canvas.
3. The **Blend** tool should still be active, but if it isn't, choose it from the toolbox. Make sure that in the Tool Options dialog, the Gradient is set to **FG to Transparent** and the Shape is set to **Radial**. Click the outside tip of the model's right eyebrow and drag toward the inside corner of that eye.
4. Set this layer's mode to **Soft Light** to produce a brighter yellow over the temple and eyebrow area, as if this is where the light is directed and most intense.

Add intensity to the warm lighting by using the Blend tool to apply a white Radial gradient.

Softening the Image

To add the finishing touch, soften the model's face.

1. Duplicate the original layer (**Layer ▸ Duplicate Layer**).
2. Open the Gaussian Blur filter (**Filters ▸ Blur ▸ Gaussian Blur**). Apply a blur of about **8 pixels**. If you aren't satisfied with the result, press CTRL-Z to undo it, and then try again using a different value for the Blur Radius. The blur softens the model's face, but her eyes, mouth, and some of her hair should be in focus.
3. Add a white layer mask (**Layer ▸ Mask ▸ Add Layer Mask**).
4. Reset the foreground color to black by pressing **D** in the canvas.
5. Choose the **Airbrush** tool from the toolbox. Select a soft-edged brush and use it to paint in the mask with black. Paint over the eyes, mouth, and hair until all three are more in focus, but leave the surrounding facial features blurred.

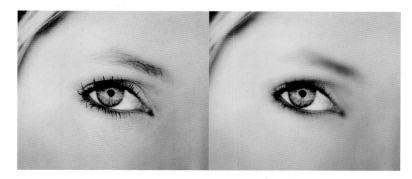

The Gaussian Blur filter is used on a duplicate layer to soften the model's face. A layer mask is also used so that details from the original layer show through the blurred layer.

Further Exploration

Lighting sets the mood in images like this. Experiment with different colored lighting layers to see if you can create images that convey moods of confusion or anger, despite the model's facial expression.

Because of my cheap nature, I rarely give myself a fancy gadget. Fortunately for me, I have a wonderful daughter who decided I needed a really nice holiday present: an iPod Nano.

The iPod is the pop-culture king these days. That title is due in no small part to the simple yet effective advertising campaign of silhouetted dancing hipsters with their high-contrast iPods and bouncing earphone wires. What's fun about all this for GIMP users is the sheer simplicity of the design. The iPod advertising artwork takes only modest GIMP expertise, as long as you (and you knew this was coming) start with good stock imagery.

In this tutorial I'm going to show how to take your own dancing fool and iPodicize him (or her) into advertising "nerdvana." All you need for this tutorial is a little straightforward selection and layer experience.

In this project, a stock image whose detail is not lost in silhouette is an important starting point.

Getting Started

Finding photos of energetic music lovers on websites like BigStock-Photo.com or iStockphoto.com is no problem. The genre is popular, and photos abound. The dancers in the iPod ads all have one thing in common: their hands and feet are typically recognizable even in silhouette. Keep this in mind while searching online image archives. Another important feature to look for in stock images for this project is a solid-colored background, preferably white.

1. Choose the **Fuzzy Select** tool from the Toolbox, and click on the white background to create an initial selection. For this image, the click should be near the light shadow by the lower hand. Hold the SHIFT key and make additional clicks to extend the selection. Clean up the selection of the background by using the **Quick Mask** and by growing the selection (**Select ▶ Grow**) by **1 pixel**.

An accurate selection isn't required for this project, but the silhouette will benefit from adjustments around the hand and white spaces at the end of the jacket arm, the sneaker, and the armband.

2. The selection created is of the background, so invert it (**Select ▸ Invert**) to create a selection of the dancer.

3. Copy (CTRL-C) and paste (CTRL-V) the selection into a new layer (**Layer ▸ To New Layer**). Name the layer *Silhouette*.

4. Enable the **Lock Alpha** option for the new layer, then fill the layer with black.

5. Remember that it's better not to modify the original image so it can be used again later if needed, so add a new white layer and move it below the Silhouette layer.

Adding a white layer named White Background below the Silhouette removes the shadow from the original image. A shadow will be added back in later, but it will be more in style with the iPod ad.

The dancer silhouette needs a little cleanup. Notice where the scarf and jacket fall away from the body in the original picture. In the silhouette these are not helpful features.

1. Use the **Free Select** tool to drag selections around most of these, then switch to **Quick Mask** mode to detail the area to be selected using a hard-edged brush.

2. Switch back to selection mode and cut the selections. Don't fill the selection with white! The silhouette is on a layer of its own with transparency around it. Editing here should replace the selected parts of the silhouette with transparency.

Normally a soft-edged brush is used to blend edges into the background, but the iPod style uses hard edges with no blending.

Adding the iPod

Creating the silhouette was easy, and as it turns out, creating the iPod is just as easy. Since there isn't a lot of detail in the device, it can be created in a separate image window, copied to the dancer window, and then scaled and rotated to fit. Scaling and rotating will blur the detail of the device, but because it's so small and lacks detail, that won't present a problem for this project.

1. Move the silhouette image out of the way for the moment, but don't close it. Open a new image window (**File ▸ New**) with a width of **380** and height of **420**. The background color doesn't matter for this task. For now, turn off the visibility of the Background layer in the Layers dialog.

2. Add a transparent layer (**Layer ▶ New Layer**) to the image window. Choose the **Rectangle Select** tool from the Toolbox. In the Tool Options dialog, enable the **Rounded Corners** option, and then set the Radius to **20**.

3. Drag through the image window to create a selection with rounded corners. The exact dimensions aren't important, though the width should be smaller than the height. Reset the foreground and background colors by typing **D** in the canvas window, then drag the background color (white) from the Toolbox into the selection.

4. The selection will still be in Edit mode at this point, meaning the selection handles can be used to resize the selection. Drag the four sides of the selection inward to form a smaller rectangle centered in the upper half of the original, white-filled rectangle.

5. Click on the foreground color box in the Toolbox and change the color to a medium gray, with RGB set to **160**. Close the dialog and drag the foreground color from the Toolbox into the image window selection. That creates the iPod display window. Remember, this style is very simple so no additional detail is required, such as adding depth around the display. Even if depth were added, it wouldn't be seen after the iPod was scaled and rotated in the dancer's image.

6. Use the **Ellipse Select** tool to drag a circular selection below the display window. The selection should span the width of the display window even if it's not circular. Drag the selection to position it in the center of the lower half of the iPod case. Once again, fill the selection with the foreground color. Clear the selection (**Select ▶ None**). Use the **Scale** tool from the Toolbox to squeeze the iPod until the dial is circular.

If the selection is no longer in Edit mode but is still active, click inside the selection to return to Edit mode.

The iPod was created on a single layer (shown over a black background to show the scaling amount), so squeezing it to make the dial circular is a simple operation that can be done just by eyeballing it.

Placing the iPod in a Pocket

1. Copy the **iPod** layer and paste it into the silhouette image. Use the **Scale** tool to shrink the pasted layer to fit, then rotate it to align with an imaginary pants pocket. Hold down the CTRL key while scaling to keep the aspect ratio for the device. Use the **Rotate** tool to rotate the iPod, then use the **Move** tool to position it near a pants pocket.

2. Add a white layer mask to the iPod layer. Use the **Paintbrush** tool and a hard-edged brush to black out a small part of the bottom of the iPod, leaving just a bit of the dial visible. This simulates the iPod being in a pocket (though not for long, the way this guy's dancing).

The position of the pocket is up to the artist. Alternative options include attaching the iPod to an arm or placing it in a shirt pocket.

Drawing the Earphones

1. Add a transparent layer and name it *Earphones*. Before drawing the paths, select a brush to draw the wires. A hard-edged brush, such as the Calligraphic brush, works well if scaled appropriately for an image of this size. The selected brush will be used to stroke the paths. Choose the **Paintbrush** tool and enable **Basic Dynamics** in the Tool Options dialog. Also, set the foreground color to white in the Toolbox by typing **D** followed by **X** in the image window.

2. Choose the **Paths** tool from the Toolbox and click near the dancer's left ear (or where that ear should be). Drag in the canvas to where the wire should meet the iPod. Click on the line you just made to adjust the shape of the wire.

The wires will probably require more fine-tuning than anything else in this project, since they and the iPod are the most identifiable features.

3. Click the **Stroke Path** button at the bottom of the Paths dialog. This will open the Stroke Path dialog. Choose to stroke using the **Paintbrush**, which will utilize the brush selected earlier. For added effect, click the **Enable Brush Dynamics** option. This causes the brushstroke to fade in and out at both ends of the path. Finally, click the **Stroke** button to apply the brushstroke along the path. Repeat this process for a wire coming from the right ear and connecting to the first wire at the chest.

Placing the Final Shadow

The last major component of this design is a shadow under the dancer. Like the silhouette, shadows in iPod advertisements are hard edged. As it turns out, that makes creating the shadow fairly easy.

1. In the Layers dialog, duplicate the *Silhouette* layer and rename the duplicate layer *Shadow*. Move this layer below the Silhouette layer in the Layers dialog. Select the **Perspective** tool from the Toolbox and click in the canvas to display the drag handles. Drag the upper left handle straight down and the upper right handle down and to the left, then hit ENTER to accept the changes.

The shadow layer may need to be moved slightly after the perspective is applied so that it matches up with the dancer's hand.

2. Add a white layer mask to the shadow layer. Type **D** in the canvas to reset the foreground color to black. Choose the **Gradient** tool from the Toolbox, and in the Tool Options dialog make sure the **Gradient Reverse** button is set so the gradient flows from white to black. Drag in the canvas from the dancer's hand to near the upper left of the shadow layer to apply a fade-out to the shadow. Finally, reduce the opacity of the shadow layer to **80 percent**.

Further Exploration

The Perspective tool will open a dialog when you click on the image window, but this dialog is of little value to most users. It shows a transformation matrix, which is nifty if you're into math but of less help to this type of design work. Ignore the dialog and just drag the handles in the image window. Then hit ENTER to accept the changes.

Also, the drag handles are not bound to the viewable dimensions of the image. Zoom out on the image window to drag handles outside the visible edge of the canvas. This will allow the perspective layer to flow out to the edge of the image and beyond. Of course, what flows outside the visible edge of the canvas won't be included in the final image, but that's a design choice.

The shadow in this project didn't flow to the image borders, but there's no reason it couldn't. In fact, adjusting the shadow provides a very specific feel to the design because it lets the viewer know the direction from where the light is shining.

You can splash a little color into this by adding color to the white background. In the end, the simplicity of the iPod style is what makes it both easy to identify with and, for GIMP users, easy to reproduce.

TIPS FOR ADVERTISING AND SPECIAL EFFECTS

Keep the following suggestions in mind as you apply GIMP tools and techniques to designing web and print ads.

Create 3-D Effects

Light and shadows are the key components of 3-D effects. If you want to add an extra dimension to your work, first determine the direction of the lighting. Then use GIMP tools to increase the light on the surfaces that face the light and decrease the light on the surfaces that would be in shadow.

Add Texture

No surface is completely devoid of texture, not even glass. Wood grains, brushed metal, and scratches can all be created by using the Noise filters in combination with the Motion Blur filter.

Use Layer Modes

Layer modes can be used to merge white reflections with textures. Try the Overlay mode to darken images or the Soft Light and Grain Merge modes to lighten and blend.

Reflect with Gradients

A gradient in a box doesn't look like much. But a gradient applied inside a shape like a circle or a rectangle can look like a reflection. Play with the Blend tool's gradients—many of them can produce reflective effects.

Emboss the Easy Way

The Emboss filter (Filters ▸ Distorts ▸ Emboss) and the Bump Map filter (Filters ▸ Map ▸ Bump Map) both work quite well, but text-embossing effects are so easy to achieve, you might as well do things manually. Just duplicate, offset, blur, and cut. To make matters even easier, the blur and cut steps are optional.

Eliminate the Jaggies

GIMP no longer leaves many "jaggies" after performing transforms such as rotations or shearing, but if you find any, you can apply a light blur to layer edges to clear those up. Zoom out to view the edges of a layer extending beyond the canvas area. A few jaggies along the edge of a package where the front and side images meet may not be such a bad thing—they can provide contrast to show there's an actual edge where common colors blend. Blurring the jagged edges may give you even better contrast.

Don't Worry About Horizontal Alignment

Don't try to align horizontal elements before applying perspective transformations when creating the front and side images for packaging projects. Applying a perspective change to any side will likely distort those horizontal elements so they become unaligned. Instead, avoid adding or using horizontal lines that need to align on the front and side of a package.

Watch Your Canvas Size

Bigger canvases take up more memory. A plain white canvas set to print at the size of a sheet of legal paper takes up 20 to 30MB just sitting there. Images destined for the Web are usually created at 98 ppi, however, and this greatly reduces the project's file sizes.

5

TYPE EFFECTS

Chapter 1 covered some of the basics of using text in GIMP. In Chapter 5, you'll see how you can use lighting, shadows, color, texture, shape, and perspective to make the most of fonts.

GIMP isn't designed to be used as a font editor; it's a graphic design tool. But what you can do with text in GIMP is far more interesting than what you can do with a font editor. GIMP offers you the ability to alter the environment in which the font is displayed. No matter which of the available fonts you use, you can alter the depth, color, and texture for a text string. And that broadens your graphic design possibilities in much more meaningful ways.

GIMP's Text Tools

The toolbox has a single tool for working with text: the Text tool. When you select this tool, GIMP opens the Tool Options dialog, in which you can choose a font and size and adjust other

text formatting such as color and alignment. Text can be typed directly in the canvas window for WYSIWYG editing of short phrases or you can use the Text Editor dialog for larger blocks of text. Text entered in either window appears immediately in the current layer and incorporates the Text tool's current settings.

The Tool Options dialog (left) for the Text tool and the optional Text Editor dialog. Short phrases can be typed directly in the canvas. Longer text blocks are more easily loaded into the Text Editor.

You'll use the Text tool, its Tool Options dialog, and the Text Editor in all of the tutorials in Chapter 5, but the text itself is only the starting point. Any time you work with text, your goal is to convey a particular message, and the words you choose are only the first step. An image editor like GIMP really allows you to get creative with text in raster effects.

Text is rendered directly in the layer as you type.

Predefined Text Effects

GIMP provides a wide set of predefined text effects, from Chalk to Chrome to Frosty to Textured. If you need to achieve a certain effect but don't have time to tinker, these predefined effects are the ticket. All of the predefined effects can be accessed by choosing File ▸ Create ▸ Logos from any canvas menu. Clicking any option in this menu will open a dialog in which you can select fonts and colors and set a variety of other options. The truth, however, is that these ready-made tools have their limitations, and you won't rely on them in the following tutorials. To achieve something really unique, you need to do it yourself.

Create ready-made logos by accessing the File ▸ Create ▸ Logos menu.

Creating Your Own Type Effects

Now it's time for you to explore GIMP's Text tool while creating your own effects, such as shadows and erosion. The following tutorials will teach you how GIMP can transform run-of-the-mill characters into a stunning graphic message.

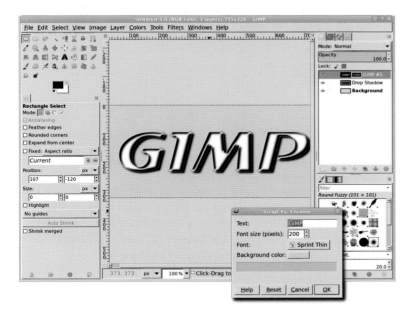

All the text logo filters, like the Chrome filter shown here, allow you to adjust a few settings, but the results are usually pretty predictable.

Metallic finishes are most often applied to text, but you can also utilize these general-purpose textures in user-interface design. Metallic finishes are created with the Curves dialog. Adjusting the curves of either a gradient or a smooth texture causes gradual changes in tone to become more dramatic and produces the appearance of shiny metal. This set of tutorials shows you how to create three different metal effects.

The letter S is made to look like brushed metal.

High contrast, generated with the Curves dialog, gives these examples a metallic appearance.

Brushed Metal

The brushed-metal effect is the product of two basic processes. First you apply the Motion Blur filter, which makes it look as though the surface is covered with tiny scratches. Applying noise to a layer adds texture to otherwise flat images. Then you adjust the image's gray tones in the Curves dialog. Adjusting the Value curve for an image with nonlinear variations—that is, an image with gray randomly distributed in the layer—accelerates the change from black to white and mimics reflective metal. The final effect is enhanced by extruding the letter into three dimensions.

Creating the Text

Begin by opening a new canvas using the default 640 × 400 template. A white background is fine, or you can try another color if you choose. Turn off the visibility of the Background layer.

1. Choose the **Text** tool from the toolbox. In the Tool Options dialog, choose an appropriate font. In this example, I've used a font called Gilde Broad Thin sized to 500 pixels. At this size the font is thick enough to show the brushed metal texture clearly; the subtle effect can be lost in fonts with thinner characters. Set the text color to **white** in the Tool Options dialog.

2. Click the canvas layer and type the letter *S*.

3. Use the **Align** tool to align the text layer. In the Tool Options dialog, set the Relative to option to **Image** and click the layer. Then click the **Align Center** and **Align Middle** buttons just below this menu.

4. Match the text layer to the canvas size (**Layer ▸ Layer to Image Size**).

Use the Align tool to position the text on the center of the canvas.

Extruding the Text with the Bump Map Filter

1. Duplicate the text layer (**Layer ▸ Duplicate Layer**). Name this layer *Blurred*.

2. Open the Gaussian Blur filter (**Filters ▸ Blur ▸ Gaussian Blur**) and apply a blur of **10 pixels** to the duplicate layer.

3. Click the original text layer in the Layers dialog to make it active.

4. Open the Bump Map filter (**Filters ▸ Map ▸ Bump Map**). Choose **Sinusoidal** from the Map Type drop-down menu, and then choose the Blurred layer from the Bump Map drop-down menu. Set the Azimuth to **132 degrees**, set the Elevation to **30 degrees**, and set the Depth to **7**. Click **OK** to apply the filter.

 Sinusoidal mapping produces a more realistic three-dimensional effect with edges that are less rounded than those produced by the Linear and Spherical options. The Azimuth slider sets the direction of lighting within 360 degrees.

The Elevation slider changes the roundness of the edges, and the Depth slider sets the softness of the shadowed sides. To get the most out of this tutorial, I've chosen values to accentuate depth.

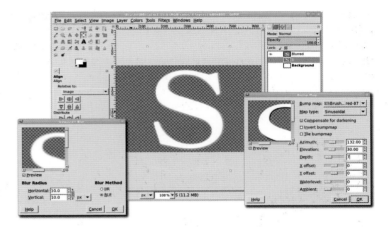

Use a light blur and the Bump Map filter to extrude the letter S into three dimensions.

5. Turn on the **Lock Alpha Channel** option for the original S layer. Turn off the visibility of the Blurred layer.

6. Open the Gaussian Blur filter again (**Filters ▸ Blur ▸ Gaussian Blur**) and apply a blur of **10 pixels**. This softens the shadow edges a bit, making the sides appear more rounded without blurring into the transparent areas.

7. Duplicate the original layer (**Layer ▸ Duplicate Layer**). With the duplicate layer active, select the text by choosing **Layer ▸ Transparency ▸ Alpha to Selection**.

8. Press **D** to reset the default foreground and background colors.

9. Choose the **Blend** tool from the toolbox. In the Tool Options dialog, set the Mode to **Grain Merge** and the Gradient to **FG to Transparent**. Drag from the upper-left corner of the canvas to the lower-right corner. Then drag from the bottom of the canvas to the top.

10. In the Layers dialog, set the Mode to **Soft Light**.

11. Press CTRL-SHIFT-A to deselect all.

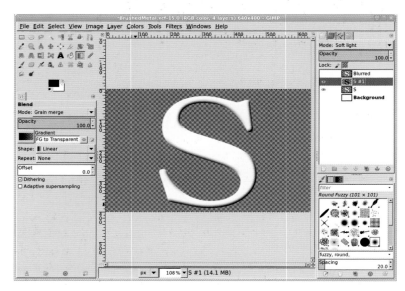

Blending enhances the three-dimensional effect. This isn't required to achieve the brushed-metal appearance, but it gives you an interesting logo.

Adding a Metallic Finish

1. Merge the gradient layer and the original S layer (**Layer ▸ Merge Down**).

2. Open the **Curves** dialog (**Colors ▸ Curves**), and adjust the curve for the Value channel to closely resemble that shown here. The actual setting will vary, depending on the variation in gray tones in your layer. Click **OK**. This will be the first visible change that looks a bit metallic.

3. Duplicate the layer (**Layer ▸ Duplicate Layer**).

4. Select the letter in this duplicate layer by choosing **Layer ▸ Transparency ▸ Alpha to Selection**.

5. Use the RGB Noise filter to fill the selection with noise (**Filters ▸ Noise ▸ RGB Noise**). Uncheck the **Correlated noise** and **Independent RGB** checkboxes. Set all three

color channel sliders to **0.44** and set the Alpha slider to **0**. Click **OK** to apply this filter. Desaturate this layer (**Colors ▸ Desaturate**).

The RGB Noise filter fills the selection with random dots—in this case, the dots are colored and must be desaturated. Setting the color channel sliders to 0.44 increases the noise. (Higher values mean more noise, and lower values mean less noise.) The alpha channel is not used here.

6. Open the Gaussian Blur filter (**Filters ▸ Blur ▸ Gaussian Blur**) and apply a blur of **2 pixels**.

7. With the text still selected, use the Motion Blur filter to further blur the layer (**Filters ▸ Blur ▸ Motion Blur**). Set the Angle to **45 degrees** and set the Length to **20 pixels**.

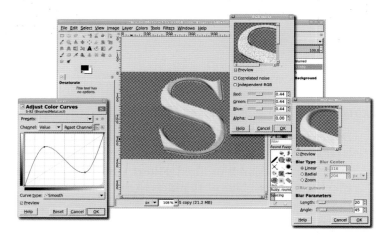

Add noise to the text and use the Curves dialog to increase the separation of dark and light noise.

8. The last step is to add the blue tint that gives metal its shiny appearance. Add a new layer (**Layer ▸ New Layer**). Name it *Tint*.

9. Click the foreground color box to launch the Change Foreground Color dialog and set the RGB values to **16/59/130**. Click **OK** to close the dialog. Drag the foreground color into the selection in the new layer to fill it with that color. (The letter you selected in step 4 should still be selected.)

Adding a blue tint completes the effect.

10. Deselect all (CTRL-SHIFT-A), and then set the layer mode to **Soft Light** and reduce the Opacity to **52 percent**.

11. Set the Mode of the next layer down in the Layers dialog to **Grain Extract** and its Opacity to **60 percent**. Use the **Gaussian Blur** filter to apply a blur of **2 pixels** to the original text layer. That's it! Just these few steps produce the results you see here.

12. Turn on the Background layer visibility again. Then add a drop shadow to better see the effect.

Heavy Metal

The heavy-metal effect is similar to the brushed-metal effect, but it uses the Solid Noise filter to produce a cloudy texture and relies on more dramatic curves adjustment to achieve a polished, reflective appearance.

Heavy metal looks more polished than brushed metal.

Creating the Text

As in the previous tutorial, start by opening a new canvas using the default 640 × 400 template.

1. Hide the Background layer by turning off its visibility in the Layers dialog.

2. Press **D** to reset the default foreground and background colors, and then press **X** to swap them.

3. Choose the **Text** tool from the toolbox and pick an appropriate font. Change the text color to white. For this tutorial, I chose GraverplateExtrabold Thin, a font that uses uppercase characters for lowercase characters (known as *small caps*). This font's wide surfaces make the heavy-metal effect easier to see. I set the font size to 182 pixels and reduced the letter space until the *E* and *T* abut each other.

NOTE *When trying to achieve this effect, always choose a font that's solid (rather than outlined) and has thick characters. If you'd like to use a particular font but the characters seem too thin, the bold version of that font might work.*

4. Click in the canvas and type *Metal*.

5. Use the **Align** tool to center the text layer within the canvas.

6. Resize the text layer to match the image size (**Layer ▸ Layer to Image Size**).

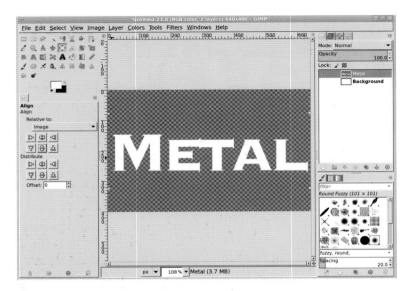

Using a thick font will make it easier to see the final effect.

Adding Depth

1. Clear any selections (CTRL-SHIFT-A).

2. As you did with the brushed metal effect, you'll now extrude the text. Note that in this tutorial the extruding isn't optional. The depth created along the edges of the text creates reflection variations that contribute to the heavy metal effect. Start by duplicating the text layer (**Layer ▸ Duplicate Layer**). Name the duplicate layer *Blurred*.

3. Use the **Gaussian Blur** filter to apply a blur of **10 pixels** to the duplicate layer.

4. Click the original text layer to make it active.

5. Open the Bump Map filter (**Filters ▸ Map ▸ Bump Map**). Set the Bump Map option to the Blurred layer. Set the Map Type to **Linear** and check the **Compensate for darkening** checkbox. Set the Azimuth to **130 degrees**, the Elevation to **30 degrees**, and the Depth to **7**. Click **OK** to apply this filter to the layer.

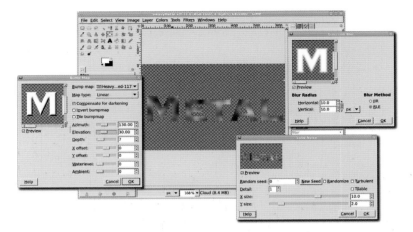

The Bump Map filter makes the original text appear three-dimensional.

6. At this point, you can delete the duplicate layer. Hide the Blurred layer by turning off its visibility in the Layers dialog.

7. Duplicate the original text layer. Name the new layer *Cloud*.

8. Select the text by choosing **Layer ▸ Transparency ▸ Alpha to Selection**.

9. Fill the selection with a cloud rendered from the Solid Noise filter (**Filters ▸ Render ▸ Clouds ▸ Solid Noise**), as discussed in Section 1.10. Set the Random Seed to **0**. Set the X Size to **10** and the Y Size to **2**.

10. The Random Seed value is used to change the shape of the cloud, so feel free to try different values as you experiment. When set to 0, the random seed value used here, you should end up with the same cloud structure as I did. However, because the cloud is rendered only within the selection, you won't actually see it. You'll just see various shades of gray inside the selection.

11. With the selection still active, open the Motion Blur filter (**Filters ▸ Blur ▸ Motion Blur**). Set the Angle slider to **95 degrees** and the Length slider to **20**, and then apply the filter to the layer. Deselect all (CTRL-SHIFT-A). The Motion Blur filter turns the clouds into what look more like reflections of light.

12. Set this layer's mode to **Grain Merge** to brighten the cloud layer and give the look of highly reflective metal.

13. Merge this layer with the layer in which you originally applied the Bump Map filter (**Layer ▸ Merge Down**).

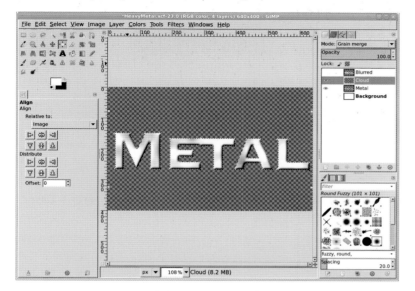

Use the Solid Noise filter to render a cloud on the text. Then apply the Motion Blur filter.

Adding a Metallic Finish

This effect can be further improved by increasing the contrast between light and dark areas.

1. Open the Curves dialog (**Colors ▸ Curves**) and apply a curve like the one shown here. This gives you the basic metallic effect, but you can still enhance it further.

2. Add a drop shadow (**Filters ▸ Light and Shadow ▸ Drop Shadow**). Set the Offset X and Offset Y values to **−2 pixels** to move the shadow up and to the left and set the Blur Radius to **10 pixels**. Apply this to the image.

3. Perhaps the edges of the text are too soft and need a more punched-out look. You can sharpen the edges of the text and get that punched-out appearance by stroking with a gray outline. Select the text in this layer by choosing **Layer ▸ Transparency ▸ Alpha to Selection**. Grow the selection by **2 pixels** (**Select ▸ Grow**).

4. Add a new transparent layer by choosing **Layer ▸ New Layer** and setting the Layer Fill Type to **Transparency**. Name the new layer *Outline*.

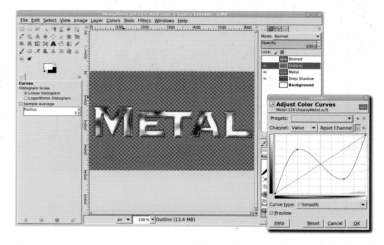

The Curves adjustment brings out the metal appearance while the drop shadow will let the effect stand out on the page.

5. Click the Foreground color icon in the Toolbox and set the foreground color to gray by typing *a4a4a4* in the HTML notation field of the Change Foreground Color dialog. Click **OK** and close the dialog.

6. Open the Stroke Selection dialog (**Edit ▸ Stroke Selection**) and set the Line Width to **2 pixels**. Click the **Stroke** button to stroke the selection.

7. Deselect all (CTRL-SHIFT-A).

8. Change the Mode for the Outline layer to **Multiply**.

9. Shiny metals like chrome have a bluish tint, so you should add that for realism. Add a new layer (**Layer ▸ New Layer**) named *Color* and fill it with blue, setting the RGB values to **16/59/130**. Drag the foreground color from the Toolbox into the canvas.

10. Set the Mode for this blue layer to **Soft Light** and reduce the Opacity to **53 percent**. Turn on the visibility of the Background layer to see result of your labor.

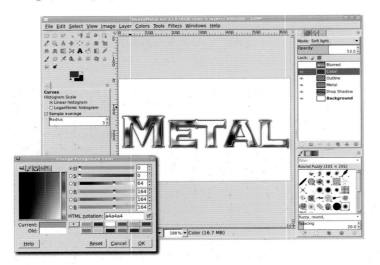

Stroking the outline of the original text in gray and blending in color using the Soft Light mode gives the text a more punched-out look.

Liquid Metal

Using the Curves dialog made a big improvement to the metal effect in the Heavy Metal tutorial. But where you can go from there—what else can you do with metallic text? Take the process one step further: add non-text components to the image.

Here you simulate liquid metal. GIMP provides the heat, of course.

Creating the Text

1. With the toolbox selected, press **D** to reset and then swap the default foreground and background colors. Then open a new canvas window at the default size. Turn off the Background layer visibility.

2. Choose the **Text** tool from the toolbox. Pick a large, thick font—I used Arial Black sized to 220 pixels. As in the Heavy Metal tutorial, a thicker font makes the effect easier to see. In this case, you also want a font with lowercase letters and dots over letters like *i* and *j*. These elements will enhance the melting effect. Once you've chosen an appropriate font, set the font color to white.

3. Click the canvas and type the word *Liquid*. When you've finished, click **OK** to close the Text Editor.

4. Use the **Align** tool to center the text layer.

5. Expand the layer boundary to the image size (**Layer ▸ Layer to Image Size**).

A thick font is essential for this effect. With thin fonts, the metal's reflective nature is harder to distinguish.

Liquefying the Letters

1. Use the **Free Select** tool to draw a round selection beneath the first letter. Hold down the SHIFT key to draw more selections beneath the text. Using the SHIFT key (or Add mode in the Tool Options dialog) allows you to add the new selection to the existing selection, even if the new selection doesn't physically touch the existing selection. Make sure the selections overlap portions of each letter.

2. After you've drawn a few selections, grow them by **1 pixel** (**Select ▶ Grow**) to soften the edges of the hand-drawn selections.

3. Fill the selections with white by dragging the foreground color box from the toolbox into the image.

4. Deselect all (CTRL-SHIFT-A).

Hand-drawn selections are added to the text layer and filled with white.

5. Open the Waves filter (**Filters ▶ Distorts ▶ Waves**). Set the Amplitude to **6**, the Phase to **107**, and the Wavelength to **29**. Click **OK** to apply this filter.

 The text and blobs below them will be distorted in a wavy fashion—the effect will depend on which font you chose for

this tutorial. If you chose a different font, you may have to experiment with different settings for the Waves filter.

6. Name this layer *Blobs* and then duplicate it (**Layer ▶ Duplicate Layer**).

7. Open the Gaussian Blur filter (**Filters ▶ Blur ▶ Gaussian**) and apply a blur of **10 pixels**. Name this blurred layer *Blur*. Click the Blobs layer to make it active again.

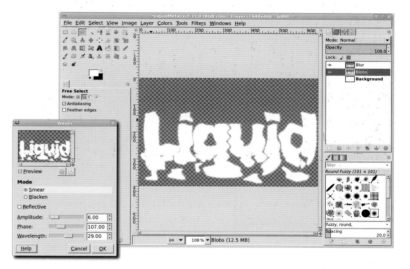

The Waves filter does the real work in this tutorial. The blurred layer sets the stage for you to add depth with the Bump Map filter.

Adding Depth and Polish

1. Open the Bump Map filter (**Filters ▶ Map ▶ Bump Map**) and use the Blur layer to apply the filter to the Blobs layer. Set the Map Type to **Linear** and check the **Compensate for darkening** checkbox. Set the Azimuth to **130 degrees**, the Elevation to **30 degrees**, and the Depth to **7**. Click **OK** to apply this filter.

2. Turn off the visibility of the Blur layer.

3. Duplicate the Blobs layer (**Layer ▶ Duplicate Layer**). Create a selection of the bump map in this duplicate layer by choosing **Layer ▶ Transparency ▶ Alpha to Selection**.

4. Fill the duplicate layer with solid noise (**Filters ▸ Render ▸ Clouds ▸ Solid Noise**).

5. Open the Motion Blur filter (**Filters ▸ Blur ▸ Motion Blur**). Set the Length to **20** and the Angle to **95 degrees**. Click **OK** to apply this filter.

6. Set the Mode for the duplicate layer to **Grain Merge**, and then merge it with the original Blobs layer (**Layer ▸ Merge Down**).

As in the Heavy Metal tutorial, use noise and blurring to simulate reflections.

7. Deselect all (CTRL-SHIFT-A).

8. Open the **Curves** dialog and adjust the **Value** curve as shown here.

9. Add a new layer (**Layer ▸ New Layer**), fill it with blue as before, and set the Mode for the new layer to **Soft Light**.

Adding a color layer makes it look as though an object is reflected in the metallic surface.

Further Exploration

This final version could be improved by more carefully controlling the distortion of the text. You could do this by using the IWarp filter instead of the Waves filter, for example. Additional color could be added as well. Try adding red and yellow layers with solid noise layer masks to make it look as though the letters are hot—there must be some reason why the metal is liquid, right?

The gel effect shown here is nothing more than soft shadows, smooth surfaces, and white reflections. Imagine how water in a glass tube looks and you get the idea. Gel effects are especially popular in web design, but you'll see them used in many different contexts. The Mac OS X user interface incorporates what Apple calls the *Aqua* style, which utilizes gel effects in shades of blue.

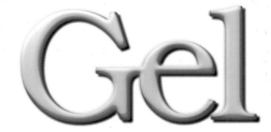

Looks like gel, doesn't it?

The process described in this tutorial can be applied to text, borders, and buttons—just about any surface. Depending on the settings you use for the Curves dialog, the Lighting Effects filter, and the Bump Map filter, your results may be different from mine. What you should take away from this process is how to use bump maps, lighting effects, and layer modes.

Creating the Text

Reset the foreground and background colors by pressing **D** in the image window. Then start with a canvas set to the default size (640 × 400 pixels).

1. Click the foreground color box to open the Change Foreground Color dialog and choose a nice blue. I've set the RGB levels to 0/51/222 for this shade.

2. Choose the **Text** tool from the toolbox. In the Tool Options dialog, choose a serif font. This tutorial uses Bookplate Thin with the font size set to 280 pixels. Serif fonts work best here because their characters are easily rounded by the process that follows. Click the canvas and type *Gel*.

3. Use the **Align** tool to center the new layer in the canvas.

4. Choose **Layer ▸ Layer to Image Size** to expand the text layer to the boundary of the image.

When using the Text tool, you can also change the text color by clicking the color swatch in the Tool Options dialog.

Rounding the Surface of the Text

1. Create a selection around the text by choosing **Layer ▸ Transparency ▸ Alpha to Selection**.

2. Shrink the selection by **2 pixels** (**Select ▸ Shrink**) and feather it by **2 pixels** (**Select ▸ Feather**).

Create a selection of the text, and then shrink and feather it. The dark edges on the letters in this Quick Mask view of the selection show that the selection is smaller than the lettering.

3. Click the foreground color box to open the Change Foreground Color dialog and set the RGB values to **31/82/255** for a slightly brighter shade of blue.

4. Create a new layer by choosing **Layer ▸ New Layer** or clicking the **New Layer** button in the Layers dialog. Name the new layer *Bump Map.*

5. Click the **Bump Map** layer in the Layers dialog to make it active, and then fill the selection with the foreground color by dragging it from the toolbox into the selection.

6. Deselect all (**Select ▸ None**).

7. Duplicate the layer (**Layer ▸ Duplicate Layer**). Name the duplicate layer *Blur.*

8. Open the Gaussian Blur filter (**Filters ▸ Blur ▸ Gaussian Blur**) and apply a blur of **10 pixels** to the Blur layer.

9. Click the **Bump Map** layer to make it active.

10. Open the Bump Map filter (**Filters ▸ Map ▸ Bump Map**). Set the Azimuth to **105 degrees**, the Elevation to **5.75 degrees**, and the Depth to **10**. Set the Map type to **Linear**, check the **Compensate for darkening** checkbox, and choose the **Blur** layer from the Bump Map drop-down menu. Click **OK** to apply the filter to the Bump Map layer.

The blurred edges of the duplicate layer are used as input to the Bump Map filter to simulate depth. Use the Bump Map filter to add depth.

11. Set the Bump Map layer's mode to **Addition**.

12. You'll need to make a color adjustment to the Bump Map layer in order to make the text look more gel-like. Open the Curves dialog (**Colors ▸ Curves**) and set the curve as shown here. When the visibility of the Blur layer is turned off, you can see that the Bump Map layer appears brighter.

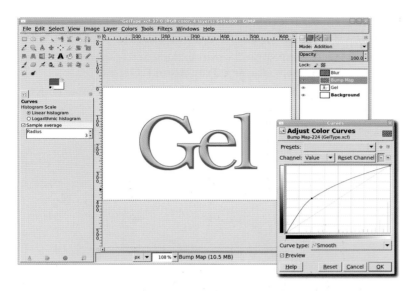

Adjusting the Curves dialog for the Bump Map layer gives the text a gel-like appearance, but be sure to turn off the visibility of the Blur layer in the Layers dialog to see the changes.

NOTE *We won't be using the Blur layer again until later in this project, so turn off its visibility for now to make the rest of your work easier to see.*

Adding Lighting Effects

Now you'll apply one more filter to the Bump Map layer.

1. Open the Lighting Effects filter (**Filters ▸ Light and Shadow ▸ Lighting Effects**). On the **Options** tab, click and drag the blue dot to the upper-left corner of the preview. The blue dot represents your light source. Position the blue dot so the gel text is highlighted to your taste. It's tricky! If you lose the dot, disable this light (by changing the Type in the Light tab to None and then selecting a different light from the Light Settings menu) and create a new one.

Positioning the light source in the preview can be difficult. Don't be afraid to click Cancel and try again.

2. On the **Light** tab, choose **Directional** from the Type drop-down menu. Your blue dot now is associated with a line representing the direction of your light source. The Intensity setting you select has a great impact on the overall effect, as do the changes you made in the Curves dialog. I set the Intensity to 1.15. If you aren't pleased with the gel effect, experiment by adjusting this value or adding additional lights. Click **OK** to apply the Lighting Effects filter.

Of all the Lighting Effects filter's settings, the Intensity setting has the greatest impact.

3. Once the Lighting Effects filter has been applied, offset the Bump Map layer by **–2/–2 pixels** (**Layer ▸ Transform ▸ Offset**).

4. Open the Gaussian Blur filter (**Filters ▸ Blur ▸ Gaussian Blur**) and apply a blur of **5 pixels** to that layer.

A soft blur smooths the edges, giving the text a more realistic gel-like appearance.

Lightening the Text and Adding a Drop Shadow

To bring out the curved surface of the gel, you can increase the contrast in the text and add a background shadow. If you turned off the visibility of the Blur layer, turn it back on to continue with this project.

1. Make sure the **Blur** layer is active in the Layers dialog. Duplicate this layer by choosing **Layer ▸ Duplicate Layer** (the duplicate layer will be named *Blur copy* by default).

2. Offset the Blur copy layer by **2/2 pixels** (**Layer ▸ Transform ▸ Offset**).

3. Click the original **Blur** layer to make it active, and then offset it by **−2/−2 pixels** (**Layer ▸ Transform ▸ Offset**).

4. Set the Blur layer's mode to **Addition** and set the Blur copy layer's mode to **Screen**.

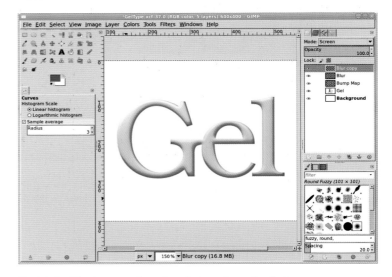

Revisit the Blur layer and use it to lighten the gel coloring even more.

5. Click the **Gel** text layer to make it active. Add a drop shadow (**Filters ▸ Light and Shadow ▸ Drop Shadow**) offset by **4 pixels** and blurred by **6 pixels**.

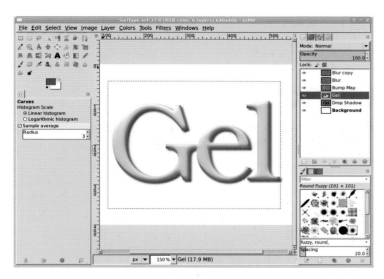

Now that the text is so light, it fades into the white background. Adding a drop shadow helps the effect stand out.

Further Exploration

The basic process for creating gel effects is the same no matter what kind of surface you modify. To add variety, try using different colors for the gel or using the Waves or IWarp filters to add distortions.

In interior design, distressing is used to give furniture an aged and weathered appearance. In graphic design, it serves a similar purpose—it gives clean and crisp objects, such as text, more visual interest. While it would be possible to design a complete font set around this effect, premade effects always limit an artist's design options. Adding your own personal touches is tough if every *F* in your text looks exactly the same.

BRoKEN SPARRoWS

An example of distressed text

Creating the Text

1. With the toolbox selected, press **D** to set the foreground color to black.

2. Open a white canvas set to the default size (640 × 400 pixels).

3. Click the **Text** tool to make it active, and then select an appropriate font in the Tool Options dialog. This example uses SoutaneBlack Thin, whose thick characters make it easier to see the distressed effect, set to a font size of 80 pixels.

4. Click in the canvas and type *BRoKEN SPARRoWS*, using lowercase for the letter *o*, just to add a little pizzazz. Press ENTER to add a line break between the words and then insert a few spaces before the word *SPARRoWS*.

5. Use the **Align** tool to center the text on the canvas.

6. Choose **Layer ▸ Layer to Image Size** to expand the text layer to the boundary of the image.

7. Add a new transparent layer by choosing **Layer ▸ New Layer**. Name it *Distressed* and set the Layer Fill Type to **Transparency**.

The distressed text effect is easier to see if you start with a thick font.

Creating a Distressed Layer

The next part is the hardest. You're going to add a series of vertical lines of varying widths to be used as the basis for the distressed effect. The difficulty here will be in positioning the lines randomly over the letters.

1. Turn on the image grid (**View ▸ Show Grid**) and set GIMP to snap to the grid (**View ▸ Snap to Grid**). You'll use the grid to make drawing perfectly vertical (and thus parallel) lines easier.

2. Choose the **Pencil** tool from the toolbox and select the **Round** brush, with the Size set to **1.00** in the Tool Options dialog. Draw a single line extending from the top of the canvas to the bottom. To do this, click near a grid point at the top of the canvas, hold down the SHIFT key, and then click near a grid point in the same vertical line as the original point at the bottom of the canvas. This will draw a straight line 1 pixel in width.

With the help of the image grid and the Snap to Grid option, you can draw straight lines with ease.

NOTE *You can also draw a straight line without the grid by pressing* CTRL-SHIFT. *This method will constrain the angle of the line to 15-degree increments.*

3. Hide the image grid (**View ▸ Show Grid**) and turn off Snap to Grid (**View ▸ Snap to Grid**). At this point you may also want to turn off the visibility of the text layer, though that isn't required.

4. Choose the **Fuzzy Select** tool from the toolbox and use it to click the line you just drew with the Pencil tool. You may need to zoom in on the line to make clicking it easier.

5. Once you've selected the line, press CTRL-C to copy it, press CTRL-SHIFT-A to deselect all, and press CTRL-V to paste the duplicate line as a floating selection.

6. Use the **Move** tool to move the duplicate line to the right or to the left, then click outside the floating selection to anchor it to the original layer. Do this a few times, positioning the lines randomly across the width of the canvas. When you've finished, you should have one layer containing many lines. Duplicate this layer (**Layer ▸ Duplicate Layer**).

7. Offset the duplicate layer by entering **1 pixel** in the Offset X field (**Layer ▸ Transform ▸ Offset**).

8. Merge the active layer with the layer below it by choosing **Layer ▸ Merge Down**. This effectively doubles the width of your lines in a single layer. You also could have used a brush 2 pixels in width from the start, but knowing how to enhance effects through duplicating and offsetting layers is a useful skill.

These randomly positioned lines will be used to mask out portions of the original text.

9. With the **Distressed** layer active, choose the **Pencil** tool again, set the brush Size to **3.00** in the Tool Options dialog, and repeat the process described above, this time drawing thicker lines overlapping the lines you've already positioned. Avoid uniformly spacing these thicker lines, and make sure they intersect the text here and there. Don't forget to use the grid to draw the first line!

Making a few lines thicker than others adds more randomness to the pattern, but make sure that the lines intersect the text, or you won't be able to see a difference in the final effect.

10. Open the Hurl filter (**Filters ▸ Noise ▸ Hurl**). Set the Random Seed to **150**, the Randomization to **10 percent**, and the Repeat to **1 time**. The Hurl filter scatters dots in the current layer, overwriting pixels if necessary. The Randomization value specifies how much of the layer should be filled with dots. Higher Repeat values indicate that the filter should be applied repeatedly, thus increasing the overall number of dots applied. Click **OK** to apply the Hurl filter to the Distressed layer.

11. Open the Pick filter (**Filters ▸ Noise ▸ Pick**). Set the Random Seed to **10**, the Randomization to **20 percent**, and the Repeat to **3 times**. Click **OK** to apply this filter to the Distressed layer. The Pick filter is similar to the Hurl filter, but it chooses the pixels and which color to use for them in a slightly different manner. In this case, using the Pick filter makes the dot distribution more random and introduces some larger dots to the pattern. After applying the Hurl and Pick filters, you'll be left with a set of distressed lines.

Using the Hurl and Pick filters creates random noise and makes the lines look distressed.

Applying the Distressed Effect to the Text

Now it's time to blend the distressed lines with the text.

1. Invert the colors in the **Distressed** layer (**Colors ▸ Invert**).

2. The Hurl and Pick filters scattered colored dots in the Distressed layer, but you're shooting for a black-and-white effect,

so go ahead and desaturate the layer (**Colors ▸ Desaturate**). Make sure to turn back on the visibility of the text layer. Change the layer's mode to **Addition**.

3. Use the **Move** tool to position the layer as necessary to get the best effect.

Because the background is white, the white lines disappear where they don't intersect with the text. If your background is a different color, copy the Distressed layer, paste it into a layer mask that you create on the text layer (Layer ▸ Mask ▸ Add Layer Mask), and then turn off the visibility of the Distressed layer.

Further Exploration

There are many other ways to use the Distressed layer to enhance the original text. Try using it as a layer mask on the text layer or as a layer mask on a colored or textured layer above the text. You can also extrude distressed text using the Bump Map filter to produce an effect that looks like erosion.

5.4 FROST

A standard GIMP installation provides several specialty filters, including the Sparkle filter (Filters ▸ Light and Shadow ▸ Sparkle), which takes specks of white in an image and stretches them out into spokes of light. You can use the Sparkle filter to produce frost, snow, and icicle effects, but the results are not always ideal, because the spokes of light are fairly uniform. This tutorial explores other ways to achieve a frost effect.

Chill out with this cool tutorial.

In this tutorial you'll use the Pick and Slur filters to randomize the edges of selections, and then you'll apply the Wind filter to those selections to generate icicles. You used the Pick filter in Section 5.3, so you should be familiar with it how it works. The Slur filter is a pretty standard noise filter; it works by replacing the color of randomly chosen pixels with the color of nearby pixels.

The lesson here is that you'll seldom find a single filter that gives you exactly the effect you need. You'll have to learn to use filters in combination—and in the correct order.

Creating the Background and Text

Open a new white canvas set to the default size (640 × 400 pixels).

1. Choose the **Blend** tool from the toolbox. In the Tool Options dialog, click the **Reset** button, then select **Horizon 2** from the Gradient menu. This gradient will fill the background with what looks like a horizon. Drag down from the top of the canvas window past the bottom. When you drag beyond the canvas window, you're effectively stretching the gradient. The result is that the simulated horizon is near the bottom edge of the canvas. The placement of the horizon doesn't matter much, as you're just using this blue backdrop to add to the frosty feeling of the design.

Use the Gradient menu in the Tool Options dialog to choose the Horizon 2 gradient.

2. Duplicate the Background layer (**Layer ▶ Duplicate Layer**). You'll merge the duplicate Background layer with an embossed text layer shortly.

3. Choose the **Text** tool. Set the font color to black and choose a thick font. I've chosen SoutaneBlack Thin set to 100 pixels. Click the canvas and type *North Pole*.

4. Center the text on the canvas using the **Align** tool.

5. Create a selection of the text by choosing **Layer ▶ Transparency ▶ Alpha to Selection**. Save the selection to a channel (**Select ▶ Save to Channel**). Click the channel name and change it to *Outline*.

6. Deselect all (CTRL-SHIFT-A).

Save the text outline to a channel.

Bringing the Text Forward

1. Click the text layer in the Layers dialog and merge it with the duplicate Background layer by choosing **Layer ▶ Merge Down**. Click the layer name and change it to *Text Layer*.

Merge the text layer with a copy of the Background layer in preparation for embossing.

2. Set the Mode for the Text Layer to **Grain Merge**. Once the text is embossed, the Grain Merge mode will allow the text edges to blend with the original Background layer.

3. Now you're ready to emboss the Text Layer (**Filters ▶ Distorts ▶ Emboss**). Use the **Emboss** function, and then set the Azimuth to **313 degrees**, the Elevation to **39 degrees**, and the Depth to **19**. You may wish to change these settings, depending on the font you use, but if you use a thick font, similar settings should work well for you. Click **OK** to apply this filter.

4. Right-click the saved **Outline** channel in the Channels dialog and choose **Channel to Selection**. Remember this process; you'll need to re-create this selection shortly.

5. Grow the selection by **2 pixels** (**Select ▶ Grow**).

6. Feather the selection by **1.6 pixels** (**Select ▶ Feather**) and then invert it (**Select ▶ Invert**). This will select everything but the letters.

7. Click the **Text Layer** in the Layers dialog to make it active. Cut this selection from the Text Layer (CTRL-X). This will leave behind the embossed text with the colored background.

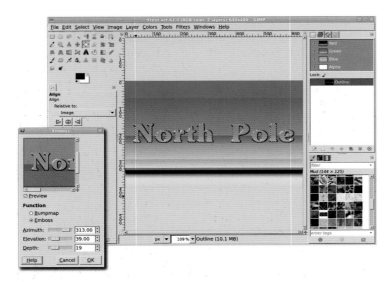

The Emboss filter has two function options: Bumpmap and Emboss. For this tutorial, use the Emboss option. Notice that the innermost areas of the text take on the appearance of the Background layer.

By removing the surrounding portion of the text layer, you get a darker background and lighter text, thanks to the Grain Merge mode of the text layer.

8. The current selection will still be displayed, but you should replace it. Retrieve the **Outline** channel selection once again. Grow this selection by **2 pixels** (**Select ▸ Grow**) and save it to another channel. Name this channel *Stroked*.

9. Set the foreground color to white. Working in the new Stroked channel, stroke the selection using a Line Width of **3 pixels** (**Edit ▸ Stroke Selection**), and then deselect all (CTRL-SHIFT-A). Temporarily turn on visibility for this channel so you can see what you're doing in the next few steps.

This technique deviates from those used in previous tutorials. Here the stroke operation takes place in a channel, not a layer.

10. Open the Pick filter (**Filters ▸ Noise ▸ Pick**). Set the Random Seed to **10**, the Randomization slider to **30 percent**, and the Repeat slider to **2 times**. Click **OK** to apply these settings to the Stroked channel. Working in a channel instead of a layer allows you to easily create a shape that you can turn into a selection later and fill with white in a layer. Not all filters work in channels. Fortunately, the noise filters are an exception, and the results are excellent.

Use the Pick filter to add noise to the saved selection channel.

11. Open the Slur filter (**Filters ▸ Noise ▸ Slur**). Set the Random Seed to **100**, the Randomization slider to **30 percent**, and the Repeat slider to **3 times**. Click **OK** to apply these settings to the Stroked channel.

12. The Pick and Slur filters add some random perturbations to a layer or selection. The noise filters may produce artifacts at the top of the channel. If this happens, make a selection at the top of the channel and fill it with black.

Adding Snow

1. In the Layers dialog, add a transparent layer and name it *Snow*.

2. Retrieve the **Stroked** channel as a selection (from the Channels dialog).

3. Use the **Rectangle Select** tool to crop the selection to half the height of the tallest letters. In the Tool Options dialog, set the Mode to **Subtract**. After cutting the bottom half of the selection, hit ENTER to accept the change to the selection.

Using the Rectangle Select tool to crop the Stroked selection.

4. Subtract the Outline channel from the current selection. To do this, select the **Outline** channel in the Channels dialog, and then hold down the CTRL key while you click the **Channel to Selection** button at the bottom of that dialog.

5. Feather the resulting selection by **3 pixels** (**Select ▸ Feather**).

6. Click the **Snow** layer in the Layers dialog, and then fill the selection with white.

7. Deselect all (CTRL-SHIFT-A).

Subtracting the Outline channel from the cropped Stroked selection leaves behind a selection that sits on top of the text. When this selection is filled with white, it becomes fallen snow on top of the letters.

Creating Falling Snow

You've created a cute snow pile on your text, but you can do more to enhance this design's frosty feeling.

1. Rotate the image by 90 degrees clockwise (**Image ▸ Transform ▸ Rotate 90 degrees clockwise**).

2. Press CTRL-J to fit the window to the image.

3. Open the Wind filter (**Filters ▸ Distorts ▸ Wind**). Set the Style to **Blast** to achieve thicker streaks, set the Direction to **Right** to indicate the direction from which the wind should blow, and set the Edge Affected to **Leading** to indicate that the streaks should flow with the wind from the point of impact. Set the Threshold slider to **20** and the Strength slider to **5**. Click **OK** to apply this filter to the Snow layer.

4. Reapply the **Wind** filter, this time setting the Style to **Wind**, the Direction to **Right**, and the Edge Affected to **Leading**. Set the Threshold slider to **20** and the Strength slider to **20**. The second application adds more streaks but softens the overall effect.

Rotating the image and applying the Wind filter turns the snow piles into falling snow and icicles.

5. To add the finishing touches, start by rotating the image counterclockwise by 90 degrees (**Image ▸ Transform ▸ Rotate 90 degrees counter-clockwise**).

6. Resize the canvas to fit the window again.

7. Open the Slur filter (**Filters ▸ Noise ▸ Slur**) again. Set the Random Seed to **100**, the Randomization slider to **20 percent**, and the Repeat slider to **2 times**. Click **OK** to apply this filter to the Snow layer. This will add icy particles to the snowy streaks.

8. Set the Mode for the Snow layer to **Grain Merge**.

9. Duplicate the Snow layer (**Layer ▸ Duplicate Layer**), and then set the Mode of the duplicate layer to **Addition**.

10. Turn off the visibility of the Stroked channel, if you haven't done so already.

When the duplicate Snow layer is combined with the original Snow layer, there's more snow overall. Set the layer mode to Addition.

Further Exploration

In this tutorial you applied a frosty effect to text, but this effect can be applied to just about any surface, whether straight or curved. You could even apply it to a photo. Using the same techniques on a photo of a house's roof line, you could take the scene from summer to winter in one day!

One of the most interesting effects in a digital artist's bag of tricks is the glowing neon sign. This was one of the first tricks available to GIMP users, and it's still one of the easiest to master. Neon is a gas that glows reddish-orange when electrically charged. Real neon signs are made to glow in different colors by being filled with gases (often argon) that emit ultraviolet light. The inside of the tube is then lined with phosphors that glow when exposed to the ultraviolet light generated by those gases.

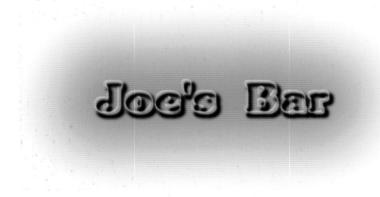

It's time to shed a little light on the subject at hand—neon light, that is.

While science can explain how real neon signs work, using GIMP-generated colored light to simulate a glowing neon sign requires a little magic. There are many ways to perform this magic, but most of them involve using the Emboss filter to transform ordinary lines into 3-D tubes, and all of them use some degree of blurring.

Experimenting with the Built-in Neon Effect

Before digging in, take a look at GIMP's built-in logo generators. The File ▸ Create ▸ Logos menu offers a wide array of ready-made logo designs. The logo filter that automatically generates a simple

neon effect is shown here, though as you can see, its default settings produce an effect that is not quite as interesting as the one you're going to try. While these ready-made logos are fine for small projects, you can create an image with more depth and character if you build the effect yourself.

The Neon logo effect is fine for small, quick projects.

Creating the Background

Start by creating a background against which the neon light will shine on a white canvas set to the default size (640 × 400 pixels).

1. Open the Patterns dialog (**Dialogs ▸ Patterns**), find the **Bricks** pattern, and then drag that pattern onto the canvas. This fills the canvas with the selected pattern.

2. Desaturate this layer (**Colors ▸ Desaturate**).

3. Click the foreground color box to launch the Change Foreground Color dialog and set the RGB values to **244/0/0** for the deep red shown here. Click **OK** to close the dialog.

Setting the mood for Joe's Bar: The outside wall is made of brick.

4. Choose the **Bucket Fill** tool from the toolbox. In the Tool Options dialog, set the Mode to **Soft Light** and set the Affected Area to **Fill Whole Selection**.

5. Click inside the canvas to color the bricks red.

Preparing the Neon Tubes

Now you're ready to work on the sign itself.

1. Choose the **Text** tool from the toolbox and then choose a font that suits your project. This example uses SoutaneBlack Thin sized to 110 pixels, with letter spacing set to 5.0. Thick fonts like this work well, especially when you're still learning how to master this technique, but neon signs can have all sorts of shapes, so feel free to experiment.

2. The text color should be set to the current foreground color, but if it isn't, set the RGB values to **244/0/0** to match the red in the background.

3. Click the canvas and type *Joe's Bar.* Use the **Align** tool to position the text in the center of the canvas.

4. Expand the text layer boundary to match the image size (**Layer ▸ Layer to Image Size**). This allows you to add elements to the layer that would otherwise be cut off by the original layer boundary.

After positioning the text, don't forget to resize the layer by choosing Layer ▸ Layer to Image Size.

5. Create a selection of the text's outline by choosing **Layer ▸ Transparency ▸ Alpha to Selection**. Save this selection to a channel (**Select ▸ Save to Channel**), and then double-click the channel name and change it to *Outline.* You'll use this channel again later.

6. Grow the selection by **3 pixels** (**Select ▸ Grow**).

7. Create a new layer (**Layer ▸ New Layer**) and name it *Stroke.* Return to the Layers dialog to see the new layer.

8. Stroke the selection by choosing **Edit ▸ Stroke Selection** and setting the Line Width to **5 pixels**.

9. Delete the original text layer and then deselect all (CTRL-SHIFT-A). You now have the outline for creating the sign's neon tubes.

The stroked outline may be difficult to see. Adding a temporary white layer can help. Also, try wider strokes but beware: you may need to adjust the letter spacing in the text before you create the selection to be stroked!

10. Duplicate the Stroke layer and name the duplicate layer *Emboss*.

11. Open the Gaussian Blur filter (**Filters ▸ Blur ▸ Gaussian Blur**) and apply a blur of **6 pixels** to this layer.

12. Open the Emboss filter (**Filters ▸ Distorts ▸ Emboss**). Set the Function to **Emboss**, the Azimuth slider to **43**, the Elevation slider to **30**, and the Depth slider to **43**. These settings give the Emboss layer a cutout appearance. Click **OK** to apply this filter to the layer.

13. Lower the Emboss layer in the Layers dialog by choosing **Layer ▸ Stack ▸ Lower Layer** once.

14. Set the Mode for the Emboss layer to **Addition**.

15. Open the Gaussian Blur filter (**Filters ▸ Blur ▸ Gaussian Blur**) and apply a blur of **6 pixels** to the original Stroke layer. Set the Mode to **Grain Merge**.

Move the embossed layer below the original text. Setting the layer mode to Addition adds this layer to the Background layer and brightens the embossed areas.

16. Add a drop shadow to this layer (**Filters ▸ Light and Shadow ▸ Drop Shadow**). Offset the drop shadow by setting the Offset X and Offset Y values to **8 pixels**. Set the Blur Radius to **6 pixels**, set the Opacity slider to **100 percent**, and uncheck the **Allow resizing** checkbox. If you were to instead check the **Allow resizing** checkbox, it would resize the canvas and place transparent areas around the edges. That's not what you want for this tutorial. Apply this drop shadow.

17. The Stroke layer should still be active, but if it isn't, click the **Stroke** layer in the Layers dialog to make it active again.

18. Add a second drop shadow. This time, set the Offset X and Offset Y values to **9 pixels**, the Blur Radius to **15 pixels**, and the Opacity slider to **100 percent**. Again, uncheck the **Allow resizing** checkbox. Applying these drop shadows raises the neon tubing above the background wall.

19. Move the **Emboss** layer above the Drop Shadow layers but below the Stroke layer.

In the Drop Shadow filter, positive Offset X values mean move right, and positive Offset Y values mean move down. Note that both drop shadows are applied above the Emboss layer.

Adding the Glow

1. Add a transparent layer by choosing **Layer ▸ New Layer** and setting the Layer Fill Type to **Transparency**. Name the new layer *Glow*.

2. Retrieve the **Outline** channel selection from the Channels dialog by clicking that channel and then clicking the **Channel to Selection** button.

3. Grow the selection by **25 pixels** (**Select ▸ Grow**). Notice that growing a selection rounds its edges.

4. Feather the selection by **15 pixels** (**Select ▸ Feather**).

5. Click the **Glow** layer in the Layers dialog to make it active. Drag the foreground color from the toolbox into the selection to fill the selection with that color, and then deselect all (CTRL-SHIFT-A).

6. Open the Gaussian Blur filter (**Filters ▸ Blur ▸ Gaussian Blur**) and apply a blur of **20 pixels** to the **Blur** layer. Apply this same blur two more times by pressing CTRL-F twice. The amount to blur is up to you. Apply the blur a few more times if you'd like to soften the edges of the glow even more.

The neon glow starts as a soft-edged, color-filled selection.

7. In the Layers dialog, lower the **Glow** layer to just above the Background layer.

8. Set the Mode for the Glow layer to **Screen**.

If you like, you can apply multiple blurs to the Glow layer.

Adding a Glass-Edged Reflection

1. Add a new layer (**Layer ▸ New Layer**). Move it to the top of the stack in the Layers dialog and name it *Highlight*.

2. Retrieve the **Outline** channel selection again. Grow this selection by **2 pixels** (**Select ▸ Grow**).

3. Set the foreground color to white, and then click the **Highlight** layer in the Layers dialog to make it active again.

4. Stroke the selection by choosing **Edit ▸ Stroke** and setting the Line Width to **4 pixels**, and then deselect all (CTRL-SHIFT-A).

5. Offset this layer by choosing **Layer ▸ Transform ▸ Offset** and setting the Offset X and Offset Y values to **–2 pixels**.

6. Open the Gaussian Blur filter (**Filters ▸ Blur ▸ Gaussian Blur**) and apply a blur of **2 pixels**.

7. In the Layers dialog, move the **Highlight** layer to just below the lowest Drop Shadow layer.

8. Set the Mode for the Highlight layer to **Hard Light**.
 This last part is what really makes the neon tubes look realistic. By adding light, you make the tubes appear rounded.

The white Stroke layer picks up color when its mode is set to Hard Light.

Further Exploration

There are thousands of variations on this technique, applicable to both text and graphic designs. Try using a piece of clipart instead of text. Use the Fuzzy Select tool to make selections of disconnected parts of the clipart. The result will be a neon outline of your clipart!

5.6 SPRAY PAINT

In Section 1.2 you learned the basics of working with layer modes, which provide a unique way of merging one layer with another. While modes are available for use with all GIMP paint tools, tool-based modes blend directly within the layer and actually change the layer's pixels. This becomes a problem if you make a long series of brushstrokes, for example, and want to backtrack later. If you haven't specified enough undo levels in the Preferences dialog, you might not be able to undo some of those strokes.

This isn't your average graffiti, but the effect is easy to achieve.

Layer modes, on the other hand, don't change any underlying pixels. The blending is done only during compositing, meaning it happens when GIMP combines all the layers to generate the display on the canvas. This sort of blending is nondestructive and offers greater flexibility for experimentation.

The spray-paint effect makes use of layer modes to blend a painted layer with a textured layer. In the last tutorial, you used layer modes to merge the light cast from a neon sign with the brick wall behind it. The same process applies to spray-painting a textured surface. First you create the surface, then you add a spray-paint layer above the first layer, and finally you use a layer mode to blend the two together.

Creating the Background

Begin just as you did in the last tutorial, by creating a brick wall. Open a new canvas window, using the default size. Click and drag the **Bricks** pattern from the Patterns dialog onto the canvas. Type **D** and **X** in the canvas area to set the foreground color to white.

Adding a Text Outline

1. Choose the **Text** tool from the toolbox, and in the Tool Options dialog, choose a font and font size. This example uses XBAND Rough sized to 210 pixels.

2. Click the canvas and then type *Kilroy*. Use the **Align** tool to center the text on the canvas.

3. Create a selection of the text (**Layer ▸ Transparency ▸ Alpha to Selection**) and save that selection to a channel (**Select ▸ Save to Channel**).

4. Double-click the channel name in the Channels dialog and change it to *Outline*.

5. Deselect all (**Select ▸ None**).

Text color doesn't matter yet. You just need an outline at this point.

Growing and feathering the text selection, shown via the Quick Mask to indicate its soft edges.

Converting the Text to Spray Paint

1. Return to the Layers dialog and delete the text layer.

2. Add a new transparent layer by choosing **Layer ▸ New Layer** and setting the layer fill type to **Transparency**. Name the new layer *Paint*.

3. Retrieve the **Outline** channel selection from the Channels dialog, and then grow the selection by **2 pixels** (**Select ▸ Grow**) and feather it by **10 pixels** (**Select ▸ Feather**). These steps will soften the edges of your selection, enhancing the spray-paint effect.

4. Click the **Paint** layer in the Layers dialog to make it active again.

5. Choose **Windows ▸ Dockable Dialogs ▸ Brushes** from the canvas menu to open the Brushes dialog, and then choose the **Round** brush.

6. Choose the **Airbrush** tool from the toolbox. In the Tool Options dialog, set the size to **20**.

7. Click the foreground color box in the toolbox to open the Change Foreground Color dialog, type *Yellow* in the HTML field, press ENTER, and then close the dialog.

8. Paint inside the selection with quick, uneven strokes, but don't fill the selection completely. Don't worry if the text doesn't look exactly like spray paint yet. Deselect all (**Select ▸ None**).

9. Choose the **Rotate** tool from the toolbox and use it to rotate the Paint layer by **–20 degrees**.

10. Open the IWarp filter (**Filters ▸ Distorts ▸ IWarp**). Set the Deform Radius to **40 pixels**, and then drag the mouse through the lettering to distort it lightly. This step makes the spray-painting appear more random.

The selection acts as a bounding area for your paint strokes.

Rotating and warping the text gives it a more sprayed-on appearance.

11. Duplicate the Paint layer (**Layer ▸ Duplicate Layer**). Set the Mode for the original Paint layer to **Color**, and then set the Mode for the duplicate layer to **Grain Merge**. These layer modes allow the bricks' shadows and cracks to show through your spray-painting.

Changing the layer modes blends the text with the wall beneath it.

12. Duplicate the original Paint layer again (**Layer ▸ Duplicate**) and name this layer *Drip*.

13. You'll reuse a technique you used to create frosty icicles in Section 5.4, this time to create paint drips. Start by rotating the Drip layer 90 degrees clockwise (**Layers ▸ Transform ▸ Rotate 90 degrees clockwise**).

14. Open the Wind filter (**Filters ▸ Distorts ▸ Wind**). Set the Style to **Blast**, the Direction to **Right**, and the Edge Affected to **Both**. Then set the Threshold to **3** and the Strength to **20**. Click **OK** to apply this filter to the Drip layer.

15. Rotate the Drip layer 90 degrees counterclockwise (**Layer ▸ Transform ▸ Rotate 90 degrees counter-clockwise**).

16. Set the Mode for the Drip layer to **Screen**. For an enhanced drip effect, duplicate the Drip layer one or more times.

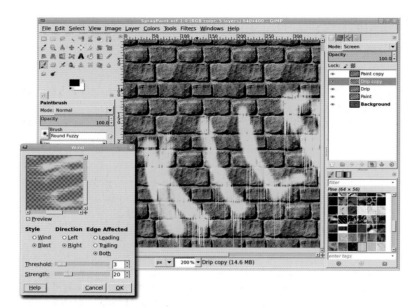

The rotated Drip layer is blasted by the Wind filter.

Further Exploration

What can you take away from this tutorial? You've learned that simple tools like the Wind filter can serve a wide range of purposes and help you achieve surprisingly numerous effects. You've already used the Wind filter to create both frosty icicles and dripping paint. What will you create next?

TIPS FOR TYPE EFFECTS

Advertising, web design, and many other kinds of projects involve combining text with images. As you begin working with type in your GIMP projects, consider this food for thought.

Make Alignment Easier

Did you find yourself repeatedly creating a text layer and then centering it on another layer during these tutorials? Use the Align tool to make this process a breeze. Remember to click on a layer in the canvas, set the Relative To option in the Tool Options dialog, and then click on the appropriate alignment buttons.

Find Good Fonts

A good font will take your message a long way. But there are good fonts and there are not-so-good fonts. While free fonts will often suffice for home, church, club, and school projects, they aren't likely to offer the same quality or features as fonts created by reputable type foundries. High-quality fonts include proper kerning, ligatures, complete character sets, multiple font weights, and even small caps and old-style numerals, all of which can add even more impact to your type designs. If you're trying to make it into print, you're going to need to pay for some high-quality fonts. Some commercial type foundries include the following:

Linotype *http://www.linotype.com/*

International Typeface Corporation *http://www.itcfonts.com/*

Bitstream *http://www.bitstream.com/fonts/index.html*

Use Only the Fonts You Need

If you're not publishing your work professionally, free font archives may provide everything you need. Even in that case, you need to decide which fonts to install. Having 1,000 fonts gives you lots of choices, but GIMP uses simple lists for font selection, so you could be scrolling through them for days. Cut out the useless fonts, such as those consisting of special symbols and nonalphabetic features you don't need.

Use Large Type and High Resolution for Print Projects

If you use a 12-point font at 72 dpi in a project that will ultimately be printed at 300 dpi, you'll need a microscope to read it. Or worse, the printer's rasterizer might blow up the text, making it pixelated and illegible. If your project is destined for print, set the resolution to 300 dpi from the start. Remember that it's easy to scale down gracefully, but it's difficult to scale up without causing problems for yourself.

Remember That All GIMP Text Is Rasterized

You can create text in GIMP and then scale it to a larger size later, but only if the text remains in a text layer. Text layers are vector layers, which means they can easily scale or edit without loss of quality. They also contain information about what the text actually says. But once that layer is rasterized, scaling the layer or the image should be kept to a minimum.

Rasterized layers contain only colored pixels, possibly with some level of transparency. So even if a rasterized layer looks like text, there is no information available about that text, and scaling it is like scaling any other photograph: the more you enlarge it, the worse the image gets.

In a similar vein, when you save your image to JPEG, PNG, or any other raster image format, all layer and text information is lost. As a result, it'll be much harder (or even impossible) to edit your file. To retain layer and text information, you must save the file to XCF format, which is GIMP's native file format.

Practice Copyfitting Manually

GIMP added bounding boxes, also known as editing boxes, for editing text in the 2.8 release. To map a paragraph to a specific space, select the text tool and set the Box option in the Tool Options dialog to Fixed. Click in the canvas and drag the editing box to the desired size and position.

If you have a large amount of text, shape the editing box to the size desired and then use the Editor dialog (available from the Tool Options dialog for the Text Tool) to read additional text from a file into the box. Inserting text with no newlines before shaping the box can create a very wide bounding box, requiring you to zoom out a great distance to find the right side edge of the box. Be sure to shape the box before reading text from a file into the box.

Edit Text Layers Wisely

You can edit a text layer at any point after creating it as long as no raster effects have been applied. Applying a blur, curve, or level change, for example, will convert the layer to standard layer. Once this happens, the text can no longer be edited with the Text Tool. If this happens accidentally, try using CTRL-Z to back out changes until the layer returns to a text layer.

When you do need to edit a text layer, click it in the Layers dialog to make it active, choose the Text tool from the toolbox, and then click in the canvas over any letter in that layer.

Plan Ahead

As with any project, a graphic design project needs an efficient workflow. Your project nearly always has two goals: it's destined for print or for the Web, and it's meant to advertise or inform. In order to reach those goals, you have to be organized. Knowing what your text should say and how it should look before you actually start working in GIMP will reduce the chance that you'll have to make changes later, when they'll cause excessive reworking. Planning out your text is just the start, however. Think ahead about images, colors, themes, and messages. It's all part of a designer's workflow.

Create Font Maps

A font map is an image containing examples of one or more fonts. GIMP can do this automatically for you, though the feature is a little hidden gem. Click on the Font Preview in the Tool Options dialog to open a menu. At the bottom of the menu is a button bar. Use the rightmost button to open the Font Selection dialog.

Right-click any entry and choose Render Font Map to open a dialog to pick the fonts to render. Use the Filter field to limit the sets of fonts to render. For example, you can create one for every font that starts with the letters *as* by typing ^*as* in the Filter field.

6

CREATIVE INSPIRATION

With this second edition of *The Artist's Guide to GIMP*, I want to encourage readers to expand beyond simple desktop artwork using GIMP. Most of the artistic effects possible with Photoshop are just as easy to do with GIMP and the reason is simple: at their roots, they both twiddle with pixels. Their menus and user interfaces differ, but the underlying processes are remarkably similar.

I often compare moving from Photoshop to GIMP to moving from one city to another. When you move to a new city, it takes time to find your way to the grocer or to the theater. But once you learn how to get there, the grocer and theater are probably much like the ones you left behind. So it is with GIMP. It takes patience to find the tools or filters that perform a given task, but the end result will be just as recognizable and familiar to you.

There's no reason to think that, once you've learned your way around GIMP, you can't create your own works of art. GIMP doesn't have to be just a glorified icon editor or photo touchup tool. It is much more than that: it's a tool to express yourself.

I like working with stock images and distorting them repeatedly until I create my own little world.

Now, it's true that art is a very personal thing. One man's art is another man's fish wrap. That doesn't change the fact that you can still create art with GIMP that you'd happily frame and hang on your own walls. Your spouse, significant other, and/or roommates, on the other hand, might have different ideas.

That said, I want to show you with some advanced tutorials on how to be creative simply for the sake of being creative. The tutorials build on techniques learned in previous tutorials and bring together the foundations for doing your own artwork: initial design, integration of external images, coloring, and highlights and shading. Work with these to gradually expose your inner Van Gogh.

These tutorials will assume a more advanced understanding of GIMP's tools, menus, dialogs and filters. But fear not . . . I won't leave you completely hanging! So dive in and explore your creative side!

This effect creates a ghostly figure wreathed in flame—a demon, an angel, a ghost, or an ifrit depending on your perspective. I simply call her the Fire Girl. The process for creating this effect can be reduced to these basic steps:

1. Isolate the girl from the background.
2. Edge-detect the girl on multiple layers.
3. Add and blend ornamental elements.
4. Blend to remove excess details.
5. Add flame and coloring.
6. Add background emblem.

Throughout the project, you'll find that flames aren't just components of the image but are also used for coloring. The easy way of using a flame to color a layer is to first desaturate the layer, and then add a flame layer above and set the flame layer mode to whatever "looks right." However, if you place an image below a flame layer, the black region around the flame may block that lower layer from being visible, depending on the flame layer's blend mode. To avoid this, you'll use layer masks on flame layers or simply copy and paste flames, taking care to omit the black backgrounds from your source image.

Note that even if you follow this tutorial exactly, you won't produce the same image. The steps allow for too many variations, especially when creating the crown of flames. Don't be discouraged if your first attempt is less than ideal. I went through seven different designs before settling on this process. And the first four or five of those are, to be kind to myself, not something I'd ever show in public. I won't even show them to my wife.

The tutorial's process starts with a large canvas (2350 × 2033) to produce a print-ready design. To reduce memory and CPU requirements, you can scale the stock images down by 50 percent before starting.

Several stock images are used in this project, but the end result bears little resemblance to those originals.

Isolating the Girl from the Background

The first step in this project is to isolate the girl from her background. This is done primarily because the background in the source image for the girl is not required for the project, and its color may cause problems when mixed with other layers. Isolating the girl will also allow background elements to be added behind her.

1. Desaturate the source image (**Colors ▶ Desaturate**) and select the **Luminosity** option. The source image has a yellowish tint when converted from its original color space (provided in the

image when downloaded from the stock image website) to the color-managed display in GIMP. The yellow tint converts to a bright white when the Luminosity option is selected in the Desaturate dialog. If you aren't using a color-managed display, it may not matter which setting you choose in the Desaturate dialog.

2. Use **Select By Color**. In the Tool Options dialog, set the Threshold to **50** and click the white background. This will select all of the background, a little of the hair, and some of the face and neck.

3. Switch to **Quick Mask** mode and paint out the white areas over the girl with a black foreground color and a large brush. Switch off Quick Mask mode and invert the selection.

Painting with black in the Quick Mask colors the white areas in the face and neck, effectively taking those areas out of the selection. The poor selection around the hair doesn't matter— you'll get rid of the hair next.

4. Copy and paste the selection to a new layer and name it *Girl*. Fit the new layer to the canvas using **Layer ▸ Layer to Image Size** so that any modifications made to the girl won't be restricted by the size of the layer.

5. In the original layer (which is titled Background by default), use CTRL-A to select the entire layer and then drag the black foreground color into the canvas to fill that layer with black.

6. Now it's time to get rid of the hair with a layer mask. Add a white layer mask to the Girl layer. Starting with a large brush and switching to smaller brushes, paint with black in the layer mask until most of the hair is removed. Leave a small amount of hair to provide an additional visual feature when using the edge-detect filters. Turn off the Girl layer visibility so it doesn't interfere with the next steps. Apply the layer mask (**Layer ▸ Mask ▸ Apply Layer Mask**).

Hair on the face will be cleaned up later. Leave just a bit of hair around the top of the head.

Edge-Detecting the Girl to Create Multiple Layers

The next step in this project is to create detailed outlines of the girl using edge detection filters. Two such filters will be used: Filters ▸ Edge-Detect ▸ Edge and Filters ▸ Edge-Detect ▸ Neon. These produce similar results, which will be combined using layer modes.

1. Duplicate the Girl layer, make the duplicate visible in the Layers dialog, and name the duplicate *Edge Detect*. Open the **Edge-Detect** filter and select the **Prewitt compass** algorithm. The choice of algorithm is based on the preview. Choose the algorithm that shows the most detail. Apply the filter to the layer and set the layer mode to **Screen**.

2. Duplicate the Girl layer and turn on the duplicate layer visibility again, this time naming the new layer *Neon Detect*. Move this layer to the top of the layer stack.

3. Invert the colors (**Colors ▸ Invert**) in this layer, and then apply the **Neon** edge-detect filter. Set the layer mode to **Screen**. Duplicate this layer, giving three layers of edge detection above the Girl layer.

Multiple copies of the edge-detect layers with layer mode set to Screen or Addition may be necessary to bring out the details in the project. In this project, only one additional layer was needed.

Zooming in on this, you may find some strands of hair that were missed with the mask previously applied to the Girl layer. These can be left, or they can be removed with the eraser. If the eraser is used, it will probably need to be applied to the same area on each of the three edge-detect layers.

Blending in Ornamental Elements

Now it's time to ornament the girl. The best places to find these types of designs are on ornate picture frames and building architecture. This project got stuck with picture frames only because I couldn't find any really good photos of Victorian architecture.

There are two ornamental pieces added to the design: one on the forehead and one around the neck. The former comes from a mostly rectangular frame while the latter comes from an oval frame.

1. Start with an image of a rectangular frame and desaturate it. (Choose a frame that's easy to isolate, like this one with a solid color background.)

2. Use the **Fuzzy Select** tool with the Threshold set to **50**. Click once outside the frame, and then hold down the SHIFT key and click inside to create a complete selection of the background. Grow this by **1 pixel** (something I nearly always do to avoid light-colored pixels along the edge of the selected object) and then invert the selection.

3. Copy and paste the frame into the working canvas as a new layer at the top of the layer stack. Name it *Ornamental: Forehead*. The layer mode should be set to **Normal**.

4. Scale, rotate, and position the **Ornamental: Forehead** layer over the girl's face. Use a layer mask to remove the unwanted sides and edges of the frame. Duplicate the layer and set the duplicate layer mode to **Dodge**. Dodging the copy over a desaturated normal mode original enhances contrast (in this case, it makes our girl shinier).

The scale, rotate, and position process takes experimentation. Rotation and scaling are easier if you set the Tool Options Preview to Grid instead of Image.

The ornament around the neck is created the same way, albeit starting with a different frame. The rotation, size, and position will be different than in the Forehead version, not to mention being masked differently. In this example, the bottom edge of the frame is kept, while the rest is masked out.

1. Copy and paste another frame selection as a new layer. The layer name for this copy is *Ornamental: Neck*. Rotate, size, position, and mask as appropriate. Finally, the mask is added to keep just the (now) bottom portion of the frame.

2. Duplicate the neck layer and change the layer mode to **Dodge**.

Note that in this example, the actual frame images were smaller than the main image window but larger than the girl. This required shrinking the size of the frames. Had they been too small you could have scaled them up. This is seldom done because the scaled image quickly becomes pixelated. However, in this case the pixelation is hardly noticeable because of the

weakly identifiable shapes (the ornate structure has no discernible objects—it's just wavy lines). Additionally, using multiple copies of a frame layer and blending layer modes hides some of the pixelation, and, later, coloring with flames hides even more. The sheer size of this image also hides some of that pixelation when working onscreen. Large prints, however, would likely show the pixelation. Therefore, any prints for this size image when layers were scaled up would need to be no larger than the size of a magazine or book page.

Later you may find that colorizing with the flames leaves the ornamental layers rather bland. If that happens, try returning to these steps and using the frames without desaturating them.

Blending to Remove Excess Details

The ornaments may not hide as much hair or facial blemishes as desired. To remove these from the girl's face, use the Eraser and Smudge tools along with a drawing pad. If you don't have a drawing pad, just use a smaller brush and vary the opacity manually.

NOTE *Drawing pads are flat panel input devices, some with built-in displays, which work with a stylus. Drawing on the pad with the stylus moves the cursor on the monitor much like moving a mouse. These pads are typically connected to the computer via a serial or USB port. Many artists find it easier to use drawing pads for design work than a standard mouse. Popular makers of drawing pads include Wacom, Genius, Adesso, and Aiptek.*

Smudging in the edge-detect layers is possible (white and black, when smudged, give shades of gray), but it would be better to leave some of the line details in the face. To accomplish that, use the Eraser with a grunge brush and set Brush Dynamics to increase Opacity, Hardness, and Size when pressure is applied using the drawing pad (or manually with different strokes).

1. Apply the eraser to each edge-detect layer, starting with the topmost of these three layers. Do only a small amount on each layer before moving to the next, rotating back to the top and repeating. The goal is to try to keep as much of the detail as possible while losing obvious blemishes in the girl's face.

Notice that the hair over the ear is not touched. That only enhances the random nature of the flames added later.

2. Turn off the visibility of the three edge-detect layers and turn on the visibility of the **Girl** layer. Enable the **Lock Alpha Channel** option for the Girl layer.

3. Choose the **Smudge** tool, using any appropriate brush to blend the hair out of this layer. Try to keep the lighting smooth across the cheek by clicking in lighter areas first (the cheek) and dragging into darker areas (the hair). Smudge the neck and clothing as well.

4. With the layer **Lock** enabled, you don't have to be careful not to smudge outside the girl.

5. When completed, turn on the visibility of the edge-detect layers.

The edge-detect layers (lower right) give the Girl layer a more glassy appearance after the original girl layer is smudged. For added effect, consider removing the Girl layer completely to dramatically change the final image.

Adding Flame Coloring

1. Choose the **Girl** layer from the Layers dialog. Open the Colorize dialog and set the Hue, Saturation, and Lightness to **30**, **90**, and **–30**, respectively.

2. Open and copy in a roaring fire image (flame and black background) as a new layer at the top of the layer stack. Scale the layer so the flame fits completely over the girl, and then crop the layer to fit the image (**Layer ▶ Layer to Image Size**). Set the layer mode to **Hard Light**. This brings out the red in the flame.

3. The layer may not span the width of the image. In that case, you can end up with a white band filling the extra space. If this happens, use the **Fuzzy Select** tool, grow by **1**, and fill the selection with black.

4. At this point the flames obscure the girl's face. You have several options: leave it alone (because you think this looks cool), use the smudge tool, or add a layer mask on the flame layer to let the face and ornaments show through.

A large, hard-edged brush (Round 101, sized to 150 pixels) was used with the Airbrush to lightly remove the flame over the girl's face.

Creating the Crown of Flames

The process for creating the crown is simple, but you'll likely need a few attempts to get it right.

1. Start with a flame image like the one shown here—a flame, not a roaring fire. Copy just the flame (not the black background) into the working canvas. Name the new layer *Flame Hat*. Scale this layer to fit from the girl's forehead to the top of the image.

2. Duplicate this layer, flip it horizontally, and position the duplicate close to the original Flame Hat layer.

3. Use a mask on the Flame Hat copy layer to blend the flames together as necessary. Then merge the two layers by selecting the top layer of the two and choosing **Layer ▶ Merge Down**.

4. Move the merged layer to the middle of the image window and size the layer to the image again. Now you have the basic flame-hat frame with space around it to create the flame swirls.

The stock flame image makes a good hat on its own, but I found its downward-pointing highlights a bit depressing. So a little warping magic will be applied next.

5. Use the IWarp filter (**Filters ▸ Distorts ▸ IWarp**) to create the flame swirls. Swirl the left side of the hat using the **Swirl CW** mode, and swirl the right side of the hat using the **Swirl CCW** mode. Choose one or more spots on each side that would make good swirls. Click (never drag) in the preview in various places to create the swirls with nearly uniform appearance. Clicking and holding also works, but hold for a short amount of time or the swirl gets too big.

6. Experiment with the **Deform radius** and **Deform amount**, as well as where to click in the preview. If the preview gets messed up or you just don't like it, hit Reset and try again. Remember: this step takes a lot of experimentation!

7. After applying the IWarp settings to the **Flame Hat** layer, position and rotate the hat over the girl's head. Set the layer mode to **Screen**. Add another copy of the roaring fire from the coloring step above this layer, scaled so the whole flame fits inside the hat. Set the layer mode for the roaring fire layer to **Screen**. Use a layer mask to blend it into the hat.

Further Exploration

To add a sort of Mayan feel to this project, select the Mandala brush from the GIMP Paint Shop collection (or any suitable oval icon converted to a brush). Use the Paintbrush tool and increase the scale of the brush until a single brush click is roughly 3/4 the size of the image window. Add a transparent layer above the Background layer, set the foreground color to white, and click once in the new layer.

NOTE *GIMP Paint Shop is an add-on package of brushes, patterns, palettes, and tool presets that allows users to simulate specific drawing and painting tools and techniques, such as watercolor, blue ink pens, and charcoal. GIMP Paint Shop is available on the web at* http://code.google.com/p/gps-gimp-paint-studio/.

Duplicating the flame layers and masking out different parts, and then setting different layer modes can also affect the final version of your artwork. Don't be afraid to experiment—just be sure to save your work periodically!

Above the Mandala imprint layer, add the roaring fire image in a new layer. Scale the fire to cover most of the imprint and set the layer mode to Multiply.

To enhance the fire hat, add a fire emblem. The emblem can be a stock image or a handmade image copied, pasted, scaled, rotated, and positioned over the hat. Piece of cake compared to that business with the IWarp swirls, right?

6.2 STAR FIELD

The process for creating a fantastical sci-fi star field is actually very simple. You'll just create a random star field that mirrors the real night sky with clusters and voids of stars; layer elements on top of it, like nearby spiral and sombrero-shaped galaxies, space dust and nebulae, larger stars in the foreground; and colorize the result. As a final touch for those who want even more flair, you can add a nearby planet or spaceship.

The last step is the hardest, though GIMP's Sphere Designer filter makes creating planets pretty easy. Other than that last step, you'll probably spend most of your time getting the star clusters just right.

This is either a shot from Disney's The Black Hole *or an opening scene from* The Big Bang Theory. *Either way, it's not just another ordinary star field.*

NOTE *This tutorial is based on the process described by Greg Martin in a Photoshop tutorial (http://www.gallery.artofgregmartin .com/tuts_arts/making_a_star_field.html). I've translated it into GIMP-specific methods, but my basic process was inspired by his.*

Starting Small

The core of this process is the use of noise filters, which provide random dots on a black background. However, these dots are too small for a typical project, especially one intended for print. To get around this, start with a small-scale version of the stars and scale the image up. Typically I wouldn't recommend scaling up raster images like this. Working with noise to create dots of light is one of the few exceptions to this rule. The first layer of this project will produce the distant background set of stars.

1. Start with a new image set at 640 × 480 pixels with a white background. Type **D** in the image window to reset the foreground and background colors to their default settings of black and white, respectively. Drag the foreground color from the toolbox into the image window to fill the Background layer with black.

2. Add a new layer to the image window (**Layer ▸ New Layer**) and name the layer *Small Stars*. Set the layer color to the foreground color. Open the HSV Noise filter (**Filters ▸ Noise ▸ HSV Noise**). Set the Holdness to **3**, the Hue to **20**, the Saturation to **90**, and the Value to **100**. Apply this to the layer by clicking **OK**.

3. HSV Noise renders the noise in color, so the layer needs to be desaturated. Open the Desaturate dialog (**Colors ▸ Desaturate**) and use the **Luminosity** setting. Click **OK** to apply to the layer.

4. The rendered noise is randomly distributed but a bit too densely populated. Open the Brightness-Contrast dialog (**Colors ▸ Brightness-Contrast**). Set the Brightness to **45** and the Contrast to **65** and click **OK**. The result will be fewer stars, some of them a bit brighter.

5. These settings are variable, meaning that changing them can have an important effect on the final appearance of the image. Increase both to reduce the number of small stars even further. But be careful not to make the stars too bright. Remember, these are just background and distant stars. The brighter, more visible stars and clusters are yet to come.

This project works on very small points of light that can be hard to see on a monitor and even harder to see when printed. To make it easier to see what's happening, zoom into the image window by **300 percent**. You'll zoom back out when the image contrast is easier to see in print.

The zoom amount (300 percent) in the screenshot can be seen in the status bar of the image window. The Luminosity setting in the Desaturate dialog was chosen because it increased the brightness of the dots more than the other options.

Growing Bigger Stars

That's enough for the background stars. Next come some larger, less distant stars.

1. Duplicate the Small Stars layer (**Layer ▸ Duplicate**) and name the new layer *Large Stars*. Thin out the stars a bit more in the Brightness-Contrast dialog with the Brightness set to **50** and the Contrast set to **110** this time.

2. The next steps will require these stars to be significantly larger. Scale the layer up to **200 percent** (**Layer ▸ Scale Layer**). Choose the percent option. Using a percent will make it easier to know the amount to later scale this layer back down. Use the default setting for the Quality Interpolation option.

3. Scaling up the layer without scaling up the image made the layer larger than the image size. That doesn't matter for now; the next steps will still work on the entire layer, and later resizing will fit the layer back into the image size.

The oversized layer, shown here with the layer boundary extended beyond the visible black layers, won't cause problems. Changes will still be applied to the entire layer even if parts of it aren't visible.

Scaling the layer by 200 percent helped make the large stars more visible, but they're still hard to see. It's time to fix that.

1. Invert the colors (**Colors ▸ Invert**) of the Large Stars layer. The large stars will be fairly dim at this point. This next step will improve that situation.

2. Open the Levels dialog (**Colors ▸ Levels**). Set the black point to **230**, the midpoint (also known as Gamma) to **1.00**, and the white point to **250**. The Levels adjustment will sharpen the large stars, making them darker and more distinct. Inverting the colors makes it easier to choose the right settings for the Levels adjustment. If the stars aren't improved with these settings, try higher values for both the black and white points.

When working on this step on the computer, you'll see that the inverted version is very clear and makes choosing Levels settings easier.

3. Invert the colors again. Now the layer can be sized back down, but not all the way. To size it back to its original size, you'd scale the layer by 50 percent (or half its current size). This is another variable point in your project. Instead, scale the layer to **60 percent** of its current size. Then the stars will

be a bit larger than their small star cousins. If this isn't large enough, increase the percentage. But don't make these stars too large. The later clustering process will bring out brighter, larger groups of stars. After scaling, fit the layer to the image, essentially trimming the excess layer, using the **Layer ▸ Layer to Image Size** menu option.

The large stars are only slightly larger than the small stars, and the clustering process that comes later will improve the look of both.

Working at a Larger Scale

Now it's time to scale up the entire project. Scaling up will produce a much nicer star field for print or the Web. It also makes the rest of these steps easier to see. Remember, starting with the smaller image size was necessary because of the size of the noise generated by the HSV Noise filter.

1. Scale the image (**Image ▸ Scale Image**) by **250 percent**. The link icon to the right of the width and height should be unbroken. That will keep the aspect ratio, so the stars remain essentially round.

2. Set the Large Stars layer mode to **Screen**. Now the entire set of distant small stars and closer large stars should be visible. The new image size should be 1600 × 1200 pixels.

3. At this point you'll get a better feel for how well your Levels adjustment worked in the previous step. If the large stars are too bright, apply another Levels adjustment or change the Brightness-Contrast to darken them a bit.

After scaling and blending the large stars with the background small stars, it became obvious that the large stars were too bright, so the Brightness-Contrast dialog was used to dim them.

Adding Space Voids

This is a nice field of stars, but there are plenty of improvements that can be made. The first is to create some voids in space, places with a lack of stars. This step seems awkward at first. There is no recipe for what parts of the fields to wipe out.

The goal here is to create some blank regions of space. Those may get filled with stars again when the clustering process is performed. For now, clean out big swatches. Don't be shy on the Large Stars layer either. Trust me: there don't need to be many big stars left when you get to the clustering step.

1. Add white layer masks (**Layer ▶ Mask ▶ Add Layer Mask**) to both the **Large Stars** and **Small Stars** layers. Choose the **Paintbrush** tool from the toolbox and select a fairly large brush. In the Tool Options dialog, set the initial Opacity for the Paintbrush to **50 percent**. Type **D** in the image window to make sure the foreground color is reset to black. Now paint through each layer, wiping out large swatches of stars.

2. No matter which brush you choose, increase the size of it for use on the Large Stars layer. Try different brushes and adjust their opacity as you go.

3. Avoid any obvious patterns in the voids and remove any patterns created when the Brightness-Contrast and Levels adjustments were applied to the original HSV Noise. Use short brush-strokes, alternating vertical and horizontal stroke directions.

4. When the voids are plentiful and obvious, save the project first in XCF format so that if the remaining steps don't produce the star field of your dreams, you can try again without having to start over. Finally, flatten the image (**Image ▶ Flatten**) into a single layer.

These zoomed-in views show that many of the large stars are reduced in brightness or even removed completely. The background stars are also now peppered in clumps, which will come in handy with the next step: clustering.

Clustering

The real artistic aspect of this project is in the clustering of stars. To create galaxies and other clusters, use the Clone tool from the toolbox. Again, a variety of brushes may be required here, depending on your personal taste. Hard-edged brushes seem to produce the best effects, but don't be afraid to try almost any brush.

1. To use the Clone tool, hold down the CTRL key and click anywhere in the canvas. This is the source location. Release CTRL and begin painting anywhere in the canvas. Cloning using the **Normal** mode in the Tool Options dialog simply replaces the current pixels under the cursor with the pixels from the source location. The source location moves relative to the brush, always staying exactly the same distance and direction from the current location.

2. To get really nice clusters, alternate among **Normal**, **Screen**, and **Overlay** modes in the Tool Options dialog for the Clone tool. Use areas with stars as the source location when creating clusters. Use the void areas as the source location when trying to separate clusters from other areas.

3. Try to create some swirling clusters or a spiral galaxy as seen from directly above or edge on. Try a few clone operations to see what you get, and then use CTRL-Z to back those changes out and try again. Once you begin to see how the clusters form, you won't need to back out the changes. Save your work frequently, and in different files, as you experiment. This allows you to return to previous variations if your experiments get out of control.

4. The next step will add a soft glow to the star clusters. Duplicate the Background layer (at this point there should only be one layer after previously flattening the image) and name the new layer *Star Glow*. Open the Gaussian Blur filter (**Filters ▶ Blur ▶ Gaussian Blur**). Set both the horizontal and vertical

blur radius to somewhere between 5 and 40. The actual amount depends on the density of your clusters. Choose a cluster with the most visibly distinct white dots in the preview window of the Gaussian Blur dialog. Adjust the blur radius based on that preview. The result of the blur should be a somewhat cloud-like appearance for the Star Glow layer.

This is a normal-sized view (with Levels slightly adjusted to make sure it shows up in print) after much work with the Clone tool. See how a dim set of background stars mixed with just a few larger, closer stars turns into a cluster of galaxies!

5. Set the Star Glow layer mode to **Dodge** (for subtle enhancement) or to **Screen** (for vivid enhancement). The glow is enhanced with some coloring. Open the Colorize dialog (**Colors ▶ Colorize**) and set the Hue, Saturation, and Lightness to **215**, **90**, and **0**, respectively.

The Star Glow layer is used to bring out detail in the clusters while leaving the background stars essentially untouched.

The first red layer just changed some blue light to purple. An intense red layer, created the same way as the first but with different Colorize settings, was added and mixed with a layer mask to bring out strong shades of red.

Coloring

Next comes a little more color. This process won't add blasts of color, just a hint of it to selected points.

1. Duplicate the Background layer and name it *Red Stars*. Move this layer to the top of the layer stack. Reduce the number of visible stars using the **Levels** dialog. Set the black point to **90**, the midpoint to **1.00**, and the white point to **160**. As with other applications of the Levels dialog, these values can be adjusted as necessary.

2. Open the Colorize dialog again and set the Hue, Saturation, and Lightness sliders to **0**, **80**, and **–10**, respectively. Set the layer mode for the Red Stars layer to **Dodge**. Don't use Screen this time as it would wash out the light coloring this process adds to the image.

3. Repeat the process as many times as you like, using variations on the Levels and Colorize settings. You can also use a layer mask to color different sets of stars in the duplicate layers.

Using Lens and Gradient Flares for Highlights

The bright points of light in the star field need to be softened and broadened. This is easily accomplished using the Lens Flare and Gradient Flare filters.

1. Create a new layer that's **250 × 250 pixels**. Set the Fill Type to **Foreground Color** (assuming here that the foreground color is still black; if not, type **D** in the canvas to reset it). Name the new layer *Lens Flare*. Move this new layer to the top of the layer stack.

2. Open the Lens Flare filter (**Filters ▸ Light and Shadow ▸ Lens Flare**). No changes are required to the filter options, so click **OK** to render the flare in the Lens Flare layer. The flare is colored, which you probably don't want (but hey, experiment with colored flares too!) so desaturate it (**Colors ▸ Desaturate**). Set the layer mode to **Dodge** and then use the **Move** tool to drag the layer over some star clusters.

3. Duplicate this layer a few times, scaling each duplicate up or down just slightly, and place the duplicates over various star

clusters. Place flare centers over space voids to use the outer edges of the flare to highlight an area. Place a flare center directly over a star to make it shine even brighter. What's fun here is to drag these small layers around and see how they pull out details you hadn't previously seen.

4. Create another black layer that's **250 × 250 pixels**. Set the layer mode to **Dodge** and name the new layer *Gradient Flare*. Open the Gradient Flare filter (**Filters ▶ Light and Shadow ▶ Gradient Flare**). In the Selector tab, choose the **Hidden_Planet**, **Bright_Star**, or **Distant_Sun** preset. Render this into the new layer. Desaturate and position, and then duplicate and position as many times as desired.

Experimentation is vital at this stage of the project. Try different Gradient Flare presets, desaturated and colorized. You may, and probably will, end up with a large number of flare layers.

Adding Space Dust

At this point the star field is essentially complete. The next step, adding space dust, just adds a bit more pizzazz to the project.

1. Add a transparent layer, name it *Space Dust*, and move it to the top of the layer stack. Set the layer mode to **Screen** and the Opacity to **20 percent**.

2. Pick a new foreground color, like a soft blue with RGB values set to **57/99/176**. Choose the **Paintbrush** tool from the toolbox. In the Tool Options dialog, set the Opacity to **20 percent** and make sure the **Incremental** checkbox is checked. Choose a variety of soft-edged brushes and change often as you paint.

3. Paint in the Space Dust layer in long strokes, brush horizontally, vertically, and diagonally. Fill the layer with more dust than you need, and then use the **Eraser** tool to clean out the excess.

The space dust serves essentially the same purpose as the Star Glow layer: to soften the bright clusters. It also adds color to the space voids.

Further Exploration

The star field is complete, but for added fun it should have a foreground object: a planet. The Sphere Designer filter makes creating planets very simple. Create a transparent, 600 × 600-pixel layer named *Planet*. Open the filter (Filters ▶ Render ▶ Sphere Designer). Notice that there are three default layers. Each layer can be edited to change its properties and transformations. New and duplicate layers are added to the bottom of the list. Keep Light layers at the bottom. The layer order cannot be changed, so duplicate Light layers to move them to the bottom of the list, and then edit the original Light layers to change them to textures or bump maps.

6.3 CREAMSICLE LOVE

This tutorial is based on a personal view of the symbols of love: the sun, beams of light, a creamsicle-colored sky, and grassy fields. This will be one of the easiest of the advanced tutorials. There are no special talents needed here. But you'll need to find some extra brushes to add to GIMP's stock collection. I'll show you where to get these and how to use them. A stock photo is also required. I'll point you to the one I'm using here. In the process, you'll cover a few remedial tasks that haven't been covered in a while: custom gradients and foreground selections.

Every day is a sunny day in GIMP-land!

Creating a Custom Gradient

The project starts with a splash of color on the background applied as a gradient. The easy way to do this is to set the foreground and background colors and use the Blend tool from the toolbox, dragging from top to bottom in the canvas. Instead, let's review how to create a custom gradient.

1. Type **D** in the canvas to reset the foreground and background colors to their defaults of black and white, respectively. Open a new image (**File ▸ New**) that's **1600 × 1200 pixels**. The large size renders the image suitable for printing a postcard-size print at 250 dpi. If it's bound for the Web, however, scale the image down when completed.

2. At the bottom of the Gradients dialog (**Windows ▸ Dockable Dialogs ▸ Gradients**) are icons for managing gradients. Click on the icon second from the left to create a new gradient. This opens the Gradient Editor dialog. The initial gradient shown uses the foreground color on the left and background color on the right. Click and hold the right mouse button on the gradient to open a menu. Choose the left endpoint's color. In the dialog that opens, set the RGB values to **219/122/2**. Click **OK** to set the left endpoint color.

3. Creating a custom gradient is all about using that menu to add new segments, setting the colors on either end of the segments, and adjusting the size of the segments. While a more elaborate gradient could be created, this is all that's needed for this project.

4. In the Gradient Editor, change the name from Untitled to *RetroLove*. Then click the **Save** icon in the dialog. Close the Gradient Editor dialog.

5. Choose the **Blend** tool from the toolbox. In the Tool Options dialog, click the **Gradient** button and select the **RetroLove** gradient. In the canvas, drag from the top of the window to the bottom.

Gradients are easy to create and can be used to provide a background color theme, create textured patterns, or simulate 3-D effects.

Creating Temporary Grassy Hills

The next step is just as easy as the gradient. Two small hills will be created, and colored different shades of green. The coloring is temporary, however, and provides only a minor visual reminder that they are on separate layers. Later the hills will get a silhouette treatment when grass is applied to them.

1. The two hills are created using Ellipse selections in separate layers. Zoom out on the image (**View ▸ Zoom ▸ Zoom Out**). Create a transparent layer and name it *Foreground Hill*. Use the **Ellipse Select** tool from the toolbox to drag a wide oval across the bottom of the canvas. Click the foreground color

box in the toolbox and change the RGB values to **60/138/60**. Drag the foreground color box into the selection. Clear the selection (**Select ▸ None**).

2. The second hill is created the same way, with the new layer named *Background Hill*. Just move the selection slightly to the right and after applying the color, use the Brightness-Contrast dialog (**Colors ▸ Brightness-Contrast**) to darken the hill slightly. This allows the second hill to be more visible as the project progresses.

3. Move this layer below the *Foreground Hill* layer in the Layers dialog. Clear the selection. Zoom back in (**View ▸ Zoom ▸ Zoom In**) so the layers fit the image window.

The reason for having two hills is so the grassy field won't be flat or have a uniform curve. These will add variation to the final image.

Adding a Background Sun

Next comes the sun. This will be made from two layers, one with a solid-colored sun and another with a soft blur that makes the sun look a bit hazy.

1. Add a transparent layer and name it *Sun*. Move this layer below the Background Hill layer in the Layers dialog. Choose the **Ellipse Select** tool from the toolbox once again. In the Tool Options dialog, click the **Fixed** checkbox and make sure it's set to **Aspect Ratio**. Drag an oval selection in the canvas and position it to span both hills.

2. You can change the size and position of the selection by moving the mouse around the squares that bound the circle. The middle square is used to move the selection around the canvas. The top, left, right, and bottom squares change the width or height of the selection. The corners change width and height at the same time. The selection will remain editable until ENTER is hit or another tool is chosen.

A simple setting sun

3. Click the foreground color box in the toolbox to edit the color. Set the RGB values to **248/236/166**. Click **OK** to close the dialog. Drag the foreground color box into the canvas. Clear the selection.

4. If the sun is too large, scale the layers down. If the sun is too high in the sky, move the layers down with the Move tool. If you move the layers, use Layer ▸ Layer to Image Size to fit them around the Background layer.

5. Duplicate the Sun layer (**Layer ▸ Duplicate Layer**) and name the duplicate layer *Sun Haze*. Open the Gaussian Blur filter (**Filters ▸ Blur ▸ Gaussian Blur**). Adjust the preview so the edge of the sun is in view. Set the Blur Radius to **150** for both the Horizontal and Vertical directions. The Blur Method should be set to **RLE**. Click **OK** to apply the blur to the Sun Haze layer. Set the layer mode for that layer to **Addition**. This results in a bright white sun with only a hint of yellow around the edge.

For a yellower sun, use a darker color on the original Sun layer and then reduce the opacity of the Sun Haze layer.

Giving It the Retro Feel: Sunbeams

This next step will add the beams of light emanating from the sun. The process involves creating an initial beam and then duplicating, rotating, scaling, and positioning the duplicates. It's easier to create these beams if you start by zooming out again. Start with a horizontal beam stretching from the sun to the left edge.

1. Add a transparent layer named *Sun Beam* and move it to the top of the stack in the Layers dialog.

2. Click on the left ruler in the canvas and drag a guide to the approximate center of the sun. Click on the top ruler in the canvas and drag to the same spot. Choose the **Paths** tool from the toolbox.

3. In the canvas, click just above and just below the intersection of the guides. Then click outside the left edge of the layer boundary and just above and just below the previous two points. Click **Selection from Path** in the Tool Options dialog. Fill the selection with white.

Try to avoid making the initial beam too wide, though blurs and opacity will help the situation if you do.

4. Now the rest of the beams can be added. This is similar to how the cogs of the gear were made back in Section 4.8, using copy, paste, and rotation operations. The selection should still be active. Copy (CTRL-C) and paste (CTRL-V) the selection as a new layer (**Layer ▸ New Layer**). Use the **Flip** tool from the toolbox and flip horizontally, and then use the **Move** tool to position the layer so its left edge aligns with the intersection of the guides.

5. Duplicate this layer and rotate it 90 degrees counterclockwise (**Layer ▸ Transform ▸ Rotate 90 degrees counter-clockwise**). Position this layer so its bottom edge aligns with the intersection of the guides.

6. Duplicate this layer and rotate it **45 degrees** (**Layer ▸ Transform ▸ Arbitrary Rotation**). After rotating, this layer's lower left corner can be aligned with the intersection of the guides. Duplicate the layer and flip it horizontally, and then position the new layer appropriately.

7. Additional beams can be created by duplicating the vertical or horizontal beams and rotating them an arbitrary amount. In some cases, the beam will not extend to the edge of the image. Use the **Scale** tool to scale the layer so it does.

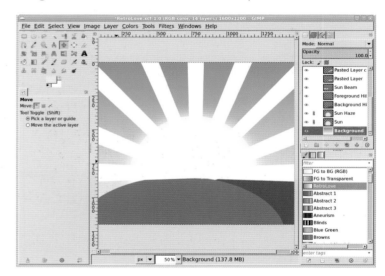

These layers provide an outline in which a radial gradient will be applied.

8. Merge the beam layers. The easiest way to do this is to turn off the visibility of all layers except the beam layers in the Layers dialog, and then merge the remaining visible layers (**Image ▸ Merge Visible Layers**). Create a selection from this (**Layer ▸ Transparency ▸ Alpha To Selection**). Add a transparent layer and name it *Sun Beam Gradient*. Type **D** and then **X** in the canvas to set the foreground color to white.

9. Choose the **Blend** tool from the toolbox. In the Tool Options dialog, set the Gradient to **FG to Transparent** and the Shape to **Radial**. Click in the canvas on the intersection of the guides and drag past the upper left corner. Turn off the visibility of the Sun Beam layer in the Layers dialog and turn on the visibility of the rest of the layers. Move the Sun Beam Gradient layer below the Sun layer in the Layers dialog.

10. Clear the selection. Open the Gaussian Blur dialog and set the Blur Radius to **20**. Click **OK** to apply to the Sun Beam Gradient layer.

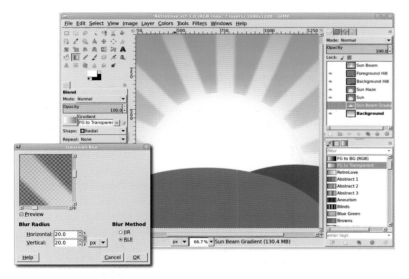

If the beams are too dim, duplicate the layer and adjust the Mode and Opacity to taste.

Adding the Lovers' Silhouette

The next element for this project is a stock photo used to create a silhouette of a couple in love. When searching for photos for projects like this one, look for photos that have a solid-colored background. This makes it easier to create a selection of just the couple. Also, this project will benefit if the couple is touching, yet separated enough to tell the individuals apart. If they're too close together, the resulting silhouette will not be easily identifiable. This particular photo is well suited for use with the Foreground Select tool.

1. With the **Foreground Select** tool active, draw a freehand selection around the couple. This produces a rough selection similar to a Quick Mask. Next, select a brush from the Brushes dialog (**Windows ▶ Dockable Dialogs ▶ Brushes**). The brush should display when you mouse over the canvas. In this photo, the brush size should be no wider than the thinnest arm of the woman. Adjust the brush size using the slider that runs from Small Brush to Large Brush in the Tool Options dialog.

2. Paint over the man and woman, making sure you cover places where shirts and pants meet and where clothes give way to skin. Essentially, cover any places with high-contrast changes you want to include in the selection. You don't have to be exact with this, and you certainly don't need to cover the couple completely.

3. To complete the selection, press ENTER. This converts Quick-Mask styled coloring into a selection. Further improvements can be made using the Quick Mask feature if necessary. Copy and paste the selection into the original canvas as a new layer and name it *Couple*. Scale and/or flip the layer horizontally as necessary.

4. Create a selection of the couple (**Layer ▶ Transparency ▶ Alpha To Selection**). Increase the layer boundary (**Layer ▶ Layer Boundary Size**) by **10 pixels** for both width and height. Click the **Center** option to center the image within the new layer boundary. Click **Resize** to apply the change to the layer boundary. Then grow the selection (**Select ▶ Grow**) by **1 pixel**. Growing the selection will smooth any rough edges in the selection before creating the silhouette.

5. Type **D** in the image to reset the colors in the toolbox and then drag the foreground color into the layer. Clear the selection (**Select ▶ None**).

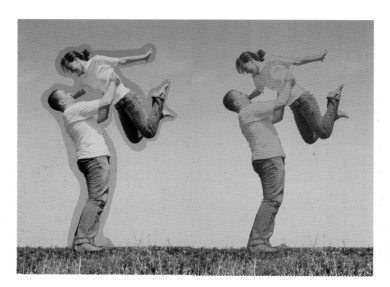

The rough selection (left) was improved (right) by using a small, hard-edged brush and a single pass over the couple. The selection isn't perfect (note the man's feet and pants), but it doesn't have to be to create the silhouette.

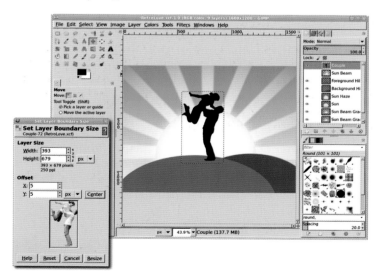

Scaling and flipping may be necessary to most appropriately position the silhouette on the hills, in front of the sun.

Finishing Off the Grassy Hills

The project is nearly complete, and the last step is to convert the hills to grassy silhouettes. This conversion will have the side effect of hiding the bottom of the man's feet, which seems natural after it's done. Also, at this point the guides are no longer necessary. You can hide them (**View ▸ Show Guides**) or remove them (**Image ▸ Guides ▸ Remove All Guides**).

1. First, change the hills from green to black. One at a time, select each layer in the Layers dialog and set the **Lock Alpha Channel**. Grab the foreground color from the toolbox and drag it into the layer, just as was done with the Couple layer.

2. Adding grass to the hills requires suitable brushes. GIMP doesn't come with plant-like brushes suitable for this project, but there are many collections of plant brushes available for download on the Internet. To add new brushes to GIMP, just unpack the collection in any folder. Open the Preferences dialog (**Edit ▸ Preferences**) and select the **Brushes** entry at the bottom of the list on the left. A set of options appears. Choose the **Brushes** option. The right side of the Preferences dialog will display the set of folders currently scanned for brushes. To add a new folder, click the **New Folder** icon to enable the text input field. Type in the name of the folder and hit ENTER or select it using the folder selection button to the right of the text field. The red circle icon will change to green if the folder exists.

3. Once the folder is added to the list of folders, click on the box to the left of the folder name to allow saving brushes to it. To use the new brushes, you must either refresh the Brushes dialog or restart GIMP.

NOTE *Many freely available brush collections are created specifically for Photoshop and are single files with the .abr filename extension. These files contain multiple brushes. GIMP can read these files well, so don't be afraid to experiment with Photoshop brushes.*

Adding brushes in the middle of a project is fairly common practice. It's just another good reason to save your project files often.

This grassy field was created using multiple brushes from a grass brush collection. Notice also how the green hills are now grassy fields.

4. Add a transparent layer and name it *Grass*. Move it to just above the Foreground Hill layer in the Layers dialog. Open the **Brushes** dialog and choose an appropriate brush. At the bottom of the dialog, set the spacing to anywhere from 50 to 150 (smaller, if the image size is smaller than the original 1600 × 1200 used for this project). Choose the **Paintbrush** tool from the toolbox. In the Tool Options dialog, set the **Scale** option so the brush outline (mouse over the canvas to see this) is an appropriate size. Paint along the edges of the hills multiple times. Switch to another grass brush and repeat. Repeat this process until the hills are sufficiently grassy.

Further Exploration

The last step is optional but adds pizzazz to the project: flying birds. Again, the trick is to find freely available bird brushes on the Internet. Add a transparent layer, choose a bird brush, scale it appropriately (smaller for more distant birds), and paint a few blobs around the sky. If the birds are not silhouettes, create a selection of the birds and fill it with black.

Comic book Hollywood hits like *The Dark Knight* and *Watchmen* are all the rage. These updates to the vision of classic superheroes come with a dark tone. *Sin City* paved the way for this new style of dark comic-book tale, bringing the grittiest original comic from the 1990s to the silver screen in 2005. Fortunately for GIMP fans, re-creating the *Sin City* effect is fairly easy.

This next tutorial will use stock photos to show a rugged hero patrolling the city under a rain-soaked, miserable night. The photo is a stylized black-and-white with a single splash of color.

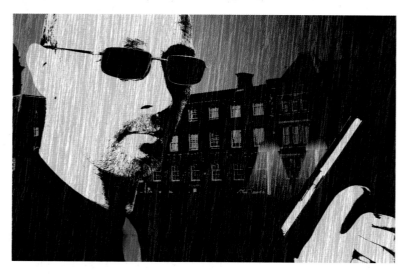

Black-and-white images can send a powerful message, especially with just a small touch of color.

Establishing the Base Image

The base image shows our main character, a tough guy with a gun, on a solid, light-colored background. This image has a 1600 × 1067 pixel resolution.

1. Desaturate the original image (**Colors ▸ Desaturate**), which is named *Man* in this project. Choose the **Lightness** option for this image, which will allow the contrast between his face and the backdrop to remain high.

2. Open the Levels dialog (**Colors ▸ Levels**). Set the white point by clicking the white point eye dropper (right side beneath the levels histogram), then clicking the upper right background of the image. This makes the background completely white, with the white point slider moving to just left of center of the histogram. Move the black point slider to the right until it's very near the white point. The result will be an almost completely black-and-white image.

The style for this project requires a high-contrast adjustment of the original stock image.

Making It Rain

1. Add a transparent layer (**Layer ▸ New Layer**). Name this layer *Rain 1*. Open the Hurl filter (**Filters ▸ Noise ▸ Hurl**). The default settings are sufficient here: Random seed = 10, Randomization % = 50, Repeat = 1. Click **OK** to render the noise in the layer. The noise will be colored, so desaturate it. While the Lightness option was chosen here, any of the desaturation options will work.

2. Open the Motion Blur filter (**Filters ▸ Blur ▸ Motion Blur**). Set the Blur Type to **Linear**, the Length to **120 pixels**, and the Angle to **90 degrees**. Click **OK** to apply the blur to the noise in the layer. Note that this blur will be hard to see in the Motion Blur dialog's preview, but that won't affect this step.

3. Scale the layer (**Layer ▸ Scale Layer**) by 140 percent. This is done by changing the scale units menu in the Scale Layer dialog to **percent** and the Width to **140**. The Height field will automatically adjust to maintain the width-to-height ratio when the **Scale** button is pressed.

4. Zoom out to see the layer boundary for the Rain 1 layer. Choose the **Shear** transformation tool from the toolbox. Click the image and drag until the edges of the shear preview touch the right and left edges of the image window. Click the **Shear** button in the dialog to apply the transformation.

5. Open the **Levels** dialog and adjust the black point to around **107** and the white point to around **116**. The actual settings will vary based on personal taste for the appearance of the falling rain. Reset the layer to fit the image (**Layer ▸ Layer to Image Size**).

6. Add a second layer of rain, using the same process as the first layer of rain but with less shear applied so the rain falls more vertically. The Levels adjustment may also be slightly different, again according to taste. Later, because of the contrast changes brought on by adding in background elements, the two rain layers' Modes and Opacity may need to be adjusted. Name the second rain layer *Rain 2* and make sure it's above the Rain 1 layer.

Motion-blurred noise is a quick way to fake rain.

7. The base image needs to be masked in preparation for adding a background. Click the base image layer in the Layers dialog to make it active. Add an alpha channel to it (**Layer ▸ Transparency ▸ Add Alpha Channel**). Add a white layer mask to the base image layer (**Layer ▸ Mask ▸ Add Layer Mask**).

8. Open the original image again. You can use the color aspect of this image to create a good mask. Choose the **Fuzzy Select** tool in the toolbox. Set the Threshold to anywhere between 70 and 90 and click the center of the blue area to the right of the man's head. Then hold down the SHIFT key and click the blue area to the left of the man's head. Repeat this process for the blue areas inside the trigger area of the gun. Copy (CTRL-C) and then paste (CTRL-V, followed by **Layer ▸ Anchor Layer**) this selection into the mask of the base image layer. Use the Levels dialog to set the black point to **254**. The checkered pattern that represents transparent regions in the image will show up where the blue areas were in the original image.

Masking the background will allow a more appropriate background to show through.

Adding a Background Building and Lamp Posts

1. Open the background building image. Scale it to fit the size of the base image layer (**Image ▸ Image Properties**).

2. Click the **Rain 2** layer in the Layers dialog. This is necessary because you can't paste a new layer if a mask is currently active from a previous step.

3. Copy and paste it into the base image and drag the new layer to the bottom of the layer stack. Name the building layer *Building*. Turn off the visibility of all other layers (click on the layer visibility icon to the left of the thumbnail) to make these next steps easier.

4. Desaturate the layer. Open the **Levels** dialog. Click the white point eye dropper and then click the darkest part of the sky. Drag the black point slider toward the white point slider until the building walls are almost completely black. If any clouds

remain in the background, drag the white slider to the left a bit more. Click **OK**, and then turn on the visibility of all other layers.

We've used this image before—with some cropping and some new lighting, the building from Section 2.7 is now a dreary tenement. Saving stock images in a library is a good way to save on your design projects.

5. Before adding lamp posts, the building's front entrance needs to be moved to the left. Open the Scale dialog (**Layer ▸ Scale Layer**). Click the chain link between the Width and Height fields to break it in order to change the aspect ratio of the layer. Scale the Building layer by **165 percent** wide and **140 percent** high. Apply this setting.

6. Use the **Move** tool to drag the layer to the left until the chimney and inverted-V-shaped rooftop are to the left of the gun. Be sure not to drag it so far that the right edge of the building is left of the right edge of the image window. Reset the layer size to match the image size (**Layer ▸ Layer to Image Size**).

7. Add a transparent layer and name it *Guideline*. Move the layer to just above the Building layer. Set the foreground color to a medium gray (HTML Notation set to **cbcbcb**). Use the

Pencil tool to draw a thin line from left to right at roughly the height of the top of the first floor of the building. This guideline will be used to draw the lamp posts. Later, this layer will be removed.

The guideline is temporary and used only to assist in creating the lamp posts. It won't be visible in the final image.

8. Add a transparent layer just above the Guideline layer, naming the new layer *Lamp Posts*. Choose the **Paintbrush** tool from the toolbox. Choose a suitably small brush, just large enough to be visible as distant lamp posts. Draw a straight line to the left of the building's front entrance, from the guideline down to the approximate bottom of the building. Repeat the process for the right side of the entrance. Duplicate this layer and offset it (**Layer ▸ Transform ▸ Offset**) by 3 or more pixels in the X direction. The amount depends on the size of the brush used to draw the posts. Use the Brightness-Contrast dialog (**Colors ▸ Brightness-Contrast**) and reduce the Brightness to **–127**.

9. The rain layers reduce the contrast in the image. In the Layers dialog, reduce the Opacity for each rain layer to around

30 to 50 percent. Click the **Rain 2** layer. Merge it with the Rain 1 layer (**Layer ▸ Merge Down**). Adjust the contrast of the merged layer using the Brightness-Contrast dialog (**Colors ▸ Brightness-Contrast**). The settings depend on the content of the rain layers, but the Brightness should be less than –100 and the Contrast raised to near 127.

Using a temporary layer for alignment purposes is a new trick, but one you'll use frequently for alignment that isn't strictly vertical or horizontal.

Adding Lamps and Lights

1. Add a transparent layer just above the Lamp Posts copy layer, naming the new layer *Lamps*. Create an oval selection in the canvas near the lamp posts. Use the **Rectangle Select** tool to cut out the bottom half of the selection. If necessary, use the Scale tool to appropriately resize the lamp above the lamp post. Use the **Move** tool to position the selection over the left lamp post. Use the **Rotate** tool to align the straight edge of the selection with the guideline. Choose the **Blend** tool and drag a Linear gradient from black to gray starting at the top of the curve of the selection down to the straight edge.

2. Use the **Move** tool to drag the selection over the other lamp post. Repeat the application of the gradient using the **Blend** tool. Clear the selection (**Select ▸ None**).

The top of the lamp posts is a simple half-circle, shown here with the Rain 1 layer visibility turned off to make it easier to see the gradients. The gray, horizontal guideline layer is visible between the lamps.

3. Create a transparent layer and name it *Lights*. Move it just below the Lamps layer in the Layers dialog. Use the **Paths** tool to outline a box below the left lamp. The box should be thin at the top and wide at the bottom with a rounded base. In the Tool Options dialog, convert the path to a selection. Choose the **Blend** tool from the toolbox and configure it to use a linear gradient that flows from white to transparent. Click near the top of the selection in the image window and drag toward the bottom. Follow the line of the lamp post to align the gradient properly.

4. Use the **Move** tool to move the selection under the second lamp. Use the **Scale** tool to adjust the size of the selection if desired and then apply another linear white gradient. Clear the selection.

5. Open the Gaussian Blur filter (**Filters ▸ Blur ▸ Gaussian Blur**) and apply a **10 pixel** blur in both the X and Y directions to the layer. Set the layer Opacity to between 35 and 60 percent. At this point you can delete the guideline layer, or simply turn off its visibility in the Layers dialog.

The lamps aren't strictly necessary, but they're a cool neo-noir touch.

Retrieving a Red Tie

1. Open an image of a gangster with a red tie. Choose the **Fuzzy Select** tool from the toolbox and set the Threshold to **95**. Click anywhere on the red tie. The high color contrast should allow most of the tie to be selected completely with a single click. If there are spots of unselected tie inside the selection, grow the selection by a pixel to pick them up. It doesn't matter if a little area outside the tie is selected. Copy the selection.

2. Paste the selection into the base image and make it a new layer. Name the layer *Red Tie*. Flip the tie horizontally using the **Flip** tool from the toolbox. Desaturate the layer. Choose

a red color from the foreground color in the toolbox. Set the **Lock Alpha Channel** box in the Layers dialog. Choose the **Bucket Fill** tool from the toolbox. Set the Mode in the Tool Options dialog to **Grain Merge** and the Affected Area to **Fill Whole Selection**. Click in the **Red Tie** layer to recolor the image. This process is done specifically to remove out-of-gamut colors for prints. Further adjustments may be required if you have Color Management configured in the Preferences dialog (Edit ▸ Preferences). Use the **Move** tool to position the tie in the proper location on the man's chest. Set the tie layer to the image size.

3. Move the Red Tie layer beneath the Rain 1 layer.

Further Exploration

The last step is to darken the background so the subject is the focus of the image. To do this, add a transparent layer just above the Building layer. Fill this layer with black. Add a layer mask to it. Choose the Blend tool from the toolbox and configure a Radial shape that runs from black to medium gray. Click in the middle of the man's face and drag toward the index finger on the gun to draw the radial, black-to-gray mask.

To give more depth to the image, you can use two layers of rain. Put the Rain 1 layer between the man and the building layer and create a new Rain 2 layer at the top of the layer stack.

A splash of color draws attention to the mobster. The inset image shows the selection with Quick Mask enabled and the mask color set to green.

INDEX

overview, 49

previews of, 5

subtle, 150

tips for using, 52–53

using Gradient editor,
51–52

using Shape setting with,
49–51

Grain Extract mode, 21, 182

Grain Merge mode, 21,
201, 203

grayscale in advertising,
153–154

Grayscale mode, 14, 154

grays, increasing middle,
79–80

guides, 8, 28

H

Hard Light mode, 20, 76–77

Heal tool, 4

heavy metal text effect,
225–228

Help menu, 8

highlights
adding, 210
of buttons
lower, 122–123
upper, 122–124
in icons, 147
Lens Flare and Gradient
Flare filters, 271–272
reflective, 169–172
in tabs, 131
in wine bottle effect,
187–188

high pass filter, 71–73

HSV Noise filter, 157, 266

Hue mode, 21

Hue-Saturation dialog, 86

Hurl filter, 181, 238, 281

I

icons
adding application
IDs to, 148
adding highlights to, 147
adding patterns, 145–146
checkered pattern, 144–145
gradient fills, 144
masking bottom of, 146
overview, 143–144
identity, defined, 179
Image menu, 7
images. *See also* effects;
restoration
alignment of, 60
colorizing using layer mask,
22–23
creamsicle love example,
273–279
fire girl example, 259–265
mobsterville example,
280–285
processing, 60–61
ripping edges of, 66–67
scanned, enhancing,
99–100
scanning for web design, 150
star field example, 266–272
using layer mode, 22
image window
features of, 7–8
menus, 6–8
overview, 6
Incremental checkbox, 272
Independent RGB
checkbox, 224
Indexed mode, 25–26

Inkscape tool, 44

Ink tool, 4, 14

inner glow, 111

Inner Ring layer, 182

intensifying light, 206–207

International Typeface
Corporation
website, 255

Intersections option, 185

Invert mask checkbox, 182

Invert option, 107, 261

iPods
drawing earphones, 215
overview, 212–214
placing in pocket, 215
shadows, 216

irregular shapes, 42–43

IWarp filter, 66, 101, 252

J

jaggies, eliminating, 217

JPEG format, 53, 59

K

Keep Aspect option, 91

L

layer boundaries, 28

Layer Boundary option, 203

layer mode, 19–20
in advertising, 217
using to colorize images, 22

layers
blending, 74
duplicate, 86
editing, 256
groups of, 18
Layers dialog, 17–19
mask, 158–159

merging, 72–73

multiple, creating, 261

overview, 17

paint modes, 19–21

text, 157–158

tips for using, 23

using mask to colorize
images, 22–23

Layers dialog, 17–19

Layer to Image Size option,
183, 231, 260, 268

Lens Flare filter, 271–272

letter spacing, 156

Levels option, 268

Levels tool, 115, 175

Lighten Only mode, 20

lighting
adjusting in high pass
layer, 73
casting light through
windows
overview, 105, 108
setting up shadow masks,
105–107
colored
cool lighting, 209
highlights, 210
overview, 208
softening images, 211
warm lighting, 210
diffused light, 204–205
intensifying light, 206–207
rays of light, 205–206
streaks of light
enhancing, 111–112
inner glow, 111
outer glow, 110–111
overview, 109–110

Lighting Effects filter, 233

Light Pill layer, 121

Q

Quick Mask feature, 34–35, 84–85
Quick Mask to Selection button, 103

R

Radius setting, 15–16
rain effect, 281–282
raised lettering, 182–184
Randomize checkbox, 203
Random Seed value, 226
rasterized text, 255
Rate value, 13
RAW formats, 59
rays of light, 205–206
Rectangle Select tool, 2, 41, 82–83
Red Eye Removal tool, 60
reflection effect
 adding to buttons, 126–127
 on glass
 adding shadows, 93–94
 adding surface for reflections, 92–93
 creating reflections, 92
 overview, 91
 placing reflections on surfaces, 93
 preparing for, 91–92
 on lake
 adding ripples, 96–97
 adding waves, 97–98
 creating initial reflections, 96
 overview, 95–96
reflective highlights, 169–172
Remove All Guides option, 120, 145

Replace mode, 176
resource folders, 10
restoration
 backgrounds, 103–104
 enhancing scanned images, 99–100
 facial blemishes, 102–103
 with multiple patches, 101–102
 overview, 99
 with single patch, 100–101
Retinex tool, 69
Reverse button, 53, 93, 189
RGB color mode, 25–26
RGB Noise filter, 46–47, 195, 224
Ripple filter, 203
ripples, adding, 96–97
rips
 overview, 66
 ripping image edges, 66–67
 tips for, 67
Rotate 90° clockwise option, 48, 192
Rotate 90° counter-clockwise option, 164
Rotate 180° option, 191
Rotate tool, 3, 44, 187
Round brush, 41
Rounded Corners option, 120, 129
Round Fuzzy brush, 74
rulers, 8

S

Saturation mode, 21
saving banners, 137
Scale Image option, 134, 268

Scale tool, 3, 65, 199
scanned images
 enhancing, 99–100
 for web design, 150
Scissors tool, 3, 32
Screen mode, 20
Select by Color tool, 2, 32, 260
Selection from Path button, 170, 186
Selection Mask copy channel, 122
selections
 complex, 84
 constraints, 28–29
 creating masks from
 feathering, 33–34
 overview, 33
 Quick Mask feature, 34–35
 discarding, 35–36
 editing, 27–28
 effects and, 115
 Foreground Select tool, 32–33
 Free Select tool, 30–31
 Fuzzy Select tool, 31
 modes, 29–30
 overview, 27
 painting, 85–86
 Scissors tool, 32
 Select by Color tool, 32
 tips for using, 37
 tools for, 27
 working with, 36–37
Select menu, 7
Select Transparent Areas option, 111
sepia tones, 80–81, 115
shadow masks, 105–107

shadows
 adding on glass, 93–94
 adjusting in high pass layer, 73
shapes
 irregular, drawing, 42–43
 predefined, drawing, 43–44
 simple, drawing, 41–42
Shape setting, 49–51
Sharpen filter, 200
sharp scans, 115
Shear tool, 3
shiny emblem effect
 adding inner borders, 181–182
 adding raised lettering, 182–184
 creating emblems, 181
 creating metallic borders, 179–180
 overview, 179
shortcuts, 9
Shrink option, 44, 107, 193
simulated cloth pattern, 47–48
Single-Window mode, 1–2, 6
sketch effect
 adding depth, 76–77
 adding touches, 77
 converting images to sketches, 75–76
 overview, 75
Slur filter, 243
Smudge tool, 4, 263
Snap to Grid feature, 185, 198
snow
 adding to text, 243–244
 falling, creating, 244–245
Sobel filter, 76
softening images, 211

UPDATES

Visit *http://nostarch.com/gimp2* for updates, errata, and other information.

The Artist's Guide to GIMP, 2nd Edition is set in New Baskerville, Futura, and Dogma. This book was printed and bound at Tara TPS in Paju-si, Kyunggi-do, South Korea. The paper is 100gsm FSC NEO matte art, which is certified by the Forest Stewardship Council.